WOMAN'S HOUR

From Joyce Grenfell to Sharon
Osbourne
Celebrating Sixty Years of
Women's Lives

Foreword by Jenni Murray

LARGE
PRINT

First published 2006
by
John Murray (Publishers)
This Large Print edition published 2007
by
BBC Audiobooks Ltd
by arrangement with
Hodder & Stoughton

UK Hardcover ISBN 978 1 405 64869 1
UK Softcover ISBN 978 1 405 64870 7

Introductions © Martha Kearney, Sue MacGregor
and Jenni Murray 2006

British Library Cataloguing in Publication Data available

Printed and bound in Great Britain by
Antony Rowe Ltd., Chippenham, Wiltshire

Contents

Illustrations

All photographs © BBC Photo Library.

Acknowledgements

At the BBC research and editing by Chris Burns, Kathleen Griffin and Kate Murphy. Thanks also to Celia Levett, Debbie Gill and Mike Levett, and at John Murray (Publishers) to Edward Faulkner and Caro Westmore.

'Annus Mirabilis' from *High Windows* by Philip Larkin is reproduced by kind permission of Faber and Faber Ltd.

Every effort has been made to clear permissions. If permission has not been granted please contact the publisher who will include a credit in subsequent printings and editions.

Foreword

Jenni Murray

On 12 May 1950, one Jenni Murray (née Bailey) was born at St Helen's Hospital, Barnsley. It was a converted workhouse—leading to a lifetime of jokes on my father's part about my being born 'on the parish'—but also a chilling reminder of how recently the old and wicked systems of caring for the poor had disappeared before the introduction of the Welfare State. It also illustrated how much working people in the industrial North still feared the ultimate degradation of having no work and no money to live on.

Woman's Hour had begun on 7 October 1946, four years before I came along and two years before the creation of the National Health Service in July 1948. Much of what I know about the factors in this new post-war order that determined how women lived their lives—including those of my grandmother, my mother and myself—has been gleaned from *Woman's Hour*. The information comes partly from trawling through the programme's archive, which one radio critic, Paul Donovan of the *Sunday Times*, described thus: 'The history of the programme—through austerity, affluence, permissiveness, feminism, Thatcherism and post-Thatcherism, is almost the story of women in Britain since the Second World War.' A lot of my knowledge, though, comes simply from being a listener and is lodged in a lifetime of memories of what the voices on the radio told me—through

childhood, my teens, my student years, life as a professional woman, then as a young mother, in middle age and through the menopause.

So, back to May 1950. There were two weeks in hospital for mother and baby to recover from the birth. This was the start of the NHS control of pregnancy and neo-natal development. My mother still doesn't like to discuss the details of our first days together. Suffice to say that, three or four years earlier, it would most probably have been a delivery at home with an experienced and knowledgeable midwife. We can't deny that better access to free care has improved the life chances of babies who face a difficult delivery, but it has had disadvantages for the majority for whom there need be no problems. In the view of mothers and midwives alike, the past sixty years have seen too much of women being told how to do what should come naturally.

We were among the victims of those early years and I have no doubt that the hospital experience contributed to my being an only child. Other women who have spoken to the programme have described similarly nightmarish ordeals; they simply couldn't face it again. Nor were dads exactly welcome. My father was excluded from the delivery room and from any sight or sound of me, except through the glass walls of the nursery, until it was time to leave the hospital. Even when we came home his role was to go out and earn the 'pennies for Jennifer'—I don't think he ever changed a nappy—and my mother's care of me at home was as regimented as it had been in the hospital. The Truby King feeding method prevailed, requiring a strict routine for baby. Feeds

were four hourly, regardless of grizzling or even screaming from starvation. There should be fresh air in the morning—I'm told the pram was put out even in the snow—and for the rest of the day, apart from feed times, the baby should be 'put down' and never picked up when sobbing for fear of 'spoiling the child'.

But those four-hourly feeds meant that *Woman's Hour* was perfectly placed for the young, nursing mother. They started at two in the morning, then the next was at 6 a.m., at 10 a.m. and, of course, at 2 p.m. Women all over the land must have sat in a comfy chair, feet up, baby attached to the breast or, more rarely in those days, the bottle, and listened to the programme. So, I reckon my association with *Woman's Hour* must have begun sometime around 26 May 1950—a couple of weeks after my arrival and four years after the programme began—and I was a regular daily listener until starting school at the age of four and a half.

Even as I grew older, that hour after lunch was sacrosanct. During preschool and primary school holidays we would start with *Listen with Mother*— Mum in the big chair, me perched on what used to be known as a pouffe (now with a rather different connotation!) next to the big Bush radio, which lit and warmed up when switched on and boasted such exotic potential as tuning in to Hilversum or Luxembourg. I was to discover these stations much later with my own tranny hidden under the bedclothes.

In the sitting room it was strictly the Light Programme or the Home Service—*Workers' Playtime*, *Children's Favourites* and, day after day, 'Are you sitting comfortably?' to which I would

shuffle and respond, politely, 'Yes, thank you.' And then, after the programme designed for me, came the one made for my mum ... 'and now *Woman's Hour*,' with Jean Metcalfe, Olive Shapley, then Marjorie Anderson and later Sue MacGregor. Alan Ivimey, the first presenter, lasted for only a year, so I never heard the programme's subject matter discussed by a man. But those daily dates with regular broadcasts helped me develop a listening habit, gave me the idea that women could occupy the airwaves with just as much authority as a man and established speech radio as the constant soundtrack to my life.

The controller of the Light Programme, Norman Collins, was responsible for commissioning the programme and based his decision on what he described as 'careful research into listening habits ... 2.00 to 3.00 p.m. on weekdays seems likely to suit the majority of listeners as the morning household tasks and the lunchtime washing up will be over, but the children not yet back from school'. It was a time of day that certainly suited the lives of the majority of women of the time. The war had opened up new opportunities for women, which had closed down with the speed of a steel trap once the hostilities were over and the survivors came back from the front looking to go out to work.

It was assumed that the women of the 1940s and 1950s would be happy to return to their housewifely duties, and the emphasis in women's magazines and on *Woman's Hour* was geared to that assumption. Although *Woman's Hour* always seemed to manage to intersperse the more traditional feminine pursuits (how to knit your own stair carpet, deslime a flannel and reuse your

blackout curtains) with items on work outside the home, politics and culture, it was primarily to focus on family, domesticity and how to look lovely for the man in your life.

Mum and I bought the lot, and I spent most of my childhood and early teens as a pint-sized replica of her—all twinset, pearls and curls tortured into my hair with a home perm called Twink. (It wasn't until my mid-teens that I began to hear of Vidal Sassoon and Mary Quant, after which I bobbed my naturally dead-straight hair, turned my school skirt over and over at the waist until it was no more than an extended belt and began a lifetime of disagreements with my mother—only recently resolved—about what a woman should wear to appear ladylike and respectable!) There were occasions during my pre-school years when subjects such as birth, family planning or the change of life came up on the programme. After the health warning (the presenter always cautioned when the 'next item was of a nature that might not be suitable for our younger listeners') I'd be packed off to the kitchen or even out to the garden for as long as it lasted.

As I got a little older, when subjects such as 'Equal Pay' or 'My Job' came up, Mum and I would discuss them. Should women go out to work? Should we expect to be paid the same as a man? She was a woman of her time and firmly believed that women should stay at home with their children, should have the welfare of their man as their prime concern and should not expect to compete with a man who needed to bring home a 'family wage'. But I absorbed the stories of women who had to bring up a child alone or who were

xvii

desperate to fulfil their own ambitions as well as having a husband and a family. I began to realise even at that early stage that there was inequality and it wasn't right!

The question arose for us at home, big time, towards the middle of the 1960s. I was fourteen and longing for independence. Dad was a busy electrical engineer, making his way, travelling in this country and abroad, working long hours even when he was UK based. We saw little of him. Mum spent some time travelling with him but, increasingly recognising that a testing teenager needed a younger and firmer hand than that of my grandmother, decided to become a full-time mum again.

Disaster. She'd be on my back twenty-four hours a day, seven days a week, and was clearly going quietly round the bend with boredom. I persuaded her to get a job. She did, although it took a huge effort of will and encouragement for her confidence to be boosted enough for her to go out into the world again at the age of thirty-eight. But I'd heard one of those 'women returners' chats on *Woman's Hour* and clocked that others were doing it, so why shouldn't she? She was transformed. Dad was consumed with shame ('People will think I can't afford to keep her') and she, to save his face, always breezily explained away her earnings as 'pin money from her little job'.

She ended up virtually running Barnsley Town Hall and did once confess that, even though she had never had to ask Dad for anything—men's earnings in respectable working-class families of the time were delivered to and managed by the woman of the house—she felt much less guilty

about 'treating' herself to clothes or shoes when she'd earned the money herself.

The only real row I ever remember having with my dad followed another discussion on the programme. It must have been around 1965, two years after the publication of Betty Friedan's *The Feminine Mystique*, which Betty later told the programme was about 'the restructure of society in a way so that men and women can move equally in the world outside the home, so that women can have a share in the decisions that affect their lives. And we must restructure the home,' Betty continued. 'Mother and father must take equal responsibility for the children. The home should no longer be a woman's world and the world outside the home can no longer be a man's world.'

Armed with all the arguments necessary to a budding feminist, I asked Dad why when he came home from work did he change, sit down at the table, eat his food, pick up his paper and sit down by the fire when Mum had also been out to work, done the shopping, cleaned and tidied, cooked the food and was now clearing the table and about to do the washing up and then the ironing. He'd obviously never so much as thought about it and said he didn't mind helping her out. He got the tirade about how 'helping' wasn't the point. Everybody had to eat, wear clean clothes and live in a tidy environment, so why wasn't it just shared equally? It was dismissed as a teen rant. He never did learn until, bless him, in his seventies he ended up as Mum's carer and now does everything. But the issues contained in that youthful outburst would be the foundation of beliefs that would inform the politics of my entire life.

Throughout my time at university—from 1968 to 1972—and beyond, into my years of establishing myself professionally, I could always rely on *Woman's Hour* to keep me up to date on the hot topics of the burgeoning women's movement. It was there that I was introduced to the great feminist thinkers of the time—Greer, Friedan, Millett, Morgan—they were all guests on the programme. At a time when most guys seemed to think it was OK to cop a feel by the copying machine or the filing cabinet, and during which it never really occurred to me that I might be paid less than my fellow baby broadcasters, my eyes were opened by discussions about sexual harassment, domestic violence, equal pay and sex discrimination.

It's made me only too aware of the importance of the political issues discussed on the programme in making sure listeners had information they might never have found elsewhere. In 1975 I was trying to buy my first house. I trudged from building society to building society in search of a mortgage. Even though I had a job with a regular salary and no history of bad debt, no one would consider me without, as they put it, the signature of a husband or a father. A conversation on *Woman's Hour* about the provisions of the new sex discrimination legislation sent me scurrying back, threatening legal action if I were still to be denied finance in my own name. I got the mortgage.

The most spine-tingling moment of my life came in the mid-1970s when my day job was presenting a three-hour daily magazine programme on the local radio station. Carole Stone, then producer of *Any Questions?* and the Bristol regional edition of

Woman's Hour, asked me whether I'd be interested in doing one of her programmes—they came round on a Friday, around once a month. The schedule in those days consisted of Monday to Thursday in London, introduced by my hero, Sue MacGregor, with the Friday programme being shared around the regions—Manchester, Belfast, Glasgow, Birmingham, Cardiff and Bristol. I leapt at the chance.

'And now *Woman's Hour*, with Jenni Murray . . .' I'm not quite sure how I managed to find enough breath to say, 'Good afternoon,' but I did. I felt I'd finally come home. I loved everything about it: the politics, the novels, the plays, the emotional stories of grief and triumph over tragedy, the girlie giggles over fashion and fellas, the womanly pursuits in the kitchen. It was my life, my interests, and you could actually earn a living at it. I've never envied anyone more than I did Sue MacGregor who got to do it four times a week.

In 1976, after I'd been involved for a few months, we regional hicks were invited to Broadcasting House in London, to celebrate the programme's thirtieth birthday. It was a small party, held in the bowels of BH in the London studio (Mecca for me at the time), and I was introduced to Sue (charming and welcoming—not the sort to pull up the ladder after her own success, but keen to encourage a young hopeful) and Marjorie Anderson who'd been there throughout my childhood. She was elderly by then and not very well, and I shyly introduced myself as a fan. She realised I was quite overwhelmed at being in her presence and told me, smartly, not to be so silly. 'After all, dear, you're doing it now. It's not such a

big thing.' But it was . . . and, if I'm honest, it still is.

Whenever I could, wherever I went—regional TV in Leeds, then Southampton, *Newsnight*, *Today*, I did my best to keep a foot in the door in Bristol. In 1985, Sue MacGregor began to present *Today* on Monday and Friday. I was asked to begin the Saturday programme with John Humphrys, present a couple more *Today*s during the week and the London edition of *Woman's Hour* in place of Sue. I was edging closer, but all the while getting the kind of news and current affairs experience that would stand me and the programme in good stead when faced with politicians and movers and shakers not only from Britain but from all over the world.

Ed, my first-born, arrived at Southampton in April 1983 and thanks to listening to *Woman's Hour* I had the right steer on how to negotiate the kind of birth I wanted. Natural childbirth was one of the hot topics of the time and a young senior registrar (male) and an older midwife (female) conspired with me to persuade the rather old-fashioned consultant to give me as much control as possible over a hospital delivery. It was quiet, private and, with the aid of a bean bag over which I crouched, as natural as can be in a clinical environment. By the time Charlie came along in June 1987, we'd moved to London, and the St George's Hospital midwifery staff were among the few health professionals in the country who were happy to attend a home birth.

I finished the *Today* programme on the Saturday morning just before the 1987 election and recall getting rather tired of reassuring Norman Tebbit that I wasn't about to give birth during his

interview. I lumbered around all day Sunday and had my baby, at home, on the Monday. The following day *Woman's Hour* called me to talk to me on air about the experience of giving birth at home—terrific and a form of delivery I heartily recommend—and the following Saturday I was back in the driving seat, operating a system of expressing milk for feeds during my absence to rival the Milk Marketing Board.

Two months later came a phone call early on a Sunday morning from the newly appointed editor of *Woman's Hour*, Clare Selerie. The controller was keen that Sue and I should stop presenting the same two programmes and would prefer one of us to do *Today* and the other *Woman's Hour*. Would I be prepared to take over Sue's position? Would I? I couldn't wait. News and current affairs was fascinating and thrilling—there's nothing quite like being in the thick of it when a major news story is breaking, but *Woman's Hour* offered that huge range of subject matter that comes under the heading of women's interests. Politics, literature, films, theatre, cooking, gardening . . . anything and everything, and in much greater depth than a news programme can cover. I can honestly say that I've never known a single day's boredom since I began.

Woman's Hour's place in the nation's affections has never been clearer than when it came under threat in 1991. The then controller, Michael Green, had identified what was described as a 'hammock' in Radio 4's listening figures in the middle of the morning—somewhere between *Today* and *You and Yours*. Canvassing of listeners had revealed a hunger for a magazine format. Well, he said, *Woman's Hour* was a magazine and it could

easily be moved from 2 p.m. to 10 or 10.30 a.m. Whilst he was at it, Michael thought it might be a good idea in 'a post-feminist age' to get rid of the title *Woman's Hour*.

It was flattering to have *The Jenni Murray Show* suggested, but not at the expense of a programme title and a focus that I and millions of others had so cherished. The editorial team (Sally Feldman, Clare Selerie and me) resolved to do whatever we could to retain the name and the programme's ethos, even it meant conceding on the time. We did try to argue that two o'clock was the most convenient time for women to listen—aided and abetted by Brian Redhead, who came up with the slightly misguided gem that, 'Without *Woman's Hour* at two o'clock, there wouldn't be a decently ironed shirt in Britain.'

We did mention to Michael Green that a slot after lunch had always been a good, quiet time for women at home, whereas the morning tended to be for hoovering, washing or going out to the shops. He was unmoved and even suggested the women of Britain could hoover at a different time if they really wanted to catch the programme. In stepped the big-gun fans. Madam Speaker, Betty Boothroyd, called to ask, 'What can the sisters in Parliament do?' There were Early Day Motions and questions asked in the House, and a constellation of actors, writers, musicians, chefs and fashion designers leapt to the programme's defence.

In the end, I think it was partly the barrage of complaints, coupled with the editor's strategy of bringing in a marketing consultant (who gave her services free—a radio budget could never have run to paying her), that swung the decision to retain the

name. She argued powerfully that a great brand name should never be put at risk. You might, she said, update the image of Marmite or Jammy Dodgers, but not change a name that is so recognisable. Similarly, if you ran a shop called Marks and Spencer's, you might move it a few doors down the High Street, change the shelves around and update the logo, but you don't call it something else. We moved, but kept *Woman's Hour*.

As far as the timing was concerned, Michael Green was proved to be right. There was a much larger available audience at that time of the morning and since then the programme has simply gone from strength to strength. The most recent listening figures in this sixtieth anniversary year rose to record levels, and the male audience, consistently hovering around 30 per cent from as long ago as 1946, went up to 40 per cent, reflecting the enormous changes that have taken place in the domestic agenda, with more men sharing work outside and inside the home as they are slowly enabled to spend more time being fathers than at any time in the past.

I'm not sure that Michael ever lived down the reputation of being the man who nearly abolished *Woman's Hour*. He began to fear going out to dinner or parties. He and his wife decided to escape the constant barrage of female fury by taking a holiday in the more remote hotels of Spain, off season. They were having a quiet dinner *à deux* one evening when the only other couple in the dining room invited them to join them for coffee and liqueurs. They felt quite safe until it came to a conversation about jobs. Michael carefully avoided

the topic until eventually he had to confess that he worked for the BBC, as a manager ... well, as a controller ... of Radio 4. 'You!' shrieked the woman, poking him with a furious finger. 'You are the man who tried to get rid of *Woman's Hour*!'

People always ask me who, among the thousands of people I've faced across the table over the years, really stands out. I suppose it was Jack Nicholson who finally blew the entirely erroneous contention put forward by certain journalists that I might be a man-hater. Like many men who've appeared on the programme—Charles Dance on his 'menopause', Michael Howard on his father's breast cancer, Michael Caine on touching his premature baby in the incubator, Tony Blair on what he's missed as a father, Gordon Ramsay on his dad—Nicholson seemed to feel free to discuss his emotional life in a way he would never have attempted elsewhere.

He explained his love, but ultimate mistrust, of women thus. His 'mother' and 'sister' ran a beauty salon, the first in America to offer the kind of perm that involved curling lotion and hot clamps, warmed up on a huge electrical contraption. Little Jack was allowed to hang around, and was pampered and spoilt by dozens of women. He saw them looking their worst and their best, and he adored them all. It wasn't until his thirties that he discovered the terrible lie at the centre of his life. He had been born illegitimate. His 'mother' was in fact his grandmother and his 'sister' was his mum. He told me all with such heart-rending flirtatious charm that I was ready to forgive him anything— even his appalling treatment of the wonderful Anjelica Huston and his affair with his daughter's best friend. When I listen again now, the arch-

feminist inquisitor is just a hopelessly seduced, giggling girl. All he'd have had to do was whistle!

Over the years, I've met all my heroes—Margaret Atwood, Bette Davies, Gloria Steinem, Lauren Bacall, Dusty Springfield, Barbara Castle, Shirley Williams to name but seven, and never found them to be other than charming, giving and fascinating. But it's Joan Baez who will always stand head and shoulders above the others. In the 1960s my best school friend, Linda Mead, and I wanted nothing more than to be her. We grew our hair long and straight, and practised for hours in Linda's front room until we knew every song on every record. We'd go into Barnsley on a Saturday night to the Wheatsheaf pub, where the folk club was held, and stand up on 'Welcome All Comers' nights to sing what we'd learnt.

Linda married a Frenchman soon after graduation and the night before Baez was due to be a guest, I called her at her home in northern France. 'Guess who's on tomorrow,' I asked her. She got it in one and could barely contain her envy and nervousness—supposing she was horrible?

She wasn't. She was beautiful; the exquisite cheekbones were more evident now that she was older and had cut her hair short (my mother was right—wearing your hair like a pair of drawn curtains did conceal a pretty face!) We talked about the music, the voice and her love of Bob Dylan. Eventually we got round to the civil rights movement and the rumour that late one night, after a long and exhausting rally, Martin Luther King had been so wired and tired that he hadn't been able to sleep. Was it true that she sang him to slumber? She confirmed that it was true, sat back

from the microphone and sang, with no accompaniment, the spiritual she had sung to him that night. The hair stood up on the back of my neck.

I never embark on any interview without a hint of butterflies. It's my belief that the day that the nerves go is the day you become dangerously complacent and lose the necessary edge to perform on demand, but I've only twice been truly terrified. On both occasions the subject was Margaret Thatcher—fiercely intelligent and uncompromisingly bullish. I prepared for days, knowing what pleasure she would take in catching me out.

The first time—at Downing Street—I scored a small triumph. She batted aside any suggestion that women needed help with childcare if they were to fulfil their ambitions, blithely ignoring my questions about her rich husband and the nannies she'd been able to afford as a result. She expressed her loathing of the crèche society she'd witnessed in the then Soviet Union and suggested that any woman who wanted to keep her hand in could perhaps do 'a little part-time work with the help of a grandmother or an aunt for a few hours a week'. She was clearly unaware that a recent poll had shown that the Conservatives enjoyed least support among women of childbearing age and I floored her with a question about it. A small triumph!

Our final encounter was in the studio on the occasion of the publication of her autobiography, which contained a few fascinating insights into her irritation with the old-guard Tories who treated her as though she were the cleaning lady. I planned to discuss with her how she coped so effectively with

difficult men and how she dealt with the constant, annoying references to her gender. I genuinely believed she might be ready to share her tactics for the benefit of others. I mentioned, in posing the question, the habit of the press of referring to her 'handbaggings'—you could never imagine a male Prime Minister being accused of 'briefcasing' an errant colleague. I also referred to Alan Clark drooling over her ankles in his diaries, and the fact that President Mitterrand had said that she had the eyes of Caligula and the lips of Marilyn Monroe. One of the Sunday critics told how he'd listened with interest to the exchange and had never before known his radio to freeze over!

Woman's Hour has never been afraid to ask the tough questions of politicians with responsibility for those areas of politics that affect our lives most closely, although they have, at times, made the mistake of assuming that sisterly solidarity might mean an easy ride. Most recently, the Secretary of State for Culture and Sport and the Women's Minister, Tessa Jowell, appeared on the programme to discuss the report of a Women and Work Commission, which had come up with what a majority of experts in the field thought were entirely inadequate proposals for closing the pay gap.

After a lively exchange about the report came the question everyone was waiting for me to put, but would I dare? Jowell was caught up in the middle of a scandal concerning her husband's business affairs. She was said to have signed a mortgage form without asking too many questions about the source from which it would be paid off (allegations of corrupt payments from the Italian premier were

flying around the press). In the gentlest of tones I asked whether we were really to believe, with her reputation as a self-confessed feminist, that she had signed such a form simply on her husband's say-so. She left the studio with her credibility as an advocate of women's right to independence somewhat dented. Our interview led the news on radio and TV, and was widely quoted in the press.

An encounter with Edwina Currie demonstrated the value of having a presenter with experience and a long memory. She had been the Health Minister in 1987 when the government launched its cervical screening programme. She made what I thought at the time was an unfortunate value judgment when she appeared to launch the plan. She declared herself perfectly happy with the five-year recall system as she'd been married to the same man for seventeen years and didn't smoke. She advised other women not to do things that would put themselves at risk (hinting for the first time that some forms of cervical cancer are sexually transmitted), including, like her, avoiding infidelity.

I remembered this exchange when she made the explosive confession in her diaries that she had had a long extramarital affair with the former Prime Minister, John Major. She gave the date in 1987 when she had sent him her 'Dear John' letter to end it. It rang a bell. I checked back in the archive. It was the very same day we'd had our discussion. When she joined me to talk about the diaries I reminded her of our earlier interview and asked her why she'd lied about her personal circumstances, whilst expecting the rest of us to behave with the highest sexual standards. It's the only time I ever saw her lost for words and, again,

the press had a field day with what had been revealed on *Woman's Hour*.

There are some interviewees who need to be drawn out with a gentler touch. One such was Monica Lewinsky, the young intern who had been maligned as a result of her short encounter with President Clinton. He claimed on television *not* to have had sexual relations with her. She was young, plump, pretty and really rather delightful, terribly nervous and ashamed.

She described how, as a twenty-one-year-old, she had been seduced by the overwhelming, full-on personality of a man generally acknowledged to be one of the sexiest and most charming in the world. I'm sure most of the audience were asking themselves, who wouldn't have been tempted? When it came to the really tough question about *that* dress and how a frock with a semen stain came to be hung back in the wardrobe, I simply asked her why she'd done it; wasn't it just a bit yucky?

She explained how she'd got home on a high, shoved it away intending to get it cleaned, never got round to it and when she did, she'd got too fat to wear it, so she pushed it to the back of the closet again, never imagining it would become central to a case that would lead almost to a presidential impeachment. She was clearly still a kid and he was a married man in his fifties. It was obvious, I think, to anyone who heard her, where the blame lay.

Other events of which I'm most proud? On the occasion of the seventy-fifth anniversary of women winning the vote, we hired the hospitality area of the Epsom racecourse, looking out on the corner where the suffragette, Emily Wilding-Davison, threw herself in front of the king's horse and was

killed whilst making her protest. To a packed audience of varying ages, the historian Joanna Burke, the former head of MI5, Dame Stella Rimington, Juliet Gardiner, Lowri Turner and Claudia Fitzherbert discussed, in the form of a balloon debate, what had been the most significant events in the liberation of women. Lowri won, arguing for the Pill, and we launched the *Woman's Hour* Women's Timeline. It's the only facility of its kind, detailing every important event in the emancipation of women, and it can be found on the programme's website.

I was also delighted when the *Observer* newspaper recently ranked me among the most influential people in the land when it comes to publishing and guiding the public towards what's good to read. I really should share the plaudits with the production team as we collectively do everything we can to bring good books to the attention of the audience—and it was the editor, Jill Burridge, who had the idea of running a project we called Watershed Fiction. We asked listeners to tell us what books had most changed the way they thought about their own lives, if they were female, and women's lives, if they were male. More than 14,000 people took part (ah! the power and accessibility of the internet) and the winning novels were Jane Austen's *Pride and Prejudice*, Charlotte Brontë's *Jane Eyre*, Harper Lee's *To Kill a Mockingbird*, *The Women's Room* by Marilyn French and *The Handmaid's Tale* by Margaret Atwood.

And so *Woman's Hour*—the longest-running magazine programme ever—is sixty years young and occupies, still, a unique position in the nation's political and cultural life. In 1946 it was described

as, on the one hand, 'laughably obsessed with domestic detail' and, on the other, 'dangerously radical'. Ten years ago, during its fiftieth anniversary, it was variously 'a feminist's forum' and 'a kind of oral WI'. I've always thought those criticisms, running alongside each other, mean that the editors have, generally, got the balance just about right.

Letters—and now e-mails—from listeners suggest they agree. At the time of the move to the morning we were flooded with post, telling us that the programme celebrated women, informed women, educated women and entertained women. Some women told us how *Woman's Hour* had given them the confidence to apply for a job, helped them to cope with a difficult teenager or a screaming toddler, prompted the purchase of insurance or a pension fund that had been put off time and time again. Some even told us *Woman's Hour* had saved lives—encouraging a visit for a mammogram or a cervical smear that had led to early and successful treatment of cancer.

Men have always formed a significant part of the *Woman's Hour* audience and have played an active role in the programme. One husband told us that he'd been able to support his wife through a mastectomy because he'd heard women discuss their feelings after the operation. Another thanked us for being the first to discuss testicular cancer on the radio. He'd examined himself after the broadcast and was treated successfully. We still receive thousands of contributions from you, commenting on the work we do, sometimes agreeing with guests, sometimes not, but generally appreciative of the entertainment and information

the programme provides.

As for me, I'm still learning from our guests. My current dilemma, as a member of the sandwich generation, is how to balance work with almost grown-up children and elderly, needy parents. As an only child, I feel guilt, exhaustion and anger from the strain of worrying about my mum and dad, and my inability to give them more attention than I do. Tony Robinson (Baldrick of Blackadder) told me in one of our most recent programmes that he felt exactly the same and that it was OK to be angry at being so torn and so powerless to get parents better services than are available.

Edna Healey told me recently that her marriage to Denis had lasted so long because they never bothered each other with their worries. A trouble shared, she said, for them was a trouble doubled. It may have been right for them, but for most of us, I think, there's great comfort in hearing that you're not alone. May *Woman's Hour* continue to halve your troubles. I always say to guests on the programme, 'Thanks for being with us.' This is my opportunity, after nearly twenty years, to say the same to you, the loyal listeners, without whom we are pointless. Thanks for being with us and, of course, do join us tomorrow.

The 1940s

The 1940s

Sue MacGregor

For anyone who wasn't around at the time, it may be difficult to conjure up the bleak austerity of Britain immediately after the war. Long after the military battles had stopped, life at home was still a struggle against a series of hardships. Over 350,000 people had died in the fighting, most of them in the armed services, but over 60,000 civilians too had lost their lives, and many families were in mourning for dead or missing relatives. The big cities felt particularly gloomy. From trains heading into London it was possible to see the Blitz bomb damage: houses literally sliced in half, with the remains of bedrooms, bathrooms and living rooms hanging on grimly to ruined brickwork. Much of mainland Europe had it worse than we did, of course, but food in Britain was scarce, and was to be rationed for many more years to come. Bread was 'on the coupon' for the first time in the summer of 1946, joining tea and sugar, clothing, butter and meat. Food shopping involved queueing, often for hours, in the generally vain hope that there would be something interesting to buy at the end of the line.

Britain was a nation of furious knitters. The price of wool became a regular talking point, as did the amazing ingenuity of those who could whisk together a skirt or a pair of curtains from the most unlikely basic materials. (One of the early editions of *Woman's Hour* had a contribution from Northern Ireland called 'Knit Your Own Stair Carpet'—

though sadly no record remains of feedback, if any, from listeners who attempted the job.) Few but the well-to-do had any human help at home; washing machines and vacuum cleaners, if you owned them, were of the most basic kind, and housework was time-consuming and unrewarding. Then, as now, it was considered woman's work; only rarely did male partners help out. The awful winter that was to come in early 1947, one of the worst of the century, with heavy snow and burst pipes, didn't do much to help the nation's morale. For all sorts of reasons post-war people needed cheering up, and radio seemed the perfect medium for reaching the maximum numbers, as very few owned television sets. Radio had brought its share of bad news in the past, but now was the time for the BBC's Talks producers to follow fully the maxim of the Corporation's founding father, John Reith; their duty was not just to educate and inform, but also to entertain.

Woman's Hour's first appearance came more than a year after the end of the war—on 7 October 1946. Both its midwife and, more curiously, its first presenter were men. Norman Collins, who left the following year to head the BBC's revived television service, was then head of BBC Radio's Light Programme. He took a special interest in two brand-new ventures on his network: *Woman's Hour*, and *Dick Barton, Special Agent*, a daily serial with the most wonderful end-of-episode cliffhangers. *Dick Barton*, broadcast just after the main news bulletin of the evening, quickly captured an astonishing audience of 15 million. *Woman's Hour*, with its first presenter a middle-aged writer called Alan Ivimey, attracted rather fewer listeners

4

at two o'clock in the afternoon, but it was considered a perfect time of day for the millions of women at home, perhaps doing the washing-up after lunch, or putting a baby down to sleep. VE Day had brought an end to many of the jobs in which they had happily replaced men, in factories and on the land, and tens of thousands of women had now returned to somewhat dreary domesticity. *Woman's Hour* would cater for them, and it soon had a solid and enthusiastic following; in its first week the programme brought in a record-breaking afternoon audience to the Light Programme of 4.5 million. Norman Collins must have been well satisfied with his new offspring.

Alan Ivimey's opening words on the first edition of *Woman's Hour*—after the signature tune, 'Oranges and Lemons'—promised talks on 'keeping house, on health, on children, furnishing, beauty care—in fact everything concerned with your sort of problems in the home'. There would also be 'a short serial reading', 'favourite melodies and songs chosen by you yourselves', and what was called 'a daily correspondence section in which listeners will be able to express their views'. This was an early example of interactive radio, and it continued without interruption to well into the 1990s. There was also to be some emphasis on poetry, but according to a warning memo sent by the controller of BBC Radio to the programme's editor, it should not be of too taxing a nature: 'Producers are asked to bear in mind the very simple nature of the *Woman's Hour* audience.'

It was not surprising that the first edition turned out to contain almost undiluted domesticity, doled out in a series of well-crafted talks. The first came

5

from Mrs Mary Manton, a self-proclaimed 'ordinary housewife', who dispensed advice on how to make a good and nourishing meal at lunchtime when, with the children at school and Father in the office, the temptation might be to have a slice of bread, which was in any case in short supply. Her suggestions of kippers, a bloater, or a strange dish made with reconstituted egg do not sound terribly appealing, but this was before the arrival on the programme of Marguerite Patten, who with her cheerful manner and more imaginative ideas quickly became one of the programme's, and the nation's, favourite cooks. Listeners to the first programme heard from Kay Beattie on 'Putting Your Best Face Forward'—'a light dusting of powder will do wonders'. Louise Donald of Aberdeen wanted 'to know how to make the best of an old-fashioned whatnot'. The firm advice of Alan Ivimey was, 'Don't alter it, keep it as it is.' Throughout the hour there was also a sprinkling of listeners' musical requests, from Borodin's 'Polovtsian Dances' to songs from Vera Lynn and the Andrews Sisters.

Specially invited to listen in and to make their own comments were Margaret Bondfield, chairman of the Women's Group on Public Welfare (in 1929 she had become the first woman to hold a Cabinet post, in Ramsay MacDonald's Labour government), the young actress Deborah Kerr, and Mrs Elsie May Crump, a butcher's wife from Chorlton-cum-Hardy near Manchester. The following day they gave their verdict: they were all very positive about what they'd heard, although they weren't sure about having a man as a presenter. Mrs Crump's was one of the influential voices persuading

management, a few months later, to replace Alan Ivimey with a woman.

Listeners too were asked what they thought of the programme, and from the beginning they were not slow to give their views. A large proportion of them agreed with Mrs Crump—they objected to a man as the main presenter. They felt that Alan Ivimey's manner, and therefore perhaps the general tone of the programme, was rather patronising, and that some of the topics were rather dull. BBC management—in its early days *Woman's Hour* was run by the Talks department, for it did not yet have its dedicated programme team—tended to agree, and gradually the topics widened. There was to be more high culture; films, books and important theatrical performances were reviewed. Child psychology, frank medical advice and current affairs also became regular additions to the menu. Audrey Russell, who had distinguished herself as a war correspondent, now reported on events from all over the UK, from a visit to one of the first factories to produce nylon stockings, to the endless conferences held by a growing number of women's organisations, including the National Conference on Maternity and Child Welfare, the National Union of Women Teachers and the Married Women's Association. A talk about the Royal Commission on equal pay by Lady Davidson was heard as early as November 1946, although it would be another thirty years before equal pay legislation came fully into force. There was also more room made for much-needed trivia and fun. Alan Melville, Joan Baker and Joyce Grenfell gave tongue-in-cheek accounts of their daily lives, or took a sideways look at things that interested them,

and made listeners laugh. There were frequent significant women guests to talk topically, including the artist Dame Laura Knight, the actress Margaret Rutherford and the Liberal MP Megan Lloyd George.

Health and medical matters were always important, and the programme quickly established a core of experts. An anonymous woman psychiatrist—doctors were generally not named in those days—gave a talk in May 1947 on 'Standing Up for Yourself', advice pre-dating modern assertiveness training by about four decades. But when *Woman's Hour* fearlessly ventured into the more intimate details of what many women might hesitate to discuss in their own doctor's surgery, especially if their doctor was male, it did not always find favour with BBC management. In 1948, Dr (later Dame) Josephine Barnes gave a series of talks about older women's health. In the section on the menopause (then more familiarly called the change of life) she referred to ovaries, lack of hormones, loss of blood and the possibility of a uterine growth. The head of the Home Service sent a memo to the head of the Spoken Word: 'I do believe that the inclusion of such a talk represents a lowering of broadcasting standards. It is acutely embarrassing to hear about Hot Flushes, Diseases of the Ovary and the Possibility of Womb Removal transmitted on 376 kilowatts at two o'clock in the afternoon.' Listeners were made of stronger stuff. There is no record of any objection at all from them to Dr Barnes' forthright approach.

* * *

By 1948 the war had been over for nearly three years and it began to feel as if life was brightening up in Britain. Princess Elizabeth had given the nation a glamorous royal wedding—she married Prince Philip in Westminster Abbey in 1947. In 1948 the National Health Service came into being, after a long battle with the British Medical Association, representing doctors, many of whom saw their personal authority being taken away. In July thirteen-year-old Sylvia Beckingham, with a kidney problem, was named officially as the first NHS patient, getting a handshake from the Health Minister Nye Bevan at Trafford General Hospital. That was also the year that London hosted the Olympic Games, and with their star performer the Dutch sprinter Fanny Blankers-Koen, the Olympics were considered a great success, as well as a much-needed celebration of the survival of the human spirit after the depressing years of war.

Fashion reflected a more optimistic mood. In 1947, Christian Dior had invented the 'New Look'—longer skirts and tighter waists—and the following year he signed the first franchising deal in fashion history, taking haute couture a little closer to the High Street. On *Woman's Hour* an emphasis on making your own clothes (Mary Hill gave a helpful talk on the subject in November 1946) was soon replaced by the likes of Elizabeth Dennis, declaring that 'Gay new clothes in bright spring colours do make one feel cheerful—now at last we're going to be a bit more individual in our styles.' In 1948 there was advice on *Woman's Hour* of what were considered the proper underpinnings to all this ('How to Choose a Corset') with an early

version of Trinny and Susannah, called 'What Not to Wear'. In September 1949 a male contributor reminded his female listeners of their traditional role in a talk called 'How Men Like Their Clothes Looked After'.

Advice on bringing up children in post-war Britain, and a focus on many wider social issues, were soon regular ingredients in a programme that was unashamedly aimed at, and by now increasingly presented and produced by, women. In June 1947, *Woman's Hour* ran its first antenatal clinic, followed later by a fairly graphic description of what happens during the birth process. However, for some frankness could go too far. Two years later in a similar talk, the word 'vagina', which had been used earlier, was replaced by the more acceptable 'birth canal'. Nevertheless there were explanations of miscarriage and the perils of sexually transmitted diseases: topics that no other programme on BBC Radio would have dreamed of touching.

In May 1949, Rosemary Sands reported a hugely significant bit of good news for women: a technical innovation recently installed in West London, which arguably did more to lighten the burden of post-war woman than any other. It was the first self-service laundry, or launderette. Suddenly here was a machine that was quick, easy to operate and relatively cheap, at 2s 6d for nine pounds' weight of dry laundry. 'You take in your soiled linen and put it in a machine, and in half an hour—no longer—you find everything clean and thoroughly washed. Nothing could be simpler. I like this launderette.' Millions of listeners would have delightedly agreed with her.

'Mother's Midday Meal'

Mary Manton
7 October 1946

This was the first talk on the first Woman's Hour.
*Before she began Mary Manton explained: 'I am
just an ordinary housewife with the children at
school every weekday and I have been studying the
problem of Mother's midday meal.'*

There's one good thing about bread rationing. It's
made us mothers look round for something other
than bread for our midday meal. Nowadays, when
so many of the children have school lunch, and
Father has his in town too, few of us cook at
midday. And we think anything will do for
ourselves. Anyhow we're too tired to bother.

I expect it depends greatly on whether the family
get a *good* meal out, as to what they have in the
evening. I always cook a meal freshly for mine, so I
need only a snack midday. But there must be a
number of women who don't cook at night, and only
have a decent dinner at weekends. It won't do, you
know!

In the past I used always to have bread with a
scrape of something for my lunch. But even before
bread rationing made me think twice about every
slice, I began to realise I was eating too much
bread. (Breakfast was often toast.) I got very tired
of so much starchy food. Besides, I began to put
on weight but lost strength and fitness.

So now, when I'm out shopping in the morning, I

11

look out for something for my lunch. Once or twice a week I buy a couple of herrings. When I get home I've very likely got the downstairs rooms to mop and dust—and I can do this, and keep an eye on the herrings as they cook. I just rub a butter paper over the frying pan; clean the herrings and flour them, and put them on a very low gas, with my plate tilted over the frying pan to get warm. They're a fine meal for a chilly day, and you can have them on a tray by the sitting-room fire.

Sometimes I get a pair of kippers or a bloater, and they're no trouble to cook.

If I don't want to go shopping, I scrub a couple of medium-sized potatoes, and put them in the ashes of the sitting-room fire. This fire gives us hot water, and during the winter we have all our meals in front of it. So, in cold weather, it's always going. In the evenings the boys often bake themselves a potato under it for a bedtime snack. They have cubes of cheese in it or a pat of dripping or margarine—and that's how I eat mine at midday.

Occasionally, when there's an odd rasher of bacon left over, I chop it and fry it gently, pouring a reconstituted egg over it, and adding cubes of cold potato, if there happens to be one in the larder. Just outside the kitchen door I've made myself a herb garden, and I use the parsley on as many dishes as I can. It goes well with this one. I wash the parsley, then, with the scissors, shred it finely over the food just before it's eaten.

Sometimes I make myself a Welsh rarebit—but I don't go to the bother of cooking it in a saucepan. I've found a very quick way that doesn't leave a trail of washing-up. Grate a little bit of cheese (about an ounce). Add a pinch of mustard, a

sprinkle of salt and pepper, a teaspoon of soya flour, if you have any, and about a tablespoon of milk or water. Scrape a little margarine on the toast and cover it with the cheese mixture. (Be sure to cover it or the edges of the toast will burn.) Now put it back under the grill, having turned the flame low, when it will heat through and brown slightly.

I remember in the old days at home when we were all out at business, I used to be so concerned because my mother had a little way of dining off bread and butter and a pot of tea. I used to put her through a third degree every evening about that midday meal. I often think now of the things I used to say to her about the stupidity of mothers not looking after themselves. But I've found we're very much the same—generation after generation—aren't we?

In October 1967, as part of Woman's Hour's *twenty-first birthday week, Mary Manton spoke poignantly about widowhood.*

Joyce Grenfell

interviewed by Jill Allgood
17 December 1946

The actress, broadcaster and writer Joyce Grenfell (1910–79) was a niece of Nancy Astor, and made her performance debut on the stage in 1939. Famous for her satirical monologues, her series How To *launched the Third Programme (now Radio 3) in 1946. She became a frequent voice on the BBC, especially* Woman's Hour, *for whom she wrote countless talks.*

Her interviewer here, Jill Allgood, was a writer who went on to work on the 1950s comedy series Mind Your Manners. *She visited Joyce Grenfell at home for this interview.*

There are people who can turn a gloomy December day into something bright and cheerful. Joyce Grenfell is one of them.

We climbed four flights of stairs—and both breathed a simultaneous and long-drawn-out 'Aah' at the top.

From the windows of her flat, miles of London's rooftops stretched as far as the eye could see. It's a strangely heartening scene—that uneven huddle of chimneypots squatting on red- and grey-tiled roofs. Joyce pointed out one or two of the landmarks. 'Those Gothic rabbit's ears are St Luke's Church,' she said, 'and that wedding cake decoration is—I think—the Victoria and Albert Museum. My bedroom is even higher than this

14

room, and I lie in bed and see nothing but sky—lovely. I never get tired of it.'

We settled down to talk. Joyce explained that she had lost most of her home in a fire during the Blitz. 'So,' she went on, 'this flat isn't really my permanent home. We had to take it half furnished and we were lucky to get it. But I've done all sorts of things to it. I got a friend to come in and distemper the walls white for me. They were originally a thick gloomy custard cream—it was awful. And the curtains and the sofa covers, they're made from non-couponed industrial tweed. It's a pale blue and stone weave—a general effect of soft grey. I found it one day while I was out shopping. Then I had them piped in lemon yellow—that's my favourite colour—the same yellow as the loose cover of this armchair I'm sitting in. And the cushions—well, I do like a splash of colour—like that red one, for warmth. Anyway, it's a nice bright room to live in and work in.'

As we talked, Joyce was working. When she's talking or listening to the radio, she uses her hands. It may be fine needlework—she says she isn't a very good cutter-outer, but she's a quite good small-stitcher. And she likes to sketch or draw. Just now she's making her own Christmas cards—delicate posies of flowers, drawn with coloured pencils. She aims to make a hundred by Christmas.

As I looked round the room, I could see many light and delicate touches that are characteristic of this brilliant and talented star. Bowls of daffodil bulbs on the windowsill—some of their green shoots almost ready to burst into flower. She likes a mixture of modern and period, and a touch of different countries. There is a hook rug from the mountains of North Carolina; the white china horses on the

15

mantelpiece come from Denmark. Joyce is very attached to the Victorian period, so there are a few bits of Victoriana, as she calls them: little footstools topped with beadwork and tapestry. The vases holding the sprays of ivy on the mantelpiece are Victorian cornucopia. 'I think,' Joyce said, 'it means horn of plenty, doesn't it? These are horn-shaped. I've got several—I think they're lovely for arranging flowers in, and,' she smiled, 'the ivy.' I confessed that I wanted to ask her about the ivy—it was pretty and unusual to see it like this in a room. 'Well,' she said, 'I love it. It's a most satisfying design. My ivy mania extends to liking it to wear as a spray on my coat or dress. It's such a clean, dark green.' I noticed that she was wearing a piece, just below her left shoulder.

Then I spotted a tiny white figure under a glass case. It was a miniature of Joyce Grenfell as she appeared when she sang her du Maurier song in *Sigh No More*. She treasures it very much, and it is perfect in every detail: the Victorian hairstyle, the dress swathed into a bustle and her arms raised in a characteristic gesture.

We talked about pictures. Joyce likes them, but not too many of them. A John Singer Sargent portrait of her grandmother hangs just inside the door. There is a French seaside picture by Philip Gerrard opposite the window; an original Kate Greenaway watercolour; and a modern watercolour by Joyce Grenfell of her husband. She almost dismissed her own picture with the remark—'That's just Grenfell by Grenfell'—but I insisted on looking at it. And silently I added 'painter' to her many other accomplishments.

Talking about pictures led us naturally to music.

Joyce enjoys music, listens to it on the radio and goes to concerts whenever she can. Then, laughingly, she touched the piano. 'Take no notice of it—those are things for Christmas on top of it, toys for godchildren and cousins' children, and goodness knows what else. But even when it isn't Christmas, it looks pretty crowded. I keep all my music on top of it. There isn't anywhere to keep anything here.'

I asked her where she did her writing. 'In this room,' she explained. 'But I never sit at my desk to write. I do it on my knee. And I put my feet on one of my little Victorian footstools to make a desk of my knees if you see what I mean.'

As we looked round once more, she said, 'I think a room should reflect its owner's way of living, and look practical and *used*. Heaven knows, *mine* does!'

And I felt as I left that it would be easy to imagine Joyce Grenfell in future, working in her bright little living room high above the rooftops—creating those vivid characters from her imagination, like Sunday's girlfriend, the librarian, the head girl at school, writing the lyrics of her songs—perhaps just sketching, or sewing those very small stitches.

In 1976 she wrote her autobiography, Joyce Grenfell Requests the Pleasure, *which she read in the following year as the* Women's Hour *Serial. Joyce Grenfell is perhaps best remembered as a performer of monologues in which she invented many different roles including the nursery teacher ('George, don't do that'), but also as a singer of songs like 'Stately as a Galleon' and for her role as Ruby Gates in the* St Trinian's *films.*

'Giving the Wife a Hand'

John Merrett
19 December 1946

John Merrett was one of a raft of speakers who gave occasional talks on Woman's Hour *during the 1940s on a range of personal subjects. For example, in 1947 he and his wife, Isabel, co-presented a talk on the thorny subject: should women keep their jobs after they are married?*

There used to be a time—and it wasn't very long ago—when there were some rather strict ideas about what they considered to be, as they put it, 'a woman's job'. And usually what was 'a woman's job' certainly was 'not a man's job'. Running a house—and all the work that's attached to it—was in this category, and although some men broke the rules and occasionally gave a hand at washing the dishes or even scrubbing a floor, they did it very secretly and no one was supposed to know. It was a disgraceful thing, in other words. Well, thank goodness we've progressed a bit since then. I'm not suggesting that we're reaching the stage when husbands stay at home and run the house while the wives go out and earn the money—even though humorists sometimes say we are. No! But at least there's no disgrace in a man taking the children for a walk or running the vacuum cleaner over the stair carpet nowadays. The Victorian father—head of the family and a little lord of creation—seems to have disappeared, and a very good job too.

Before I go any further I must ask you not to get me into trouble over this little talk. I'm going to try to be very careful because I realise just how foolish it would be to lay down the law about husbands doing this or that for their wives. I've seen trouble happen too often that way. You know the sort of thing I mean. Mrs Smith says to her husband, 'You know, Henry, Mrs Robinson has got a good husband! He's always making things for the house and won't let her carry as much as a bucket of coal. He even brings her breakfast up to bed on Sundays.' Well, of course that annoys Mr Smith, who promptly decides that Mr Robinson is something quite unspeakable—and he probably says so! Next thing there's an argumcnt and everybody's unhappy. So you see, the last thing I want is that you tell your husbands about someone on the wireless who said that men ought to help their wives more! But of course you won't—you know how to handle your husbands better than that!

What's the position of the normal husband and wife? I think the war has made a big difference. Back in the 1930s there must have been quite a lot of men who hadn't the faintest idea about how their houses were run. There were no reasons why they should know. For these luckier people the shops were full of every kind of food, which made getting meals an easy matter, and there were maids and daily helps to be had to do the housework—or help with it, anyway. But that was only one side of the picture. There were the other people, those who found things very different. The wives who worked and scraped—often half starved too—in order to keep the house on unemployment pay. Their husbands often knew only too much about keeping

house on insufficient of everything. Some of them helped at home; some felt their position so keenly that they got into the habit of going out each day, just to get away from it all. Now the war has changed both those pictures. Men found work—women too—and daily helps and maids disappeared just as rapidly as unemployment and poverty. When men were lucky enough to remain at home they usually found that their wives started going out to work—even if it was only part-time work—and, if you want to keep your home going under those conditions, you've both got to take a hand. And so we did. I think it was a good thing. So many men didn't appreciate how much there was in running a home efficiently. So many different jobs—specialist jobs, all of them—a proper time for doing each of them, and very often, inadequate tools for doing them with. Well, that was the war. The point is: are the husbands still taking a share of the job, or are we slipping back into the old days of leaving it all to the wife?

Of course a lot of women are still working. I must say I admire them. Industry needs them very badly and we should feel proud of the women who still run their homes as well as doing a job in an office, shop or factory. These women deserve the right sort of husband—one who doesn't mind giving a hand at washing the dishes or peeling the potatoes. And that introduces another question: what jobs in running a home can a man do best?

The commonsense answer is that it depends on the individual. Be frank about it and be sensible. And for heaven's sake don't bring the question of whether its 'a man's job' or not into it! That phrase died with Queen Victoria.

It's simply a question of deciding what each of you can do best, and then getting on with it.

The first thing that men discover when they start helping their wives is how badly women have been treated concerning their working conditions. We only seem to have realised during the past few years that a woman spends a very large part of her life in her kitchen. It therefore follows that the kitchen should be one of the best rooms in the house—bright, sunny and cheery, with as many labour-saving gadgets as possible. But is that the case? You know you wouldn't get many workers in a factory who would put up with conditions twice as good as those of a great many housewives. The result of male help in the house should be an improvement in labour-saving ideas. Men usually aren't nearly so patient as women over difficulties. Many a man, after helping his wife, has come to the conclusion that the vacuum cleaner or something like that which she's been asking for, perhaps for years, really is necessary after all.

Now you're going to ask me how I help my wife. I'd rather you asked her that question but I will tell you this much. I usually buy the vegetables for her. Although we live in London the nearest greengrocer's shop is nearly half a mile away—and you have to walk. Several pounds of potatoes, carrots, onions, a cabbage—it all makes up quite a tidy weight—too much for a woman to have to carry for half a mile if there's a man who can do it for her. I usually do this job early in the morning before I go to my office. There's one other job I'll tell you about. Sometimes I clean the silver and brass as I sit listening to the wireless. And that's all I'm going to say, but please don't forget that most

21

husbands are very willing to help if it's put to them in the right way.

Just one last word. I've been reminded about this by the fact that it's nearly Christmastime. In the South of Ireland they sometimes call the Feast of Epiphany (which is the twelfth day after Christmas) the Women's Christmas. They say that the woman of the house has worked so hard during Christmas for everyone else's enjoyment that on that day everyone waits on her and she has a complete rest. It's a nice idea and one we might copy. Anyhow I'm pretty certain that if I could speak for all your husbands now, they would agree with me very heartily in saying 'thank you' to the wives of Britain for the way they've run their homes this last year. It's been a tough job feeding the men and children, washing and mending their clothes, organising their homes and keeping them bright and healthy and cheerful. You've done it splendidly. Thank you, wives and mothers.

'Sharing a House'
19 June 1947

Intense bombing during the Second World War led to a serious post-war housing shortage. This anonymous young Belfast wife is, as she says, describing a condition affecting hundreds of thousands of others.

Bill and I are just two out of the millions of young married people who have no house of their own, nor any prospect of getting one for years to come. Our story isn't an unusual one; it is just the kind of thing that all those other millions are experiencing every day.

We were married three years ago, and at first we stayed with my parents. Here, we converted the front sitting room into a combined room—a measure that was only carried out in the face of some opposition from Mother, who couldn't understand why we should want to sit apart from our own folks. She finally accepted the position, but for some rather obscure reason was especially hurt when I occasionally carried our evening coffee into our own room. Sitting in the firelight, talking and sipping coffee is one of those little things that make sweet the first months of married life—but mothers seem to forget things like that. The real trouble came, though, when I decided it was high time I learnt to cook. Working since the age of fourteen had given me little opportunity to do so, especially as I had always been shooed out of the kitchen whenever I had shown any sign of interest! However, I was determined to acquire this

23

necessary accomplishment, so I arranged with my employer to be allowed off work an hour earlier each day, in order that I could help to prepare the evening meal. However, when I came in, it was only to find Mother had forestalled me by doing everything that could possibly be done before I arrived. I hung around desperately, hoping there might be *something* I could do. But it was all in vain; I was regarded as an interloper in the sacred precincts of the kitchen, and in six months' attempts at learning to cook, the nearest I got to its mysteries was setting the table and washing the dishes.

So it was with some trepidation that I accompanied my husband to live in Belfast, where a friend had found us accommodation. I dreaded the scorn of the landlady when she saw my bungling culinary efforts, but strangely enough, cooking turned out to be surprisingly easy, and anyway the landlady was usually out while I was doing it. But the accommodation was, unfortunately, of the kind in which the only privacy afforded is in a tiny bedroom. We had to eat and sit with our landlord and lady in their small living room. Very shortly the lady of the house informed us that she 'wasn't used to lodgers' and hinted that she and her husband had decided that they preferred their privacy.

We decided that next time we too must have our privacy, and accordingly looked out for two rooms or a bedsitter. We had, however, overlooked the fact that privacy, these days, can be a very expensive luxury.

Eventually, humbled into the recognition that privacy was not for the likes of us, we accepted the

24

offer of a bedroom with a cousin of Bill's. The cousin and his wife lived in a tiny semi-detached, and had a small son who was just emerging from the crawling stage. For a long time, this little boy was a source of delight to us, and despite the cramped conditions we were for many months quite happy. However, it wasn't long before the cousin's wife, Edna, discovered that the presence of lodgers in the house provides a wonderfully convenient scapegoat for anything that goes wrong. If there was a lack of hot water when her husband wanted a bath—it was I who had used it. If the bathroom floor showed signs of splash—it was Bill's doing. If the child woke from his slumbers, it was our noisy tongues—never their own—to blame. To heighten the atmosphere, trouble began to develop around the little boy. Edna, when annoyed by him in any way, was never loath to administer a terrific smacking. But we were expected to endure any amount of pestering from him with nothing but charming smiles. Now, both of us are as fond of children as any reasonable human beings, but when we found we were the subject of our small nephew's constant and undivided attention, our smiles began to sag a little. Bill came in from work an hour before his cousin, so whilst I was preparing our evening meal, Edna was reading beside the fire. My efforts were not noticeably helped along by the presence of her little boy, whose usually grubby fingers were with the utmost difficulty kept out of anything I was preparing. Then, while Bill and I were eating our dinner, Edna replaced me in the kitchen. But where was her small son? Running round her, the way he had run around me? No!—he was crawling over the table, dropping his grubby tram-tickets into the soup,

sticking his fingers in Bill's dinner, even trying to stand on the table itself. All I could do was to ask him, gently and repeatedly, to get down and go and play and be a good boy etc., etc. Our meal-hour together became something to be dreaded, and it is no exaggeration to say I trembled at its approach. Edna, far from distracting her child's attention from us, seemed to consider our aversion to such activities as evidence of our inhumanity. One evening, when I had gently begged the kiddie not to spit in his uncle's tea, the explosion came. 'What do you want me to do with the child?' she burst out furiously. 'Muzzle and chain him?'

So the room-hunt began all over again, with all its street-tramping, letter-writing weariness—and with the same lack of result as before. After many unpleasant months, our problem was solved by the departure from my mother-in-law's household of her other married son and his family, so we were able to take over a large bedroom, which we promptly furnished as a bedsitter, thus experiencing for the first time the pleasure of sitting upon our own chairs.

As I have said, it is just the story of millions. Of course, each person's story varies widely in detail, just as humanity varies. But we share one impression in common with most young people experienced in living in 'digs': that landladies expect their tenants to possess qualities altogether inconsistent with human nature. We are to be meek, gentle, subservient creatures, amenable to all kinds of criticism and uncalled-for advice. Our domestic habits must be a mere reflections of hers; we must be prepared to listen with sympathetic murmurs to all her reminiscing and

gossip. Often, we are expected to act as unpaid domestic servants. In short, we should be paragons of sweetness and never-varying amiability. And when we fall short of this conception of the Ideal Lodger—as we always do—heaven help us! Now, I am not suggesting that all landladies are ogres. Many of them are kindly and motherly souls. But their very kindliness and anxiety to help young people may lead to untold irritation.

Good lady, it may be that *you* are sharing your home, or thinking of sharing it, with a young couple. If so, and if your motive is not downright avarice—heaven bless you. But would you be above taking a few words of advice from a young wife? You might feel strongly tempted to give young Mrs Smith the benefit of your experience in cooking. But—please don't! Believe me, she'd rather profit by her own present mistakes than by your past ones. Besides, her methods might not be wrong, just different from your own.

And, of course, I'm sure *you* don't need to be told not to gossip about your tenants. We all know the kind of landlady who makes the habits and outlook of her tenants the common knowledge of the neighbourhood. The idea that mere lodgers deserve to be regarded as dignified human beings, deserving of respect and the right of privacy, is completely inconceivable to her! Naturally, you know you would never stoop to such an attitude. All the same, when you feel tempted to be critical of your lodgers' ways, it's always as well to remember they're only human!

'Supplies and Shortages in the Shops'

Joan Petrie
10 July 1947

Rationing of various items was continually being relaxed and then tightened in the immediate years following the war, depending on availability. In Britain, rationing didn't finally end until 1954. This was one of a number of talks offering information and advice to listeners on shortages. Joan Petrie of the Board of Trade is unusual in that she was a senior woman civil servant, one of very few at the time.

By now, one of the most familiar, but least popular, words in the English language must be 'shortage'. For you housewives particularly it means a weary history of shop-to-shop tramps, queues, and frustrations; of counting up coupons, worrying when the laundry will come back, and putting in overtime with the mending basket. Thank goodness some of the difficulties and shortages that have burdened us all in the last six or seven years are now just history. The days are past when we wondered whether we would ever see things made from rubber—slowly but steadily the hot-water bottles, roll-ons, crêpe soles and elastic are coming back . . . You don't have to scrounge for a saucepan now, nor hunt the shops for a toothbrush or comb. You can get a blanket without dockets and your shoes mended without weeks of waiting. Toys, fountain pens, electrical goods, kitchen gadgets are among the things back in the shop window, and in

most kinds of shops there is a greater variety of goods to choose from. But we still have to go without some things that we really need and a few more that we would like. Why is this? And how much longer is it going on?

Let's look at the sheet situation, although most of them, I know, will hardly bear looking at! This brings us straight up against one of the biggest problems: shortage of textiles. There's no lack of raw cotton or of new raw wool, but in the textile industry we're short of some 200,000 workers compared with before the war. Conditions have got to be improved somehow—and machinery has got to be modernised so that we can get more people to work in the mills and to produce more material. These improvements *are* going ahead steadily but it will take time before we can produce all the yarn and cloth we want. Clothes, knitting wool, household linen and curtains: all depend of course on the number of people working in the mills.

As sheets are obviously important, and we have all been suffering from a sheet famine for years, it was decided recently that the ordinary housewife really must have a chance to buy. Previously, as you know, the bulk of supplies were being reserved for the newly married, the bombed out, and children going from a cot into a bed. It was impossible to produce enough sheets to meet the accumulated demand so they were put on coupons. This might appear to be rather hard, but it does mean that a housewife who desperately needs sheets can get them now. It means fair shares.

It has often been suggested that things would be easier for the housewife if special coupons, earmarked for household goods, were issued, even

29

if the allowance were at the expense of personal clothing coupons. If this were done, the individual household's choice—whether to buy sheets or clothes—would be more restricted than at present. And there is another difficulty. How could a 'housewife' or 'household' be defined? Should bachelors and other people living alone be refused a chance to buy sheets and towels? What could be done about lodgers? A flat rate of issue to every house would obviously be unfair, but an army of people would be needed to arrange an issue varying according to the size of the family.

Let's turn to another trying shortage: pottery. Here too it's true that if we could get more skilled labour in the potteries, there would be more cups and saucers, plates and teapots all round. But there is another reason too behind the scarcity in the shops and the lack of colourful china. The raw material for pottery is nearly all home produced, and this makes it one of our most valuable export lines. The craft of our British potters is greatly prized abroad—all of us who visited the exhibition 'Britain Can Make It' will not wonder why—and it is of vital importance today that as much of it as possible should be exported. The small quantities of decorated china that do appear on the market are pieces made for export, but rejected because they are slightly imperfect and therefore unsuitable to maintain our reputation abroad.

The fuel shortage held up supplies in practically all our industries. For example, you've probably noticed the shortage of mending wool. Mending wool, like knitting wool, comes from the wool-spinning industry. We were getting along pretty well until the fuel crisis just tipped the balance the

wrong way.

Now that I've mentioned knitting wool, those of you with babies will be expecting to hear a special word about baby wool and some other items of baby wear. Efforts *are* being made to see that the babies don't go short of the things they need, but it does mean making special priorities. In 1946 far more babies were born than in the years before the war, and the 1947 record promises to be even better. Where the ration limits the amount that can be bought, the demand is for better-quality articles than before the war. But the result is that although last year we produced more prams and many more pairs of children's shoes than before the war, there were shortages of both.

So far we've been talking about difficulties due to shortage of labour, as this is the main cause of the trouble with household commodities and clothes; and about the limitation of supplies of certain things at home, because of the need for export, but there is a third reason behind some of the shortages. After the long war, the whole world is short of a number of raw materials like coal, steel, timber, high-grade leather and linseed oil. We can't buy all we need. We can't get enough timber for housing and furniture, or for pulp to make paper. Linseed oil too is short, and this means a shortage of linoleum and floor coverings. India, which used to be one of our chief sources, no longer exports it. This also means scarcity of paints and varnish.

There, then, are the three main problems behind shortage in the shops: lack of labour, especially skilled labour; lack of raw materials; and the urgent need to maintain and increase our exports. These problems are big and serious, but they *are* being

31

tackled. Don't let's be too gloomy about the prospects—for we can expect some improvement as these three problems are gradually overcome.

Peggy Ashcroft

8 March 1948

Peggy Ashcroft (1907–91) was the first modern English classical actress. She made her stage debut in 1926 and during her long stage career played all the leading Shakespearean roles, the first being Desdemona to Paul Robeson's Othello in 1930. In 1935 she played Juliet with John Gielgud and Laurence Olivier alternating the roles of Romeo and Mercutio. She made her first film appearance in 1933; one of her earliest roles was in Alfred Hitchcock's The Thirty Nine Steps.

As a child I suppose I was in love with the theatre—the theatre I'd read about, as well as the theatre I'd seen. Like most children I was only taken, when there was something suitable. But I remember when Shakespeare companies played in our town, the exciting glimpses they gave me into that magic world that I had read of in books—in Ellen Terry's *The Story of My Life*, in stories about the great days of Irving at the Lyceum, in Shaw's works of dramatic criticism: books that portrayed the theatre as I imagined it still to be.

And then the adventure really began for me, and I started off on the stage at eighteen, after two years' training. At first I was among that large number of eager, anxious, tired, and disillusioned people looking for jobs. After the first excitements of finding myself actually doing the job—being on the stage—were over, I felt a sense of

disappointment, saying to myself: Oh, but this is not what I have imagined the theatre to be. On the whole I was very lucky. Jobs came with not too great intervals between; work in small theatres, touring companies and so on. And then came what was called one's 'big chance'—it was the part of Naomi in Matheson Lang's production of *Jew Süss*. After that I was properly launched. I was considered a promising actress, and I continued to get very good parts. But still this feeling persisted of disappointment, of not finding what I'd expected. Of course, it was thrilling to be working and to play parts like Desdemona, and to meet and even work with people I'd read about. Each new engagement was a fresh excitement, and all the while I was learning my job—but I always felt there was something lacking. In a way work in the theatre seemed aimless.

Then I went to the Old Vic, in its humbler days in the Waterloo Road, when Miss Baylis was still its inspiration; and from that moment I knew exactly what had been missing. It was that wonderful feeling of belonging to a company who were all working for a theatre and for its reputation, and who had the security of knowing that they were to work together for some time. Security, in every sense of the word, is something theatre people seldom have. But, mind you, a season at the Old Vic was something of a battle in those days. There was not time or money enough to make productions smooth. We seldom achieved the standard we aimed at, but we achieved something.

After that season was over, I went back to the chance engagements of the ordinary theatre, doing what turned up. And once again, I began to feel

34

dissatisfied, and wondered whether I'd ever realise my dream of belonging permanently to a company.

Then John Gielgud asked me to play Juliet at the New Theatre, with himself and Laurence Olivier both playing Romeo and Mercutio in turn; and Edith Evans as the nurse. That was a prospect that I think any actress would think herself blessed to have. Apart from the joy of that production, which I shall always remember, it began my association in the theatre with a company of actors—a company that was later to include Gwen Ffrangcon-Davies, Lee Quartermain, Angela Baddeley and others. We were not actually *organised* as a company, and there was then no plan of our being one! We didn't always play in the same building, or even under the same management; but Gielgud kept so many of us together in one production after another, that we had that feeling—and I can assure you that for me there is no other feeling like it—of belonging to a company of players. You see, by working constantly with the same people, you have the sense of building something together, which I think is the greatest of all joys in the theatre, which is, in fact, what I like in the theatre.

Peggy Ashcroft was appointed Dame Commander of the British Empire in 1956. In 1984, the 77-year-old actress received an Oscar for her role in David Lean's A Passage to India.

Eleanor Roosevelt

14 April 1948

Eleanor Roosevelt (1884–1962) was already a well-known campaigner for women and civil rights when, in 1933, she was thrust into the limelight as the wife of the new President, Franklin D. Roosevelt. She continued to work tirelessly for the underdog and became a key player in the drafting of the Universal Declaration of Human Rights. In 1947, she appeared on Woman's Hour *with a message about this.*

I am particularly happy to have this opportunity to talk to *women* in their own hour. The women of Great Britain have many of the same problems that we women have in the United States. I suppose that seems very odd when you know that we have no restrictions and that we have no price limit, or coupons, or any of those things to have to think about. But, you see, what happens with us is this: that because we have done away with restrictions and price levels and so forth, people can hold their produce for a higher price. They don't bring it to market. And we have inflation at present so the housewife who wants to find something to buy may find that the price is far above anything that she can pay. Sometimes women go to five and six stores and find nothing that they want in any of them; and at times we've had what they call a buyers' strike at home—because the prices were so high that women just said they wouldn't buy.

And so in a curious way, for entirely different reasons, we have many of the same difficulties and

36

the same trials. And if only women in both countries understood this I think they might co-operate together. I'm sure there are women in America who know very little really about what the women over here have gone through, who would be glad if they knew to do a great deal more than they are doing. And I think it is important that we should know. I like the idea of exchanging letters; I like the idea of any contact that can be made because in the national arena, understanding begins in the home.

I think that it is in the home that women really teach democracy; a home can be made the miniature of what democratic life in the nation and between nations should be. And women who today are so closely tied in almost all countries to their home, to their children, have a very great responsibility. I think that most of us also have responsibility to take an interest in the civic and municipal general political situation as far as we are able to, because our opinions can carry weight, not only through the influence we have in our own circle, but through the way we can go out to encourage the way other people manage their lives both at home and abroad. I always say at home that the woman's influence goes from her home out into her neighbourhood and her state and her nation, and finally out into the world as a whole. I feel sure that as we understand that, and as we really develop friendship, we will have a very great influence and understanding and goodwill, first among democracies and then in the world as a whole.

'What Not to Wear'

Athena Crosse
28 April 1948

Athena Crosse was a regular speaker on Woman's Hour, *particularly on fashion.*

It's such a pity that so many women miss being really well dressed because they wear clothes that are right in themselves, but wrong together, or the right clothes in the wrong place and at the wrong time; or maybe they're the right clothes on the wrong woman. These failings have very little to do with coupons; good taste and good judgment are the only answer.

Sometimes when I'm shopping, or waiting at a bus stop, I long to go round tapping some of the women I see on the shoulder, saying, 'Don't.' Of course they'd think I was mad and would call a policeman. Before he arrived to arrest me, though, these are some of the things I'd have said. 'Don't wear a flowery hat with tweeds; don't, ever, wear high heels with slacks; don't ruin your ultra-feminine new-length skirt with tough, country shoes. Touches of white or spots of colour—such as a pink hat and gloves—are charming with a dark suit, but if you add a pink blouse, bag and buttonhole, you'll merely look spotty. Don't wear a fussy hat and a fussy dress together; don't, if you can help it, wear a printed dress with a patterned coat; and don't smother yourself with bits and pieces of jewellery till you look like an accessory

counter.'

As for the right clothes in the wrong place—when you're dressing, try to picture yourself in those particular garments, in the setting in which you'll be wearing them, and the chances are you won't find yourself tottering down a country lane in high heels. Above all, I'd say, 'Don't ignore the warning voice of your own taste.' If your first reaction is that a dress is wrong for you, don't argue yourself into thinking it is right. I believe first impressions with clothes, as with people, are usually reliable. And if you've found some particular style that really becomes you, don't be too eager to change it— especially if you're no longer young.

And when it comes to picking colours, firmly refuse any shade, however tempting and fashionable and springlike, unless you are absolutely confident you will be better-looking with it than without it.

But even the right colour won't help you to get away with the wrong line. Many women, I feel, never look at themselves in a full-length mirror, or you wouldn't see little dumpy figures in three-quarter-length fur coats, looking for all the world like bears at the zoo, or very tall women wearing a straight, unbroken line or the very short with large, overpowering hats that turn them into animated mushrooms. And speaking of hats, don't leave your sense of humour behind when you go into a hat shop. I've been known to pick a little number that made me look like the music-hall star Nellie Wallace [who used to dress the part of an eccentric spinster with appalling dress sense]. Lots of perfectly sane women become slightly unbalanced when it comes to hats. They see themselves in the

milliner's mirror through a romantic haze and they come out looking like one of the seven dwarfs, or an over-decorated cake. Sometimes, you know, there's a very thin dividing line between a fashionable woman and a figure of fun, and it's only by knowing what *not* to wear that you can steer a safe course.

Your clothes should always be a help, never a hindrance. The other day I came across these charming reflections by a seventeenth-century Chinese philosopher: 'The important thing about a woman's dress is not fineness of material but neatness, not gorgeous beauty but elegance, not that it agrees with her fully standing but with her face . . . If a wealthy lady's face does not agree with rich patterns but agrees with simple colours and she should insist on having rich patterns, would not her dress be the enemy of her face?'

What was true in China 300 years ago is equally true today. When you choose clothes, don't forget it's you who have to wear them . . . and make quite sure that what you buy is the friend and not the enemy of your face.

'My Life in the Police Force'

Barbara de Vitre
4 August 1948

Barbara de Vitre (1905–60) was one of the first women to get to the top in the police force, as Assistant Inspector of Constabulary with responsibility for all policewomen. She held this post until her death.

When people ask me why I first joined the police, I can really only say that as soon as I left school I knew I wanted to do work that brought me into contact with people. I think it was because of this that one of the first jobs I took was in a factory in the North of England. While I was working there, I began to realise how much the police loom in the lives of some people. The policeman was the one who smoothed out family quarrels, who helped the children when they were in trouble, and who acted as a sort of uncle to everybody. So later, when I was training for industrial welfare work, and got the chance to go to the Sheffield Police Force, I jumped at it.

At that time, of course, there weren't any women police to speak of. Lots of people didn't even know they existed. Only a few local authorities had the foresight to see that there was a real job for women to do in the force, and one or two of us were taken on here or there to help out with questions that concerned women and children. We didn't even have a proper uniform—it was a sort

41

of frightful adaptation of the men's: boots, a helmet and a heavy coat. We looked pretty awful and one of the most unnerving experiences of all my career was being followed by small boys who whistled after me as I went on patrol in those days. We didn't get any training at all—but had to pick up the job as we went along. Of course we learnt a lot from the old hands among the men who, when they saw we were game for the job, were very good to us.

The disadvantage about women's police work in those days was that all the most depressing, difficult and delicate problems that might concern women were thrust on to them simply because they were women—questions of assault, immorality, desertion and so on. You had to have a pretty steady mind not to get overwhelmed by them. After a couple of years of this, I asked to be given more general work, so that I got no more of this kind of thing than was my natural share. From that time on, I led the life of a regular bobby. That meant the usual round of patrolling, taking statements, dealing with petty thievery and street betting, stopping family quarrels, attending race meetings to keep an eye on pickpockets (that has to be done in plain clothes, for obvious reasons), traffic regulation, and of course dealing with all the emergencies that come one's way, from catching burglars to getting people out of burning houses.

On the subject of my first burglary, I'd been in the force about a year and wasn't perfectly sure of myself yet. Going off duty about twelve o'clock one night, I saw a torchlight flashing about in a factory and a window half open. So I went to telephone the police headquarters, then came back to watch the

factory and see that no one escaped from it. All the time I was waiting, I was very nervous—not of the burglars so much, but of what my fellow police would say to me if the burglars got away and they found they'd been called out for nothing. I knew they'd say it was just like a woman. Before they arrived, I saw a leg emerge from the window, so I shoved it back with all my might. But then a hand came out and knocked me hard over the head. Then the burglar jumped out on top of me and we rolled together in the gutter as his companion rushed off. While we were still rolling—I think I was sitting on him by then—the police car came up so I felt I hadn't done too badly.

As you can see, women in the police force certainly worked under disadvantages in those early days. But in recent years things have changed and women police are now really on the map. They are now on the same footing as men. Today there are over a thousand of them. They are trained in all branches of police work side by side with men and they do just the same work, though they do have a particular interest in work that concerns women and children, of course.

Sometimes people say to me: 'Why are women police necessary? The men have done the job all right for a hundred years now.' I entirely agree about the men. But I feel very strongly that as our population consists of both women and men—rather more women than men in fact—so our police should be mixed too, because only a mixed team can really cope adequately with all the problems presented by a mixed population. Two minds are better than one, and there are many cases where a woman is in trouble—either through

her own fault or someone else's, or where she's in distress through fear or some tragedy, or even illness—where another woman is in a better position to understand what's going on in her mind. There's another reason too. A policeman's job isn't just tracking down and catching malefactors; a lot of it is the routine work of keeping the machinery of civic life going. It calls for cool heads, kind hearts and a great deal of common sense, and these qualities aren't the monopoly of either sex. But they aren't very common qualities either and the police force can't afford to lose people who possess these qualities simply because they're women.

When I was appointed the first woman Assistant Inspector of Constabulary a little while ago, it was really a mark of recognition by the Home Office of the importance of the work women police can do. Now my job is to advise the local authorities how the women police in their force can best be used to do the work in their locality. Another thing I'm interested in is getting women instructors appointed who can, from their own experience, give the new women recruits advice on the work they have to do.

Being a woman, I've been particularly interested in—and it isn't so unimportant as you might think—uniform. I remember well how we suffered in the old days. It's awfully important that the girls in the force should have the self-respect that comes from being smartly and becomingly turned out. It makes a difference to the public too; anyone would rather take their troubles to someone who looks attractive and normal, rather than to a forbidding caricature of a woman.

I was twenty years in the police and I wouldn't

44

have missed one of them. Police work is the only job I know that calls for everything you've got and I don't believe there's a job existing that gives more satisfaction.

'Is There a Future for Feminism?'

Honor Croome
15 October 1948

Honor Croome was a well-known economist who became a regular contributor to Woman's Hour.

It's quite rare nowadays to meet a real, old-fashioned, raging, tearing 'Women's Rights' feminist—the sort of person who used to go around saying that since men had made such a mess of running the world, they ought to step down and let the women do the job. It's ever rarer to meet a real old-fashioned, raging, tearing Manly Man who maintains that women ought never to be allowed out of the kitchen. For on the whole, the feminists have got what they wanted: freedom to be educated, to earn their own living, to practise the professions, to control their own property, to share the rights and the duties of citizenship; and, on the whole, everyone agrees that it's a good thing. It's a surprisingly new thing; it's practically all been won in the last hundred years. Hardly a movement in history has covered such a distance in so short a time.

I wonder how much further we can expect to go, whether there is a future for feminism, for the pushing forward of women's activities and the enlarging of their rights. One big fight certainly remains to be won: equal pay for equal work. I can't see a shadow of justice in paying women less for the same job than men—if it really *is* the same job,

46

equally well done. I know the argument that men are more apt to have families to support; and I think that argument worth listening to when family men get higher wages than bachelors, or when widows with children to support are paid at a man's rate. Not till then. But there is another side to the question. What is equal work? Does equal pay for really equal work mean economic equality?

Equal brainpower, energy, conscientiousness, all the other personal qualities, don't necessarily add up to truly equal work in the long run. And it's the long run that counts, and counts for something, in pay and in promotion. One is paid, really, not only for the job one is doing now, but for the qualifications one is gaining to do it better next year; and next year is apt to be a less certain matter for a woman than for a man. The great majority of women marry sooner or later, and then have to carry, for a good many of their best years, the responsibilities and burdens of family life. A man who, for a similar number of years, had to handle a whole extra job outside his career wouldn't expect to do so well as one who could give that career his whole energy. And there's no use pretending—as some of the early feminists did to a quite extraordinary degree—that wifehood and motherhood needn't compete with a woman's professional or business life. They do. They must. Modern science can speed up many things, but not the time that it takes for a baby to develop and get born. Modern organisation can do a great deal, but it can't organise a child's need for the daily love and the personal care and security of home. I don't mean that children need their mother hanging over them every hour of every day; it would be very bad

47

for them. But their need for her loving company does compete—let's hope successfully—with the needs of business or the professions for her single-minded attention. So even with equal pay for genuinely equal work, I don't believe there is a future for the grand feminist dream of complete economic equality for women.

But that's not to say that there isn't a future for feminism, only it's got to be a different sort of feminism from now on. Instead of occupying itself mostly with the opportunities, rights and grievances of the exceptional woman who wants to live as a man lives, with no more home ties and duties than a man has, it needs to pay some attention to the opportunities, rights and grievances of the ordinary woman whose main interest lies inside her home. I speak of the woman who is in the majority and likely to stay in the majority.

At present I don't think anyone will deny that she's rather short of rights and pretty well supplied with grievances. The grievances that I mean follow from the bland assumption that Mother doesn't matter; that when any change or reform is being put through, her interests don't count. It's a very good thing, no doubt, that bricklayers shouldn't be overdriven; but it's Mother who bears the brunt of the housing shortage. Shop assistants must have reasonable hours—quite right too; but it's Mother who has to queue. Girls must have proper schooling—yes, indeed they must; but Mother has to get on without a 'little mother' to help her. Everyone else has their trade union rules, their professional standards, their statutory holidays, limited hours, definite duties. Even convicts rest on Sundays; even soldiers on active duty get leave. Not

48

Mother. There's no limit to her liabilities, so long as she's physically capable of standing on her feet. Many a woman gets the only real rest of her married life when she's in bed with a new baby. Equality of the sexes, my eye. I'd like to see feminism turning its attention in *that* direction. It seems to me that women's rights would be pushed a whole lot further by a decent home-help service, available to all overworked mothers, than by opening the House of Lords to women or appointing one or two woman ambassadors.

And on the other hand there are the innumerable women who aren't overworked but underworked and bored; the women with no children or with older children, often highly trained and qualified women, who could perfectly well take a part-time job and would love to, but who can find nothing but full-time openings that won't fit in with their home ties. There are part-time openings here and there, both in the professions and in business and industry; but not nearly as many as there could be with a bit of organising and a bit of enthusiasm. There's just been an appeal for home workers and part-timers to speed the production drive. But far too many of the women who responded to it have been simply told that nobody wants them. What a silly waste. One found the same thing at the beginning of the war, when thousands of eager volunteers were kicking their heels for months because no one could be bothered to organise their work. It was organised fast enough when the real crisis came. Lots of practical difficulties vanish when tackled really resolutely. But why wait for a crisis, why expect a crisis in order to do something that could help to raise our standards and solve our

economic problems, make our lives richer and more interesting? Here's another field for the feminism of the future; and speaking as a busy, happy part-timer, I hope feminism gets to work and cultivates it.

Kathleen Ferrier

6 December 1948

Kathleen Ferrier (1912–53) went from being a telephone operator in Lancashire to an internationally acclaimed opera singer and was arguably Britain's best loved singer of the twentieth century. At the age of twenty-five and already a talented pianist, her husband dared her a shilling to enter the singing and piano competition at the Carlisle Festival in 1937. She won both and started performing professionally as a contralto. In 1943 she sang her first Messiah. *The composers Britten and Bliss were both inspired to write for her.*

In a bus one evening going back to my hotel after a performance of the *Messiah*, I was told the story of the second opera that Benjamin Britten proposed writing: *The Rape of Lucretia*. It sounded fascinating, and at the end of the description, I was asked whether I would consider singing the part of Lucretia. Heavens, what thoughts raced through my mind! Could I even walk on a stage without falling over my own rather large feet, not to mention sing at the same time—that is, of course, if I could ever learn the music!

It was to be at Glyndebourne—that most lovely opera house on the Sussex Downs—and in the late spring when I wasn't busy. To be able to stay in one place for several weeks, I thought—to be able to unpack, instead of living in suitcases—to have regular meals instead of a succession of

51

excruciatingly dull sandwiches! I would learn that music if it was the last thing I did!

The opera still had to be written, but by the end of May the first pages began to come in. It was lovely music—the first act was peaceful and most beautiful—and as I studied it, it became simple. The second act was very different; there was terror, sorrow, hysteria and a suicide with which to cope! But with the help of my accompanist, and much hard work in the course of incessant railway journeys, I learnt each portion of the work as it came through. Now, too, I was being fitted for the gowns. This new experience was exciting and I never found standing for two hours or more exhausting; I was much too interested seeing the wonderful designs of John Piper emerging from paper to reality in yards of lovely material. From a gown fitting I would rush to a wig fitting and the first sight of it gave me the surprise of my life. To give the impression of a sculptured head, it was made of papier-mâché curls stitched on to a lining, and reaching down to my shoulder blades. It was hard and headache-making, and I wouldn't be able to raise my eyebrows to get a top note with *this* on, however hard I tried!

It had been decided to have a double cast, to avoid singers becoming tired, and one day in June we all met on Lewes station and were taken in omnibuses to Glyndebourne.

After we had settled down and unpacked, notices were posted about rehearsals, and we began in earnest to really know the music, and everybody else's parts, by dint of many and careful rehearsals. Until this time each singer had only had their own parts, and now it was fitting together like a jigsaw

puzzle. Long before we made acquaintance with the stage we all knew the music well and I, for one, was terribly anxious to get going.

We had much time off when we weren't rehearsing—a singer is lucky in this respect; he or she just can't work all day or the vocal cords will go on strike!

Sometimes in the evenings, we would sing madrigals in one of the lovely rooms of the house, or play table tennis or knit furiously. Bright yellow socks, I remember, growing apace with every hour and, on red-letter days, trips to Brighton in an open car and a browse round the old junk shops—a real holiday after months of living in trains and not always hospitable hotels.

When the work was becoming knitted together, there was not so much free time and now we were to walk the boards. I remember the first day trying to walk in a pair of heelless shoes that flapped like a tap-dancer's as I moved or curtsied. That was a mistake I didn't repeat. This first day let me down lightly—I was sitting most of the time anyway, but I couldn't believe how difficult it was just to make the simplest arm movements without looking like a broken-down windmill. I used to practise them anywhere—on the lawn, in my room and for hours in front of a mirror, and watch other people's gestures when they were acting, and when they weren't. It was hard going and I was an embarrassed beginner.

I was helped enormously by the other singers. They could have been very intolerant of my inexperience and impatient of my readiness to giggle or cry but they gave me tips, advice and encouragement for which I can never be grateful

enough. I found the second act so moving that I went round the place with a permanent lump in my throat, and was relieved when rehearsals were over for the day and I could breathe again until the morrow.

About the only other time I had been on a stage was at school as Bottom in *A Midsummer Night's Dream*, which is rather a far cry from the chaste Lucretia! Of course to do the job really properly I should have had lessons in deportment, acting and make-up, but this is a branch of art which it seems has, until just recently, been neglected by opera singers—in this country at any rate. I am so glad to hear of an opera school that has been formed here in London for speech, acting, deportment and interpretation, and which I hope will thrive and produce singers who can make an opera as convincing as an actress can a play. Good luck to Miss Jean Cross who has had the brains, courage and unselfishness to make this a tangible reality out of a dream.

The dress-rehearsal came and when, struggling to change gowns and shoes in about four minutes, I missed my entry, and when I stabbed myself and fell like a hard-backed dinner roll, I thought it was time I 'shuffled off this mortal coil' and did an Ophelia-like exit in the lake with only a belligerent swan for company! What a life! Oh, for a peaceful *Messiah*!

I was given more instruction and help, and by the time the first night came along, I was feeling a little better. Apart from the fact that my wig stuck on my shoulder pads every time I moved my head, and I had to free it by a series of jerks, nothing went very wrong for the remainder of that memorable

evening!

In February 1953, she finished what was to be her last appearance in Orfeo *at Covent Garden, singing in great pain. Although she only had ten years as a professional singer, the quality of her voice and the fact that she remained a down-to-earth Lancashire lass endeared her to her audiences. She was at the height of her powers when she died of breast cancer, aged only forty-one.*

Gertrude Lawrence

interviewed by Olive Shapley
11 April 1949

Throughout the 1920s and 1930s, Gertrude Lawrence (1898–1952) was the 'First Lady' of musical comedy on both sides of the Atlantic and the epitome of 1930s glamour; smart, sexy and fun with her elegant dresses and long cigarette holders. Born in London, she was already a professional performer by the age of ten. So outstanding was her style that many of the great names of the day, including the Gershwins, Cole Porter and Kurt Weill all wrote for her. She was great friends with Noël Coward who wrote Private Lives *for her, and she is particularly remembered for her performances in his plays.*

Olive Shapley presented Woman's Hour *from February 1949 to August 1950.*

LAWRENCE: Acting in America makes greater demands on the actress; there is a much keener sense of competition. It is most stimulating. One can't just draw on one's past successes, no matter how well-known one is. It's not good enough for an actor to live up to what he knows he can do; we've got to go beyond what audiences expect of us.

We can't say: 'This is the kind of part I like; I'll stick to it.' Over here, I think the public is more willing to accept us because they love us—and that's a very loveable quality—but it's not quite so invigorating.

SHAPLEY: Tell me, Miss Lawrence, how do you feel

56

about the custom we've had in London since the war of opening most of our theatres at about seven o'clock instead of at eight-thirty as they still do in the States?

LAWRENCE: I like it very much—it gives one a chance to have some sort of social life. If I want to have a reasonably comfortable dinner with my friends in New York before going to the theatre, I simply can't because they're wanting to dine just about the time I should be making up. Whereas here, in London, I can join my friends for supper after the play at ten o'clock, and still be in bed by midnight. And I think earlier openings suit us, because as a nation we don't like staying up as late as Americans do.

But I would like to register a complaint. I do wish smoking was forbidden in *all* the theatres, as it is in America. It would make all the difference in the world to us—and to the audience. They wouldn't cough so much, and they wouldn't fidget so much, and they wouldn't distract the attention of others around them by striking matches and flicking lighters. Sometimes it's like acting in front of a forest of fireflies! And the noise! All you can hear is the flick-flick-flick of cigarette lighters. Last Saturday night, exactly two minutes before the curtain came down on the second act—when they knew they were going to have an interval—I saw five people pass a lighter down one row, lighting their cigarettes from each other.

SHAPLEY: Yes, it's inconsiderate to the actors.

LAWRENCE: Oh, and there are other tiny customs I'd like to suggest might be adopted here at home too—nothing to do with the theatre. For instance, the habit of writing your name and address on the

57

back of an envelope when you send a letter. I had a whole packet of mail this morning, and there was only one letter (from G.B. Stern who has been in America) with the name and address of the sender written on the back of the envelope. I think people would find that a great time-saver—especially anyone in business.

SHAPLEY: Anything else?

LAWRENCE: In America, they use paper handkerchiefs and paper napkins. It's so much cleaner and cheaper. They just use one and throw it away, and there are not so many laundry bills. And with paper handkerchiefs you're not so likely to spread infection. My husband wouldn't dream of using anything else. Every man over there has a box of face tissues in his office drawer. Of course my husband has a lovely linen one for his pocket—but they are 'showies' not 'blowies'!

SHAPLEY: What about everyday life in America?

LAWRENCE: Naturally I love all the labour-saving conveniences over there—they give a woman so much more leisure. But, in spite of that, life in America *is much more tiring*. I know that when people first come to New York they say it's like being in Switzerland—the air is so invigorating; but after a few months you see them looking pretty tired. I love my home in America, but after all I'm a Londoner, and I'm used to the English climate. And I feel I can *do* so much more when I'm in London. If I were broadcasting in New York, I'd go straight back home and rest until the evening show. When I leave here today, on the contrary, I intend to go for a singing lesson, and also I'm going to buy some brass stair-rods to send to New York. I haven't been able to find any over there. Another

58

thing I haven't been able to get in America is a knifeboard of all things. I've got an old set of beautiful knives made for Queen Victoria—real old Sheffield steel with ivory handles and crowns on them, and I want a knifeboard to clean the blades. Actually I ran up a makeshift one in our garage toolshed out of a piece of linoleum and an old splint I had when I was in the Red Cross.

SHAPLEY: Do you fancy yourself as a carpenter, Miss Lawrence?

LAWRENCE: Well, I wouldn't say that, but my grandmother used to say, 'Gertie, you must grow up able to turn your hand to anything. Remember, there's no such word as "can't".' I was brought up on a whole lot of those old adages—'Where there's a will there's a way' and 'Never say die' and 'If at first you don't succeed'. I kicked against them as a child, of course, but many's the time they have become very handy since I've grown up.

I'd like to be serious for a minute, because there is something I very much want to say. You know, going backwards and forwards between the two countries, as I do, makes me aware of a certain difference between British women and American women. You often hear people say that America's a woman's country, and to a certain extent that's true. When American women want something they band together and get it. They form powerful clubs and associations, and if need be they'll go to their congressman or senator and complain until they get what they want. In my opinion, English women don't assert themselves enough. No matter what their station or social position, every woman in England has become a housewife—yet they don't begin to know what they deserve. If British women

59

want something, they should be firm and stand together, and there won't be a housewife in the world that won't uphold them, because of the way they carried on during the war, and ever since. I don't think they realise their own splendid courage, and they deserve every consideration and the highest praise.

Her stormy marriages and legendary love affairs, with both men and women, added to her fame and mystique. When she died the lights were dimmed along Broadway and in the West End in tribute.

Dame Edith Evans

25 April 1949

Dame Edith Evans (1888–1976) was one of the leading stage performers of her generation. She had a distinguished career both on stage and screen, making her debut as the lead in Shakespeare's Troilus and Cressida *in 1912. She played many of the major Shakespearean roles with the Old Vic and revealed a talent for comedy playing Rosalind in* As You Like It *and the nurse in* Romeo and Juliet. *She was created a Dame of the British Empire in 1946.*

I feel very strongly that there are a lot of different women in me, who find their outlet in the various parts that I play.

During the last four weeks I have been in a film called *The Queen of Spades*, in which I play a strange old Russian countess of eighty-three—a very arrogant woman; then in another film called *The Last Days of Dolwyn*, written by Emlyn Williams, in which I play what I think is a darling Welsh peasant woman.

Then I am on stage at a London theatre every night, and two matinées a week, in a play called *Daphne Laureola* by James Bridie. In this I play quite a different kind of woman to my two film parts—I wear the most lovely fashionable clothes, and I look as beautiful as I can. And just to round off this work, I recently played the name part in a broadcast of George Bernard Shaw's *Candida*. And so it goes on.

Even as a child I must have had the germ of a multiple personality in me. I remember that when I used to go to children's parties, I never knew what sort of person I was going to be when I got there—I didn't know whether I would sit in a corner, quiet and shy, or whether I'd be a tomboy and lead the noise. I think a good many children have this feeling and some, like myself, develop it as we grow up—others don't. I've got school friends, for instance, who cut away the frills quite early in life, and just went straight ahead, quite content to be, as it were, one person. And they're very happy women. But others feel this conflict in themselves; they feel they are several different people, and that upsets them. I'm very lucky in that I have my outlet for this in the theatre.

And yet, you know, in spite of feeling there are a lot of different people in me, there's an essential part of me, the spirit, if you like, which remains *unaltered*. In fact it grows stronger and stronger, the more different parts that I play. It's rather the same with any artist; whatever he paints, he is giving his interpretation of what he sees.

I love my work very much, but if I were honest I would confess that I don't want to go to the theatre *every* day. Some days I long to be . . . oh, lots of different women! And I don't just want to be them for a few hours on the stage, I really want to live their lives for a little.

Sometimes I think I would like to be a traveller. I get very excited when I read about historical finds in Egypt and other places. I want to be out there exploring.

There are days when I want to be a housewife doing purely domestic jobs. I can't tell you how

much I long sometimes just to have a morning at home to practise my cooking! At the moment I am simply dying to make a cake. But leading the sort of life I do—filming and broadcasting and playing a part each night—I've always got these things on my mind and I can't shed them, and throw myself into a busy domestic life.

Sometimes I long to be a dancer or a skater—I love those beautiful flying movements, the amazing way they seem to float. But to be either of these people you have to give a lifetime—or nearly a lifetime—up to it. I think it was Jane Austen who said, 'It takes one a lifetime to become proficient.' And if it came to the point, I expect I'd hate the discipline of dancing and skating, just as I often hate the discipline of acting.

Dame Edith Evans also appeared on the screen, including some early silent films and a role in Look Back in Anger. *Renowned for her deep resonant voice, her most famous performance was as Lady Bracknell in Oscar Wilde's* The Importance of Being Earnest. *She had already played the role on the stage in 1939 and then again in the 1952 film version, when she asked the question that was to become her signature—'A handbag . . .?'*

'The Self-Service Laundry'

10 May 1949

The first self-service laundry in the UK opened on Queensway, in West London, on 9 May 1949. Woman's Hour *sent Rosemary Sands to report on it.*

I liked the idea and I liked the way it was being carried out and I think that in time it's going to be one of the really useful and practical labour-saving devices for all kinds of women. Let me tell you what I admired most about it. I liked the speed of it. You take in your soiled linen and put it in a machine, and in half an hour—no longer—you find everything clean and thoroughly washed.

Then I like the practical side of it. There's the minimum fussing. You weigh your laundry when you arrive—nine pounds can go into each machine; you turn a knob, put in some soap powder provided by the laundry and leave everything to soak for five minutes. Then you add the rest of the soap powder, start the machine and leave it for another twenty-five minutes. You can go away and leave it whilst you shop elsewhere, or you can wait in the laundry and knit or talk or read in the same large room where the washers are.

The machine cuts itself off in due course; you take the wet things, in a special little metal container on wheels, to another machine that whirls off most of the water; that only takes three or four minutes. Then you go home with your laundry ready to iron—nothing could be simpler.

I like this laundrette service for its hygiene. The shop is very fresh and clean, the twenty machines all white and spick and span, and the attendants who give you a hand are nice and human. The clothes are well washed and well rinsed; I believe, in fact, that they're better done than by ordinary home washing because it's a gentler method.

I must say I liked the economy of it all, the economy of your time and your purse. You can make an appointment for a machine. At the moment they're open between nine in the morning and six in the evening and all day Saturday—and they're planning to arrange some late evenings for all-day workers. Now the cost, including everything, even the soap powder, is 2s 6d for nine pounds of dry laundry. Nine pounds is, for instance, about four sheets, four pillowcases, teacloths, tablecloths, towels—really all the household linen for a family of four, or for two people, the household and personal linen, such as shirts and handkerchiefs and blouses.

This is the first commercial self-service laundry in the country. America has over 5,000 of them and when we manage to get them all over the place they will be, I am sure, part of most housewives' weekly appointments and a great help in the house. There must, eventually, be sufficient so that one is near enough to you to make the fetching and carrying a small effort only. There seems no other problem than that. They really wash clean—even the heavily soiled things; it's recommended that a paste of soap powder and bleach is rubbed beforehand on the badly dirtied parts like collars and apron fronts. Coloured things can go in a separate machine. Even woollens can be trusted; there are no grabs in the

machine to tear or spoil. When you go out shopping in the morning you can bring back with you the week's wash—clean and nearly dry.

Elisabeth Lutyens

28 November 1949

Elisabeth Lutyens (1906–83) was a pioneering woman composer and the daughter of the architect Sir Edwin Lutyens. An exponent of modern music, she composed both orchestral and chamber works as well as songs and operas. Elisabeth Lutyens also liked to shock and was famed for being outrageous. This talk was titled 'I Wanted to be Normal but Am I a Freak?'

I don't think anything is more natural—or normal—than doing what one wants to do, and *thereby*, one hopes, becoming what one wants to *become*—in fact doing 'what comes naturally'.

I started, like the rest of you, wanting to do things that seemed quite normal to me. I took myself seriously, which is so natural to children, and wished to burn the midnight oil, to work hard to become a real composer, like Handel (his Largo from *Serse* was the only music I had heard at the ripe age of nine). Nanny—yes, I had so dear a person—disapproved. It was to her unnatural that I should be 'strumming' (writing masterpieces to me) when as a future little lady I need not work. Already, by doing what came naturally to me, I became the problem child, unwittingly challenging the class, sex and age to which I belonged.

I was plain and unpopular and bit my nails—a deplorable habit, but one that has, strange to stay, enabled me to learn my job. As 'occupational

67

therapy' I was put to learn the violin. This was bliss, but I was a poor violinist—and you must admit it is an agonising instrument to practise in family circles. A solution was found and I was sent to a boarding school. Here I was, at last, a success and in the first-eleven hockey team (there were only seventeen girls in the school).

But, oh dear, it didn't pan out quite right—I naturally got into trouble. I felt, for example, that letters home should be private, unsupervised, and I said so. I naturally also thought that pupils know more what they wanted to learn than the teachers—and said so. As a result of these simple feelings I asked for 'self-government', and as our headmistress was a wise woman, she agreed to let us have it. This government for the pupils by the pupils was brutal while it lasted—and it lasted for a term! (Oh, the cruelty of children to children!) I learnt a lot. But I learnt no music so asked to be allowed to go to Paris to study. I went. These were the precious years; these are the years that count.

Then I wanted to fall in love—mind you, the wanting to sometimes comes first. I was young and wanted all youth's sweetness. It hurt—but I did it!

Also there came a time when I naturally wanted to marry and have children. 'You cannot marry and have a career,' they said. These—these ogres. I thought, naïvely, men marry and work and have children. 'Truly,' they said, 'but you are not a man, you must choose.' What ghastly tyranny this choice between the work that one loves and the natural, normal life for a woman, which usually means a man, children and a home.

Well, I did marry, I've had my children—two boys and two girls—and I've continued working at

music, by day and by night if necessary. Also, loving independence and to justify my wants or my greed, I've earned my living by music—copying, writing for films, for radio and by concert performances. Difficult, but possible, even for a woman.

It has been thought odd, unnatural—a woman's place is in the home etc. For me this combination of composing and running a home has become quite normal, and I hope it will for my daughters too.

Only it is hard, hard work and harder responsibility and it takes its toll, this double life, on one's health—the one vital prerequisite for an artist. I remember during the war I was single-handed with four children under seven, with the cooking, shopping, housework, etc. to do by day, and most of the nights, in spite of disturbances from the children and air-raids, I wrote music—and no one can write my music for me.

My life, as I said, all seemed and seems normal to me. Wherein, then, lies the oddness—the freakishness? Well, in the last generation, one could count on one hand the number of women who adopted composing as a career. Now they are accepted as naturally as men, but I still grew up during the period when it was considered an odd vocation. Many women composers now earn their living by their work, many are also mothers of families—but do you know that, even today, I personally do not happen to know of any woman who combines the three activities—composing, motherhood and livelihood—bar myself. So I naturally feel odd—though I feel sure the next generation will be following in my footsteps. I can tell them it's been well worth while and I would not

have had it otherwise.

To end on a moral, as many stories do, I would only add Polonius' adage:

> This above all, to thine own self be true
> And it must follow, as the night the day
> Thou canst not then be false to any man.

The 1950s

The 1950s

Martha Kearney

My own images of the 1950s are firmly in black and white, inspired in part by the set of Homemaker crockery I own, which was made for the Festival of Britain in geometric monochrome, then the height of modernity, with patterns of coffee tables and standard lamps, objects of desire for the modern housewife. The mental pictures are also black and white because of my parents' honeymoon pictures, which I pored over as a child. Ambitiously for a young couple on a lecturer's salary, they headed for Italy where my mother was photographed in 'New Look' dresses and glamorous sunglasses on a beach in Ischia. She returned to a drab Dublin where spaghetti had to be hunted down in special delicatessens and it was regarded as pretentious to put green pepper in a salad.

It would take a little while for Elizabeth David to make her mark. Her first cookery book, *Mediterranean Food*, was published in 1950 with lists of ingredients like garlic and aubergines that were rare sights in the local greengrocer's, to be cooked in olive oil, which could be bought only at the chemist's and then only to relieve blocked ears. But at least rationing had finally come to an end—though not fully until 1954.

After the war, during which women had done so many traditionally male jobs, there was almost a fetish for housework. There would have been no irony around the term 'domestic goddess'. *Woman's*

Hour ran talks like 'I'm Thankful I'm a Housewife', 'Make a Clean Sweep'—a talk about new vacuum sweeps for cleaning chimneys; 'Is Spring Cleaning Really Necessary?' and 'How to Hang Your Husband's Suit'—by a West End tailor! The 1950s housewife had a wonderful variety of modern gizmos at her disposal. Self-service supermarkets were introduced. A new phenomenon was making its way over from America: the baby buggy. But not everyone had access to the new world of white goods; as late as 1958 a speaker on the programme could say, 'For those of you who are lucky enough to have a refrigerator or who are thinking of buying one, here are a few hints.' And I must say I am sorry to have missed the 1957 classic, 'What's New in Nylon'.

Many of the old pre-war social assumptions still held, although cracks were beginning to appear. Marriage and motherhood was the life that most women lived. If they had a job they generally gave it up on getting married. Indeed, in some professions like diplomacy, married women were not allowed until the 1970s. In 1953 equal pay was introduced for women teachers and was agreed two years later for civil servants, though not fully implemented until the 1970s. A whole generation of women had to choose between a career and marriage; this was particularly true in the teaching professions and in the Civil Service where the only way to advance was to stay single. *Woman's Hour* discussed the work possibilities open to women— 'On Taking a Part-Time Job'—or the difficulties of older women (those over thirty-five) finding work.

Role models for women on the programme included Elizabeth Pepperell in 1954, describing

what led her to become the first woman assistant director of the Industrial Society, and Chief Inspector Margaret Mackenzie in 1956: 'Why I Joined the Police Force'. Educating the next generation of girls who were to have completely different lives from their mothers and grandmothers was often a topic for discussion. *Woman's Hour* went to visit the first purpose-built comprehensive school in 1954.

The country itself was on the cusp of tradition and modernity. In 1951 the Festival of Britain was organised to mark the centenary of the Great Exhibition of 1851, to demonstrate Britain's 'contribution to civilisation', past, present, and future, in the arts, in science and technology, and in industrial design. In February 1952, the old king George VI died and a new young queen was proclaimed. Queen Elizabeth II's coronation in June 1953 was the first mass television event, though few households had a television; people clustered round those of their more fortunate neighbours and friends. The occasion was marked by many celebrations across the country and by the invention of the dish Coronation Chicken by Constance Spry, which was to become a staple of buffet tables across the land for the next fifty years. It's still available in the BBC canteen.

Marriage and motherhood were the most frequently debated issues on the programme. There was even a series on marriage to unusual husbands: for example, 'I Married a Rat Catcher'; 'I Married a Lion Tamer'. Other topics included 'The Children of Broken Marriages'; 'I Married a Family', a talk on being a second wife with stepchildren; and a whole series on being a

spinster. There was a particular poignancy to the account of being stuck in an unhappy marriage in 1953: 'I Wish I Were Single'. Although we think of the 1950s family as having two parents—mother at home, father at work—life wasn't as simple as that. Many women had lost their sweethearts, fiancés and husbands in the war and were struggling to bring up a family on their own.

Childcare experts, like Dr Winnacott, continued to stress child-centred parenting and the dangers of maternal deprivation for the child, even for short periods. Dr Spock caused a revolution in childcare with a book that was to become a childcare bible.

Babies were a staple for *Woman's Hour*; in early 1950, there was Sister Margaret Myles' series 'Looking After Your Baby' and, in 1951, a whole 'Baby Week' of programmes, followed by the series 'Having a Baby in 1951', which considered all current views on childbirth, including a live relaxation class in the studio, with BBC female members of staff roped in to take part. In 1954, the Natural Childbirth movement took off, under Dr Grantly Dick-Read, with his methods being championed by the programme including, in October 1957, a whole programme dedicated to childbirth, which contained a graphic recording of the birth of a child. It was preceded by a health warning: 'We know this is a programme that may not appeal to all our listeners—but since childbirth is something that concerns so many of us, we felt it would be worth while to devote one whole programme to it. We hope listeners who don't think it's a subject that should be talked about will forgive us and join us again as usual tomorrow.' Within a few days *Woman's Hour* had received 500 letters,

mostly in support. *Woman's Hour* was one of the first to raise the issue of how children were treated in hospitals and it inspired listeners to press for changes.

Philip Larkin may have declared that sexual intercourse didn't begin until 1963 but *Woman's Hour* did broach the subject albeit rather delicately. By the end of the 1950s there was even mention of sexual fulfilment, although a discussion entitled 'Has Conventional Morality Lapsed?' was introduced as follows: 'You may remember that the question of sexual relations between unmarried men and women was recently aired in a BMA publication, which was subsequently withdrawn. There was a good deal of controversy about this matter and we asked Joan Yorke to find out from a sample of people what they think about it. If some listeners would prefer to join us again at the end of this item, which is suitable for adults only, they can do so at . . .'

This was a decade of many firsts. In 1953, Lita Rosa became the first female number one in the charts with 'How Much is that Doggy in the Window' and that same year Ann Davison became the first woman to sail single-handed across the Atlantic. The 1950s saw the first woman bank manager, newsreader and managing director of an advertising agency. The ascent of Everest was celebrated with a special interview on the New Year's Eve programme, 1953, with the wives of the Everest team—Lady Hunt, Lady Hillary and Mrs Bourdillon. In 1958 women were allowed to sit in the House of Lords for the first time and Baroness Wootton, a regular speaker on *Woman's Hour*, was celebrated by the programme.

At the beginning of the decade, young men and women still dressed like their parents: the boys in suits and the girls in twinsets and sensible shoes. Debutantes continued to be presented at court. Fashion persisted in looking to the Paris collections for guidance. In 1950, Anne Edwards talked about 'The Paris Dress Shows'—'the big fashion news from Paris is that dresses are going to be short and straight again'; by 1953, the subject had become 'Importing the Spring Collections from Paris'. 'So far it's been a bit of a battle between the loose middy look and the fitted, waisted, rather long slim look. Waists have won!' The triumph of the waist may well have led to the item 'Choosing a Foundation Garment', on buying brassières and corsets.

In 1955 the first call of modern British fashion was heard when Mary Quant opened her shop Bazaar on the King's Road, the street that was to become the temple of youth, rebellion and modernism. Youth culture was struggling to express itself and a new expression, 'teenager', was coined. Fears about 'youth' were common fodder on the programme: the menace of the flick knife, a mother speaking up in defence of Teddy boys, a discussion on youth clubs and on juvenile delinquents. Listeners were invited to join in with talks called 'Relax More Often' and 'Learn to Rock and Roll'.

There were signs that women wanted to talk about things other than the domestic world, but the programme had a markedly less feminist agenda than in the immediate post-war years. In 1952 the programme tackled foot-and-mouth disease. In 1954 there was an item perhaps betraying a certain

78

prejudice—'Behind the Headlines: The Problem of Jamaican Immigrants'. There were also stories about apartheid, the hydrogen bomb and the link between smoking and lung cancer.

Some subjects are still staples of the programme now. Women's health has always been a major topic of interest to the programme and the 1950s saw some subjects discussed for the first time, including slimming and breast cancer. In 1954 *Woman's Hour* broadcast a personal story about a breast cancer operation, 'I Conquered Fear', followed by information from a doctor about the diagnosis and treatment of breast cancer.

'The change of life' had been discussed on the programme before, in two series in 1947 and 1948. As sexual health was considered an issue of key concern to the *Woman's Hour* audience, the pioneering Dr Jean Malleson was invited to present two series on the subject in 1950 and 1952. 'In the first place I want to make sure that no listener here will ever become shocked or frightened if she experiences such troubles herself; and that she will, through this knowledge, be able to be both sympathetic and helpful to other women who suffer in this way.'

The second series was repeated in 1956, with this comment: 'After the first series of these talks we were astonished to find how much they had been appreciated. We received some hundred letters about them. Many were written only to express gratitude but others to ask for information about symptoms that I had not dealt with in the talks. There were just a few letters of criticism from listeners who felt that it is better not to discuss matters like the change of life for fear of making

people think too much about themselves.'

In 1958 the visiting Canadian gynaecologist, Dr Marion Hilliard, insisted for the first time in calling 'the change' the menopause and she described how it often brought the enjoyment of sex: 'With this goes a sense of rebirth and exhilaration beyond description. Now that the fear of unwanted pregnancy is past, many women find themselves enjoying sexual relations with their husbands for the first time in their lives. I've met women in their fifties as blushing as newly weds, and with good reason.'

Woman's Hour has never been shy of addressing controversial subjects; topics in the 1950s included prostitution, family planning, marriage to an alcoholic, mental illness and pornography. In 1958, in the series 'You Ask About it', Dr Clifford Allen talked about 'homosexuality, specifically today male homosexuality, about how it can be made, prevented and cured'.

The decade saw a change in the *Woman's Hour* presenter: Jean Metcalfe took over from Olive Shapley as main compère in 1950. Her marriage to Cliff Michelmore, whom she had met 'over the airwaves' when they had both presented *Two-Way Family Favourites*, meant that she was already known to the public. From 1958, Marjorie Anderson was in the chair.

The 1950s also saw the introduction of the *Woman's Hour* columnist: a range of regular voices who talked about anything and everything. Some, like Joyce Grenfell, Nancy Spain, Vita Sackville-West and Naomi Jacob, were well-known figures. Others, like Catherine Cookson, Barbara Woodhouse, Elizabeth David, Phyllis (Fanny)

80

Craddock, Marjorie Proops and nursing sister Claire Rayner, became known through their appearances on *Woman's Hour*.

The 1950s was a decade in which the old world was changing but the new one had not quite arrived. And *Woman's Hour* reflected both the change and the feeling of uncertainty in the lives of women. If in January 1950 the guest Vera Lynn looked back to the era of the war, by 1957 the Prime Minister Harold Macmillan was telling us, 'You've never had it so good.' In October 1959 a new young woman MP, Margaret Thatcher, made the first of many appearances on the programme. The writer Iris Murdoch came on to talk about 'Regrets at Not Having Been a Teenager'. The freedom of the 1960s beckoned.

Vera Lynn

16 January 1950

Vera Lynn was born in 1917 and by the age of seven was already a regular entertainer. She made her broadcast debut in 1935, and in 1940 appeared on her own BBC Radio show, Sincerely Yours. *Famous for serenading the nation during the war, she became known as 'The Forces' Sweetheart'.*

I sang at my first concert when I was seven. I was billed as the 'descriptive juvenile vocalist' and was paid the handsome sum of 7s 6d for that performance.

At school I never had any encouragement to sing. They didn't consider that I had a decent voice because I could never sing high. I always have to have my songs transposed several keys down. But after school, in the evenings, I sang just as I wanted to. I'd joined a troupe called The Cracker Cabaret Kids, and we used to perform at cinemas, concerts, etc.

At fourteen I left school to stay at home and help Mum, but I soon tired of having nothing much to do, so I decided to go into business on my own. I bought an outfit for leather-making, and did a roaring trade with my family and friends with bags, purses and wallets. But when they were satisfied there were no more customers, and once again I had to think of something else to do. I decided to look for a job dressmaking. Mum had been a dressmaker, and after about six weeks I got a job as

a finisher. The first (and only!) morning I turned up at nine prompt, carrying my lunch basket, and was shown into a workroom full of girls. I was given a lot of buttons to sew on to a dress, and I was told that the girls were not allowed to talk to each other. We worked by artificial light and the day seemed endless. By the evening I was feeling so miserable that I went home determined never to go there again. And I didn't. A few days later I was sent 1s 1d for that day's work.

I had of course been carrying on my singing during this time, but it wasn't until I was sixteen that I got the sort of job I really wanted, as a vocalist in a dance band. It meant evening work, full evening dress and, for the first time, singing into a microphone. After a while I was sent to Manchester to sing with Billy Cotton and his band. My first week was a success, so I went on to Sheffield with them. Halfway through the week Billy decided he didn't think me good enough. I shall never forget how I felt going home, but it made me all the more determined.

After about two years I thought it was about time to step out a bit, so I began to frequent the music publishers to find out whether any of the West End dance bands were looking out for a vocalist. One day Joe Loss turned up and said, 'I want a girl to sing for next Wednesday night. Who's free?' They suggested that Joe should give me an audition. He did, and he engaged me for a broadcast. During the same week I gave an audition to Charlie Kunz at the Casani Club, and I was again successful. From playing with Charlie I went on to Ambrose's band; and it was there I met my husband Harry—he played the saxophone.

I don't think we really took to each other at first sight. He told me he didn't like my singing—he thought it was 'corny'. The only praise he'd give me was to say that I sang in tune! Then he softened; and at rehearsal he offered me a piece of chewing gum. Afterwards he asked me out to lunch, but I wouldn't go. As the week went by, however, I began to think that perhaps I was wrong and next week I offered him a piece of chewing gum. We became friends. We married. But he still thought I was a 'corny' singer.

In 1952 Vera Lynn became the first British artist to hit number one in the American charts with 'Auf Wiederseh'n Sweetheart'. In 1975 she was made a Dame of the British Empire. In 1993 she published Unsung Heroines: the Women Who Won the War.

Catherine Cookson

30 January 1950

The novelist Catherine Cookson (1906–98) had spoken on Woman's Hour *once before, in August 1949, when she gave a talk entitled 'I Learnt to Draw at Thirty'. She gave several more talks over the years, for example on buying second-hand furniture. During 1958, two of her 'Mary Ann' novels were serialised on the programme and by 1961 she was one of* Woman's Hour's *Guests of the Week. This particular talk was entitled 'Dreams Come True'.*

I think I began to daydream when I was twelve years old, when I first realised I didn't like the sunshine. It's a dreadful thing for a child not to like sunshine, but I found that it showed up my surroundings and made them painful to me. The grey streets of Jarrow, the proximity of the docks, and that stretch of mud, seemed bearable only when merged together on a dull day. But pour sunshine on them and they were dirty and stark.

So my first daydream took shape: a big house, filled with beautiful furniture, standing in its own grounds, and, of course I was in it, gliding through the rooms, in still more beautiful clothes.

When I was eighteen, the dream, far from fading, had become an intense desire, and as there were no princes riding around the Tyne looking for brides, it would be entirely up to me to make the dream come true. But how? A slump was hitting the country and it was not unusual to see men walking about with

their feet bound up in rags. I have memories of seeing such men pushing little hand-made barrows to a tip near my home, where they would pick cinders during the night. In the early dawn, I would wake and hear the wheels of their barrows on the road and perhaps a voice, here and there, bravely singing. Oh, the desolation with which that sound filled me.

Without realising it, I was listening to the unquenchable spirit of man, and of the Jarrow man in particular. At that time even girls with training could find no work, as there was an outcry about women in jobs while men walked the streets. So I considered myself very fortunate to get a job as a checker in the office of the Workhouse Laundry. My wages were just over £2 a month, plus uniform and keep, and every month I saved 10s towards my dream. I loved clothes and was often tempted to go bust on my savings, but I would ask myself the question, 'The dream, or more clothes?' The dream always won.

As the years went on I rose to manageress, moving from one place to another, wherever I saw advancement. And with every rise I received, I put the money away and watched the dream come nearer. But, even then, I had only pounds, and the dream would take hundreds and hundreds, but still I dreamt.

I remember an old North Country businesswoman saying to me, 'Get your first hundred, honny, an' yer there. It's the best magnet in the world.' She was right. I felt I had come to a turning point once I had reached my hundred.

With this behind me, and a sure job, I took out a big insurance on my life, so big that there were

questions asked by the company why a single young woman should want to insure herself for that amount. This insurance policy was my security. I mortgaged my life and I got my dream, an old fifteen-roomed house standing in a garden. And for the first time I stood on land that was mine, and my dream of fourteen years was fulfilled.

But I still had to work for the dream. With the help of a housekeeper, I ran my house as a guest house, managing the laundry at the same time. There were no good times as many young women have, but fifteen hours a day hard work.

The war came, and with it the end of many dreams for some of us. The end of the war, though, found me embarking on yet another dream. I was going to write! In my more sensible moments I said to myself, 'Don't be daft! Think of the spelling, the grammar, the technique.' I am not going to suggest that my dream of being a writer was so vivid that I just sat down and wrote. No, I struggled for weeks, months, before I wrote anything readable. Not that I didn't think it was beautiful while I was doing it. To me every sentence was a gem. I was fortunate in having a stern critic in my husband. 'Listen to this!' I would say, and read.

He would listen, then say, 'Scrap that flowery bit in the middle.'

'What! That's the basis of the whole thing.'

'Well, scrap the whole thing then,' he'd retort, but all this was good for me.

Now a year ago, three years after my dream first awoke, I actually began my novel. And I finished it, 75,000 words, written at all hours of the day and night, for with the big house, and the garden, and the cooking, and the washing, I was unable to give

set hours to it. But it's done. And miracle of miracles, it is to be published.

So you see what purposeful daydreaming can accomplish. My advice is, try it. Dream of what you want most and dream of it really hard, when you are tackling the washing, when you're cleaning out the ashes, when your hands are full of cinders and your teeth are on edge, or when your back is breaking in the garden. Daydreaming, that's just a hazy indefinite imagining, no good at all. You've got to work at it. But I must warn you of this. It may not be exactly as you dreamt. It may be like my dream of the wonderful, big house, standing in its own grounds. I got it. But I forgot to dream up the servants and the gardener. But would I have it otherwise? No, not for a moment.

Catherine Cookson went on to write more than eighty novels, which have sold millions of copies worldwide. For seventeen years, up until 2004, she was the most-borrowed author from British libraries. She was created a Dame in 2003.

Dr Margaret Mead

interviewed by Olive Shapley
28 February 1950

Dr Margaret Mead (1901–78) was a renowned American anthropologist. Her first book, Coming of Age on Samoa, *published in 1928, was highly controversial with its exploration of the sexual lives of young women. In this interview she is talking to Olive Shapley about her book* Male and Female, *which was published in 1949.*

SHAPLEY: Do you think men and women should be treated equally?
MEAD: No, I don't. When you consider women in the modern world, there are a good many things that America and Britain have in common. I try to look at all the experience that we can accumulate over the whole world, and it seems that it's very important not to treat men and women as equal, because if you treat them as equal you deny the significant differences between them. When you take two things that aren't equal to start with, that aren't alike, and merely treat them equally, you come out with very peculiar results.
SHAPLEY: So what exactly do you advocate in your book?
MEAD: I think it's important to realise the differences between men and women. We've civilised men and we haven't done much with women at all, except brought them along and married them from time to time. But we've done

89

awfully little with developing women as human beings. We've thought that we'll give them a little education and possibly a little needlework but otherwise their function was all cut out for them by biology, whereas in order to cut men's functions out for them you have to give them education.

SHAPLEY: You think that's still true today?

MEAD: Yes, I think it is. When a girl's born in this country, do you think the average father and mother thinks about the same things? Are they going to have to lay aside, perhaps, the same amount of money or effort for their education? Do they look at their minds or are they more likely to look at their faces and their figures? Are they more worried about whether they'll marry than whether they'll be people? I should certainly think that there are a lot of able women who aren't being given a full chance at present, but I don't feel that's the most significant thing that we have to work at. It's not a question of getting the doors of the Law Courts open to women so much as changing our view towards the average woman, towards the average girl.

Following her death, there was some controversy about the reliability of Dr Margaret Mead's methods in Samoa. While there is agreement that there are some flaws with the original research, her place as one of the most significant anthropologists ever remains intact.

'Equal Pay'

29 March 1951

Thelma Cazalet-Keir (1899–1989) was a Conservative MP, who represented Islington East from 1931 to 1945. She was a passionate campaigner for women's rights and, after her defeat in the 1945 General Election, she tried but failed to re-enter Parliament. Despite her 'retirement' to her market garden, she continued to campaign on women's issues, sitting on numerous committees and public bodies. In 1957, she became a governor of the BBC.

Next week I shall be taking my first lettuces to market, and if any of you who are listening intend to buy a salad, and provided the lettuces are all equally good, you won't worry whether the one you buy has been grown by a man or by a woman market gardener. You certainly won't expect to pay two different prices for the same vegetable—you will, in fact, pay the going rate for the lettuce without question. Why doesn't the principle that holds good in the case of the lettuce hold good for all work that is equally well performed by both men and women workers?

This whole question of equal pay for equal work is still full of anomalies. For instance, the government decided some time ago that equal pay should be given to women who reach the very highest rank in the Civil Service. There's only one such woman at present, and the lower ranks are still excluded, although they took a deputation to

the Chancellor on this question in January and are still awaiting his reply.

Can you imagine a minister like Dr Edith Summerskill not getting £5,000 a year the same as all Cabinet ministers do, or Megan Lloyd George, for example, being paid less than Michael Foot or Bob Boothby just because she's a woman MP? Of *course* you can't! The rate for the job has always been paid in Parliament, as it is in journalism, broadcasting, the stage, medicine and the law.

As you know, outside the public services women's wages as a whole are very much lower than men's. No doubt you will have already heard on the wireless or seen in today's papers that the average wage for men is now £7 10s and for women it's £4 2s 7d. But here wages are settled by trade unions and employers, and are no direct concern of the government.

Of course, tradition and prejudice play their part in this question. Nevertheless, I should think that rarely has any subject been submitted to quite so many investigations as equal pay. It's astonishing that no less than eight different committees and inquiries have probed into this question since 1914, finishing up with a Royal Commission in 1944. This Commission sat for two whole years, about 4,000 questions were asked by its members, and it had to study a huge amount of written evidence sent in from a wide variety of organisations.

Two small bits of evidence given to the Commission by the Treasury always make me chuckle. The first was a remark about 'the difficulty of women adapting themselves to new circumstances' and this, mark you, just at the end

of the Second World War!

The other amusing bit of evidence described women's 'lack of capacity to deal with surprise situations'. Personally, I should have thought that every married woman finds her husband—not to mention her children—a constant source of surprise. I know I have during the past twelve years. But I'm not for a moment saying that we don't all surprise our husbands at times!

I know quite well that some of you who are listening may have different views. Here are just a few of the arguments that are often put to me. A man may have a family to support and it would be most unfair for a spinster to get the same wages. This sounds reasonable but it isn't the whole story. A man can have ten or twenty children but he will receive the same pay as a man doing exactly the same job who has only one child, or none at all. And by the way, bachelors get the same pay as married men.

The next argument against equal pay is surely that a woman needs less than a man and can live more cheaply. Here's my answer. Even if some men do eat more than women, it should be remembered that during the war the Minister of Food never dreamt of giving women fewer rations than men. As to women living more cheaply, all I can say is that they spend exactly the same on rent, food and fares as men.

Another question I get asked rather less frequently than I used to is whether the work of a woman is really equal to that of a man. Mr Ernest Bevin answered this in 1944 by saying that when he went to the Ministry of Labour, he had estimated that in war trades it would take three women to do

the work of two men. He discovered, however, that by the combined efforts of everybody, one woman had been equal to one man. But after all, you and I know that women passed the tests of courage, efficiency and reliability in two world wars. The First World War established their claim to civil and political equality, the last established their claim to economic equality.

Constance Spry

5 December 1951

Constance Spry (1886–1960) was a florist, cookery expert, teacher and best-selling author. In the 1920s she began professional flower arranging and founded a school of floristry in the 1930s, becoming hugely influential in teaching Britain how to decorate their homes; her gift was to show people how to make floral decorations using not just flowers, but fruit, berries and leaves. After the Second World War she helped to found the Cordon Bleu Cookery school. In this interview, Constance Spry was talking to Mary Ferguson, an occasional Woman's Hour *presenter.*

SPRY: As a young child I was always playing about with flowers—generally wild ones, because I wasn't allowed to pick the garden ones—things like primroses, wild violets, cow-parsley and crab-apple blossom. As a result of that, I was always late for meals and always in trouble. Father thought I ought to be artistic, and he tried to have me taught to draw, and then he tried to have me taught to paint. I wouldn't like to tell you what the results looked like, and my failure annoyed him particularly because he said that *if* he gave me a needle with a piece of wool I could make a really lovely rose without the slightest difficulty.

FERGUSON: What made you start doing floristry professionally?

SPRY: A casual visitor who came in one day said: 'I

can't think why you don't do this in London.' That remark absolutely terrified me. I had no idea how to set about it, but it started me thinking! And then the late Norman Wilkinson asked me whether I'd like to do the front for a scent shop that he'd designed, and I took the plunge into what is a very professional world. And the mistakes I made! But by and by—greatly to my surprise—people began to *ask* about these arrangements I did, partly, I think, because my arrangements weren't at all professional looking, and partly because that was the time when women began to have much more say and freedom in the decoration of their homes.

Once you think of your flower arrangement as a decorative piece and not as a sentimental trophy, your whole horizon becomes widened. You find yourself looking at things from quite a new point of view. I remember once when I was asked to decorate a big room in green and cream and it was the time of year when there didn't seem to be any cream flowers. Suddenly I passed a market garden with a whole field of rhubarb, which had been allowed to flower; and I just went in and bought it.

FERGUSON: It was you who made this mixing of fruit and flowers and vegetables so fashionable.

SPRY: By mixing fruit and flowers you get contrast in shape as well as colour and that helps enormously. Take a look at Flemish flower painters. They mixed fruit and flowers in a most magnificent fashion.

In 1952 she was commissioned to do the flowers for the Coronation and her domestic science school invented the dish 'Coronation Chicken' for the occasion. In 1956 she published The Constance Spry

Cookery Book, *which became a classic, teaching a whole generation the basics of cookery as she had taught them how to arrange flowers. It was reprinted in 2004.*

'On Taking a Part-Time Job'

23 January 1952

This is a personal story from a listener, Rosalind Keyte. It was still rare for married women to work, even part-time.

Recently I have taken up a part-time job, this after much thought and deliberation on the part of my husband and myself. Like so many other couples these days, it had got to the point where there just wasn't enough money available for the extras that make life pleasant. Therefore, after due thought, it was arranged that my husband's parents would look after our small son Geoffrey, aged four, mornings only.

At first, I was very apprehensive in more ways than one. Most important of all, of course, was Geoffrey's reactions to being left. How would he feel, knowing that I just wasn't there if he needed me? To everyone's relief he settled down extremely well to the new routine, which eased my mind considerably and enabled me to concentrate better on the new job.

Naturally I was apprehensive too about my ability to tackle the new job successfully. When one has been out of touch with office routine for nearly five years it seems quite alarming to consider picking up the threads again.

In my old job I had had responsibility and plenty of opportunity to use my own initiative. Leaving work and having my baby, I had been my own

mistress (after a fashion) so how would I react to being an absolute nobody as it were, and starting from scratch?

Fortunately for me, my new colleagues were most understanding and ready to help me settle down. Quite a few of them were, like myself, young married women with homes and children to look after, so I didn't feel alone.

And oh, how invigorating it was to belong to the fraternity of working women, acting and paid! However happily married one is—and I can truthfully say I am—it is very depressing to be a head cook and bottle-washer, acting unpaid. Our husbands do their best for us, but how many of us ever buy anything for ourselves without feeling guilty, thinking that really the money should be buying tomorrow's dinner, or something for the home that is very much needed?

Goodness knows we deserve it, but ordinary housewives don't receive personal allowances. So we get down in the dumps—at least I did!

Now, however, for a brief spell, I am able to buy (within reason) some of these things that make life more enjoyable. Buying my first new lipstick in five years was quite a thrill; buying two pairs of stockings at once—the sheer luxury of it all!

After two months at this new work, I find myself taking stock as it were. Am I really happier? Is the extra rushing about worth while, and is my family getting a square deal as a result of it all? I do honestly say yes. One is so apt to become self-pitying, contemplating the seemingly never-ending drudgery of housewifery alone. However much you care for your family and home, you find yourself sighing for the 'good old days' when you were 'one

of the girls'.

To be a good homemaker is a worthwhile ideal, but we so often stop at that; we don't make time for outside interests. I know this from my own experience. Apart from visiting fellow housewives, a very occasional evening at the pictures, one is left with the day-in, day-out routine of housework, looking after the children, mending, and only the wireless for relaxation.

Making a break, as I have done, has meant much more than giving up my title of housewife. It has renewed my somewhat flagging spirits, and made me feel a different person with a different outlook.

Do I sound dreadfully rebellious? Truly I don't mean to be, and I know from my circle of friends that many of them feel the same. At heart we are all devoted wives and mothers plus! It is that plus that prompts us to want that little extra difference in our lives.

Life seems so full of things to do now. Fitting in the housework is something of a puzzle, but I have adopted the only commonsense method: that is, necessities only during the week, and then a good clean-up at weekends.

Sunday morning has its own attraction of being able to cook at leisure; now we all look forward to Sunday lunchtime—not just my husband. One of the advantages of being a 'working housewife' is that you do appreciate things more, the weekend cups of tea in bed for instance. My husband and I try to take it in turns to provide for each other on alternate days, but his kind-heartedness often produces two cups for me.

To sum up, I'd say that being a part-time mum and office worker really has made a new woman of

me. I don't say that I don't sometimes wish life wasn't quite so hectic, or that I never get tired or crotchety, but in the main I am better for it.

'I Knew Amy Johnson'

17 November 1952

In 1930, Amy Johnson (1903–41) made her epic solo flight to Australia. She became an international celebrity, with crowds lining the streets to cheer her aviation triumphs. During the Second World War, she worked for Air Transport Auxiliary and it was whilst ferrying a plane that she was tragically killed.

In this talk, she is remembered by Dame Caroline Haslett (1895–1957), the first woman to qualify as an electrical engineer and the first secretary of the Women's Engineering Society. From 1947 to 1956, she was the first and only woman to serve on the British Electricity Authority.

In June this year I was flying over the Atlantic in a Stratocruiser, and was scarcely aware that we were crossing hundreds of miles of ocean. I had been sitting in my office at six o'clock the previous evening and now we were coming down to breakfast in New York. As I was trying to adjust my mind to the incredible speed and comfort of such travel, I remembered by contrast a run down the Thames that I had once taken with Amy Johnson one Saturday afternoon. We started off from a North London airfield and came down at Gravesend. It was near that strip of water that was to be her final resting place. I thought how odd her small aircraft with its open cockpit would look alongside the giant cruisers of the air today. The planes in which Amy made her record flights would

seem very frail to us, yet I remember her saying how she used to nurse them, and put patches on when things fell off. When she spoke of *Jason*, the aeroplane she piloted solo to Australia, it seemed somehow like a pet, not something by which you crossed oceans and deserts. We took only fifteen hours on the flight to New York, but Amy had taken twice as long. Yet it was her pioneering and record-breaking flights that helped to make possible the safe, speedy and luxurious air travel we now enjoy.

Yes, Amy's achievements have meant a great deal to our world today, but they meant something else to the millions of the 1930s, who followed her famous flights to all parts of the world. She represented 'Records' and also 'Romance'. Never shall I forget her arrival back from Australia when the roads from Croydon Airport to London were lined by wildly cheering crowds standing in places ten and twenty deep.

Amy was impelled to fly by two reasons: she loved adventure and she wanted to make a real career in aviation. How much solid work lay behind Amy's famous flights was not always realised by the millions who acclaimed her 'Queen of the Skies'. They did not know that it was not just luck and superb courage, but real engineering skill that brought her safely through. Amy was witty and gay, and her charm in telling a story often made people forget that record-breaking has its serious side. To her the dangers were part of the adventure, and she just took the engineering knowledge for granted as an essential part of the business of flying. As a start to her own career she had done two years' practical work on the maintenance and overhaul of aeroplane

engines, and was the first British woman to gain her ground engineer's licence. The Society of Engineers gave her the President's Gold Medal for her paper on 'Jason's Engine'. Later, she studied aviation design and manufacture in America. She declared that women who wanted to succeed in the world of aviation should first be sure of themselves on the technical side. I can remember a group of women being enthralled when she told quite simply of using her suitcase to prop up the plane's front wheel in the desert while keeping a pistol handy for lions!

Anyone who ever saw her remembered her beautiful hands, those hands that piloted her aircraft through so many 'sky roads of the world', to quote the title of her own book and which also expressed another side of her—that of the artist. She brought down to earth with her the wonder of the strange beauty of the skies, and the unfamiliar aspect of nature seen from the pilot's seat, and she recorded them in vivid prose for her earthbound friends' delight.

Amy's love of beauty was expressed too in the clothes she wore. She had a flair for wearing them with elegance, whether it was a tailor-made suit or a striking green evening dress that I can still remember. The picture I like to carry in my mind is of a young woman with a serene yet eager face, her lovely blue eyes inherited from seagoing forebears looking out into the distance that her love of adventure urged her to explore. Her sense of fun, and her love of the beautiful and strange, helped her to enjoy the details on the way, for to Amy it was not just the arrival that counted.

Thousands remember the Amy of the spectacular triumphs, but not as many were privileged to know

the kindly, modest woman who was an inspiring and entertaining friend, who had made her own dreams and visions come partly true, and who was interested in helping other women to make their mark in aviation human relations. On the day before her last flight we lunched together and discussed her plans for the future to which in the dark days of 1941 we were all looking forward.

In 1937, Sir Francis Shelmerdine, Director General of Civil Aviation, said: 'The services to aviation by Miss Amy Johnson may be said to have been equalled by few individuals, and it is a matter of speculation whether in their cumulative effect they can have been excelled by anybody, man or woman.' In echoing this public tribute to a famous flyer, I would also add my own personal appreciation of a brilliant, generous, indomitable and friendly woman, whose passing took something gay and vital from us all.

Vera Brittain

interviewed by Jean Metcalfe
4 November 1953

Vera Brittain (1893–1970) was a writer, pacifist and feminist. After persuading her father to allow her to go to university, she became a nurse during the First World War. During the war her brother, fiancé and countless friends were killed. Testament of Youth, *published in 1933, the first part of her autobiography, described these tragic years. In 1940 she published* Testament of Friendship, *describing her friendship with the writer Winifred Holtby.*

BRITTAIN: I want to talk to you about confidence. I'm going to tell you two stories that explain why I started life without nearly as much of it as I needed, and I daresay you've had the same sort of experience.

I went to school just before the First World War, and one evening, when I was spending the holidays at our home in the Midlands, a business friend of my father's came to tea. He asked me how I was getting on at school, and I was too young to realise that he was just being patronising and polite. So I plunged into an excited description of my ambition to be a writer and my longing to be given some really responsible work.

But he soon interrupted this prattle with a devastating remark. 'My dear child,' he said, 'surely you don't imagine that anyone would put real confidence in one of your sex?'

106

Soon after that I went to college, and got to know a delightful young man who ran a local business. He had recently married a charming girl, and they were expecting their first baby. One day he stopped me in the street, looking thoroughly miserable, and said: 'Have you heard of our fiasco?' I hadn't an idea what he meant, so I asked him to explain, and he told me: 'Our baby arrived yesterday—and it's a *girl*!' Only a girl! How often did you hear that when you were young? Only a girl when Father and Mother wanted a boy! Whatever you feel about this yourself, I do hope you never say anything of that kind to your own daughter, for it might affect her outlook for the rest of her life.

There's an idea of that kind in a book by Barbara Stephen about Sarah Emily Davies, the pioneer woman who founded Girton College, Cambridge. If you know the book you may remember that Lady Stephen used these words: 'Probably only women who have laboured under it can understand the weight of discouragement produced by being perpetually told that, as women, nothing much is ever expected of them.'

My father's accountant imposed that discouragement on me when I was just at an age where encouragement is needed most. I've often wished he'd lived long enough to see the secrets of great businesses safe in the hands of confidential women secretaries, as they are today. Or he might have learnt a thing or two from the jobs some women did in the Second World War. Do you remember how the girls in the Women's Auxiliary Air Force used radar for two years before the public even knew it existed? And don't you agree that keeping secrets comes as naturally to women as to

men?

METCALFE: But, Miss Brittain, some women still lack confidence. Do you think there's anything they can do to give themselves more?

BRITTAIN: I've found that one of the best methods is just to keep on doing the thing you dread. For instance, when I was first asked to make a public speech I was absolutely terrified, yet I knew I should never respect myself again if I didn't do it. So I stood in front of the looking-glass, and talked to myself till I knew the subject by heart and stopped feeling a fool. Don't laugh, but I even dressed myself up in a hat and a fur, there all alone in my bedroom. You see, I was still very young, and my family had always rubbed into me that I was rather small and unimpressive looking. So the hat and the fur made me feel a bit more important and bolstered me.

Of course, what I'm saying doesn't apply only to public speaking. You may not ever want to do that, but the same thing is true about much more usual experiences—meeting people, or sitting on committees, or going to new places where you feel rather strange.

Don't you think it's a good idea, if you're shy of meeting people, to meet as many as possible? If you go to the parish hall or the Women's Institute, you'll find others there who feel as strange as you do. And if you know more than your neighbours about something or other—bringing up children, dressmaking, or teaching history—try to get yourself put on to some local body where that knowledge will be useful. Above all, don't think of yourself as 'only a woman'. Say instead: 'I'm a woman and proud of it! In my household it's I who

keep the peace, so I'm going to try and do the same thing, however humbly, in the world outside my home.'

You and I, and people like us, who have had to learn to patch up family quarrels, are needed to do that very thing in politics and local government and parish councils and village institutes. In other words, we're needed as women.

Once we get that idea into our heads and learn to believe in ourselves, we shall stop using men as yardsticks, and stand on our own feet.

In 1957 Vera Brittain published Testament of Experience, *describing her work for peace. She continued to campaign for peace throughout her life.* Testament of Youth *was made into a hugely popular award-winning television series in 1979. The politician Dame Shirley Williams is her daughter.*

Nancy Astor

interviewed by Mary Stocks
7 October 1956

Nancy Astor (1879–1964) was the first woman to take her seat in the House of Commons, as Conservative MP for Plymouth South, in 1919. A frank-speaking American, she introduced her first parliamentary legislation in 1923, outlawing the sale of alcohol to those under eighteen. She remained in Parliament until 1945, when she reluctantly resigned her seat, certain to lose in Labour's post-war victory.

Mary Stocks (1891–1975) was a leading figure of the 1950s. A women's rights campaigner, she was appointed Principal of Westfield College in 1939. A frequent broadcaster on the BBC (she was a leading panellist on Any Questions?*), she became Baroness Stocks in 1966.*

STOCKS: Nancy, I of course was up to my ears in the women's suffrage movement when you first got into Parliament, and I will not conceal from you that we who didn't know you were disappointed. We thought we'd have a real old stager and somebody known as a social reformer, and then we suddenly got you, and we were exceedingly surprised. I can say this now because, within a fortnight, we adored you.

ASTOR: Nobody was more distressed that I was that I should have been the first woman in the House of Commons, because I am a proud Virginian and I realised that, no matter how long an Englishwoman

110

lived in Virginia, I wouldn't want her to be the first in the legislature. I remember telling Mrs Fawcett and all of them [Millicent Fawcett founded the National Union of Women's Suffrage in 1897. 'All of them' refers to all those women who fought for the right of women to vote] that I would apologise to them for being there, but I can truthfully say the loyalty of the women of England once I got into the House was past everything, and it made it possible for me to stay there.

STOCKS: What did you feel like when you suddenly went in all alone? It must have been rather like being on a television set with lights all round and a huge public looking on. What did it feel like?

ASTOR: I didn't mind the election at all, because I liked that, but in order to reach my seat I had to walk up the House of Commons between Arthur Balfour and Lloyd George (both of whom had said they believed in women, but who would rather have had a rattlesnake in the House than me at that time) and it was really very alarming. And do you know, sometimes I would sit five hours in that House rather than get out of my seat and walk down again. But I knew what really kept me going: I was an ardent feminist. I always knew women had more, shall I say, moral strength. It was amazing how well the men treated me considering how few of them wanted me.

STOCKS: You know, the thing that struck us almost immediately when you came on the scene was your courage. You say you felt nervous, but we got the impression that you weren't afraid of anything. I've only recently learnt that there's one thing you're afraid of, and that's cats, but you're not afraid of bombs, you're not afraid of people and you weren't

111

in those days afraid of your party whips.

ASTOR: I wasn't afraid of my party whips because the women had voted me in and I felt it was my duty to vote the way I felt right. I was mainly interested in women and children and social reform, and I felt it was my duty to do it. Someone said that I was rather rude, and I said, 'But you don't know what I've got behind me, I've got the women, and some day you'll hear from them.'

STOCKS: Was it a relief when Mrs Wintringham came to join you? [She was the second woman elected to Parliament, for the Liberals in 1921.]

ASTOR: Oh yes, she was perfectly wonderful, I mean she couldn't have been nicer, but do you know, it's a funny thing, she could never sit in that House unless I was there. She said to me afterwards she couldn't do it. The atmosphere of not being wanted is not very easy, is it?

STOCKS: It wasn't only your courage that brought us all to your feet, it was also your unexpectedness. We'd never met quite that sort of mixture of evangelical piety and wholly irreverent wit.

ASTOR: I like your cheek—'evangelical piety'. It really was a religious thing with me, because I wanted the world to get better and I knew it couldn't get better if it was going to be ruled by men. As a matter of fact I think it's amazing how well the men did for two thousand years, considering they tried to do it alone.

And another thing I wanted to tell you, I remember Winston Churchill. Even my best friends couldn't speak to me, they really couldn't, not in the House. I met him at a dinner about two years afterwards and he said to me, 'It's a very remarkable performance.' And I said, 'What?' He

said, 'You staying where you are.' And I said, 'Well, Winston, why on earth didn't you speak to me? He said, 'We hoped to freeze you out,' and then he added, 'When you entered the House of Commons I felt as if a woman had entered my bathroom and I'd nothing to protect myself with except a sponge.' I asked him, 'Had it never occurred to you that your appalling appearance might have been protection enough?'

STOCKS: Did you ever find, either in Parliament or out of Parliament, that being much richer than other people let you in for criticisms or taunts?

ASTOR: Oh, not the slightest, I adored being rich. I remember someone yelled out one night, 'Mr Astor's a millionaire, ain't it?' And poor Mr Astor looked very embarrassed, but I jumped up and said, 'I pray God he is, that's one of the reasons I married him.' I'd be ashamed if I made money badly and spent it badly, but to have it, that's no problem to me.

There was a woman Member of Parliament who, whenever she went to the East End, put on her worst clothes and went on a bus, but when I went to the East End I would have considered it rude not to wear my good clothes, they know you've got them.

Janey Ironside

17 October 1956

Famously stylish and beautiful (and always dressed in black), Janey Ironside (1918–79) was appointed Professor of Fashion at the Royal College of Art in 1956, at a time when few women, let alone young mothers, worked. She became a fashion and media icon of the swinging sixties and promoted designers like Ossie Clark and Bill Gibb. Janey Ironside gave occasional talks about fashion on the programme, for example on 'Showerproof Coats' in April 1959. Here she is talking about winter fashions.

This winter, fashion suggests we should look like a cross between Tsarist Russians and Davy Crockett. Personally, I'm all in favour.

Fur is undoubtedly the most noticeable fashion feature. Designers are using it like mad, above all for hats. If you want to look really new you must have a furry hat. It may be anything from a vast affair in long-haired white fur, pure Genghis Khan, to a small sleek turban pulled down over your ears. Heavenly for cold days!

The coats are comforting too, built on loose, bulky lines, they look like winter coats, and I like them. They are of thick tweed, usually with either a fur collar or a fur scarf, and sometimes with big capes, which give you nice double warmth round your shoulders. In fact, some of Dior's coats were made to look as if you were wearing one coat and had another round your shoulders, with false

114

sleeves crossed in front like a scarf. Then there are the fur-trimmed and lined tweed cloaks with slits for your arms. Coat and cloaks are nearly all wide and round at the shoulders, narrowing towards the hem.

The only thing that lets down this theme of warmth is the fact that to look really elegant you must be wearing slender pointed shoes of the softest kid or suede, with pinlike heels and toes. Personally I would rather have cold feet and be smart. I'm talking about fashion—you may prefer to keep warm!

Suits have the same loose bulky look. The jackets are short, semi-fitted and achieve a high-waisted effect by means of seams or tie-belts a few inches below the bust.

Having made sure that at any rate we will be warm out of doors, the designers have decided to let us freeze indoors. Dresses are of thin materials, silk or wool crêpe, silk jersey, and for evening and cocktails, chiffon and organza, satin and taffeta, flattering and feminine—and how nice. These soft, draped dresses for parties all have the loose, unfitted, high-waisted look. This is a development from the strictly empire line of last year, and I think it's much more elegant and subtle. In the evenings, of course, slender pointed shoes again, usually in satin or velvet. In order to keep warm in spite of fragile party dresses, designers have been showing stoles of satin or fur, and sometimes satin lined with fur, which must give an incredibly luxurious feeling.

How can we apply this new fashion to ourselves, without spending too much money? Perhaps some of us can afford to buy a new fur hat, and I

recommend everybody who can to do so, because they make you feel in the fashion at once, but when it comes to bigger and more expensive items, such as coats and dresses, it is rather difficult. Still, you can make your coat look very much this winter's by adding a high fur, or fur fabric, collar and cuffs, and if you are clever at sewing you can have your last year's loose coat narrowed in towards the hem, because this slightly hobbled look is very characteristic. Another easy alteration that makes a lot of difference is to move the low-slung half-belt of last year's coat up to just below the shoulder blades. As regards dresses and suits, it is true that anything very waisted or fitted is not in the very highest flight of fashion, but not all of us can either afford to be, or wish to be, in that rather exhausting position. But if you are going to buy a new dress or alter an old one, keep the waistline high and a soft round line at the shoulders, and again, a slightly hip-jutting narrow hem to your skirts. Shoes, I think, are the most important of all. In fact, now that the pointed look has come so firmly into fashion I find that the solid heels and round toes we have taken for granted for so many years now seem strangely ungainly.

So my advice to those who want to add a fashionable touch to their wardrobe without spending too much is: buy a new hat and some new pointed shoes; and, by the way, don't imagine they are uncomfortable or bad for your feet, as they are specially designed to allow extra length.

Janey Ironside's daughter, Virginia Ironside, became a celebrated writer and columnist, and has been a

116

regular contributor to Woman's Hour. *In 2003 she published* Janey and Me: Growing up with my Mother.

Shirley Bassey

interviewed by Mary Hunter
27 May 1957

Born in Tiger Bay, Cardiff, in 1937 to a Nigerian father and Yorkshire mother, the singer Shirley Bassey started work in a local factory before being discovered by Jack Hylton in 1955. In early 1957 her debut single 'The Banana Boat Song' reached the top 10. It was followed by 'Kiss Me, Honey Honey, Kiss Me', and the number one 'As I Love You'. She is famous for singing the three James Bond themes; 'Goldfinger', 'Diamonds are Forever' and 'Moonraker', but also for her glamorous cabaret costumes and her diva performances.

HUNTER: As you were the youngest of your family, I expect that you led a pretty merry sort of life, didn't you?

BASSEY: I was a real tomboy and my mother kept saying to me, 'You should have been born a boy.' I used to jump from tree to tree and go picking apples and blackberries and come home all scratched, and my dress torn to pieces. It was very hard for my mother to keep me dressed properly.

HUNTER: Throughout your school days, each year brought a different ambition. However, when the time came to leave school, you went into an enamel factory.

BASSEY: I used to sing in the factory and the girls used to stop their work to listen. The supervisor would come round and tell me off. I was always

118

getting told off about singing, and the girls said, 'Why don't you get with a band?' I said, 'I'm not interested, I'm quite happy where I am.' So I didn't do anything about it until it came to me.

HUNTER: How did the opportunity for a singing career come about?

BASSEY: I never wanted to go on the stage really. I used to sing at Sunday concerts, or working men's clubs. One night I was singing at one of the concerts and there was a producer there who was putting on a show in London called *Memories of Jolson*, and they didn't have a female singer. Three months later they decided to send me to London for an audition. I passed the audition and I was in the show. It was my mother really, she kept pushing me and said, 'Go on.'

HUNTER: And then Mother said, 'You will make a career of it,' or words to that effect?

BASSEY: Well, she said, 'Have a go at it.' I didn't like it at first, being away from home for the first time, and being so far away from home alone. I kept writing home to say I didn't like it, and she kept writing letters back to say, 'Stick it out.' Really it was her that kept me going.

HUNTER: But you did break up once, didn't you?

BASSEY: Yes, I went back and worked as a waitress in Cardiff. Then I had a telegram to say there was a new show. I rang the people and they said, 'Well, we're going to Jersey for only two weeks, but something might come of it,' which it did. That's where I met my manager while I was rehearsing for this show, and he signed me up with a contract for three years.

HUNTER: From that moment things happened very fast. You were booked at London's Astor

Club, where Jack Hylton heard you. He was so impressed that when Muriel Pavlow fell ill he asked you to stand in. You were such a success that Hylton engaged you with Al Read at London's Adelphi Theatre in *Such is Life*, and a new star was born. *Such is Life* ran for eleven months and the result was a booking at the Café de Paris for two weeks. The Café de Paris appearance marked an important point in your career.

BASSEY: My worst opening night was at the Café de Paris. I said to my mother, 'I'll never go on. I am going to fall down the stairs—I know it.' Mother said, 'Don't take any notice.' I was impossible, I couldn't speak to anybody, I was walking up and down in my dressing room. I was quite certain I was going to be a flop; I had no confidence at all—after eleven months at the Adelphi, I still didn't have any confidence. I said to myself, 'I hope I'll never get like this again.'

HUNTER: To your mother belongs a great deal of the credit for your success. How did your father feel when he knew he had an international star for a daughter?

BASSEY: He saw me the first time he'd ever been into a theatre in his life. It was when I was playing at Cardiff New Theatre, and he came to the opening night and he was as pleased as Punch, so much so that he picked up a programme on his way out, thinking that I was in it. He went home and said, 'Missus,' that's my mother, he called my mother 'Missus', and he said, 'Missus,' he said, 'I've got a programme of your daughter,' and my mother opened the programme and it was the following week's programme.

HUNTER: Did he go back and get the right one?

BASSEY: He said, 'I'm so proud of her, I'm going back to see her again,' and I think then he went back and got the right programme.

Shirley Bassey was made a Dame in 1999. She topped the bill at the opening of the Welsh Assembly in 1999, and performed the anthem 'World In Union' with Bryn Terfel for the Rugby World Cup in 2000.

Iris Murdoch

25 September 1957

A brilliant academic and philosopher, Iris Murdoch (1919–99) studied Greats at Oxford. In 1952 John Bayley saw her pedalling past on her bicycle and fell in love with her; it was the beginning of a famous literary partnership. Her first book was Sartre, Romantic Rationalist *in 1953. She had her first novel* Under the Net *published in 1954. She went on to produce another twenty-five novels, including the critically acclaimed* The Sandcastle *in 1957 and* The Bell *in 1958.*

I wish I had been a teenager. But when I was that age the conception didn't exist; or if it did, it didn't come my way. So I never wore my hair in a pony-tail, or danced rock'n'roll till I was ready to drop, or wore drainpipe trousers (not then, anyway) or shrieked when I saw pictures of film stars, or wore bright pink luminous socks. I daresay I was well enough off without the shrieking and the socks; but the rest I regret.

What was I when I was in my teens? I was a schoolgirl. Now being a schoolgirl is, I submit, something essentially dreary; at least I found it so. There are plenty of story books about school life, but school life is not like the story books. I discovered no myth, no picture, that could lend colour to those years, years that can be about the most wretched in one's life, when one can't either play as a child or enjoy as an adult. The heart-free

years of one's life.

What I want to argue is that 'teenagerism' is a good thing because it provides young people with just this necessary myth, or role, or part to play, or way of picturing themselves, however one puts it. It gives them, at this dreary time, something rather gay and jolly to be. You may suggest two obvious objections. First, you may say that surely there's no reason why people should have such myths, such parts to play, at all. Doesn't this stop them from becoming individuals? And second, that the teenage myth is in itself a bad one.

As to the first objection: I think that human beings inevitably tend to picture themselves as being what, in some way, they already are. One knows, for example, businessmen, university dons, technicians from Harwell, etc., who bore one stiff by all the time acting the part of businessmen, university dons, technicians from Harwell, etc. This sort of pretending may be harmless, it may even help them to do their job; but it may also be constricting, it may stop them from realising that they're human beings with other aspects and possibilities. It may stop them from becoming what surely it should be the aim of every adult to become: eccentrics. But in the case of young persons whose personality is not yet formed, I think the having of a role, or myth, is harmless, and may be helpful. I remember how wholeheartedly, when I came up to Oxford, I began to play the part of being a student. I don't think it did me any harm. I remember too that being able to put on the part of being a student gave me confidence at a time when I needed it badly.

This leads to the second objection. You may say

that the student myth is on the whole a good one; students are supposed to be wild, but they're also supposed to be bookish, and full of ideas, and ready to discuss anything under the sun, whereas the teenage myth is a bad one. One can't deny that there are at present some unpleasant aspects to 'teenagerism'—and they've been talked about a good deal. But what I like about the teenage myth is that it has a certain touch of the exotic. It has colour. You may not like the music (I do actually) but at least it's noisy and gay. You may not like the clothes and the hairdos (I do in fact), but they're colourful, and they can and usually do express the individual.

I lately went to Paris with a young friend aged nineteen (who had also never been a 'teenager'), taking her there on her first visit. We were sitting in a café in the student quarter, and she exclaimed to me how very individual, how delightfully vivid and eccentric all the young people looked who surrounded us. This is part of what I mean. 'Teenagerism' provides just that touch of colour, that flamboyancy, that licence with one's appearance and one's behaviour, which can have bad results, but which can also be a way of expressing and developing the individual. A way of setting people free.

Let's face it, the pattern of English life, whether in school or out of it, can be something rather dull, something that makes little appeal to the imagination. Whether it's the climate, or the price we pay for having such good characters in other ways, I don't know. But I'm sure you understand what I mean. Hence a nostalgia, which is very general in England, which used to be, I think, a

nostalgia for the South—for the sun, for the Mediterranean, for cafés, for Latin lovers. Now, with many people, I suspect it's a nostalgia for America. In any case, it's a deep desire for something exotic, colourful, vital, which seems to be missing from English life. And 'teenagerism' is one manifestation of that nostalgia.

The true teenager doesn't just want to sit in front of the TV set. He or she wants to dance or tear around or join a skiffle group or change his or her hairstyle. And, in my view, even rushing down the street shrieking is better than sitting dazed in front of the television. At least it shows one's alive.

The sheer vitality of the teenager myth makes it a place from which new things can start. And such developments can benefit the rest of us. I'm not sure how we first got the long-overdue blessing of espresso coffee bars in this country; but there's no doubt who most frequents coffee bars. It may be too much to expect that Teddy boy dress styles may lead to an improvement in the tedious clothing of the adult male; but one might even hope for that. It's staggering how soon the imaginative touch disappears, if it has ever been present, and the emotions become blunted as we grow up into our somewhat conventional society. So let's be thankful for the teenage gaiety and wildness, even if it does go with the shrieking and the pink socks.

Iris Murdoch won the Booker Prize with The Sea, The Sea *in 1978. In 1987 she was made a Dame. In the last years of her life she struggled with Alzheimer's. Her husband John Bayley wrote a memoir,* Elegy for Iris. *In 2001 Judi Dench starred in the film version* Iris.

Claire Rayner

14 April 1958

Claire Rayner (b. 1931) is a writer, broadcaster, social campaigner and patron of more than sixty social and charitable organisations. She trained as a nurse and then went on to become an agony aunt in newspapers and on television for more than twenty years. She made her debut on Woman's Hour *as 'Sister Rayner' in 1958. She was soon giving regular advice on the programme, for example on children in hospital, on stings, sunburn and first aid.*

I seem to have heard it several times in the past seven years. 'You must be an angel of mercy to do the work you do. Such dreadfully long hours, and the awful things you have to do and see—and for such little money! You must be wonderful!' Well, I'm not. I'm an ordinary person doing a necessary job of work for which I have been thoroughly trained, and which demands certain qualifications—skill on the heavenly harp *not* being one of them. I am, in fact, a nurse. I am a nurse because seven years ago I had to decide how I was going to plan my life, and at the time nursing seemed to be the career for which I was best suited. I had the required amount of formal education, and good physical health. Above all, I wanted to be able to earn my living during training. There are not many professions that enable a girl of twenty to support herself fully, as nursing does. A student nurse receives tuition, uniform, board and lodging,

126

and pocket money. With care she can clothe herself adequately, if not luxuriously, from this allowance.

I had had a bent towards the natural sciences at school; I enjoyed studying, and I liked people, but I was certainly no angel of mercy! I had not the smallest desire to devote myself to other people's welfare. My motives were completely ulterior. No one could say I had a vocation—a burning desire to help the sick—but I was interested in medicine. Frankly, I think any girl of twenty who can say that she has a vocation for work that she has never attempted is deluding herself. But if, after a year of nursing, she can say she has a vocation, then she is worth listening to.

So, I became a nurse. The first year was hard work, both physically and mentally, and at times I was asked to perform duties that were rather unpleasant—but then, changing a baby's nappy isn't exactly pleasant, and mothers do that countless times and think nothing of it. Within the first three months this side of nursing had ceased to bother me.

During the three years of training I had a wonderful time. There was the exhilaration of belonging to a group of lively young people; the lovely, important feeling of doing a job that required skill; there were parties, there was theatre going—all the fun of being a young student in London.

On the reverse of the penny, admittedly, there were long dull afternoons in hot stuffy wards and classrooms in high summer; there were examinations to fret about; there was night duty, which was tiring—but even these things had their own brand of enjoyment compensation. To say I enjoyed every minute of my training would be a

barefaced lie—but I did enjoy 80 per cent of it, and that's pretty good.

By the end of the three years I had learnt quite a lot about the human body and mind; quite a lot about how to make people comfortable during illness; and, above all, how to be pleasant, kind and attentive to sick people, when I could quite cheerfully have consigned them to the nether regions—and probably would have done so, had I not been on duty and in uniform.

There is an odd sort of ambivalence to the trained nurse's personality. There are things I can do when in uniform that I could not do in my own clothes. In uniform I am kind, cheerful and usually good-tempered. In my own clothes I am hasty, often irritable—very, very ordinary, in fact. I shed my virtues with my starched uniform at the end of the day. So, I reiterate, I am *not* an angel of mercy. Haloes and wings are not necessary equipment for the girl who wants to be a nurse. What is needed is the ability to behave with loving kindness to order, even when your patient is very crotchety and you have toothache.

Now, seven years after starting nursing I find that I enjoy my work enormously. I find great satisfaction in the relationship I have with the patients I meet—mostly children now, and I like to feel that I can be of some help to them.

But I still deny that I have a vocation. What I have got now is a good training for the work I do, which has, over the years, transformed the original interest I felt into a deep affection for it. I maintain that it is not necessary to feel called to this work, as one would need to feel called to be a missionary. If our hospitals had to depend only on the people

who had a true vocation for nursing, they would be even more understaffed than they are. To any girl who thinks she would like to be a nurse, but who is worried about some aspects of it, I would say this. Try it. If you are really unsuitable the hospital will soon tell you, if you don't find out for yourself. If you *are* suitable you will find that you can have just as much fun, and meet just as many eligible men, as your sister in a nine-to-five office job. Don't be ashamed of your wish to have fun and meet young men. It is quite normal at your age, and very important, too, if in your turn you wish to become a wife and mother.

You may marry, as I have done, and continue your nursing career, and when you have children you will find that motherhood will be less of a problem because of what you learnt while you were training. I found that although I had never done any housekeeping or cooking, and hadn't a clue about the details of making a home, my nursing training stood me in good stead when I first embarked upon the business of being a housewife.

Almost automatically, I planned each job as though it were a nursing procedure—thinking first about what I had to do, then about the things I would need to do it; going on to decide the best method of doing it, and finally finding the quickest and cleanest way to tidy up afterwards.

The methodical ways taught in hospitals apply just as much to cleaning a room, or making a cake, as to performing a surgical dressing or making a hospital bed. I also find that I have no trouble in providing a well-balanced diet for my husband. My nursing training has helped me in other ways, too, in less practical fields than that of housekeeping. I

129

used to be rather shy, and tongue-tied in the presence of strangers, but now I can talk to people about almost anything, with no shyness at all.

In short, nursing is a satisfying and exciting career for any girl of intelligence and spirit who is prepared to learn about people—both inside and out; is prepared to fit into a community life; and is eager for adventure—for hospitals are exciting and adventurous places, with new discoveries coming along almost every day.

But just remember this: a hospital is a place where people spend their working hours in combating illness and death. Like any other groups, hospital staffs consist of normal people with their own personal idiosyncrasies and problems. In seven years I haven't met a single angel—and I don't suppose I ever shall.

Claire Rayner has written many practical advice books about motherhood, baby care and medicine, and more than fifty novels, including the popular novel series The Performers *and* The Poppy Chronicles. *She was President of the British Humanist Association from 1998–2004. She published her autobiography* How did I Get Here from There? *in 2003.*

'I Wish I Were Single'

29 May 1958

The Second World War had a devastating effect on many marriages. In the aftermath, a tidal wave of divorce ensued, with thousands of ex-servicemen reportedly queuing up to end their wedding vows. This personal story from a married woman highlights the ongoing problem.

I was married as long ago as 1938 so I have had plenty of time to make up my mind about marriage. Now that I am in my mid-forties, with no children, there is such an unbridgeable gap between my husband and myself that it is inconceivable that we could ever have been in love.

Last December, I heard the special edition for single women. How I envied those women! How successfully, how courageously, and even how joyously some of them coped with their state of single blessedness. I use that phrase with heartfelt meaning. How I longed for their freedom of choice! How I wished I could change places with one of them.

Let me tell you something about myself. Like my husband, I come from humble working-class people; but while he had to start work when he was fourteen, I won a scholarship, stayed on at school and eventually became a teacher, joining the vast numbers of single women who, in those days, taught in council schools. I must admit that when I was in my twenties, I was intolerant of single

131

women, who seemed dull and unenterprising, and I dreaded to think I might become one of a type so mercilessly caricatured. I was unhappy both at work and at home, and I looked everywhere for the means of escape and salvation. That was the background and why I married the first man who paid serious attention to me.

It was at a local evening institute that I met him. My efforts to escape led me to the thought of travel abroad and, with this in mind, I had joined a class to learn German. My future husband had already made a cycling trip in Germany and had mastered the German language very well. He was also studying English and Economics, and I admired his obvious desire to get on. Our relationship at first was much more intellectual than anything else, for poverty and thwarted desires had made us both look upon love as an out-of-reach luxury. As for me, I was simply obsessed with the idea of escaping from a sordid background, and what seemed to me then an unrewarding and distasteful job. So after a three-year engagement we married and I hoped that at last my personal problems were solved.

By this time I honestly thought I was in love and, for the first six months of our marriage, I was a full-time housewife and desperately anxious to make a success of the job. I had never been domesticated and I made mistakes; but, in those days, my husband bore them with patience and good humour, and we seemed to be settling down quite happily together. But were we?

As the months went by, I was gradually aware of a vague disquiet. My hope had been to inspire my husband to a more successful and promising career; but as this hope faded, I was disappointed

132

and unhappy. Then the war came.

My husband was called up in 1942 and went abroad the next year. As there was such a need for teachers I had, rather reluctantly, joined the staff of a senior boys' school. But I was enjoying the job after all and found working with men of such different types a most interesting experience. My husband and I were still in love and it was sad to say goodbye; but, before long, I realised I was enjoying living on my own. I was enjoying a fuller, richer life than I had ever known before. If I didn't feel like cooking and cleaning, I could put it off until I did; I could have a bath at midnight if I wanted to; I could read and write in bed—and, best of all, I could invite my friends home as often as I liked. This was a rare pleasure, for my husband was not at all sociable and disliked entertaining.

The end of the war intensified my problems. My husband returned, unscathed, to his former badly paid job. He seemed completely to have given up any idea of advancement, and all his leisure time was spent in gardening and pig-keeping. I continued teaching, for not only was the money urgently needed if we were to maintain a reasonable standard of living, but I could no longer face the prospect of unrelieved domesticity, day in, day out.

It seemed impossible to adapt ourselves to each other again. My husband spends most of his time out-of-doors, and when he comes in, seldom changes, and is not above sitting in filthy corduroys, reeking of pig-muck, in an easy chair with clean covers on. After a meal, he sits over the fire and before long his snoring shakes the room. We seldom go out together or entertain. After an

argument about money, we each began to keep our own, and paid it into separate accounts. And so the rift between us has widened. As we both dislike scenes and realise how ineffectual they are, we have given up trying to solve our differences, but go our separate ways, often not exchanging more than a dozen words each day. We have separate rooms and, as often as possible, I contrive to have my meals alone.

But although my privacy is respected, I feel unbearably constricted by the daily routine of preparing meals that are, as often as not, eaten in silence behind a newspaper. I feel I can't go on and on passively enduring it. You will tell me, as I often tell myself, that my marriage vows were taken 'for better or worse'; and, if the better is not as good as I hoped for, and the worse is worse than I expected, the blame is largely mine. Perhaps you are right; but I would like the spinsters to know that at least one married woman really does envy them.

Joan Sutherland

15 July 1959

Known as 'La Stupenda' by her fans, the Australian soprano Joan Sutherland (b. 1926) made her professional opera debut in 1947 singing Dido in Purcell's Dido and Aeneas *in Sydney. She joined the company at Covent Garden in 1952 where she sang a broad range of roles. In 1954 she married the pianist and conductor Richard Bonynge and they formed what was to be a lasting and famous musical partnership. In 1959 her performance in* Lucia di Lammermoor, *conducted by Tullio Serafin and produced by Franco Zeffirelli, propelled her to international fame.*

My mother was the first person to help me. When I was a very small child she was already a well-known concert singer in Australia. She had studied extensively with an Italian teacher who had come to Australia in his old age. He was a great teacher and a very hard taskmaster. My mother practised her scales and vocalised every day, and I imitated her as I followed her about the house. So I was brought up in an atmosphere of song.

As I grew older I also wanted to study singing seriously, but this was never permitted as it can be dangerous for a voice to do any extensive training before the late teens. So I just went on listening to my mother and copying her. Of course, I was born with my voice, I was taught to use it in the right way, but I can take no credit for what is a gift from God.

135

Admittedly, I have worked hard to perfect what I was given, and I still work very hard—the more famous one becomes, the harder one has to work. I've found out that to maintain or surpass a standard is much harder than to arrive at it!

It wasn't until I was seventeen that my mother gave me my first real lessons—but listening to her singing had already taught me much and my voice was far more fully developed than is the case with most seventeen-year-olds. I think I owe that largely to her.

About a year later a well-known Australian teacher called Aida Dickens heard me sing and offered me a scholarship to study with her. She trained me as a dramatic soprano and to her I shall always be grateful. At this time I was singing concerts and oratorios in Sydney. One of my earliest was an orchestral concert of Wagnerian excerpts in which I sang Isolde's 'Liebestod' from *Tristan und Isolde*, Elizabeth's 'Greeting' from *Tannhäuser*, Senta's 'Ballad' from *The Flying Dutchman* and the 'Bridal Duet' from *Lohengrin*. Perhaps this accounts for my intense dislike of singing Wagner now. I don't think any young singer should ever attempt it—it is far too great a strain on the voice.

Then I went in for a competition that grandly set out to find the greatest voice in Australasia. It was sponsored by an oil company and the first prize was £1,000—to me an unheard of sum! I won it! My mother had always told me stories of the great opera singers and opera houses of the world, and I had cherished a desire to sing at Covent Garden. For a long time this was my only ambition. So, with £1,000 in my purse I came to London.

When I arrived in London I went to study with a wonderful old man, himself a former pupil of the great tenor Jean de Reszke: Clive Carey. Then after a year I wrote a letter to the directors of Covent Garden and they asked me to give them an audition. I gave not one, but three auditions and sang thirteen different arias. In the end they engaged me for the following season.

One of the first operas I appeared in was *Norma* —I was the nursemaid to Maria Callas's children, for she was singing the role of Norma. How I admired that woman—and as I listened to the tumultuous applause and shouts of acclamation that she received every night, I wondered whether this would ever happen to me. I doubted it very much. Now that it has eventually happened, I still find it hard to believe. It couldn't have happened without the help of so many people.

For instance, I have learnt a great deal from many producers. There was Carl Ebert, under whose direction I sang the Countess in *The Marriage of Figaro* at Glyndebourne in 1956. Then Günther Rennert, who produced *Don Giovanni* when I sang Donna Anna at the Vancouver Festival last summer; and of course, Franco Zeffirelli, who produced *Lucia*—he at last gave me real confidence in myself as an actress. As a singer I have not been unconfident but as an actress—that was another matter. And Tullio Serafin, who to me is the greatest of all conductors and who conducted *Lucia*, he taught me to look for deeper meanings in the words I sang—to feel deep emotion—to live my roles completely.

But the one who has helped me more than all the others put together is my husband Richard

Bonynge. He was a concert pianist with every chance of a brilliant future, but has now given this up to help me. As long ago as 1951, three years before we were married, he told me that I was pursuing my career in the wrong direction. You see, I was trained to sing the heavy soprano roles—Wagner and suchlike—and Covent Garden wanted me for these. He told me that I should specialise in the music of the eighteenth and early nineteenth centuries. I laughed and told him he was a fool! But he was determined, and since then he has worked unsparingly on these roles with me, and *Lucia di Lammermoor* has been the result. He himself disclaims any credit and says that I am now singing the music that was written for my type of voice. All the same, I would never have sung it but for him. He coaches me every day —I never work with anyone else. He understands and knows my voice better than I do myself.

People ask me what I do when I am not working. I always seem to be working. When I have a few moments I spend them with my three-and-a-half-year-old son, Adam. I often think how lucky I am to have both a family and a career. I am grateful that I have been given so much in life. In return I try to sing well, it's the only way I know to say thank you.

Joan Sutherland was widely known as the 'voice of the century'. She was made a Dame in 1979 and retired in 1990. Her final Covent Garden appearance was as guest performer in the New Year's Eve performance of Die Fledermaus *in 1990, when she sang duets with Luciano Pavarotti and Marilyn Horne. In 1991 she was awarded the Order of Merit.*

'Hooray for Being a Housewife'

26 July 1959

Ba Mason was a regular contributor to Woman's Hour.

It amazes me how much blather goes on about the lot of a housewife, usually from most gifted and intelligent women, too. Why do they think it's boring and frustrating and drab and dreary?

Don't think this is going to be a ghastly little homily about the privilege, the joy, the satisfaction there is in being a Homemaker with a capital 'H'. Women talking like that make me quite sick; I want to kick saucepans about. I'm not a super-domestic type at all, but surely—surely being a housewife is an extraordinarily good job, isn't it?

Well, can you think of any other profession into which one goes in at managing director level purely on looks and personality? I can't.

To qualify to be a housewife one doesn't have to put in any capital. You don't have to have any previous experience, pass any exams, do an apprenticeship, have any pull. Right away you're at the top level, a full-blown housewife, with your taste dictating the whole business, answerable to no one—in fact if not the actual captain, at least first mate.

I think this is one of the very nicest things about being a housewife. No one can boss you about. I worked for seven years in offices and there was always some terrifying woman in charge of me, who

had the right to haul me up, criticise my work, dress me down, point out my failings and then give me the sack. Once in your own home you can do exactly what you like, when you like and how you like.

'Ah'—I can hear you saying it—'she's got no children . . .' But I have. And no one knows better than me that children discipline one's day, but although they are a tie, a responsibility and all that, you, the housewife and mother, are still the supreme authority, only more so. Your word is law.

'Can I go out?'

'No.'

'Must I go to bed?'

'Yes.'

'Drink your milk.'

'Why?'

'Because Mummy says so.'

And children do grow up and go away, you know, frighteningly quickly.

When they're gone, if you feel like picking dust out of crevices with a pin or wax polishing underneath tables, you can. If you want to cook and cook and cook and fill the larder to overflowing with bottles and jars, flitting from one bubbling saucepan to the next, tasting, stirring, seasoning, you can. Or you can dig out the tin-opener and slop whatever it is out on a plate—dinner's ready. You can spend five minutes or an hour and a half on your lunch; you can have a huge breakfast with no gobbling eye on the clock; or none at all. You are your own mistress. It's wonderful.

You can go to bed early or very late. Play the wireless all day. If you're an animal lover the house can become stuffed with dogs and kittens and

budgies and tortoises and hamsters; it's you who'll feed them and clean up the mess.

Of course a housewife's job is boring sometimes, what job isn't? Don't tell me that occasionally those high-powered women executives don't long to be away from their desks, running up some net curtains or dividing the polyanthus or just looking at the shops. You've got to be jolly high up at the top of any business before you can slam off and do any of those things on the spur of the moment. We housewives can—any time we want to.

Another point: housewives are terribly important. We are argued about in Parliament, we can influence our husbands, or so I understand. A would-be Member of Parliament called on me the other day and poured out a lot of frightfully boring facts about butter and bacon, none of which I understood. When I asked him why he told me all this, he reverently said, 'You are a housewife.'

When I have to fill in a form I put 'housewife' in the space left for occupation with a great flourish—not because I'm proudly conscious of the fact that I'm a good one, but happily aware that I'm in a job where I can get away with a hell of a lot and there's no one who'll come and sack me.

The 1960s

The 1960s

Jenni Murray

If you can remember the 1960s, goes the legend, you probably weren't there. I was, as was *Woman's Hour*, but I suspect we were both observers rather than enthusiastic participants in the decade that was credited with bringing about the sexual revolution. The former poet laureate Philip Larkin told us,

> Sexual intercourse began
> In nineteen sixty-three
> (Which was rather late for me)—
> Between the end of the *Chatterley* ban
> And the Beatles' first LP.

But it was far too early for Barnsley!

The decade began with the election of the first woman Prime Minister in the world when Mrs Sirimavo Bandaranaike took over what was then Ceylon, and John F. Kennedy became President of the United States. Princess Margaret and Antony Armstrong-Jones married, the hated traffic warden was introduced and a jury in London concluded that D.H. Lawrence's *Lady Chatterley's Lover* was not obscene. It was published by Penguin in 1960, hence the Philip Larkin reference. It took three years—we were in the second form at school and thirteen years old—for me to obtain a copy, cover it in brown paper and pass it around the class under the guise of a Latin primer. What an eye-opener that was for a

gaggle of teenage girls.

We would witness the building of the Berlin Wall, the death of President Kennedy, the first cosmonaut launching into space, the imprisonment of Nelson Mandela, the start of the Vietnam War, the Beatles, the Barclaycard, the gaoling of the Moors murderers, the breathalyser, the death of Martin Luther King and Bobby Kennedy, the first men on the moon, the troops deployed in Northern Ireland and the Woodstock festival—free love and flower power. *Woman's Hour* reflected the politics of the era as they affected women, and reported the music, the fashion, the fiction and the sexual revolution faithfully, but invariably a little fearfully.

There was the occasional foray into the Swinging Sixties but, apart from the odd celebration of the pop culture of the time (there was an interview with Cathy McGowan, the presenter of *Ready, Steady, Go!* about her short skirts and long, straight fringe and hair) there was a delicate balance to be achieved in appealing to my mother's generation as well as my own. I clearly recall my mother's horror that I might choose to emulate McGowan's style and it was her generation that generally was served by the programme rather than mine.

There was a report on the phenomenon of the psychedelic disco (no mention of the cannabis that must have been smoked there; mustn't frighten the horses) and an interview with a couple who had committed what then continued to be considered a heinous crime against the social order—living in sin. They had made the decision to live together without getting married. But the programme tended on the whole to reflect the domesticity and family life that was still the heart of the experiences

146

of most listeners. 'Living with a Rocker', for instance, was not about trends in modern music, but about a child who continually rocks to and fro.

Marriage and family were always key ingredients of the programme. A 1960 report entitled 'Why Doesn't Daddy Come Home?' discussed the effects of divorce on young children. Mary Stott, the former editor of the *Guardian*'s women's page, described the delight of becoming a grandmother for the first time in 'My Daughter's Daughter', and in 1968 a lawyer explained the practical details of what responsibility a husband then had for paying any debts incurred by his wife. There are numerous other examples. 'My Chinese Daughter' examined inter-racial adoption. 'My Husband is Alive Again' was a wife's story of living with an alcoholic husband. The agony aunt Marjorie Proops, Lady Stokes and author of *Superwoman* Shirley Conran (described in the broadcast as a famous journalist who was married to a successful businessman—no brand promotion of any kind in those innocent days) asked whether marriage can survive a woman's success.

The debate on a woman's place gathered pace during the 1960s. There was plenty of advice for the housewife along the lines of the 1960 series 'For the New Housewife' in which there were tips on buying cuts of meat, how to make milk puddings, the proper way to lay a fire and what you have to know about turning out a room. There was a talk about the growing use of refrigerators—in 1960 only one in every five homes had one—and a quiz in 1963, 'How Houseproud Are You?', with three housewives on the panel, which began with the question, 'Do you wash nylon curtains every

month or only when they look dirty?'

Not all the listeners were happy with the focus of this kind of subject. In 1965 a listener from Hampstead wrote of her determination to 'give the programme a sharp slap in the face' when she wrote in a letter, 'I'm flabbergasted that any woman of intelligence can waste your time, and that of the listeners, asking a question like "How to get a face flannel free from slime".' (I'm afraid we were guilty of repeating the offence sometime in the 1990s when we discussed the germs that lurk in a slimy dishcloth and how to get rid of them, to no complaints as I recall!)

The dilemma of staying at home or going out to work was often posed, as in the 1963 talk 'A Home or a Career?' and in 1966 journalists Joan Bakewell and Kate Wharton discussed 'The Conflicts of the Housebound Mother', prompted by Hannah Gavron's book *The Captive Wife*. Employment was frequently examined with the programme occasionally being used for recruitment drives by the government. In 1964 the Right Honourable Anthony Barber sent out 'A Call to Midwives', explaining the need for more women to enter the profession as a result of the rising birth rate. In 1966 the shortage of teachers saw *Woman's Hour* running items on retraining, illustrating why older women were suited for the job and making efforts to introduce more part-time posts in schools.

The close of the decade saw items such as 'Part-Time Work for Professional Women' and, later, one of those confessional items where women admitted that whilst they could afford to stay at home, they preferred to go out to work. The position of women in the Church—and the

pressure for ordination—was first talked about in the late 1950s and was returned to many times. Equal pay—a mainstay of *Woman's Hour* throughout its sixty years and still far from resolution—included a report on the Ford strike at Dagenham, which occurred in 1968.

The programme did inevitably discuss the main political debates of the decade that would have profound effects on the way women lived their lives. The introduction of the Pill and proposed changes to the abortion law, neither of which would come into full effect until the end of the 1960s, were both discussed as early as 1960. An edition of the series 'In My Opinion' was presented by Dr Ethel Dukes, Honorary Secretary of the Marriage Guidance Council Medical Advisory Board, in which she expressed her concerns about the possible risks of taking the Pill for long periods.

In 1962, 'What Do We Know about Oral Contraception?' heard a Dr Alison Giles (who remained anonymous during the broadcast) assuring listeners that it was perfectly safe, but a few weeks later Baroness Summerskill challenged her assertion. By 1967, Dr Eleanor Mears, as well as considering the Pill and the IUD, looked to other possible future birth-control methods, including injections. When the Pope's encyclical, banning the use of all artificial methods of birth control, was announced in 1968 there were endless discussions, with speakers often saying how worried they were at what its impact would be. It was not until the beginning of the next decade that the Pill was available to all free of charge on the NHS, although the debates since about its safety seem never to have stopped.

149

In 1960, after many years of haranguing *Woman's Hour* editors, a Mrs Alice Jenkins (there's no record of what organisation she represented) was finally allowed to give a talk on why abortion should be legalised. Her 'Legal Termination of Pregnancy' was followed by a talk from a doctor—Professor Jeffcoate—on why it was a false notion to think things would improve if the abortion law was changed. As the date approached for the introduction of the legislation in 1967, put forward by the young Liberal MP, David Steel, the subject was returned to on many an occasion and there were several updates on how it was thought to be working during 1968 and 1969.

Although sex and sexuality had been alluded to in the early years of the programme, the 1960s inevitably brought controversies to the fore that could not be ignored. In 1960 'A Mother Talks about Casual Relationships' asked what the correct relationship between a teenage boy and girl should be. By 1964, young people were being warned of the dangers of promiscuous sex and in 1966, a talk on 'Self-Control' insisted that all young people should say a firm 'No' to sex before marriage. But in 1965 *Woman's Hour* hosted a very frank discussion about sexual relations within marriage where the wife complained that she had never had an orgasm. The following year 'A Doctor' spoke openly about impotence and frigidity, and Dr Wendy Greengross, who became a regular contributor from the late 1960s, offered advice on sex in later life as well as birth control.

Questions about pregnancy, childbirth and the care of children were all widely aired and there was one important, noticeable development during the

150

decade—the role of the father. In 1962, the actor Windsor Davies was 'Awaiting our Baby'. In 1965 there was an item on 'Symptoms in Expectant Fathers'; and in 1969, a personal experience, 'Father at the Birth'—a very new phenomenon at the time. It was also during this period that questions were asked about the way the National Health Service wanted women to have their babies—carefully monitored and in hospital; was more reliance on doctors, even for normal pregnancies, the right way to go? In 1961 there was an interview with Sonia Wilmington, one of the founders of AIMS (Association for Improvement in Maternity Services), followed a year later by a discussion of the pros and cons of a home or hospital delivery.

By 1965 there came the first hints of the brave new world of genetic manipulation. They began with a report on the genetic research units that had just been established. In conjunction with twelve clinics around the country, the first tests could take place for foetal abnormalities. In 1968 an interview about a book titled *The Biological Time Bomb* put forward the possibility of test-tube babies.

New thinking on childcare saw the rejection of the regimented pattern of life for mother and baby devised by Truby King. Dr Spock and Dr Hugh Jolly discussed difficult questions such as bedwetting from a child-centred point of view, and advocated warmth and sympathy as a better approach to raising children than the old idea of making them think they were in the army.

Parents such as actor Brian Rix talked about their children's disabilities, both mental and physical, in a way that had never previously been acceptable, contributing significantly to changes in the way the

151

disabled are viewed. Brian's child, in the broadcast, was still referred to as 'mongol' and now would be described, more accurately and sensitively, as 'Down's syndrome'. But, of course, some of the more unpleasant facts about family life also began to emerge. Anorexia was discussed for the first time and, in 1968, a Dr Heffler presented a 'Report on Battered Babies'. He estimated that in the UK around 300 to 400 babies each year were severely injured, usually by their mothers.

As always, health was a mainstay of the programme. Breast cancer was joined by cervical cancer as a cause for concern and there was frank information about smear tests. 'Fear of Going Out' was talked about in 1961, but wasn't called agoraphobia until 1967. Tranquilliser addiction, fibroids and self-help (in 1963) were newcomers to the programme, whilst the menopause and hysterectomy continued to be high on the agenda, no doubt encouraging those critics, who clearly didn't think women should have such information, to claim *Woman's Hour* was simply obsessed with 'down below'.

For the first time, the environment became a subject of serious discussion, following on from anxieties about nuclear testing at the end of the 1950s. Speakers on a report of an all-female meeting about nuclear disarmament included the novelist Iris Murdoch. Rachel Carson's book, *Silent Spring*, prompted items on food additives, atmospheric pollution and population control, whilst in a series in 1968, factory farming and animal testing were discussed, in which the expression was first heard: 'beauty without cruelty'.

Parliament was regularly reported on and in

February 1960 there was a talk that described how 'Mrs Thatcher, the new Member for Finchley, made an impressive maiden speech but, of course, she is a barrister and her legal training must have stood her in good stead.' Barbara Castle rose to the fore, first as Minister for Overseas Development and later as Minister for Transport. In 1966, Ted Heath, then leader of the opposition, explained why he would like to see more married women going back to work as well as more female politicians. Prime Minister Harold Wilson closed the political decade by being asked about equal pay and childcare.

But there was always space on *Woman's Hour* for popular culture too. The sixties saw Michael Parkinson, Ringo Starr and a then still gorgeous Georgie Best appearing on the programme. Shelagh Delaney, who wrote *A Taste of Honey*, the singer Helen Shapiro and her mother, the model Jean Shrimpton, Cilla Black, Jane Asher, Joan Baez and the owner of Biba, Barbara Hulanicki, also appeared. There were discussions on dropouts, drugs, the generation gap and the 'short, short skirt'. In 1965, the columnist Jean Rook stressed: 'If you're over thirty, I reckon [raising a skirt] one inch is enough, which brings your skirt to a fraction above the knee.' Advice, I would venture, that still holds good!

'May We Feel Your Hair?'

8 January 1960

Beryl Gilroy (1924–2001) came to the UK from the West Indies in 1951, becoming one of a small group of pioneering black teachers. In 1969 she was appointed as Britain's first black headmistress—of Beckford primary school. This was her second talk for Woman's Hour.

I had come from British Guiana—a country in which the approach to teaching was arbitrary and formal. It was usual to find seventy or more children, sitting huddled on high benches, doing their lessons in unison and only correct answers mattered. The good children sat silent, passive and orderly, and the good teachers controlled the class by methods that would be regarded as obsolete, unfair and unorthodox in this country.

One dull October morning six years ago, I was on my way to my first school in England. I was bewildered and wondered how I was really going to cope. I had been used to our traditional chalk-and-talk methods and working to a strict timetable. Discipline for me meant regimentation and conformity. Now the whole philosophy of education was different. The children were different too. How would we get on together in the classroom?

When I reached the school, I was surprised to find that the headmistress was a nun. Offering her hand, she said, 'We haven't had a coloured teacher here before, but I am sure the children will like

154

having you and that you will be happy. Meanwhile I'll help as much as I can until you get the hang of things.'

I felt reassured. She had not referred to me as 'black', a term that, in common with many West Indians, I find very offensive. I had heard stories of prejudice against coloured teachers but I decided to ignore all these stories and to carry on being polite and reasonable in my dealings with the people I met.

I soon found out that getting the hang of things was a major task. In British Guiana our children are expected to absorb specified bits of knowledge at the same rate, and at the same time. If they didn't, then it was their own silly fault.

Now, all the classroom activities must be child-centred. The children began the day with self-chosen activity. I quickly learnt to guide and encourage this activity but I could only with difficulty link it with work in the basic skills. So at the end of each day I wrote a self-criticism. Some days it just read: 'Golly!'

The class was very chatty. I remember the day I was asked, 'Why are you made of chocolate?' After I explained that I had come from a hot country and was not made of chocolate, the questioner ran on: 'But why did you sit in the sun for such a long time? Did you have no mummy to take you indoors?'

Then another voice said, 'May we feel your hair?' Soon a score of tiny fingers were racing over my head and then came the remark, 'Me mum says them black people's 'air must feel the same as fibre mat—bristly like—but it ain't true.'

I stayed at the school for two years and I enjoyed it immensely. Through the children I was able to

155

reach the parents. The children spoke with inoffensive innocence and the grown-ups with an ignorance that to me was revolutionary. All my life I have had to acquire facts, and now here were people who didn't care two hoots whether they knew a single thing about the rest of the world.

In the beginning I was sceptical of activity methods. But I have found that whatever else they may not do, they bring out native intelligence. They help the teacher to re-examine her attitudes as she goes along. And these methods really do emphasise the need for alertness, youthful thinking and a sense of fun that is so necessary when dealing with young children.

Now it would be difficult for me to work as a teacher in my own native land. After my experience here, it would be hard to go back to the dull, docile children, the huge classes, and the drudgery of teaching a class that just sits and waits.

Beryl Gilroy was also an academic, a psychologist and a writer. In 1976 she published her autobiographical Black Teacher. *Her novels included* Frangipani House *(1986), set in British Guiana, now Guyana, exploring issues of ageing, and* Steadman and Joanna *(1996), which looked at the history of the Caribbean and African diaspora in the period of slavery.*

'Contraception'

19 September 1960

Information about the birth control pill had slowly been trickling into the public domain ever since it had been synthesised by Carl Djerassi in 1951. It was introduced to the UK in 1961, at first only for married women. Dr Ethel Dukes was the Honorary Secretary of the Marriage Guidance Council Medical Advisory Board. The broadcast contained a health warning: 'We think we should say that today's talk is intended for adults; and there may be listeners who would prefer to rejoin us after it is over. They may like to know that the talk lasts just over five minutes. The subject is contraception and the controversy over birth control by pills.'

How wonderful women have been down the ages, coping with hard work, responsibilities, childbearing and motherhood, and trying to be at the same time a wife, a housekeeper, a mistress and a mother to their husbands—and sometimes a wage earner as well. I think women in some ways have a greater sense of responsibility towards life than men. Yet what a lot a man gives up to take on the cares of married life. What a good thing it is that the glamour of love beguiles them! To be responsible all his life for a wife and her children up to a certain age provided she behaves herself!

The childbearing life of a woman, as we well know, may last thirty to thirty-five years. But in these days many young married women have produced all the

children the family think they can afford by their middle twenties. There then stretches before these women many years of possible childbearing life. Every month the woman anxiously looks for the oncoming of menstruation. If it is delayed for any reason whatever, she may suffer from anxiety about pregnancy. No wonder, then, that women long for some simpler method of birth control. How often have they said, 'If only we could take a dose of medicine or a pill!' Well, here is the Pill!

What is the Pill? It is composed of hormones and it prevents ovulation in the woman; that is, it prevents the ovaries from producing female eggs. It was formerly used as a remedy for certain complaints of women and accidentally was found also to act in this way as a contraceptive. But I fear that it may be harmful if taken in its present form during the long reproductive years stretching ahead of many women. After all, we are talking about something that is a very powerful chemical. Its whole purpose as a contraceptive is to interfere with a process that is not only natural, but basic to women. How can it be a good thing to tamper with the normal cycle of events in the female reproductive system? Can it be right to alter the normal functions of a woman's body for so many years?

It's entirely different not only in practice but also in principle from the present contraceptives. The way these work is by keeping the male and female apart from each other. This is a very different thing from stopping the manufacture of the female cells.

As a woman doctor who has been interested for many years in the problems of marriage, I think the less one interferes with the course of nature the

better. On the other hand I recognise that contraceptives are necessary. The best ones to use, therefore, are those that interfere least with the natural rhythm of a woman's sexual and reproductive life. I hope that something less harmful for long-term use will be found soon.

The Pill was to transform women's lives; for the first time in history women could control their own fertility and the number of children they had. It was to be the lynch pin of feminism in the seventies, which opened up society, jobs and education for women. The debate about the safety of the Pill continued for many years— and still continues. Nowadays, much lower doses of hormones are used and the progesterone-only 'mini-Pill' is available. It's estimated that about a hundred million women worldwide use the Pill, and in the UK about three and a half million, or roughly one in three women of reproductive age, use the Pill.

Indira Gandhi

interviewed by Tanya Zinkin
1 May 1962

Indira Gandhi (1917–84) was India's first woman Prime Minister. A graduate of Somerville College, Oxford, Indira Gandhi was the only child of Jawaharlal Nehru, India's first Prime Minister. In 1962, when this interview was broadcast, she had already been President of the Indian National Congress and had stood in for her father on a number of occasions. Woman's Hour *reporter Tanya Zinkin spoke to her during a rare visit to the UK. She was introduced as Nehru's daughter and asked about her involvement in politics when she was a child.*

GANDHI: Our house was the centre of political activity, and as I was an only child it was perhaps natural that I should be involved and interested in what was happening right inside the house. My mother came from a rather orthodox household where she hadn't been out very much, or mixed with people. But she entered into the spirit of the thing, and in fact my grandmother felt that she was the one who egged my father on. My mother felt very strongly about women's rights and education, and of course later on she took an active part.

ZINKIN: Was she educated in the sort of modern sense or not?

GANDHI: No, because in those days the women mostly had tutors at home, and she'd learnt various things like our own classic language, plus minimal

160

mathematics, and so on at home. When she got engaged to my father she learnt English. But although her family was orthodox it's very remarkable how Indian women knew how to cope with almost any situation or any restriction that might arrive. When my mother was quite a small girl they moved to Jaipur, which had a great deal of purdah—seclusion of women. Her uncle was the chief minister of the state and he felt that it would be very undignified for a girl of twelve or thirteen to go out with her face exposed; she was supposed to stay at home and be ladylike. Well, my mother had been rather a tomboy because she had two brothers, so this didn't suit her and she became very pale and ill-looking. My grandmother found a way out—without telling my grandfather or the rest of the family. That was by dressing my mother as a boy . . . and hiding her pigtail in a turban so that she could go out with the boys and retain her health and complexion.

ZINKIN: When you were small, when did you first do something political? I think you once told me you were lecturing to your dolls about the iniquity of the British.

GANDHI: I can't remember what I was lecturing about, but that was my favourite game—either lecturing to the dolls or collecting all the servants together and standing up on the table and lecturing to them.

ZINKIN: When you were a little girl your father, of course, was all the time going in and out of gaol in his fight against the British. Did you also go to gaol?

GANDHI: I've only been once, in 1942, for about thirteen months. We had to sleep on cement

161

tombstones. And the cells were completely open to sun, rain, dust, everything. I had no visitors or letters, very little reading material, but on the other hand I had conditioned myself to put up cheerfully with whatever came. It was only when I was released that I realised that I had sort of blocked up whole sections of my mind, and it was quite a shock to come out into the world of colour and texture and tunes and so on.

Indira Gandhi's father died in 1964 and two years later she became the country's first woman Prime Minister. She served twice as Prime Minister, from 1966 to 1977 and from 1980 until her death in 1984, when she was assassinated by two of her Sikh bodyguards. Her son Rajiv Gandhi then became Prime Minister.

Barbara Castle

19 July 1963

Barbara Castle (1910–2002) was brought up in a socialist household and entered politics as a Labour councillor in 1937. She was elected to Parliament in the post-war election of 1945, and represented her constituency of Blackburn for thirty-five years. In 1950, she was elected to the National Executive of the Labour Party and was Party Chairman from 1959 to 1960. She would get her first ministerial appointment, as Minister for Overseas Development, the year after she wrote this diary of a day in her life for Woman's Hour.

7.30 a.m.
The alarm goes off. It's my turn to make tea so I crawl sleepily out of bed and touch my toes in front of an open window while the kettle boils. Back to bed with a pile of newspapers and my daily losing battle to keep abreast of the world's news. About an hour later I get up, bathe, and race through a few personal domestic chores. Soon the telephone starts its perpetual interruption of my life. Telephone calls almost make me late for the lift that my impatient husband is waiting to give me on his way to work. I like to go with him if I can because this gives us one of our few opportunities to be together.

10.30 a.m.
Arrive at the House. I have no committee

meetings this morning so I settle down for a long session with my secretary. My post is the usual mixed bag. There are letters from constituents asking me to take up their personal problems. There are letters asking me to put down amendments to various government Bills. There is a plea from a political refugee from South Africa who wants permission to stay in this country—an all too frequent headache. Every outcast in the world seems to write to me. Once again the telephone brings its jarring interruptions to our work. One of my letters is from the National Equine Defence League, asking me to present a petition to Parliament pleading that the castration of animals without anaesthesia should be made illegal. I know there will be some titters in Parliament when I raise this—just as there were when I demanded the abolition of turnstiles in public lavatories. But cruelty to animals—or to women—makes me see red. If the law needs changing, I don't see why a few sniggers should put me off. So I break off to take the petition to the Clerks of Parliament to see whether it is in order and to fix a date.

1.15 p.m.
A quick lunch in the cafeteria when I seize the opportunity to beg some tickets for the debate from those MPs whose turn it is to be allocated them.

2.15 p.m.
Meet my constituents in the Central Lobby. Together we watch Mr Speaker's procession into the Chamber, where he arrives at exactly 2.30, a

simple but dignified little ceremony that always makes me feel proud to be a Member of Parliament. Into Question Time, one of the most exciting hours of our parliamentary day, when MPs impatiently wait their turn to heckle ministers. I always like to have a go. This time I am trying to persuade the Minister of Health to issue invalid cars to all the severely disabled who need them to get to work and I quote the case of a man in my constituency who is trying to earn a living although totally disabled with multiple sclerosis. Mr Bernard Braine, the friendly Parliamentary Secretary, makes sympathetic noises but I suspect that I have not persuaded him to change his policy. So I warn him I will return to the attack.

3.30 p.m.
I dash along the corridor to the Minister of Education's private room. People often ask me how I keep slim; the answer is that I am always on the run. The problem this time is the minister's refusal to allow my local education authority to include any new schools in their building programme for 1964/65. I lecture the minister severely about his niggardly attitude, but in vain. So I tell him I shall raise the matter on the floor of the House. Next, a break for a cup of tea. In the tea room, MPs are chatting about the day's news and picking each other's brains about points of policy. Not much respite here.

5 p.m.
I go upstairs to one of the committee rooms where the Parliamentary Group of the United Nations

Association has brought an expert along to talk to us about disarmament, one of the subjects close to my heart but which, unfortunately, like everything else these days, is becoming increasingly technical. I make a few notes of points on which to prod the government.

6 p.m.
Another session with my secretary. She reminds me that I am supposed to be attending a reception at one of the foreign embassies. I have brought my best frock down for it and even found ten minutes to press it in the Lady Members' Room but I tell her I cannot get away and that she will have to send my apologies.

7 p.m.
A quick wash in the Lady Members' Room where a few of us have our usual moan about how difficult it is to find time for those little feminine luxuries like a visit to the hairdresser. Then into the dining room. Here I sight one of my colleagues who is a solicitor and I get some advice from him about how to help a constituent who has got himself into a legal mess. After dinner I go into the library where I work on a speech I have to make that night. I have been lucky in the ballot for the adjournment—the last half-hour of every parliamentary day when MPs can ventilate their grievances about the government. I want to raise an anomaly in the regulations about teachers' training grants which has been brought to my attention by a young teacher in my constituency. I have already raised it at Question Time without much success and am using this opportunity to

follow it up. If I am not in my place when official business ends, I shall miss my chance, so I have to be at the ready from 10 p.m. I look into the Chamber and find that the debate on the Local Employment Bill is still going strong. I telephone my husband who is still at work in Fleet Street to tell him that my speech may come on late.

10.30 p.m.
My long-suffering husband arrives at the House and I put him into the public gallery to wait for me. I install myself on one of the back benches and wish that my colleagues would not talk so much. I also wonder wearily why I cannot take 'no' for an answer.

11.30 p.m.
My turn at last. I make an impassioned speech about the government's stupidity to a Chamber from which all have fled, save two government whips and the parliamentary Secretary to the Ministry of Education, Mr Chataway. But despite the discouraging atmosphere, this time I am in luck. Mr Chataway promises an immediate review to get rid of some of the anomalies of which I complain.

Midnight
I collect my yawning husband and head home for bed.

Not all my working days are as cramped as this, but the majority are and I never go home without being acutely aware of all the many injustices and stupidities that remain unremedied. Already I am

167

turning over in my mind the work that is piling up for the next day. Why then do I do it? Because I cannot think of any other job in the world I would rather do.

Barbara Castle went on to hold many of the most senior jobs in government. She was Minister for Overseas Development (1964–5), Minister of Transport (1965–8) and Secretary of State for Employment and Productivity (1968–70). It was in this capacity that she introduced the legislation for equal pay in 1970.

Coretta Scott King

interviewed by Michael Freedland
11 December 1964

Coretta Scott King (1927–2006) was the First Lady of the civil rights movement in America. Her husband, Dr Martin Luther King, came to prominence in the American civil rights movement in 1955, when he led the first bus boycott. He had married the concert singer Coretta Scott in 1953 and she was constantly at his side during his time as the country's foremost black leader. In 1964, Dr King was awarded the Nobel Peace Prize. Before travelling to Oslo to receive his award, he and Coretta were briefly in London. This was when Woman's Hour *sent Michael Freedland to interview Mrs King. She spoke to him about her life.*

KING: Certainly our lives are geared completely to my husband's activities. He is a minister of the Church, with his father, and our life is either the Church or the civil rights struggle, and I think they are both really one and a part of the same big cause. I don't see the Church as being separate from one's life. We feel that we belong to the people, and we would not have it any other way.

FREEDLAND: How did it all start?

KING: In Montgomery, Alabama, a woman by the name of Mrs Rosa Parks boarded a bus one afternoon, as she was coming home from work. And the bus was usually crowded at that time of day, and there were seats available, but they were

169

reserved for white people only. Mrs Parks decided that she wanted to sit down in the reserved section for whites only, because she was tired and she felt that she had a right to sit down, and so she did, and was arrested. Consequently, the negro community became aroused and felt that something should be done about it, and they decided to boycott the buses. They asked my husband to serve as spokesman for the 50,000 negroes, and he of course, willingly agreed to do so, and this is how we became involved.

FREEDLAND: Malcolm X said on British television, a few days ago, that he was a very, very angry man. Your husband is working for negro rights, but in another sphere. Would you call him an angry man?

KING: No, I would say he was just the opposite. My husband is a non-violent leader, and I think he personifies non-violence. I'm not saying that just because he is my husband, but he has no malice, no bitterness, and he fights this campaign with love and understanding.

FREEDLAND: Does it hurt to hear him criticised and attacked by people? I'm not mentioning particularly J. Edgar Hoover, but he is one person that comes to mind.

KING: Does it hurt? Well, of course it does. I have to admit this, and yet I do expect a certain amount of criticism in public life, but it still hurts, because I know he is not all of the things that many people say he is. But I feel there are enough people who believe in him and his integrity, so that he will continue to be effective.

FREEDLAND: I know you're the mother of four children. How have they been affected by all this,

by your husband's work?

KING: My children are still fairly young, the oldest being nine, and the youngest twenty months. The two older ones are pretty much aware of what we are doing. They have not been affected too deeply in terms of being discriminated against, because they were so young when we first started. But they are aware of the fact that, because one happens to be negro, one can be discriminated against. They realise that we are trying to make things better for them, and to make better opportunities for all people.

FREEDLAND: Do you ever feel that you would prefer your husband to stop being something of a statesman among his people and go back to life as an ordinary pastor?

KING: Not really. I would like for the time to come when he would have some more time for the children, and for me, of course. But I would not like for him to withdraw, because I feel what he is doing is too important, although I would certainly like to see the time when the pressures are less, and that he can live a more normal life and really enjoy his children. Many times he can't be present for their birthdays or the other important times in their lives, which mean a lot to children. However, I must say that on holidays and on other occasions when he has time, or he makes time for them, they enjoy it thoroughly. I think really ultimately this is what counts: how well you spend the time when you are together.

Martin Luther King was assassinated in 1968 while on a civil rights mission. Coretta King continued to be a figurehead of the civil rights movement, establishing

the Martin Luther King Jnr Center for Nonviolent Social Change. She died on 31 January 2006.

Cilla Black

interviewed by Ailsa Garland
5 January 1965

Cilla Black (née Priscilla White, b. 1943) was spotted by the impresario Brian Epstein in a Liverpool club in 1963 and she became the most successful female vocalist to come out of the city. Her debut single had a modest chart success but it was 'Anyone Who Had a Heart' that propelled her to number one—and stardom—in January 1964.

GARLAND: Did you want to be a singer from a very early age?

BLACK: Yes. Oh, ever since, you know, I could talk I've wanted to perform. If there was a party I was one of those horrible kids that wanted to be in the front and do a dance and sing.

GARLAND: When was your first performance that really brought you any notice?

BLACK: It was in a club called The Iron Door where I was more or less discovered by a group called Rory Storm and the Hurricanes—a terrific name, isn't it?

GARLAND: Do they exist today?

BLACK: Yes. Ringo Starr was the drummer at the time in this particular club. I was having a friendly argument with the bass player, and then in the middle of a song he passed me a mike, so I thought—you know—getting all cocky, he's not going to make a fool out of me, I'll show him. So I took the mike off him and I sang the rest of the

song and then the word just spread around Liverpool, like wildfire. Then all of a sudden all these groups wanted me to join them because it was a gimmick, you know—a girl singer, and I was still the only girl singer in Liverpool.

GARLAND: You've been an 'only' quite often. Because you are well known and because you're prominent, you are definitely a fashion setter. You've helped to spread the fashion of the fringe with the straight, swinging hair. How long have you had your hair like that?

BLACK: Ever since I can remember and I'm really fed up with it but I'm terrified to change it because I have had letters from people saying, 'Don't ever change your hairstyle.' I mean, I can't have the same hairstyle when I'm thirty-five—I would look ridiculous with this heavy fringe.

GARLAND: What enthuses you tremendously, what excites you?

BLACK: I like to hear a full house applaud, you know? Oh, it's marvellous.

GARLAND: You need an audience, then?

BLACK: Oh, they're essential.

GARLAND: How do you manage with television or with radio or records if an audience is essential for your success? Because you're longing to get close to them again, to get to your fans. How do you manage so well?

BLACK: I don't look upon television as work actually. When people say, 'Are you working tonight?' I say, 'No, I'm only doing so-and-so or such-and-such a programme.' I don't look on it as work. I say, 'Well, this is my night off and I'm going to entertain myself.'

Cilla Black went on to have twenty top-forty hits, before bowing out of pop music in 1971. In the 1980s she relaunched her career as a television presenter with Blind Date.

Freya Stark

interviewed by Teresa McGonagle
19 May 1965

The indomitable traveller Freya Stark (1893–1993) embarked on her maiden journey in 1927, to the Lebanon, the first of countless adventures all over the world. She published the first book of her travels in 1933, followed by more than twenty other works describing her experiences in countries as diverse as Nepal, Turkey and Canada.

MCGONAGLE: When I told Miss Stark that I was seeking this interview for a programme in our series on twentieth-century women, she denied belonging to this century. She was born in 1893 in a studio in Paris to parents who were artists. Her parents, she has said, 'treated Europe with extreme nonchalance as a place to run about in'.

STARK: One just looked at a map of Europe and had no passports to think about and no currency questions and went wherever one liked. I always wanted to travel and we were brought up to travel. We were carried across the Dolomites, my sister and I, when I was about two and a half, in a basket by the guides, so that we began very early. I think travel was taken in one's stride rather in those days.

MCGONAGLE: You spent many years studying Arabic. What drew you to that part of the world?

STARK: Two things, I think. One was the great area over which the Arabic language is spoken, which covered countries that I was always drawn to in the

East and their history. And then I thought that any country that had to do with oil would be full of interest in my lifetime. And so it has been. The thoughts of the world have centred on oil for about a generation, which covers the years I travelled there.

And the fact is that the Arab, tiresome as he often is, is a very interesting human being. So that one is never bored with an Arab. He's got human qualities. He is an individualist. The fact is that Arabs are extremely good company. And everybody who has travelled to Arabia has always found them so. They have a great many noble qualities. They have a deep feeling for religion in spite of a modern sort of scepticism, and also for nationalism, which I think is spoiling half the world, as well as feelings of friendship and devotion. They'll follow an idea and sacrifice themselves for it.

MCGONAGLE: Your formal education, you tell me, was scanty.

STARK: We never went to school; we were brought up on four European languages and allowed to read. We had the run of a quite good library at home and that was about all. I've always loved words; from when I was a tiny child I would love pieces of poetry. I was always told by my teachers that I ought to write. But then there was a war and one thing and another, and I had given up the idea. I just kept a diary of my first journey in Persia. My mother typed it out and sent it to a friend who showed it to the editor of *The Cornhill*. John Murray found it in his safe and offered to publish it. And that was how it started.

MCGONAGLE: Do you take notes when you're on your travels?

STARK: Yes. I keep a diary. And I take very concrete notes. I don't think it's much good writing what you feel. The thing is to feel when you see something or have an adventure of any kind. The more you feel it, the stronger the remembrance will be and therefore you mustn't spoil it by trying to describe it at the moment. But a lot of concrete things, like the colour of the atmosphere or the details, those are apt to slip one's memory and those should be recorded. The unexpected is necessary in a travel book and modern methods of travel work against that. I think these motoring tours are against good travel because you're shut away from the world; you're going through it but you're not a part of it. You ought to be a part of the world that you're describing. I think you ought to describe more than just the things you see, you ought to be thinking about them and thinking what they mean. Of course, historical travel is odd, it's travel in depth. Most things have been discovered, but as soon as you travel in time as well as in space you open up a completely unexploited world, which is infinite in its possibilities.

Freya Stark was made a Dame in 1972. She continued to be an intrepid traveller even in her seventies and eighties, braving the Euphrates on a raft, crossing Afghanistan in a jeep and trekking through Nepal on horseback.

Joan Baez

interviewed by Bob Holness
14 December 1965

The American singer Joan Baez was born in 1941 and started singing in coffee clubs during her university days in Boston. Her performance debut was at the Newport Folk Festival in 1959 and the following year her first album Joan Baez *was released. Her second album,* Joan Baez Volume 2, *released in 1961, went gold. A Quaker, she was one of the artists most strongly associated with the civil rights movement of the 1960s, famously singing 'We shall overcome' at Martin Luther King's March on Washington in 1963. She later became a passionate campaigner against the war in Vietnam.*

Bob Holness became a presenter of the popular children's television quiz Blockbusters.

HOLNESS: If there were no racial discrimination and nobody had invented the atom bomb, do you think there would still be protest singers finding something to protest about?

BAEZ: I don't think we'd have to look very far! A lot of people say, 'You fool, what are you all going to do if there's no bomb?' I think there will always be things to take care of—like diseases and starving people. There's plenty to do, putting the bomb aside; segregation, for example.

HOLNESS: In your concert you at one point referred to somebody asking you whether you considered President Lyndon B. Johnson was

responsible for the mess the world is in today. And you said you consider yourself responsible. Why?

BAEZ: Because if I, individually, don't take it upon myself to make a change, in myself—and as much of a change as I can in the rest of society—then nobody's going to. I absolutely can't leave it to anybody else. Most people at this point don't want to do anything, but if each individual doesn't see it and do something about it, I really think we're all doomed. It is all different at this point—1965—from what it's ever been before. At this point, if somebody decides to push the button, that means you no longer sit there and hold a microphone and I don't sit here and talk. We all get blown up.

HOLNESS: How much sincerity have you found in this country concerning the issues you raise in your songs? Have you found a hostile reaction at all?

BAEZ: Oh no, in this country it was, at least at one point, probably even chic to be pacifist but that's a state that's never been reached in the United States, and so where do you go from there? This country isn't acting any more intelligently, I don't think, about world affairs than America. The reaction in concerts might be a little bit better here than in the States when I say some of the things that I do. I think that America is more of a threat to the world right now than any country, because the way Americans have been acting is like a bunch of kids, and much more so than the communists at this point, although I don't care for communism.

HOLNESS: It's been said that you've indulged in meditation. Do you in fact do this?

BAEZ: In the school that I'm running right now, we

180

have a lot of meditation and according to everybody at the school the meditation was the thing that made the difference to them. In other words, it could have been just a series of seminars if it hadn't been for these quiet times that we had. Some of it was group meditation and some of it was solitary, where you'd be alone for an hour and you couldn't reach for a cigarette or grab a book or anything, and this really made a difference. It was really the first time in my life that I've sat down and meditated. Although I came from a Quaker background, and my parents and the family went to Quaker meetings, I was busy being a child and I just hated it. You can't really get anything out of it when you're ten and you're sitting there, biting the inside of your mouth trying not to giggle, but I think meditation is absolutely essential.

HOLNESS: What is the essential aim of the school?

BAEZ: The eventual aim of the school—we have to say it with a smile, but at the same time we're serious—we'd like to end war. If something isn't changed, then I really think we haven't got too long to live, all of us, so at the same time you smile a little bit because it sounds absolutely insane. The first lesson at the school was absolutely magnificent and went beautifully, and we had to smile a little bit because there is still a war going on in Vietnam. These fifteen people found out incredible things about themselves. Some of them probably won't have anything to do with peace movements, but everybody was awakened to a certain degree in that group. Say, for instance, on a picket line of a thousand people that two of them really know what they're doing. It can make all the difference in the world.

In 1965 Joan Baez founded the Institute for the Study of Non-Violence. In 1973 she had an international hit with her album Diamonds and Rust. *Still a committed pacifist, she has continued to be politically active, supporting various causes across the world. She has also had a highly successful singing career. Her latest CD* Bowery Songs *was released in 2005.*

Jean Rook

1 June 1966

'The First Lady of Fleet Street', Jean Rook (1931–91) started out as a fashion writer for a provincial newspaper before joining the Daily Mail *where she became the paper's first celebrity female columnist. Here she is talking about ambition.*

When I was in the Third Form, I came thirty-first in mathematics out of a class of thirty-two—the bottom girl was all but mentally deficient. In the Fourth Form, I came tenth out of the same class, because I'd persuaded the girl in the next desk to do my homework. I didn't like her. I never gave her anything in return. I can't even remember her name. But she was my rung up the ladder that would take me into the swankiest class in the Fifth Form. So I telephoned her every night and picked her brains with a hatchet.

I am relentlessly, burningly, nearly murderously ambitious. If it came to a choice between getting where I wanted to be and treading on my best friend, I wouldn't give my best friend a fifty-fifty chance. I'm not saying this for effect. I'm not proud of it but neither am I ashamed of it.

Ambition is a disease with me. It really hurts. If I'm not top dog—in fact you could say bitch—in anything I put my hand to, it simply eats into me. Before I landed a job in Fleet Street I used to cover the London fashion shows for a provincial newspaper. Since I wasn't important, the fashion

183

houses used to cram me away in a rotten seat four rows behind the national newspaper writers on the front row. I *hated* those national paper girls. Just looking at the backs of their sleek, successful necks used to fill me with raging ambition—it feels like toothache, except that it goes right through you. I swore to myself then that, whatever lengths I had to go to, I'd one day sit on that front row. So, five years and a good few lies later, I do. I lied about my age—knocking years off or sticking them on, as the job demanded. I lied about my experience—and worked fifteen hours a day when I got the job to make up the experience my employers thought I had in the first place. I once told an editor I could do a hundred words per minute shorthand. I could do about five. So I took secret late-night classes and worked up to sixty. I just hope my present editor isn't listening in, because he thinks I can do 120.

I cultivated people I despised in case they might come in useful. I smiled in the faces of girls whose jobs I thoroughly intended to pinch if I got the chance. I pretended that I was just a jolly, cheery Yorkshire girl who asked an awful lot of questions. Very humbly. So they gave me the answers. And I learnt then—fast—and I learnt how to use them.

My good luck is that I don't look in the least like Lady Macbeth. You know—all thin and hollow-eyed and jealous. I'm one of those extrovert, non-sinister people of whom other people say oh-yes-dear-old-Jean-such-a-good-sort. I'm terribly friendly with rivals on other national papers. One fellow fashion editor is genuinely a close chum. If she were ill, broke, unhappy, I'd run my blood to water to help her out. I mean that. But when we're

on a job together I'd all but break her leg before she got a better story than mine. I'd fib to her, put her on the wrong scent, give her the wrong contact. She would—and has—done the same thing to me. But, if she hadn't, it wouldn't worry me. When you're as ambitious as I am you wouldn't give quarter to a blood relative.

I remember a fellow journalist once taught me how to tie up a telephone so a rival journalist couldn't use it. Years later, he and I were on the same job, working for different papers. And it was tough on him that I got to the telephone first and stuck him with his own dagger.

For those of you who haven't switched off and started writing me nasty letters, I am going to put in a word of my own defence—which I suppose proves that I have some sort of conscience. I haven't really got where I wanted to be using my friends' faces as stepping stones. Not that I wouldn't. I've worked crazily hard. At school I slogged at my books while the rest of the class was at the pictures. University chums used to spend their vacations popping all round the Continent. I spent mine in a small back room at home working twelve hours a day. On provincial newspapers I flogged away from ten in the morning, sometimes until ten at night, writing up fires, murders and budgerigar shows.

I broke two engagements because my career meant more to me than home and a washing machine, and it didn't seem fair on the chaps. By the time I married a chap who is sweet enough to recognise my ambition as a recurrent illness—like bronchitis—most of my pals were settled with two children.

I have low days when I wish I had six children and to heck with the job. I have high days when anybody can have six children, but how many women have my exciting, ever-changing life? By the way, you may wonder how, when you've achieved your ambition, you keep the job you want. It's easy. Keep an eye on all the girls who are as ambitious as you are. And keep a foot on them too.

In 1977 she was poached by the Daily Express, *becoming chief columnist and Assistant Editor. In 1968, she published her book* Dressing for Success. *She was the original inspiration for* Private Eye's *columnist Glenda Slag.*

Judi Dench

15 March 1967

By 1967, Judi Dench (b. 1934) had already appeared in more than forty plays, five films and TV series such as Z Cars. *She had trained at the Central School of Speech and Drama, winning the prestigious gold medal in 1957. The same year saw her professional debut in London as Ophelia; she was just twenty-three. Her appearance on* Woman's Hour *as Guest of the Week coincided with her starring in* The Promise *by Aleksei Arbuzov.*

INTERVIEWER: Did you find that early success had any pitfalls for you?

DENCH: Simply starring as Ophelia at the Vic was in a way a pitfall in itself, because people were inclined to think that that was the top of the profession really. It's a great big starring part, so you come in for a lot of adverse criticism very early. This is not necessarily a bad thing actually because you get all that over with very early on in your career. You can take more of it later. I feel that sometimes there's a lot of unnecessary publicity about people. If they want to write things about plays and things that's fine, but I don't think that publicity about you buying a new hat or getting a new flat or going abroad somewhere is really necessary.

INTERVIEWER: After ten years in the theatre is it possible for you to define just what it is about acting that you like?

DENCH: It's simply the way one can communicate a play or oneself to other people, just those certain people who come into the theatre on that particular evening. You don't meet them personally, but you're bound up in one thing all together for one evening and you hope that you've conveyed something good or bad—that everybody's thinking perhaps a bit more or about something that they've not thought about before.

INTERVIEWER: If you had to name just one quality that you consider is essential to the craft of acting, what would it be?

DENCH: Vitality or energy is the one thing that one needs, because everyone thinks it's very glamorous.

INTERVIEWER: You need a lot of relaxation to go with it, I should imagine. What do you do about that?

DENCH: I draw, I paint and I do tapestry. I do petit point and but I don't do any of them very well. I do them at extraordinary times. I mean, this sounds mad and nobody will believe this, but it's true that this morning I got up at half past nine and made my breakfast and got back into bed and did the most enormous piece of tapestry. I can't sit still for a long time, but I enjoy just doing something with my fingers quickly—knitting, drawing, or anything like that. They're my mind distiller.

INTERVIEWER: You've toured in the United States and Canada, and in West Africa, where you played Lady Macbeth. How did this go down with West African audiences?

DENCH: It went down very well and was to them very funny, and it was thrilling to do it. I mean, it was so unexpected, the audiences' reaction to us

all. We were hissed and booed . . .

INTERVIEWER: But didn't that throw you?

DENCH: It did at first. It threw us enormously on the first night. We thought, good gracious, something awful has happened that we can't recognise. But then we simply realised that it was the most marvellous reaction. And the sleepwalking scene literally went down like Morecambe and Wise. It really did. It made it very difficult for me to overcome my tendency to laugh myself a lot of the time. The audiences knew the plays very well indeed, and loved our productions. It was absolutely thrilling. I would love to go back.

Judi Dench went on to become the leading actress of her generation. She starred in the long-running and immensely popular TV series, A Fine Romance *and* As Time Goes By *(for which she received a BAFTA award). Her huge body of theatre work has included such critical successes as Trevor Nunn's* Macbeth *with Ian McKellen,* Mother Courage, Antony and Cleopatra *with Anthony Hopkins,* Amy's View *and* A Little Night Music. *Her many films include* Mrs Brown *in which she played Queen Victoria, the role of M in four James Bond films, the role of Iris Murdoch in* Iris, The Shipping News, Shakespeare in Love *(for which she won an Oscar) and* Pride and Prejudice.

Edith Summerskill

interviewed by Joan Yorke
18 April 1967

Edith Summerskill (1901–80) trained as a doctor, venturing into politics in the 1930s first as a Labour councillor and then as an MP in 1938. She served as Parliamentary Secretary to the Ministry of Food (1945–50) where she oversaw the legislation to pasteurise milk, and then as Minister of National Insurance (1950–51). She became a peer in 1961. An outspoken feminist, Baroness Summerskill was at the forefront in the campaign for married women's rights and equal pay. This interview, which took place at home in Highgate, was part of a series on twentieth-century women.

SUMMERSKILL: I had a father who believed that a girl should have an equal opportunity with a boy in the world of education. Then I married a man who's intelligent and unselfish and who believes in his turn that a woman, if she has certain aptitudes, should be permitted to use them. I therefore feel that it's only right that I should try to help other women, perhaps as the suffragettes in the past and Elizabeth Garrett Anderson [the first English woman doctor] has helped me. That's why I'm an unashamed feminist.

YORKE: Would you have been a militant feminist, do you think?

SUMMERSKILL: Oh yes, without doubt. I'm aggressively minded.

190

YORKE: You were a doctor's daughter and followed in your father's footsteps with a particular leaning towards preventative medicine. You became interested in politics after being co-opted in your capacity as a doctor on to your local maternity and child welfare committee. A year or two later, you were elected as a Labour member to the Middlesex County Council and then, in 1938, to the House of Commons. You were already married to another doctor and had two children. Was combining the jobs of wife, mother and MP difficult?

SUMMERSKILL: Very, very difficult. The male Member of Parliament has his wife in the constituency, organising bazaars, doing his secretarial work, smiling sweetly at difficult constituents, but a woman, of course, if she's married and has a home, like all women who work outside the home, does two jobs. But don't forget, we do it willingly. When Shirley was put into my arms, when I looked at my red-headed little daughter, I experienced a much greater satisfaction than when the returning officer said that I was a Member of Parliament. Let me quickly say that I realise that I had responded to my maternal instincts and satisfied them, but if I hadn't been able to use my mind, I think I would have been so frustrated that I would not have been an extremely pleasant wife and mother, because I should have felt that I had certain other energies that I wanted to express.

I used to practise in the morning and then I used to go to the House in the afternoon and evening, and now people are saying, what about your children? Well, when my son Michael had measles

191

and all these children's complaints, I used to phone home from the House of Commons to see how they were getting on.

YORKE: In 1945, when the Labour Party came to power, you were appointed Parliamentary Secretary to the Ministry of Food. Food, of course, was still rationed and in short supply and people couldn't get enough protein. The government was advised that a South African fish with the unfortunate name of snoek had the same protein value as beef and you, as the new Parliamentary Secretary, were deputed to go and tell the housewives this.

SUMMERSKILL: Oh dear, I used to enter a hall packed with irate women who were fed up with trying to feed their families on the rations and I had to explain the protein value of snoek. Well, I used to be shouted down. Of course, looking back, we were too technical. We should have said this has a good protein value but it has a most horrible name. I think if we'd changed the name, it might have been much easier, but I nearly lost my political reputation on snoek.

YORKE: But later in your career at the Ministry of Food, you put through a Bill that gave you great pride and satisfaction and which has had remarkable effects on the health of the nation.

SUMMERSKILL: I was brought up in a medical household where bovine tuberculosis—tuberculosis that stems from infected cows' milk—was very, very common and our orthopaedic hospitals were full of small children with crooked backs and stiff knees who were lying there perhaps for years and years. My father used to campaign in his little way—he fought one election at the beginning of the century

in 1905—where dirty food and unclean milk were the only planks to his election platform. So I knew that if one could only clean the milk supply of the country, we could save the lives of thousands of children. I'm afraid I nagged at the Ministry of Food and said we must get this Bill ready. In 1951, I think it was, I rose in the House of Commons and I looked at the Speaker and said, 'Mr Speaker, this is my finest hour, as I introduce the Clean Milk Bill.' And if I may say so, although it sounds frightfully immodest, the interesting thing is that if you look at this country, those orthopaedic hospitals have hundreds of empty beds and we're wondering now how to use some of those beds for other conditions.

You have to feel you are right to stand up in the Commons in front of a hostile audience. I've been very fortunate in getting one or two Private Members' Bills through. For instance, the Married Women's Property Act, 1964. I asked the Lords whether they thought it was equitable for a woman to clean, wash, scrub, look after the children, be a nurse, do all the hard work of a household but still not be entitled to one penny in her own name, which was the position then of the married woman. Now when I first introduced this Bill in 1954 in the Commons, of course I couldn't get support although some of the finest men were with me— like the Attorney General and the Solicitor General. At least we have now established the principle that a married woman has a right to a half-share of the savings out of the housekeeping money.

And the position now is that if a woman is deserted by her husband, she has no legal right to stay in her own home. So in 1964, I introduced the

Matrimonial Homes Bill, which gave the deserted wife the right to remain in her own home. Now we've got that through the Lords. I'm still waiting for it to go through the Commons, but I'm an optimist. I believe that it's morally right and that finally Parliament will sanction this.

Edith Summerskill's daughter Shirley was Labour MP for Halifax from 1964–1983 and as a junior minister at the Home Office helped to introduce the Sex Discrimination Act in 1974. Her grandson Ben Summerskill is chief executive of the charity and lobbying group Stonewall.

Sheila Scott

interviewed by Marjorie Anderson
27 November 1968

Sheila Scott (1927–88) started flying in 1959, going on to hold scores of world records. In 1966, she was the first British pilot to fly solo around the world in her single-engine plane, Myth II. *Her first book,* I Must Fly, *was published in 1968 and she appeared on* Woman's Hour *to talk about it. Marjorie Anderson asked her what it was about flying that captured her imagination.*

SCOTT: Apart from it being great fun learning to fly, I find enormous beauty up there. The colours are quite different and there are enormous extremes of emotion. One is never bored, and I'm a terribly lazy person; unless I love something, I don't work at it. And above all, I find enormous friendship around the entire world as well as in my own country, and, I'd go on for that alone.

ANDERSON: What drove you to the competitions and record attempts?

SCOTT: This was quite by accident. The boys who rebuilt my old Tiger Moth found she was a very fast one and insisted that I enter the national air races. I couldn't really fly terribly well then, but somehow won her first race—my first race—and so she led me into racing. Well, by racing in Europe and North Africa, representing my country, I became more deeply involved in all sorts of aviation, and this naturally leads to record-breaking, I think, or

195

record attempts.

ANDERSON: What have been the most frightening moments for you?

SCOTT: This is terribly difficult to answer because my flying isn't normal. Flying is the safest thing in the world—it's safer than driving here in a car, but of course, as a record-breaker, I must push my aircraft way beyond what it was built for, as well as myself, and it's frightfully difficult to say which is the most frightening moment. I would say probably when you are lost in the monsoons, when you're in thick cloud and being bounced upside down. As a record-breaker I have to take off in bad weather sometimes because I simply must. I'm up against time, I sometimes have to take a risk.

ANDERSON: You've said that any pilot who doesn't get frightened now and then isn't worth his salt.

SCOTT: A pilot without imagination is usually rather a bad pilot. No, it's much wiser to plan all the things that could happen to you, even the bad things, and then of course you know how to cope with them and usually you survive.

ANDERSON: You do seem to establish a very close affinity with your aircraft, don't you?

SCOTT: Oh well, she's a very special person. I mean, I don't even think of her as a bit of machinery. She's a person in her own right, and you see, I owe a very great deal to *Myth II*. She's my home, my child—everything. Of course I was terribly lucky. This was an aircraft straight off the line, and she turned out to be a wonderful one. Tough male pilots have often said to me, 'Oh, you're much too sentimental about your aircraft.' She is . . . a person as far as I'm concerned. It's as exciting as a love affair, though probably far less

196

dangerous.

In 1971, Sheila Scott became the first pilot to fly a light aircraft over the true North Pole. She also made three solo circumnavigations of the globe, a record that stood until 2000.

Elisabeth Frink

interviewed by Marjorie Anderson
30 July 1969

The sculptor Elisabeth Frink (1930–93) was best known for her outdoor works and her naturalistic forms. Her favoured medium was bronze, which she treated to give a scarred, spiky effect. In 1967 she moved to France and Woman's Hour *invited her to be Guest of the Week during one of her short visits to the UK. A month previous to her interview she had been awarded the OBE.*

ANDERSON: You do seem to concentrate on certain subjects, like your birds, birdmen, horses, dogs, masklike heads. Is this a kind of obsessional theme?

FRINK: Yes it is. I was brought up in the country. I naturally brought all the forms that I used in my sculpture from the things that I saw round me. And it is an obsessional theme, because I work in a series, and I always work through the series until I've finished it, and exhausted it.

ANDERSON: Why do you work in a series?

FRINK: Because I find that the end of one sculpture, one idea, isn't enough, and I then invariably do ten of them—or maybe more. I also destroy a lot of my work when it doesn't feel right.

ANDERSON: There's a lot of aggression and menace in your work—attitudes of attack, or of being attacked. Is this how you see life?

FRINK: I do. I feel strongly that life is very aggressive right now, and I think that for artists,

198

when they work, naturally this brushes off on their ideas. They tend to translate what's going on around them.

ANDERSON: You've said you were brought up in the country. Your childhood was during the war, wasn't it?

FRINK: I was nine when the war started, and it had a great effect on me, because my father was away for all of it. And I think this has a lot to do with, or an influence on, my work at the time.

ANDERSON: I read that you used to shoot animals.

FRINK: I did, because before my father went away he taught me to shoot, which is very useful, because I used to shoot animals, rabbits and hares, to eat. I don't really like shooting very much now.

ANDERSON: Do you think all this violence in your work is a kind of exorcism?

FRINK: No, I don't think it's an exorcism. Well, perhaps you could call it that. I think it's another part of me. I'm not a violent person at all. I think artists are particularly sensitive to what is going on around them.

ANDERSON: Yes, of course they are. And your work has a very strong impact, almost frightening at times, and some of it has been described as ugly, even hideous. How do you react to this kind of criticism? Does it bother you?

FRINK: It doesn't bother me at all, and I think a lot of my work is ugly. I think it takes time to get used to it.

ANDERSON: Yes, I think some people find these modern forms—the spiky men, for instance, with long thin legs—difficult.

FRINK: Well, yes, that's largely to do with the forms I use, to get the maximum amount of tension

199

and movement, and perhaps velocity. I think any reaction is good, and it means that people are interested. If they find it ugly I don't think that matters. I think eventually a lot of them come round to liking them in the end.

ANDERSON: I read that you'd given up the hammer at one point because it brought you out in muscles.

FRINK: Well, yes, I don't have to use the hammer a lot. For the bigger pieces I'm doing now, I need more physical strength. I think when one's younger, one worries about muscles less than when one's older.

ANDERSON: Plaster is quick?

FRINK: It's very quick. It goes off in five minutes. Therefore I do work very quickly, and in fact more thinking goes into my work beforehand than actually takes the time to do it.

ANDERSON: How do you actually manage your day? I mean, you have a family to look after.

FRINK: Well, I set myself a very disciplined day. I work pretty well office hours. I get up at half past five, I ride the horse for an hour. From then on I work in the studio until midday, when I knock off for three hours. And then I work again later on in the day. I do about six hours' work in a day.

ANDERSON: And what about your son? How does he fit into the picture?

FRINK: When he's at school he's away all day, and in the holidays naturally I see him at lunchtime, and I swim with him in the river—we do things together. The evening I spend entirely with the family—I cook and listen to music. When I'm not in the studio I make sure that I relax one hour a day in the sun, which is very important. It's the only

time I can relax, because I don't really relax ever.

Elisabeth Frink created the Eagle statue that is presented to winners of the Women of the Year Awards. In 1982 she was made a Dame.

The 1970s

The 1970s

Sue MacGregor

On 1 January 1970, Judith Chalmers introduced a special edition of *Woman's Hour* looking ahead to the new decade. A whole hour was devoted to its 'hopes, fears and aspirations', and studio guests predicted many things, some with prescient accuracy: the gradual withering away of the institution of marriage, cordless telephones, the ability to record television programmes, and the growth of the leisure industry. The 1970s were sometimes called, not least by the American writer Tom Wolfe, the 'me' decade, for if they started with protests against the Vietnam War and in favour of women's liberation, they ended with the election of Ronald Reagan and Margaret Thatcher, both determined believers in the role of the individual and in the liberating nature of competition. But the 'me' decade was also the 'she' decade. Women's liberation had crossed the Atlantic at the end of the 1960s. Germaine Greer published *The Female Eunuch* in 1970, and thanks to a number of important new laws (the Equal Pay Act and the Sex Discrimination Act came into being, and divorce also became easier) there were, for women, profound changes of aspiration and lifestyle.

I became chief presenter for *Woman's Hour* in 1974, bang in the middle of all this change. It was a fascinating time in what used to be called women's politics. 'Consciousness raising' was a buzz phrase,

205

and although many found the thought of women's liberation exciting, some women and not a few men saw it as a threat to a man's time-honoured role as husband, father, chief breadwinner and boss.

Woman's Hour entered the decade determined as it always had been to reflect and nourish the interests of its audience, but its audience was subtly changing. More women were out at work during the day; the younger generation, unless they were at home looking after small children, had to catch up with the week's topics in the Saturday omnibus edition. Women's work patterns had altered a lot since the programme first went out. The Pill, many argued, was the single most important factor in changing women's lives in the twentieth century. With contraception now freely available, pregnancy, unless you had religious objections to contraception, was much more a matter of choice. The days of pregnant teenagers feeling rushed into marriage were disappearing, and for married women it was possible to choose not just when to start a family, but how to space it, and therefore whether to continue working between pregnancies. And ambitious women were beginning to eye the jobs traditionally held by men. By the middle of the decade, with equal opportunities and equal pay legislation on the statute book, the BBC—not without some initial reluctance in some quarters—had introduced its first full-time women newsreaders on both radio and television, after it was agreed that women could, after all, produce the necessary gravitas to introduce serious matters. Margaret Thatcher was elected Leader of the Opposition in 1975. By the end of the decade Britain had its first woman Prime Minister, and she

gave her name to the overriding political philosophy of the decade to come.

The BBC at the start of the 1970s was still considered to be a fairly formal institution, not unlike a branch of the Civil Service. Uniformed commissionaires manned the front reception areas of Broadcasting House in London, and female members of staff were discouraged from wearing trousers to work unless they were on duty overnight. Skirts—and not too short—were the order of the day. 'Talks', carefully scripted and rehearsed, were still the mainstay of many radio magazine programmes, including *Woman's Hour*. I remember when I joined the programme as its new presenter in 1972—I had been a reporter on *The World at One*—I was astonished to find that each edition was given a full rehearsal every morning, including quite a number of the interviews, questions and all. After a rather grand sit-down lunch for the participants, *Woman's Hour* was transmitted live just after 2 p.m. It was all very well organised and civilised, but a world away from the seat-of-the-pants current affairs broadcasting I had just come from—and to which eventually I was to return. But things soon changed. The old rehearsals were scrapped and there was now a much greater emphasis on live topical discussion and on last-minute updates, although interviewing techniques remained on the whole a great deal more deferential than today's more confrontational approaches.

In 1973, *Woman's Hour* was given its own regular and separate morning phone-in slot, Tuesday Call, with subjects ranging from the gently domestic ('It's National Pot Plant Week!') to the highly political.

207

This sort of live interaction with the audience, pioneered in the 1960s by local radio, had now become an accepted (and relatively inexpensive) strand of BBC programming. What the producers called 'RYL' ('Reading Your Letters') continued happily in the main afternoon programme.

In this decade of change for women, the editor of *Woman's Hour*—by 1971 it was Wyn Knowles—had to steer a fairly careful editorial line if she wanted to keep a broad-based audience happy. This meant dealing with the concerns of younger women, many of whom were willing to be more politically active and longing for all the old rules to be overturned, as well as with those of women who were, happily or not, filling the traditional role of mothers and housewives. Too much concentration on successful careers, on equal rights, on 'having it all', meant that half the audience might feel alienated, and that *Woman's Hour* was no longer for them. So there was always room made for cooking, household tips and advice about babies. But there was also an increasing number of interviews with women politicians and leaders of pro-women pressure groups, among them Germaine Greer, who had devoted followers but was never part of a coherent movement. Another, from across the Atlantic, was Betty Friedan, whose book *The Feminine Mystique* spoke for married women staying at home who asked themselves, 'Is this all there is?'

There was also detailed coverage of all the legal changes affecting women. Some of the most important of those were the result of campaigns by determined individuals. In 1971, Erin Pizzey opened the first women's refuge for victims of domestic

violence, in a modest house in West London. Two years later she told me in graphic detail on the programme just what being beaten up by a husband or partner could do to a woman. 'We're not just talking about the odd slap . . . If a man beats his dog the RSPCA is after him; if he attacks his children it's the NSPCC; but if he beats his wife there's no one to help.' Three years on, legislation was passed that not only encouraged police intervention for the first time, but aimed to provide dozens of refuges for women around the country. The inevitable backlash against militant feminism came too: in 1975, Arianna Stassinopolous published *The Female Woman*, a rejoinder to Greer's *The Female Eunuch*, which infuriated feminists but which for a while threatened to rival the earlier book in the best-selling charts.

Interestingly it was a man—Stephen Bonarjee, in charge of radio current affairs at the time—who suggested in the early 1970s that *Woman's Hour* needed on its staff more women with direct experience of motherhood. He encouraged Mary Redcliffe, a print journalist and the mother of three children, one of them with disabilities, to join the team of producers. Mary signed up both Dr Penelope Leach, guru to many young mothers at the time, and Dr Hugh Jolly, a frequent contributor to *The Times*, to give regular hints about baby and childcare. At one point my sister Kirsty was roped in to talk, from her own recent experience, about recommended and ingenious techniques for breastfeeding twins, both at the same time if possible. The progress of the 'Woman's Hour Baby'—Sharon Philpott—was followed over several months, and two years later, in 1973, despite the predictions about the gradual demise of marriage,

'Diary of an Engagement' followed a young couple in close detail as they prepared for their big day.

If kitchen tips and recipe ideas were not forgotten, this was also a decade in which eating out cheaply in our larger towns and cities had suddenly become a more exotic experience. The corner café with its mugs of tea, soggy chips and brown sauce was rejected for plates of taramasalata, hummus and kebabs at our local Greek eateries. For those with more conservative tastes, a different kind of fast food from America was about to hit the High Street: the first McDonald's opened in Britain, in Woolwich, in 1974, sounding a warning note to home-grown Wimpy bars. Cooking at home caught its own flavours from abroad. In the 1960s Elizabeth David had encouraged keen cooks to attempt Mediterranean food and to use plenty of fresh garlic and olive oil. Now it was no longer considered odd to experiment with exotic ingredients, and we were inspired to try new food by cheaper package holidays—and not just to Spain. By the beginning of the decade long weekends in exotic Istanbul or even in Leningrad could be had for not much more than £50. *Woman's Hour* picked up on this new willingness to be different; Claudia Roden encouraged us to make Middle Eastern dishes, Evelyn Rose suggested traditional Jewish food, and Olga Franklin once memorably tried whipping up a Russian bortsch from scratch with the help of some raw beetroot and the studio Baby Belling. Delia Smith, Mary Berry and John Tovey were regular studio chefs. As no cameras were involved, some of this live studio cooking had to be taken on trust by the listeners, but in most cases the unseen results were good enough to be polished off behind the

scenes as soon as the programme was off the air.

Woman's Hour could still make waves with BBC management. In November 1971 it announced that it would take 'a frank look at present-day attitudes to sex', in a recorded feature with contributions from John Lennon, Yoko Ono, Dr Martin Cole and a young man who used the F-word to illustrate what was available on the newsstands in alternative publications like *Oz*. Official approval had to be sought, and Stephen Bonarjee stepped in again. He decided that if the programme team were not offended, then it was fine to go ahead. After the broadcast the tabloids went into their full shock-horror mode, and the Managing Director of BBC Radio, Ian Trethowan, issued a personal apology to anyone who had heard the programme and found the word unacceptable.

In the end the 1970s, when it came to outlawing discrimination against women, may have been more about good intention than achievement. Barbara Castle, Secretary of State for Employment and Productivity, presented her Bill on Equal Pay to the House of Commons on 28 January 1970. In an interview for *Woman's Hour* the following day, she explained that by the end of 1975 it would be illegal to discriminate against women over pay or employment conditions. She would no doubt be dismayed to know that thirty years on, the hourly pay gap between men and women (which in 1975 was 29 per cent) had shifted down to just over 18 per cent, and that for part-time workers the gap had barely shifted at all—down from 42 per cent to 40 per cent. The Equal Opportunities Commission, which will be replaced by a new all-embracing Commission for Equality and Human Rights in

211

2007, had in itself no real powers of enforcement; its outgoing chairman confessed recently that she thought the gender pay gap would never close.

But the 1970s was also a decade of strong and inspirational women, and dozens of them came to talk to us in the *Woman's Hour* studio. I think of the Olympic athlete from Belfast, Mary Peters, and the glamorous feminist Gloria Steinem, who invented *Ms* magazine in the States. There was Shirley Conran, who thought we could all be Superwoman if we could only get the better of our housework, and the distinguished writer Dame Rebecca West, talking about her early career in journalism. Baroness Seear, the Liberal peer who had tried to steer her own anti-discrimination bill through the Commons, and the actress Sheila Hancock joined us, as did Dr Nawal el Saadawi, the Egyptian woman doctor who fought to end the practice of female circumcision. There were interviews with the anthropologist Margaret Mead, and Barbara Walters, the doyenne of American television political reporters. *Woman's Hour* did not of course neglect the popular music of the decade, and one can perhaps read the runes in the hit singles with which the period began and ended: 'Band of Gold', one of 1970's biggest chart-toppers, told the sad tale of the end of a marriage. But 1979's smash was Gloria Gaynor's defiant post-break-up anthem 'I Will Survive'. Thirty years on, no girls' night out karaoke evening would be considered worth the name without it.

212

Kate Millett

interviewed by Maureen Bartlett
24 March 1971

Kate Millet (b. 1934) is an American feminist, activist, writer and sculptor. In the 1960s she was actively involved in the civil rights movement and was one of the early members of the National Organization for Women. Her book Sexual Politics, *published in 1970, was not originally written for publication, but was her PhD thesis. It became a seminal work in the women's liberation movement; calling for an end to monogamous marriage and proposing a sexual revolution. It also criticised the sexism of famous novelists like D.H. Lawrence and Norman Mailer. The book brought her instant fame; she used the money she made to set up the Women's Art Colony Farm, a community of female artists and writers. When* Sexual Politics *was published in the UK, Millett was interviewed for* Woman's Hour *by reporter Maureen Bartlett.*

BARTLETT: There's been a great deal of talk about the way the press and the media in general treat women's lib. How do you feel they handle it?

MILLETT: I think they handle it with the kind of contempt that is general in our society, the contempt that is reserved for women. They are really deeply threatened by the idea of women's liberation. Here you have a majority of the population of women, who are in a minority—as they have been for thousands of years—insisting on

213

their rights.

BARTLETT: I'm sure a lot people wonder why it's taken women so long to rebel and do something about it. Why do you think it is?

MILLETT: I think that oppressive systems don't really operate without a certain consent from those they oppress. Otherwise it would be open hell all the time, so that there is a very careful indoctrination into a sort of a co-operation with one's oppression, not only among women but among many other minority classes of people. So that one does wonder, how do they put up with this for so long? The answer is that they're carefully trained to put up with it for so long and they also have very few options.

BARTLETT: What about brainwashing children? How early do you think children are brainwashed?

MILLETT: I think it happens pretty early. You call it brainwashing, but it's a careful separation into two polar sets of values which everybody really in our society truly believes in, and regards as a sort of religious goal in education, and it appears to be accomplished by the time a child starts to speak and perhaps a good deal earlier than that. And a great deal of this is done kinetically, that is, by touching the child and speaking to it in different ways.

BARTLETT: Do you deal at great length with the role of women in literature in your book?

MILLETT: Yes.

BARTLETT: You've studied writers like D.H. Lawrence, Thomas Hardy and Arthur Miller. How do you think they've changed people's ideas towards women?

MILLETT: What I was examining was the way

214

literature expresses modern social attitudes, with the writer as a kind of a reflector, reflecting what are general opinions. Lawrence is particularly interesting. His position changes and he ends up with a revival of the female suprematist attitude.

BARTLETT: In your discussion about Thomas Hardy, you call his work a significant step in the right direction as far as the feminist is concerned. Why is that?

MILLETT: Anyone else in his time was equally concerned with the position of women, which was one of the most enormous social issues. In many ways he's not quite able to assimilate or to express fairly the contradictions and conflict, but the picture he draws is still admirable in many ways.

BARTLETT: What's going to happen to the structure of marriage, if women get equality in every sphere? Surely, they will not want to get married. What happens to the family structure then?

MILLETT: I think that what happens is that marriage changes. Its historical injustices and oppressiveness will simply not be tolerated any more, but what's valuable in relating to one other person, I think, will.

Throughout the 1970s Kate Millett was actively involved in feminist politics, particularly in campaigning for the Equal Rights Amendment. She has continued to work as a sculptor. In 1991 a drunken Oliver Reed tried to kiss her on C4's show After Dark. *She protested and he was removed from the set.*

Mary Quant

interviewed by Marjorie Anderson
31 March 1971

Mary Quant (b. 1934) invented the miniskirt, the emblematic garment that represented the spirit of the 1960s. She also pioneered the wet look, leather look and hot pants. She was educated at Goldsmiths' College of Art and she met her husband Alexander Plunkett Greene there. Together, the two of them with another friend opened a shop in the King's Road, called Bazaar.

ANDERSON: Let me first of all describe what Mary Quant is wearing, listeners; she is dressed in army green, I think you'd call it?

QUANT: It's military—from an ex-army surplus shop.

ANDERSON: It's a subtle colour. It's a skinny jersey with gold buttons up the sleeve, on the shoulder and on the pockets at the back, and it's made of— well, you tell me.

QUANT: It really is ex-army gear. Not quite literally but there are canvas patches here. These are military hot pants or 'warm pants' perhaps because they're not terribly short.

ANDERSON: How do you account for the terrific impact that you made when you burst on the fashion scene?

QUANT: We were making clothes for our friends, art students and actresses and a few crazy people around Chelsea. I don't think any of us ever

216

anticipated that anybody else would like them, and that people from other countries and other places would come and buy these clothes.

ANDERSON: Was this just chance, do you think?

QUANT: Absolute chance, absolute luck. I think luck really is timing; you can't plan your time to be around. I hated fashion the way it was. I wanted clothes to be fun or casual and easygoing and yet sort of sexy. I didn't like the artificiality that went on at the time—but I didn't realise that so many other people felt the same.

ANDERSON: You were brought up, I know, in Wales, in Pembrokeshire, the daughter of Welsh Baptist schoolteachers. What sort of childhood did you have?

QUANT: Blissful, because I loved Pembrokeshire. My brother and I more or less ran wild, scrambling over the cliffs and studying birds.

ANDERSON: At the age of six you cut up a bedspread, didn't you?

QUANT: Worse! I was in bed with the measles at the time. I've never really lived down the disgrace of it but I cut up a bedspread to try to make myself a dress, in a completely new shape. It was a bit of a disaster. I used the nail scissors.

ANDERSON: You were sixteen when you came to study at Goldsmith's College in London. Were you at that time more interested in designing than anything?

QUANT: Yes, my parents thought that the fashion business was much too precarious and we arrived at a compromise that I went to a straight art school rather than a fashion school. Looking back on it I was very lucky because at that time fashion schools really still taught students in England to just do

217

imitations of the Paris couture and not use their own ideas at all.

ANDERSON: What about your actual designs, how do they emerge?

QUANT: I often think of a design fashion because I get bored with clothes terribly quickly. I'm never satisfied with whatever it is, I'm always experimenting with something new. Fashion seems to evolve quite logically, a kind of fed-up-ness with the last thing and then experimenting again. The new things grow out of whatever one's been doing before.

ANDERSON: How long do you see this craze for hot pants lasting?

QUANT: I think it will be absolutely mad crazy all the summer—but the most important thing that's happened is complete freedom from fashion halls. This is the great thing; we can wear all the hemlines, there's no obsession with 'this is what's in' and 'that's what's out'. The same girl can wear the most frivolous and flamboyant and female clothes and then very boyish clothes. I mean, we can all have such fun—and there are no rules any more.

ANDERSON: I think this is absolutely super what you, the young, have done for us older people, we can wear anything. Presumably when you're designing you have in mind not necessarily an age group but, anyway, a woman who's kept her figure, shall we say. What about the middle-aged woman who's let herself go a bit, does she ever come into your scheme of things?

QUANT: I've never felt that fashion is for any special age or doing any special thing in. I thought that Chanel understood this very well. I remember seeing her just a couple of years before she died—

she must have been eighty. I remember her sitting in the Ritz in Paris, wearing a cream linen suit with a chocolate-brown trim round the edge and a brown velvet hat. It looked absolutely wonderful. Yet that suit could equally have been worn by a girl of fourteen who in her own way would look marvellous. Fashion is for enjoying, being alive in.

Mary Quant changed the outlook of her generation, using fashion to sweep away outdated conventions about what could be worn. She then moved from clothes to cosmetics, using her famous 'Daisy' logo. In 1988 she designed the interior of the Mini using black-and-white striped seats with red trimming.

Shirley Chisholm

interviewed by Maureen Bartlett
29 December 1971

Shirley Chisholm (1924–2005) was the first African American woman elected to Congress. Born in Brooklyn, her father came from British Guiana and her mother from Barbados, where Shirley Chisholm was sent to be educated. She was elected to Congress in 1968 and during her first term she employed an all-female staff. She always spoke out on civil rights, women's rights and the poor. Woman's Hour *reporter Maureen Bartlett interviewed her in New York.*

CHISHOLM: Since I have been in the political arena for approximately twenty-one years of my life, only emerging publicly seven years ago when I first went to the New York State legislature, I have found consistently and persistently that both black men and white men have a definite feeling against women operating in the world of politics. So I speak to you on the basis of my very, very real experiences with men. They have been revolting against my activities in my determination to move ahead in the political arena. I have certainly met more discrimination in the world of politics in terms of being a woman than being black.

BARTLETT: Very often women are accused of not supporting their own sex. Have you found this as well?

CHISHOLM: Oh yes, you would find women who feel that Shirley Chisholm and other women in the

political arena should stay at home and take care of their home duties, whatever those are. I think this has a great deal to do with the fact that in our society women have been just as brainwashed as blacks have been brainwashed for a number of years in terms of believing, or being made to believe, that they were inferior. As soon as a baby girl is born in America, she is wrapped in a pink blanket and the decision is made for her that she must become a secretary or a typist or whatever it might be. The people in America seem to feel that this is the prescribed role for women, just as for many years they felt that the prescribed role for blacks was in the menial services. So that many women, of course, cannot accept women moving into the political arena or women moving into other arenas because many of these women have never known any other kind of world.

I don't want anyone to misunderstand. When a woman is married and has young children it seems to me that her first responsibility is to her home and to those children. A family unit is very, very important in the guidance and direction that children need, especially during those formative years. But we must remember also in America that there are numbers of women who will never get married, so should they just stay at home and take care of the pots and pans? If they are creative, if they have ability, if they have talent, and if they choose to go out and make a contribution to society on the basis of their talent, it is wrong to think that women should only fit into a certain role. There is no psychological test yet that indicates that either one of the two sexes has a superiority of brainpower. What we need is the

combination and utilisation of the best talents and brainpower of the two sexes to make our country move. But we get ourselves lost and completely hung up on whether a person wears pants or a skirt. It's ridiculous. In our country it becomes an obsession and it bothers me, but I think in terms of the women's movement in America we're slowly but surely moving away from that kind of old-line thinking.

BARTLETT: I was interested that you were bought up in Barbados and you were educated at a school that was very influenced by the British system. How important do you think this system was in your life, in your career?

CHISHOLM: I think it was very important to my own life. I think it's the very reason that I am able nowadays to withstand the insults, the abuses and the misunderstandings of American society on the basis of the fact that I have two stripes against me—I am a woman and I am black. My moving out here in this political world and now daring to say that I am interested in running for the presidency, the very fact that I am able to stand up under all of this and keep moving in terms of the goal that I've set for myself and the goal that other people feel I should be moving in: they are all attributable to the discipline, the upbringing, the early teaching in my life on the part of my family that I was somebody, that I have something to offer, that I was bright and that the amount of melanin in my skin should never in any way make me feel inferior. And this is why in a very real sense people sometimes don't understand how Shirley Chisholm can fight the way she does and how she stands up under all the pressures. I have a

great deal of confidence in myself. I know I have ability and I am not saying this to be boastful about it, but I am saying it because if any person in a society—whether a man or a woman—does not have good feelings about themselves and doesn't realise that they have talents, they are always going to be in difficulties with themselves. I know I'm somebody, and that's why I'm so thankful for the kind of discipline and early training that I received in the British system. I make no bones about it. I really believe that basically those first six or seven years of my life, which were spent on the island of Barbados, have had a great deal to do with the final mould of my personality today.

BARTLETT: One final question, because I know you are in a great hurry and have a very tight schedule. If you become the first woman President of America, which would be the greatest achievement: that you had got there as a woman, or as a black person?

CHISHOLM: I think it would have to be looked at in terms of two in one, because at this moment in America black people are saying, 'Why not a black President?' and women in America are saying, 'Why not a woman President?' I happen to be black and I happen to be a woman, so actually I would be killing two birds with one stone. Hopefully I will have opened the doors for future women in this country to realise that they can move out on the very top level of this society, and it will also open the doors for my black brothers to say there's nothing wrong with being black and also being the leader of a nation.

In 1972 she ran for the Democratic nomination for President but was beaten by George McGovern. She retired from Congress in 1982. In 1973 she published her autobiography The Good Fight.

Spare Rib

interviewed by Judith Chalmers
21 June 1972

Spare Rib *attempted to provide an alternative to the traditional image of women portrayed in the media. It addressed feminist issues, but at the same time drew heavily from the traditional women's magazine agenda; home, beauty, fashion and personal relationships were all featured. When it was first published W.H. Smith refused to sell it. The launch editors were Rosie Boycott (b. 1951) and Marsha Rowe (b. 1944), being interviewed here by broadcaster Judith Chalmers.*

CHALMERS: Why the title *Spare Rib*, Rosie?

BOYCOTT: I think that women's liberation is always taken very seriously. People do have the idea that it's incredibly boring. When we first started out we had names like WL or WR for women's rights. Then we went on to *Distaff*, which is really tedious, but we were quite keen on it for a while. And then in fact a friend suggested *Spare Rib* in a Chinese restaurant. And after about two weeks, when we were sort of churning over the facts, thinking we'd be called a butchers' liberation magazine, it suddenly clicked and that had to be the name.

CHALMERS: How did *Spare Rib* start and why?

BOYCOTT: It started about six months ago. Marsha and I had been working on the Underground Press and we had had some women's meetings to discuss

the role of women's liberation in a sort of alternative society, and we got a very negative reaction. We decided that what we needed was a national women's magazine that didn't have an Underground image, something that looked nice, appealed to women and talked about women's problems sympathetically. I don't think either of us actually really thought it would ever happen. But the enthusiasm was fantastic and it's really snowballed.

CHALMERS: Rosie, you talk a lot about the involvement of women, but in fact men are included, aren't they, Marsha, in this?

ROWE: They are included in the magazine as contributors, but we are not working with men at the moment because I think we need the support of one another as women. I personally would find it quite difficult to work with men at present, because when I do I am rather terrified about putting across my ideas as in the past my ideas have never been taken seriously by men. I hope honestly that will change.

CHALMERS: The magazine does cover the same sort of subjects as do a lot of women's magazines. There's beauty, there's fashion, there's cooking in a sort of way. How is it you are aiming to be different from the others and why is it different, because the magazine does look different even though it covers the same subjects?

ROWE: I think all those subjects are relevant to everyone's lives. You can't just ignore them completely. Nobody indiscriminately goes out and buys the first pair of trousers that will fit them. Everybody likes to know a bit about what they're doing. We are not dictating what people should wear; we are just giving suggestions. We are very

226

lucky, in that we don't have the advertising problem that most women's magazines have.

BOYCOTT: That was almost a direct result, in a certain sense, of using the women's magazine format, because if we looked too different, in the way that the Underground looks too different, people would be alienated from us. They wouldn't perhaps want to buy.

CHALMERS: Talking about clothes, you do this article on jeans—garb as you call it. I found that very difficult to read. I could hardly see the red print against the yellow of the front page.

BOYCOTT: That was a mistake really.

(Laughter)

ROWE: It's one of those learning processes that we go through.

CHALMERS: Who are you aiming at with your readership?

ROWE: A lot of women's magazines start with a market in mind. You know, a certain age bracket, a certain income bracket. Our magazine hasn't arisen from that. Women within women's liberation are aged anything from fifteen up to ninety. And hopefully we can have readers of different generations. But at the beginning I think women will probably buy it who perhaps have been married, had some children, don't quite know where to turn. They perhaps don't feel completely fulfilled, but they don't know why.

CHALMERS: But, Rosie, you've got a children's section, you've got something on older women, pensioners if you like—you seem to be spreading your net over the country as a whole. Is that what you are trying to do?

BOYCOTT: Oh very much so, yes. I know when I

227

lived out of London that what used to annoy me incredibly was this whole fixation about London and the idea that things only happened in London. For instance, we've got a piece about the National Housewives Register and that's very active out of London. It does a fantastic amount of good and there are lots of groups and they are all doing things. And it's nice for people to find out about each other, and from that you can learn a lot. There are so many little things going on that are uncoordinated and if they could get in touch then they could move a lot faster.

CHALMERS: The magazine does look very different. One of the main reasons, I think, is that there isn't advertising. Now you've talked a bit about the consumer issue. Are you against advertising?

ROWE: We're against advertising that perhaps uses a woman's body to sell a product that is totally irrelevant to a woman—a car for instance. But we need only about five pages to survive, so that's quite good. And I think people get rather sick of buying a thick magazine and when they come to read it, most of it's advertising. But then we do have to accept ads. One ad we have is for a store that sells good cheap clothes, so we found that quite acceptable. And it is £200, and we need the money.

CHALMERS: Where do you hope most of your money will come from? From sales?

ROWE: From sales, yes.

BOYCOTT: And maybe we will attract helpful advertisements, educational advertisements and advertisements from organisations like the Family Planning Clinic.

Spare Rib *continued to be published until 1993 and had an average circulation of 20,000 a month.*

Yoko Ono

interviewed by Sue MacGregor
7 May 1973

Yoko Ono (b. 1933) is an experimental artist and musician. She was thrust into the limelight when she married John Lennon in 1969 and was blamed for the break-up of the Beatles. Together Yoko Ono and John Lennon created the Plastic Ono Band. Yoko Ono appeared on Woman's Hour *following the release of her album* Approximate Infinite Universe.

MACGREGOR: How do you see yourself, as an ordinary housewife, that women in this country could relate to? Because one doesn't see you in that role at all.

ONO: Well, the concept of housewife nowadays is quite different from the housewife of the eighteenth century and there are still some housewives living in the eighteenth century really. But when I use the word housewife, you know, a housewife has to be a secretary, an ambassador, all sorts of things. A house is almost like a country and you have to play twenty different roles, to sort of run the house.

MACGREGOR: But does John do the cooking for instance, while you might go out and earn the bread, occasionally?

ONO: Luckily we are in a position where we are always together and everything. Yes, while I make the coffee, John's playing the piano or something, and when I'm playing the piano sometimes, John makes coffee for me. You know, if we take roles,

exchange roles, and share roles, then we're happy about it. But John is learning cooking now because he thinks it very interesting. Cooking's sort of like a fad among the New York artists and they're all doing it and most of the male artists arc vcry good at it. I think John is going to be a marvellous cook as well.

MACGREGOR: You were brought up in Japan where women, in my understanding, are fairly unliberated, or perhaps they were when you were young. Did this have any effect on the way you think now?

ONO: I think the Oriental women are much more liberated.

MACGREGOR: In what way?

ONO: They're more independent, they don't have the usual slavery situation as much as the West. For instance, in every town in Japan, they have a sort of dance club where women can go and pick up men. I mean, like Playboy Club except the Bunnies are men. [Laughs] And that means there are enough women who are independent enough, financially and morally or whatever, that they can just go to those places freely. And it's not the kind of place that is shady. It's done in the open.

MACGREGOR: Yoko, does this record, which you've done off your own bat, also have anything to do with you wanting to be known once again as Yoko Ono, which you were some years ago, and not as Mrs John Lennon, wife of ex-Beatle?

ONO: Ah well, you see, the thing is that I'm many things. My situation typifies the women of this age, in that we have to be very many things and we have very many labels. I am a housewife and I am married to John, and at the same time I'm an artist

231

and a mother too.

MACGREGOR: Which is your favourite role?

ONO: Well, all of them, I suppose.

Yoko Ono is still an experimental artist, film maker and musician.

Mary Peters

interviewed by Sue MacGregor
9 May 1973

Mary Peters won a Gold medal in the Munich Olympics in 1972, in one of the most demanding events, the pentathlon. She was born in Liverpool in 1939, moving to Northern Ireland as a child. For her sixteenth birthday, her father gave her two tons of sand to put in their back garden, to practise her jumping. The Munich games marked her seventeenth year as a pentathlete and she was awarded an MBE following the games.

MACGREGOR: When you were at school, did they pick you out as being good at games?

PETERS: Yes, in fact the headmaster, Mr Woodman of Portadown College where I was a pupil, was taking the girls for a cricket game one day. He took me by the hand and led me to an athletic coach called Kenneth McAllen, who was taking the boys for some extra training, and he encouraged me to join the group. I was a bit shy because they were all boys, but from then on, I learnt to accept that I had to do a little bit of hard work. From my early beginnings, the staff, the headmaster and my parents all gave me every encouragement.

MACGREGOR: The facilities in Belfast in those early days can't have been as good as they are now?

PETERS: We used to run on grass that was rather long at times and instead of having the lanes

233

marked out with white chalk, we used to have bits of thread to divide the lanes.

MACGREGOR: You have had years of gradual international success. Was this perhaps because the pentathlon, which was the event you decided to specialise in, isn't really an event that catches the imagination of the public?

PETERS: No, I don't think it does and there are not enough internationals where the pentathlon is included. In fact the Olympic Games in Tokyo was the first time they had a pentathlon competition and we were very fortunate because Mary Rand was second there and I was placed fourth. But because Mary had the success in the long jump, the pentathlon wasn't highlighted as much. I believe I hold the world record for having done more pentathlons than any other person, and yet it took Munich to really highlight this event.

MACGREGOR: Before Munich, you were awarded the Churchill scholarship to go to America.

PETERS: That's true, I went to Pasadena in California, and my reasons for wanting to go were because the weather was so good, because they have fantastic facilities for athletics and also because it gave me an opportunity to train away from the tension of the troubles here in Northern Ireland.

MACGREGOR: How much difference did that make to you, being able to get away from the tension of Belfast?

PETERS: It was very good for me to be able to relax, although it was hard for me to accept that I didn't have to do a hard day's work first before I began my training; I had twenty-four hours in a day that I could use for that purpose.

234

MACGREGOR: Did your times improve immediately?

PETERS: No, not immediately. In fact I had two injuries during my visit to the States and it wasn't really until I came back that I really found the benefit it had been to me.

MACGREGOR: We're all very much aware in this country of the troubles you have in Belfast. Is it difficult for you to forget them, when you're undergoing hard routine training?

PETERS: It is hard to forget, because I love Belfast and Ulster, I love the people and I feel so sad that all this is going on, but I think that it helped to inspire me to do what I did in Munich, because I wanted some good news for Northern Ireland.

MACGREGOR: This was the first bit of good news out of Belfast.

PETERS: It was, unfortunately.

MACGREGOR: I gather that even the street where your coach Buster McShane's gym is, in Belfast city centre, has been cut off and you have to be searched before you go in and train, is that right?

PETERS: It is true, yes, but it is security for us.

MACGREGOR: Mary, at Munich last year, you had this great success and there was tremendous encouragement for you from the British crowd. Did this make a difference, do you think?

PETERS: Oh it was tremendous, because I'd never ever been in a stadium where people were wanting me to do well. At the stage when I was in the high jump, I was the only competitor left. There was only one other person competing in the whole stadium, and that was Wolfgang Nordwich, the East German who was also left in the pole vault. It was like being on a stage; the whole audience were

235

behind both of us, and the roar that went up every time I cleared the bar certainly helped to lift me over the next height.

MACGREGOR: What sort of thing were they yelling at you?

PETERS: Oh, they were chanting, 'Mary Peters, Mary Peters—yeah!' And it was a tremendous feeling.

MACGREGOR: You didn't know then, but your father was there, wasn't he, and you hadn't seen him for some time?

PETERS: That's right. He emigrated to Australia two and a half years before the Games, and I thought he was in Canada on holiday. After I had heard that I had won, one of the British press people came and told me that my father was there. I wouldn't believe him but he said, 'You'll see him later on,' and he described him in full detail. There's only one Arthur Peters and that was undoubtedly him.

MACGREGOR: What was it like when you clapped eyes on each other?

PETERS: In fact it was in the television studios. I was being interviewed and they brought him in. It was a wonderful surprise and a great thrill.

MACGREGOR: That must have been a really marvellous end to that day for you.

PETERS: It was indeed.

MACGREGOR: We can't go any further without mentioning Buster McShane, who has undoubtedly been the biggest influence on your sporting life. He died tragically a few weeks ago, but you did compete in this country a week after his death. [Buster McShane was killed in a car crash but Mary Peters continued to compete in his honour and

236

later dedicated her gold medal at the New Zealand Commonwealth Games to him.] This must have been a very big and difficult decision to make?

PETERS: It was very difficult for me because Buster has always been at my side, no matter how small the competition might be. He had decided that he would come over to England for this athletics meeting, and it was the first outdoor meeting since Munich. My first reaction after hearing of his tragic death was that I would give up athletics completely, but I know that he always said I wouldn't reach my peak until I was thirty-six, and I knew that I would really let him down if I didn't carry on. So I intend to carry on for him for at least a year.

MACGREGOR: You say that you will carry on for at least this year, Mary. Next year, 1974, the Commonwealth Games are being held in New Zealand in January. What happens after that for you?

PETERS: Buster had talked about me continuing to the next Olympic Games in Montreal, but I feel that without his help and guidance, and his great knowledge of athletics, I couldn't go and do him justice. So I think I'll be retiring after the Commonwealth Games, but he had booked four medals for me, out in Christchurch, and I don't care what colour they are, I'm going to get them for him if I can.

MACGREGOR: We very much hope you will, Mary. So you are retiring after the Games next year?

PETERS: I think so, yes.

Mary Peters won another Gold medal at the Commonwealth Games in 1974. She then ran her own health club for twenty years and was very

237

involved in promoting sport—there is an athletics track in Northern Ireland named after her. She is currently an ambassador for the British Olympic Association. In 2000 she became Dame Mary Peters for her services to sport.

'Sexual Nature'

14 March 1974

Woman's Hour has always had a strong tradition of campaigning journalism. This extract is taken from a three-part series looking at sexual identity. The reporter Doreen Forsyth talked to Barbara, now a woman in her forties. She had been married and had two children before she decided that she was gay. Barbara went to an all-girls' school. Doreen Forsyth started off by asking her whether she had ever had an adolescent crush.

BARBARA: No, I never had a crush on a girl of my own age. I did have a crush on the gym mistress when I was about thirteen. But I don't think that worried anyone unduly. Not even the gym mistress.

FORSYTH: Did you then have boyfriends?

BARBARA: I didn't really have boyfriends until I was about seventeen or eighteen, but then in my generation that was perfectly usual.

FORSYTH: Did you enjoy going out with boys?

BARBARA: Oh yes, I did. I had a lot of fun. I was twenty-two when I met my husband; he was thirty-seven.

FORSYTH: And how long did you know each other before you got married?

BARBARA: We knew each other for three years before we were married. I think we had a fairly ardent courtship. It never occurred to me not to get married. No alternative had ever been offered to me.

239

FORSYTH: How happy was your marriage?

BARBARA: I think my marriage was reasonably happy. It was just as happy as many of the marriages that I see now. It wasn't desperately unhappy at all.

FORSYTH: Just run-of-the-mill contented?

BARBARA: Yes, I think it would be fair to say so. I had a child about eighteen months after I was married. And then the next one a year later.

FORSYTH: This all sounds perfectly—in quotes—normal. When did you first begin to realise that you weren't heterosexual in your inclinations?

BARBARA: Well, I still wouldn't say that I wasn't heterosexual in my inclinations. What happened in my case—and I would like to state this is only my case—was that I met another woman with whom I found a quality of relationship that I had never believed possible.

FORSYTH: Emotional or physical?

BARBARA: Both.

FORSYTH: Was she married or single?

BARBARA: She had been married, but she had since been divorced. I had a very good relationship with my husband. We did talk to each other. But anyway, I'm the sort of person who can't really keep anything to myself. It's not necessarily a virtue, but things tend to come straight out of me. So it was discussed from the very beginning. His initial reaction was that he didn't seem to be at all threatened. Perhaps he would have felt more threatened had I fallen for another man. I don't think he was angry. He's a very sensitive person. He was trying to be understanding. At the same time, of course, he was unhappy and threatened. This double-sided life went on for two years. This

240

didn't happen in England; we were all living abroad at the time. And my girlfriend came back to England, which we found quite impossible.

FORSYTH: Were you trying to break the relationship off at that point?

BARBARA: Yes. Things seemed to become inevitable. We were all very unhappy. And after a great deal of thought and a great deal of misery for all of us, I left my husband and came to England and joined my girlfriend here with my children.

FORSYTH: Did your husband make any attempt to stop you bringing the children?

BARBARA: No, he didn't. He never threatened me in that way. But then, as I said, he is a very sensitive and understanding person. Again I don't think I'm typical here. I do know many woman who have been threatened.

FORSYTH: You're now divorced and living with your girlfriend, and you have the children with you. How do you find that life works out, both for you and for your children?

BARBARA: I wouldn't want to live any other way. Again, as I said before, it's an inevitable thing, I feel, for me. It's the only course I could have honestly chosen. But again I'm not typical here. Some women do go on living with their husbands and have a girlfriend, too. But that wouldn't have been possible for me.

FORSYTH: How old are the children now?

BARBARA: The children are now fourteen and thirteen.

FORSYTH: And they're both girls?

BARBARA: They're both girls, yes.

FORSYTH: Do you ever worry that they're having an unusual upbringing?

241

BARBARA: I used to worry a lot about that when they were younger. We've all lived together now for seven years. But I don't worry about it any more. We all get on together very well. We all talk to each other very openly. And, if anything, I feel my children have an advantage that they can talk, because they can understand many other things that other children perhaps don't understand. And I've found in fact that when their friends are in any emotional difficulties, particularly with their parents, they go to my children to sort them out.

FORSYTH: You don't find that it makes for social embarrassment for your daughters?

BARBARA: It doesn't at all. My children both go to day school in London, and although they both go to a single-sex school, they have a completely mixed environment of boyfriends and girlfriends. They have friends whose parents have separated, friends who live in single-sex families, and friends whose parents live together. So they don't feel in any way odd. Also my girlfriend and I publish a magazine for homosexual women. The children read the magazine and criticise it. Jackie and I began this almost by accident. Somehow we felt that women in our situation were so isolated that somebody had to do something about it. And somehow or other it just happened to be us. I think we're contributing something to other women who find themselves in the same situation that we were in when we first met, which can be very frightening.

FORSYTH: Do you feel any regrets about the way your life has gone?

BARBARA: No, I don't feel any regrets at all.

Fay Weldon

interviewed by Sue MacGregor
26 June 1974

Fay Weldon (b. 1931) was christened Franklin Birkinshaw, which she claimed contributed to her being accepted at St Andrews University to read Economics, as the university assumed she was a man. She worked as a journalist and then in advertising. In her thirties she went through a mid-life crisis, went into therapy and subsequently stopped working in advertising and started writing full time. Her first novel, The Fat Woman's Joke, *was published in 1967, by which time she had already written many plays for radio and television including the very popular* Upstairs, Downstairs.

MACGREGOR: Fay Weldon, you didn't start writing, I believe, until you were into your thirties. How did that happen?

WELDON: Well, really, I suppose, first of all I didn't have very much to say and secondly I didn't really know how to finish anything. I must have written about thirty unfinished novels by that time. I really didn't know how to carry a story through from the beginning to the end.

MACGREGOR: Would you say a television play is more difficult for you to write than a novel?

WELDON: No, I think that if you write a novel you have to have made up your mind about all kinds of things. If you write a play you can proceed in a way by not knowing very much but simply putting your various thoughts into the minds of your

characters. With a novel you have to be responsible for every single word. You can't blame the cast, you can't blame the directors, you can't blame anybody—it's all yours.

MACGREGOR: You write quite often about women who seem to be terribly alive and real. One wonders how much you identify with your heroines.

WELDON: I identify with them quite totally. I'm a hundred different women in my mind—I'm this person or I'm that person.

MACGREGOR: How much do you control your own writing day? Your youngest child is only three, which must make her quite a handful to have to look after, as well as your writing. What sort of disciplines do you impose upon yourself?

WELDON: Whatever disciplines I can, I do. Real life does have to come first because writing isn't life. If they don't come first, I really don't think you would have very much to say. It does seem to me one of the advantages that women have over men when they're writing. Men have wives who look after everything and I think this is a great pity.

MACGREGOR: You think women writers have advantages over men?

WELDON: Yes, I do. I don't think it would be very nice to be shut away in a room writing by yourself peacefully. What would you write about?

MACGREGOR: So you write with lots of things going on all round you?

WELDON: Yes. Sometimes circumstances are perfect and everybody's out and it's all quiet and the telephone doesn't ring and yet I don't write anything. I potter about and make cups of coffee and eat bread and butter, which I shouldn't do, this kind of thing.

244

MACGREGOR: I'm sure that if I wanted to sit down and write something, I'd take myself off to a room shut off from everybody. What do you do?

WELDON: Well, I sit in the front window and people go to and fro. Sometimes they see me sitting there and they knock on the door and come in. And then somebody else comes selling flowers, and other people come with questionnaires, and I have the radio on.

MACGREGOR: I know that somebody on this programme once said that *Woman's Hour* gave them lots of ideas.

WELDON: They come in all the time from many sources. They come from the people who come knocking at the door—you have to be receptive to these things. I can't have too much of my attention taken up by the radio so I tend not to listen to people talking—I listen to those programmes when I'm ironing or whatever. I listen to music, Radio 1 because it's easy and familiar, and it sinks in and doesn't take up too much concentration. It just involves one part of my mind, which seems to enable the other part of my mind to concentrate on what I'm doing. It focuses my attention.

MACGREGOR: A lot of your writing has been encouraging women to think of themselves as individuals and as free individuals, and yet you had a previous career in advertising as a copywriter, which, I suppose, a cynic might say was encouraging women to conform. Was there a moment when you decided that you must break away from that and do something completely different because you got fed up with it?

WELDON: I wish I could claim that it was some kind of moral decision, but it wasn't. I couldn't go

back to it now, though, I couldn't, because I don't think I could bring myself to write those words any more that give women a view of themselves that I don't think is in their best interests.

MACGREGOR: Do you think it was a good discipline for you as a writer—good training as it were—for what you're doing now?

WELDON: It was practice. It was certainly dealing with words all the time. You get to learn how to control them and how not to be self-indulgent, and to concentrate on communicating. It gives you a great sense of audience.

MACGREGOR: Is it true that you were the person that thought up the slogan, 'Go to work on an egg'?

WELDON: I don't think I can even claim that really—I worked on the 'Go to work on an egg' campaign and was largely responsible for it.

MACGREGOR: I think you are somebody who wants to change the way women think about themselves, aren't you?

WELDON: I don't want to change it, but I do have certain preoccupations. I feel one has been, as a woman in this country, led into certain ways of thought and belief that don't do one any good. I think it's a mistake to be only a wife and mother; it's not fair on your husband and it's not fair on your children. What they want is a person; they don't want a role-player.

Fay Weldon has written dozens of novels and several collections of short stories. Much of her work looks at the lives of women and how they are trapped by their domestic lives. In October 2002 Fay was named the first writer-in-residence at The Savoy Hotel. Her memoir Auto da Fay *was published in 2002.*

'On My Daughter's Recent Abortion'

21 October 1975

Abortion had first been discussed on Woman's Hour *in 1960 and the programme had closely followed the debates during the decade that led to the 1967 Abortion Act. In an attempt to outlaw back-street abortion, the procedure had been legalised in circumstances where two doctors believed that the woman's health was at risk. The nation was divided on the issue: into those who believed that the termination of life in any form was wrong, pitted against those who believed it was a woman's right to choose. During the 1970s, several attempts were made to amend the Act. In 1990 the time limit for an abortion was reduced from twenty-eight to twenty-four weeks. Sue MacGregor introduced the speaker for this item, explaining that she was a mother of a teenage daughter, who wished to remain anonymous.*

I had never read the Abortion Bill, nor thought it necessary to have an opinion on it. After all, I am well over forty and hardly likely to be affected by it. If I'd been asked, I should undoubtedly have said that, on principle, I held all life to be sacred and that moral laxity was not to be condoned. I grew up in a quite different moral climate from today's, when unwanted pregnancies had to be endured and the option of legal abortion was just not there. Besides, one had principles.

It is easy, of course, to have principles until you're actually faced with the dilemma of a teenage and

possibly pregnant daughter. Principles are fine so long as someone else is facing the consequences of them, and as long as they are far enough away for the whole fabric of your life not to be affected by them. All right, so life *is* sacred but I knew that, in practical terms, *I* would be the one who would have to bear the brunt of this particular life, and that, having brought up three children of my own, I was not prepared to do that. All right, so moral laxity was not to be condoned—but this was *my* daughter and that made it different.

It was, of course, *her* decision, not mine—and she was quite adamant that she wanted to have an abortion. So . . .

'Can it be arranged?' she asked our doctor.

'Yes, if you can pay for it,' he said.

Our local hospital gynaecologists wouldn't countenance it, and it would have to be done privately.

'And what does that entail?'

'Oh—in one day, out the next—nothing to it,' he said casually.

We were to find that this is the typically male and typically professional attitude throughout. And while I—and I'm sure my daughter—felt reassured that the process should apparently be so brief and simple and safe, *I* was irrationally irritated and even appalled that everyone with whom we came into contact *should* be so casual. *I* couldn't be casual through the three weeks of mental anguish during which we waited for the pregnancy test results. At the first test it was declared negative, to be confirmed. I couldn't be casual about the increasing symptoms that my daughter suffered. What should, in normal circumstances, have been a

happy time for us all was, in fact, one of extreme anxiety and misery, which we tried hard, for her sake, not to show.

The afternoon came, though, when we presented ourselves (and the consultation fee of £7) at the Pregnancy Advisory Service. It was a hot afternoon and, as we sat in the crowded room along with eighteen other pregnant women and girls, I couldn't help wondering what we were doing there, waiting for the wheels to be set in motion for the destruction of new life. I was—again—appalled at what my daughter and all the others were about to do, while at the same time I was hypocritically anxious for 'someone' to get on and do it.

My daughter had a letter from our doctor confirming that she would suffer from mental illness if the pregnancy were allowed to continue. He may have been right, although her initial encounter with him had been very brief. In any case, no one questioned his judgment and I was infinitely relieved that they didn't (while, again, feeling tremendously guilty because they didn't!). My daughter was counselled. She was shown great kindness and consideration, for which I was grateful, while not being able to shake off the feeling that we had no business being there. She was given an appointment to see a second gynaecologist a week—it seemed like a year—later.

In reality, however, she was referred very quickly to a private clinic, and told to arrive early the following morning with an overnight bag and £60. There were sixteen others admitted on the same day. (Sixteen times £60, my mind kept trying to work out, although I'm not complaining—who am I to complain?) And the day after she, and all the

other sixteen, were duly discharged. 'They' had been right: there *was* nothing to it. It was soon over, although 'they' hadn't thought to warn us about the remorse, the tears to be shed and the weeks of depression to be lived through.

It will be a long time before the memory of it all fades away. With my strictly moral upbringing I don't suppose it ever will. It will be a long time too before I can stand on 'principle' about anything again. And I don't, even now, know what I'm trying to prove—to myself or anyone else—except that in the last resort we do what it suits us to do. I would do exactly the same again, whether it cost £60 or £600, however appalled, guilty, or hypocritical I might seem to be. So maybe others should have the right to do the same.

Margaret Thatcher

interviewed by Sue MacGregor
28 April 1976

Margaret Thatcher (b. 1925) was first interviewed on Woman's Hour *in 1959 soon after she was elected to the House of Commons as MP for Finchley. Sadly no transcript exists. She then went on to appear on the programme many times, especially in her capacity as Minister of Education. In February 1975, she was elected leader of the Conservative Party. She was the first woman to lead the Conservatives and the first woman to head a major political party in the Western world.*

MACGREGOR: Mrs Thatcher, can we begin with finding out something about you as a person, then perhaps get on to more political material. A lot of people as you know think that we're all products of our own background, very much of our childhood and the sort of people our parents were. Do you think you are?

THATCHER: Oh, I think we all are to some extent. They are, after all, your most formative years and you can't just cut yourself off from them. I was brought up in Grantham, a small town in Lincolnshire, with 25,000 people. My father had a grocer's shop. We lived over the shop for my early years. He was a very keen practising Methodist Christian. He was also involved in almost every charity or every voluntary cause there was, and he was on the local council. I think one of the main

251

differences between then and now is that in those days, of course, there was no television, although we had a radio when I was about ten. I can remember the day when it arrived. And so you had to make a lot of your own amusement. Also in my life we used to do a lot of talking and discussing. Inevitably, being part of the shop, we knew a lot of people. They came in, we chatted. Because we lived over the shop, people would often call. In a Church background, we attended lots of church meetings. I often went with my father to anything that was on in the town. So I was brought up in a background of discussion. And of course they were interesting times politically too.

MACGREGOR: Were you brought up in the sort of context that you should do well? Did your parents expect great things of you?

THATCHER: It was part of our upbringing that you just had to do your best. You were expected to do your best. It was also very much part of one's upbringing that what mattered was what a person was. It wasn't the background that you came from at all, but your character that mattered. And you had to develop that, and you had to do unto others as you'd expect them to do to you. So you were expected to make your own way. And you were expected to do the best with whatever talents and abilities you had. And in a way it was rather a sin not to. There was a strong streak of duty.

MACGREGOR: It can't have been much fun, though.

THATCHER: Well, yes, it was fun. We had different sorts of fun in those days. If you went out for a treat for the day it really was a treat because it was comparatively rare.

MACGREGOR: Of course you went on, Mrs Thatcher, to do very well at school. You went up to Oxford, you had a degree in chemistry and you were later called to the Bar. Did you always have clear goals in your mind as to what you wanted to achieve, before you went into politics?

THATCHER: I had a number of different ambitions. I got on to the scientific conveyor belt. You know, at school you had to decide whether you went on the arts side or the science side and I went on to the science side, I think probably because there were a lot of scientific opportunities in those days. I thought there would be a lot of new scientific industries and I could go into one of those as a research chemist. Then perhaps very much because of the Church background, one had really rather a passionate interest in people and I remember very much at one time that I wanted to go out to be part of the Indian Civil Service. You know, it's not a thing that children would ever think of these days.

MACGREGOR: And that, again, was very difficult to achieve, wasn't it?

THATCHER: Very difficult to achieve. But India was a massive country with a lot of things that needed doing in it. So I had various different goals but I never thought in those early days of going into politics for the very simple reason that neither I nor the family could have afforded it. We hadn't any of our own income other than what we earned, so there was no question of my becoming an MP when MPs were paid extremely little.

MACGREGOR: What was it that changed that situation? Was it getting married?

THATCHER: No, no, it was the different pay for

MPs. You remember that they ... Perhaps you don't remember. In the early days MPs were paid, I think, £400 a year. Mind you, that's a lot more than it sounds now, but it wasn't really until after the war that their salaries were put up to a level that enabled people to be MPs and nothing else.

MACGREGOR: You didn't become an MP until 1959, although you were always interested in politics. In fact, you first stood, I think, in 1950. It's interesting that in 1959 there were twenty-five women MPs and now there are twenty-seven. I believe that number has remained pretty constant going right back to the 1930s. Did you find it difficult being a woman going into politics?

THATCHER: I don't think I found it any more difficult than a lot of my colleagues going into the House, who are men Members. It might be a little more tricky getting selected. I can remember going before several selection committees and some of the women on them saying, 'But you have young children,' and they therefore thought I ought not to become a Member of Parliament. In fact I didn't become a Member of Parliament until after my children had started to go to school because I think that when they're very young they need Mum and Mum certainly needs to be with them.

MACGREGOR: So they were really your first priority at that time?

THATCHER: Yes, and the years nought to five, you know, they're important years. I hope the children would have missed me and I should certainly have missed them.

MACGREGOR: Of course, when women go into politics and then become as well known as you have, they are subject to the sort of personal attention and

personal criticism about the way they look, the way they sound, that men aren't. I think of Angela Rippon reading the news. She gets quite different remarks passed about her than, say, Richard Baker does.

THATCHER: She always looks very nice too.

MACGREGOR: Does it bother you that people comment on your hairstyle, your image?

THATCHER: No, it rather surprised me at first because I really didn't think it worth commenting on. And there was a time when the commentators went through a period of saying, 'She always wears pearls'. I thought, well, why shouldn't I wear pearls? There is a very strong reason why I wear them: they were given to me by my husband when the children were born. And I shall go on wearing them. But it seemed to me so trivial. However, you get used to these things.

MACGREGOR: Of course you must know, Mrs Thatcher, that people say you are enormously cool and calculating—I don't mean that in a pejorative sort of way, but you—

THATCHER: Calm would be better, wouldn't it?

MACGREGOR: Calm, yes . . .

THATCHER: Calm would be better.

MACGREGOR: Unpassionate, almost, this is the sort of image you have. Do you think you are like that in real life?

THATCHER: No, not really. I count to ten before I say things sometimes, just like anyone else does. But, you know, I've seen other people on television get cross and angry. Then I think they say things that they might wish they hadn't said and certainly they are then at a disadvantage. If you're really to assess the problems in front of you, you really

ought to keep calm. You don't make the best decisions if you get agitated about something. But naturally things irritate me just the same as they irritate everyone else.

MACGREGOR: But you believe in not letting it show?

THATCHER: Sometimes it does show.

MACGREGOR: What criticism has really bothered you? I remember that when you were Minister for Education, when you stopped the free school milk, people were really quite sharp in their criticism. Did it hurt you, personally?

THATCHER: What I wanted to do was build more primary schools. I well remember that my father, who had a very much lower income than many people have today, used to pay for me at school to have school milk. If he could do it then I felt that most other parents would be perfectly willing today to pay for their own children to have milk, and that would release a good bit of cash for me to use in other directions. After all, people can pay for their children's milk but they can't build schools. So that was the reasoning behind it and we put up the price of school meals at the same time. And of course the present government will have to put up the price of school meals too. There was, to some extent, an outcry.

MACGREGOR: You were called 'Milk Snatcher', I think, at the time.

THATCHER: Yes, isn't it jolly interesting? Do you know, the present government, £20,000 million worth of expenditure later, has not restored it. So they really approved of it. But they had to make the maximum political capital out of it. But then, you see, if you look at the amount that's being spent on

subsidies today on school meals—I looked at it the other day and I was absolutely amazed: it's over £300 million a year, and that's not very different from the amount we're actually spending on building new and better schools. So I think the difference is that when the present government does what has to be done in putting up the price of school meals, I won't complain because I know that it's sensible, because you've got to get money for other things in education and I know it has to be done. And I'm not prepared to make political capital out of what I believe to be sensible. But they were.

MACGREGOR: Of course, a lot of people do feel, Mrs Thatcher, that although you say you are not prepared to make political capital, you are keeping a fairly low profile at the moment, personally. Is this because you don't want to rock the economic boat in a sense, and Britain's in a jam?

THATCHER: Well, goodness me! 'Because I don't want to rock the economic boat!' It's not I who am rocking the economic boat, my goodness me. The fall in the value of Sterling, the high rate of inflation, the high rate of unemployment have nothing to do with me! A Conservative government never had the levels of unemployment we've got now. I mean, the people who are rocking the boat are the present members of the government and their economic policies, not mine. But I haven't been exactly quiet, you know, except over the Easter recess. We had a tremendous debate in the House just before the recess when, you remember, we won and the government lost the expenditure White Paper and we had to have another debate, a vote of confidence, the second

257

day. And then we had a budget and one had a great deal to say about that. So there's only just been the Easter recess period when I was quiet and of course afterwards I was at it again. But as for rocking the boat, my goodness me! I'm jolly thankful I haven't been in charge while we've had what's going on now.

MACGREGOR: I know, Mrs Thatcher, that you lead obviously an enormously busy life and have for years, but you very much believe in running your own home, supervising what goes on there. You get up at seven o'clock in the morning, and you're often working until late at night. Do you have to have, as a woman in politics, do you think, a certain sort of stamina?

THATCHER: I think most women who go out and do a job and run a home have to get used to working harder for longer hours. It's not just women in politics. Many, many women now do their own job outside the home and they just have to keep going, in the evenings and at the weekends. So we're all really used to getting on with a job that has to be done.

MACGREGOR: Who's particularly helpful to you at home? Do the twins still live at home?

THATCHER: Yes, they do. Fortunately we have a small house and so it doesn't need a great deal of attention. I'm very, very lucky and always have been in the health I've had, jolly lucky, and am I grateful for it? I really am. Of course things get untidy, and a house always does when it's lived in. And, that's just inevitable, and things aren't kept as perfect as otherwise one would wish. But then we are all doing what we want to do. And when we all get home at night we talk about it.

MACGREGOR: Mrs Thatcher, you've been doing what I'm sure you've particularly wanted to do for ages: lead your party for the past fourteen months. Do you think the Tories now have new images with voters?

THATCHER: Well, I hope so but I think that's really for them to say. I hope we've taken politics away from some of the impersonal stuff. After all, when you come across expressions like 'nationalisation of the means of production', and 'distribution exchange', I don't find them very attractive. I hope that we're talking more about people, about the pay packet, about what they can do with it, about their hopes for their children, and about the sort of world in which their children will grow up in. In other words, a world and a policy and politics about people instead of about economic systems.

MACGREGOR: Talking of people, when are we going to have our first woman Prime Minister?

THATCHER: I am hoping to get promoted, you know.

MACGREGOR: This year?

THATCHER: Well, whenever it comes I shall be ready.

In May 1979 she became the UK's first woman Prime Minister and was the longest serving Prime Minister in the twentieth century, winning three successive General Elections as party leader, until she resigned in 1990. In 1992 she was given the title Baroness Thatcher and since then her direct political work has been as head of the Thatcher Foundation.

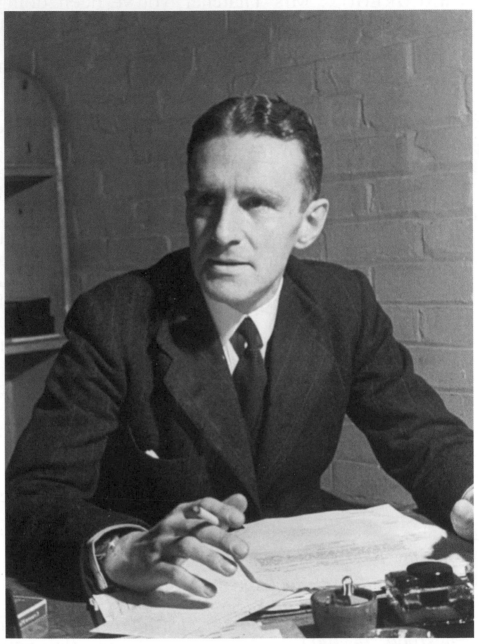

As Controller of the Light Programme Norman Collins was responsible for commissioning *Woman's Hour* in 1946

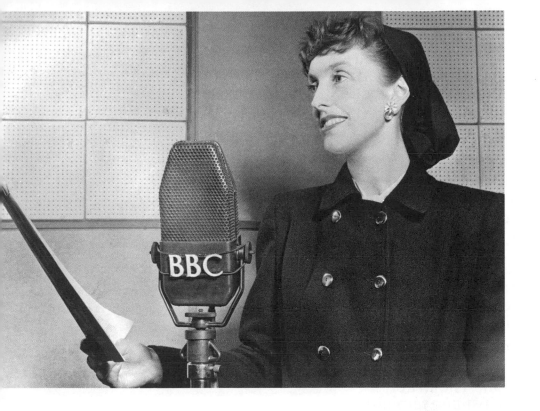

Left: Writer, broadcaster and actress Joyce Grenfell wrote and presented countless talks for the programme in the 1940s and 1950s

Right: The Lancashire telephone operator come singer, Kathleen Ferrier's career began after winning the contralto class at the Carlisle Festival. She was at the height of her powers when she died of breast cancer, aged only forty-one

Right: The writer, pacifist and feminist, Vera Brittain's book *Testament of Youth* was based on her own experiences during the First World War, where she lost her brother and fiancé. She considered becoming an MP, an ambition eventually fulfilled by her daughter Dame Shirley Williams

Left: The legendary English actress Peggy Ashcroft. In a career spanning seven decades, she performed all the leading Shakespearean roles and won an Oscar in 1984 for her role in *A Passage to India*

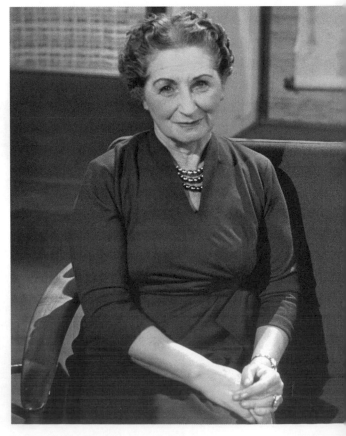

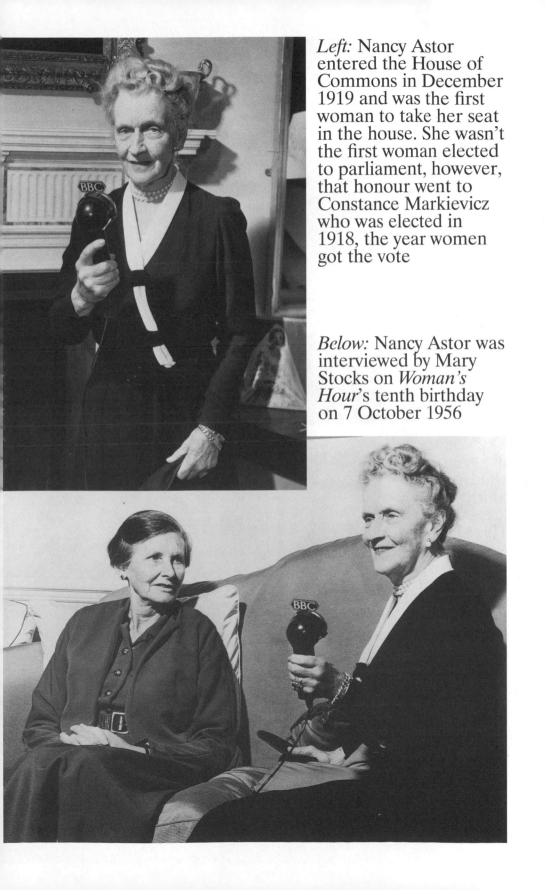

Left: Nancy Astor entered the House of Commons in December 1919 and was the first woman to take her seat in the house. She wasn't the first woman elected to parliament, however, that honour went to Constance Markievicz who was elected in 1918, the year women got the vote

Below: Nancy Astor was interviewed by Mary Stocks on *Woman's Hour*'s tenth birthday on 7 October 1956

A fashion and media icon in the 1950s and 1960s, Janey Ironside promoted designers such as Ossie Clarke and Bill Gibb

The youngest of seven children, Shirley Bassey grew up in Tiger Bay, Cardiff. She was discovered by the band leader Jack Hylton and had her first international hit in 1964 when she sang the theme to the James Bond film of the same name *Goldfinger*

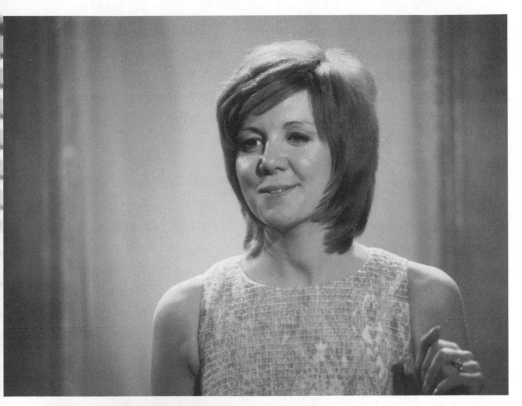

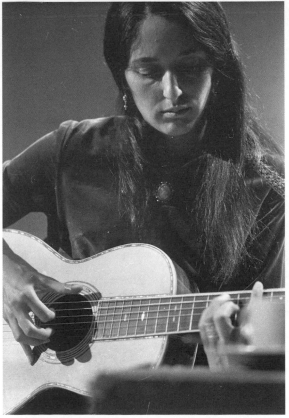

Above: Born Priscilla Maria Veronica White, she became Cilla Black when the music paper the *Mersey Beat* misprinted her name

Left: Singer-songwriter and political activist, in 1964 Joan Baez withheld sixty per cent of her income taxes in protest at American military spending

Born in 1934, Judi Dench is the leading actress of her generation. She won an Oscar in 1999 for her performance in *Shakespeare in Love*, although she appeared on screen for just eight minutes

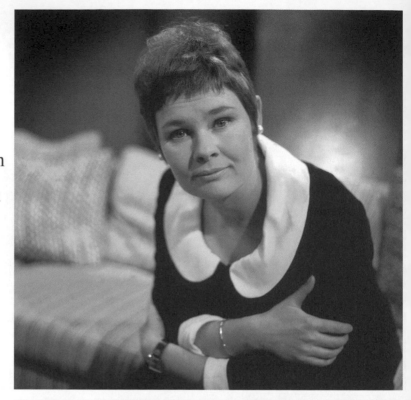

An outspoken feminist and MP, Edith Summerskill was at the forefront of the campaign for married women's rights and equal pay. She was once quoted as saying that 'Nagging is the repetition of unpalatable truths'

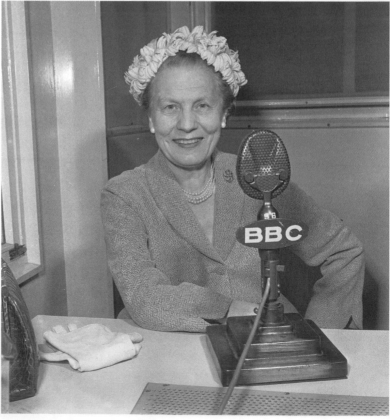

One of Britain's leading artists, Elisabeth Frink specialized in outdoor sculptures. She also created the eagle that is presented to winners of the Women of the Year Awards

Mary Quant is credited with inventing the miniskirt, 'paint-box' make-up and plastic raincoats. In the 1960s she was described as being the leading fashion force outside Paris

Left: Shirley Chisholm was the first African American woman elected to Congress in 1968. She always spoke out on civil rights, women's rights and the poor. In 1972 she ran for the Democratic nomination for President, but was beaten by George McGovern

Below: The experimental artist and musician Yoko Ono came to prominence in the UK when she married John Lennon. Together they created the Plastic Ono Band, which influenced a generation of musicians like Talking Heads, Blondie and The B-52's

Olympic Pentathlon Gold medallist Mary Peters. For her sixteenth birthday, her father gave her two tons of sand so she could practise jumping in her back garden

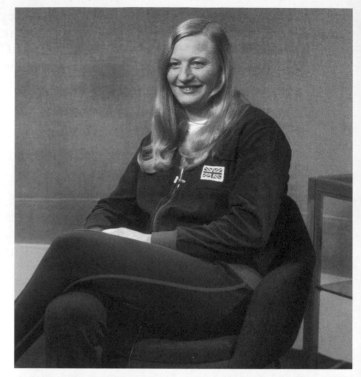

Christened Franklin Birkinshaw, Fay Weldon claimed that her name led to her being accepted at St Andrews University as people assumed she was a man

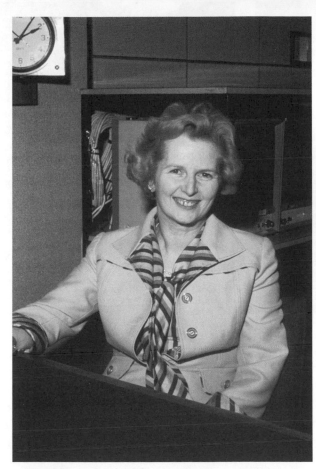

Left and below: Margaret Thatcher first appeared on *Woman's Hour* in 1959 and twenty years later became the UK's first woman Prime Minister. She once said 'Being powerful is like being a lady. If you have to tell people you are, you aren't.' She was the longest serving Prime Minister of the twentieth century

She was interviewed by Sue MacGregor on 28 April 1976

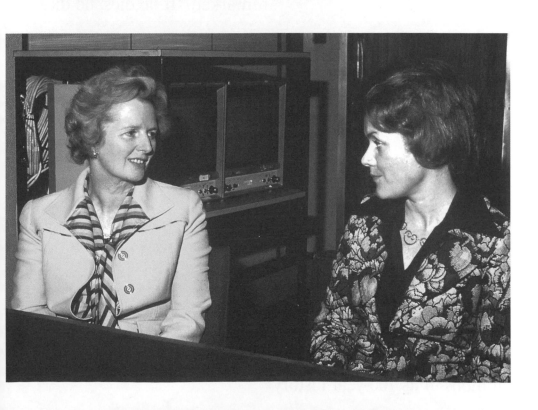

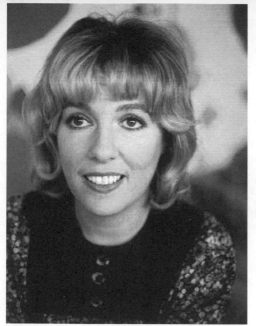

Above: Esther Rantzen first appeared on screen in *Braden's Week*. She produced and hosted the consumer programme *That's Life!* for twenty-one years, which, at the height of its success, was watched by more than twenty million people

Above: A former RADA student, the 1980s Joan Collins's television role in *Dynasty* made her synonymous with padded shoulders and power dressing. In 2002 she married Percy Gibson who was thirty-two years her junior. When asked about the age difference she remarked, 'If he dies, he dies'

Above: Born in Yorkshire, Betty Boothroyd worked for Britain's most famous chorus line the Tiller girls before she became an MP in 197 In 1992 she became the first woman Speaker in the House of Commons in its 700-year history

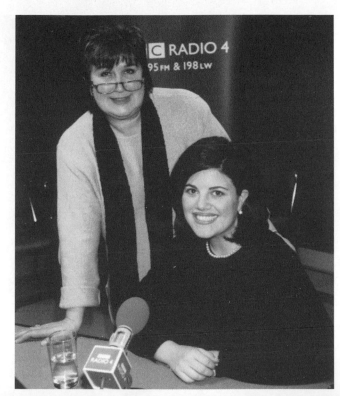

Monica Lewinsky was interviewed by Jenni Murray on 10 March 1999. The former White House intern's affair with President Clinton led to his impeachment

Right: Anne Robinson, the former hard-drinking Fleet Street journalist, who became the highest paid woman in television

Below: The former teenage runaway Ms Dynamite seemed to have turned her life around when she became the youngest ever winner of the Mercury Music Prize

Edwina Currie was a regular on *Woman's Hour* in the 1980s and 1990s. In 2002 she talked on the programme about her affair with John Major

When she met Bill Clinton at Yale Law School he claims she strode up to him and said, 'If you're going to keep staring at me, I might as well introduce myself.' The two were soon inseparable partners in court, political campaigns, and matters of the heart. Interviewed by Martha Kearney on 4 July 2003, Hillary Clinton is the first First Lady to be elected to the United States Senate

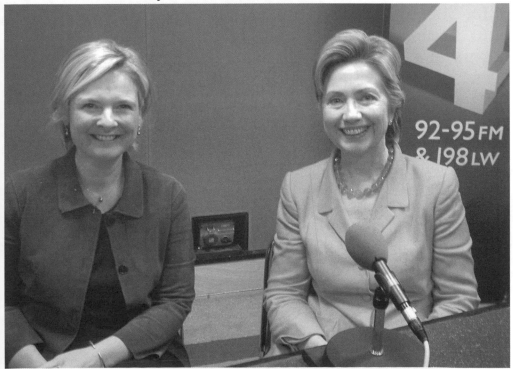

'The Women's Peace Movement in Belfast'

Elizabeth Williams and Patricia Knox
interviewed by Sue MacGregor
9 September 1976

In 1975, three young children were killed when an IRA-driven car careered out of control after being shot at by British troops in Belfast. The incident pushed their aunt, Mairead Corrigan, into action and along with Elizabeth Williams, who had witnessed the accident, they formed a women's peace alliance. Thousands of women on both sides of the sectarian divide took to the streets in support. Patricia Knox was one of the early organisers of the mass protests. This interview took place when the peace movement was in full swing.

WILLIAMS: It's very difficult to lead an ordinary life. Socially we have the barriers up, so the social life here is practically nil. Even going out for a drink at night you think twice before you do it in case the bar gets blown up and your children are left without parents.

MACGREGOR: Does social life, Pat, tend to be with people of your own religion rather than Catholics mixing with Protestants and vice versa?

KNOX: Yes, I think it does very much. You socialise in your own home and you have your own friends along, but it's very difficult crossing the divide between the two communities and there isn't really a lot of mixing socially together.

MACGREGOR: Is this because Belfast is very much

divided up into areas where Catholics or Protestants tend to live?

KNOX: Yes, you have the Falls and the Anderson Town area, which is Catholic, and then right at the other side of the town you have East Belfast and Shankhill, which are Protestant areas, and there's just no coming and going between them.

MACGREGOR: Is there much intermarriage at all or has there been in the past, Betty Williams?

WILLIAMS: I myself married an English Methodist. I met him long before these struggles started. We're fourteen years married but now there's an awful lot of intermarriage. It's Catholic marrying Catholic, Protestant marrying Protestant, and again a little vicious circle of fear starting with the children of these marriages.

MACGREGOR: What in fact does this do to the children because this must be an enormous worry to both of you as mothers?

KNOX: I'm fortunate in that I live in a fairly mixed area. It's an older community and so we haven't got the problems of violence but we still have soldiers patrolling and this sort of thing and it does have an effect on the children. I mean, my four-and-a-half-year-old talks quite frequently about bombs. We were in town one day when we saw a building being blown up. And, you know, this stayed with her for a long time afterwards. We happened to be on holiday in England this year and she said she didn't want to come back home. She didn't want to see all the soldiers again.

MACGREGOR: What about you, Betty?

WILLIAMS: This is true for me too. I was in Belfast on Bloody Friday—as they call it over here. Within the space of twenty minutes, we had thirteen

261

bombs go off. I had been shopping in Marks and Spencer's with Deborah. She was then just two and I ran out of Marks and Spencer's with Deborah under my arm and I literally ran into walls. My child had two awful black eyes, I had the most atrocious cuts on my face, because I didn't know whether I was running into a bomb or out of one.

MACGREGOR: When you're not in any particularly violent situation like that, do you notice the effect generally on your children of the sort of life you're leading?

WILLIAMS: Yes. My daughter who's now five will say when we hear an explosion, which we do frequently, 'Oh Mummy, is that the bad boys again doing that?' Deborah was born into this, she doesn't know anything different.

KNOX: Yeah, the same would be true of my children. As Betty says, when you hear a bang you know Kerry will say, 'Mummy, what's happened? Is that a bomb?' It's just quite natural for them.

MACGREGOR: Do you think they're frightened or do they really, as you say, almost take it for granted?

WILLIAMS: Well, my thirteen-year-old will be much more frightened because he's much more aware now. But my five-year-old really doesn't know what it's all about.

MACGREGOR: I assume the schools are segregated along religious lines as well?

BOTH: Yes.

MACGREGOR: What about the children going out to play? Is it possible for them to meet and play with Catholics if they're Protestants and vice versa?

WILLIAMS: No, the communities are segregated. When I moved into the estate I'm now living in, it

262

was very mixed, but as these troubles escalated the Protestant people moved out because they were afraid of the Catholic people, so it's now a totally Catholic estate, which means the children can only meet Catholic children.

MACGREGOR: And presumably they're all brought up to loathe the other side, are they?

WILLIAMS: Patricia and I, and people like us, don't bring our children up like that, but generally, yes.

KNOX: And it's not even so much that they loathe the other side, they just don't know anything about them. It's a position of total and complete ignorance. They hear the words bandied about, Catholic and Protestant, and it's just a label. They don't really know what lies behind it. Just that these people are people they don't associate with.

MACGREGOR: Betty, you mentioned a moment ago going shopping. What is it like for a housewife to go shopping in Belfast at the moment?

WILLIAMS: The city of Belfast is surrounded by gates, which you have to enter. There are four places where you can enter the city of Belfast. On a busy Saturday you can be standing in that queue for anything up to thirty minutes waiting to actually get into the city. You're thoroughly searched going in. You enter a shop, you buy a package, you come out. You enter another shop and you're searched, yourself and your package—and it just goes on and on and on and on. Where in London it would probably take a woman one hour to do her shopping, it would take a woman in Belfast four to five hours to do the same amount of shopping.

MACGREGOR: Is it never possible for you to get away from this situation at all, to go on holiday for

instance?

KNOX: I think this is when it really hits you. When you get away you realise the strain you've been living under. I mean, it's just complete freedom to get away from the situation and when we were on holiday, the whole family was just totally depressed at the thought of having to come back.

MACGREGOR: Let's talk now about your peace movement that's arisen out of this situation. What was the real spur to get it going in the first place, Betty?

WILLIAMS: We'd had seven sickening years of people dying. Nobody should have died here. One death was too many but we have 1,600 dead, apart from 3,000—the last figures—maimed for life. They've lost limbs, eyes. You know these atrocities, my God, they've been so bad. I hang my head in shame that I didn't do something before.

MACGREGOR: Was this the first time do you think, that Protestant and Catholic women had got together to any great extent to try to do something?

KNOX: Yes, it's totally the first time. There have been little peace movements here like PACE and other small such movements that have been doing an awful lot of good work in Northern Ireland. But they have been banging their heads against a wall for seven years because it was sort of 'Shhh, don't let anybody know you're doing it' or 'Don't let them know you're over here tonight on the Protestant side of town'. We have now got the people themselves coming out to show their abhorrence of violence. Our first rally, Sue, was 10,000. Our second was 20,000, our third was 30,000 and Derry, on Saturday, was 40,000 people. If you count those figures up, you can imagine

how many normal Northern Irish people we have in our movement.

MACGREGOR: What was it like when, for instance, Catholics including nuns and priests went into, say, the Shankhill for the first time?

WILLIAMS: It was the most moving thing I've ever seen in my life.

KNOX: People were standing on the pavements in tears, they were so moved. We never thought this could happen. It was so marvellous to see these people walking up the Shankhill and the Shankhill people receiving them the way they did. It was absolutely wonderful and I think what is so different this time about the movement is that it's happened in the areas where violence has been taking place. It's not a middle-class thing at all. It's not happening from the top. It's happening in the actual areas. It's the people themselves standing up and saying we've had enough.

MACGREGOR: Have you had threats against the movement?

WILLIAMS: No, not really. They're so minimal, they're not even worth talking about because we've had so many hundreds of beautiful letters and so many messages of support from the English women too. The English women have been writing some really beautiful letters. I had a letter from a mother who'd lost a son over here and, honestly, I had to go upstairs and cry, I was so moved by it.

MACGREGOR: She'd lost a son in the army?

WILLIAMS: She had lost a son and she had taken the trouble to write and thank someone as humble as myself for standing up for peace. I thought this was so marvellous of her.

MACGREGOR: How has this movement changed

your lives in the last few weeks?

WILLIAMS: Mine's been completely turned upside down. Ralph and I were very private people and now our whole life's on public display. But it's for a good cause so I don't really mind.

KNOX: I went along just sort of to say, 'I'm with you, I'm supporting you'. I had no idea that I would become so involved. But, you know, I think it's the most marvellous thing that has happened to me really, you know, a liberating thing. I think it has liberated women here in northern Ireland.

WILLIAMS: It's given them back their self-respect.

KNOX: It really has.

In 1976, Mairead Corrigan and Elizabeth Williams shared the Nobel Peace Prize for their contribution to peace in Northern Ireland.

Delia Smith and Josceline Dimbleby

interviewed by Doreen Forsyth
12 January 1977

Delia Smith (b. 1941) has taught several generations the basics of cooking. Do you want to know how long to roast a joint, how to test marmalade's setting point, or make perfect pastry? Her television series and accompanying books have been credited with reversing the trend for takeaways and ready meals, and reviving enthusiasm for cooking at home.

Josceline Dimbleby (b. 1943) spent part of her childhood in Damascus where her stepfather was the British ambassador; she became accustomed to using spices, mint and lemon in food. In 1976 she published her first cookery book, A Taste of Dreams.

Josceline and Delia were asked on to Woman's Hour *as part of a series called Cookery Club. At a time when food prices were rising, they were asked to come up with recipes that would impress but not swallow the whole week's housekeeping.*

DIMBLEBY: I find that a delicious soup can be made out of turnips. Some people hate the idea of turnips—and I never used to like them very much, just having them as a vegetable, but in soup they're really wonderful. They have a very subtle taste and a very creamy consistency. And if you make a soup out of turnips, thickened with a little flour, with stock and milk added, and then whizzed up in your liquidiser and flavoured with mild French mustard, plenty of salt and pepper

267

and a little lemon juice added at the last moment, it's wonderful.

SMITH: I like French onion soup in winter and it's also very economical. I just sweat off the onions for about half an hour with a little bit of sugar in with the butter and oil so they go a nice caramel colour. Then I pour in stock, preferably home-made, which can be made very cheaply with bones. And then at the end when the soup is cooked, just put croûtons of French bread on the top, scatter cheese all over it and then flash it under the grill. It's terribly filling and very luxurious even though it's cheap.

FORSYTH: Let's get on to our main courses now. What generally would you like to say about luxurious main courses, Delia?

SMITH: I really am a great believer now in having some dry cider in the kitchen, because a great big litre bottle of dry cider is so much cheaper than using wine and it adds the touch of luxury to dishes that wine used to add. I can't afford to have wine in the kitchen any more. I've done really classic dishes, replacing the wine with dry cider, and it works beautifully, especially something like coq au vin or boeuf bourgignon. If you use dry cider instead, you still get the luxury flavour without spending the money.

FORSYTH: Do you use dry cider, Josceline?

DIMBLEBY: Yes I do. I use it actually in a chicken pie. I always think that at a dinner party, a pie looks much more special than it really is. I make a delicious chicken pie, which is very unusual because it uses cider and boned chicken, which you either get the butcher to do or you can often buy it already boned in supermarkets nowadays. You

268

cook it with chunks of green cooking apples and you add either some coriander seeds or some dill or fennel seeds, which are quite easy to get, and it's a very subtle, delicious flavour. I always think that chicken is a real vehicle for a good sauce.

FORSYTH: Any other main dishes with meat?

SMITH: I quite often do boned rolled shoulder of lamb, stuffed and wrapped in pastry, which sounds very complicated and looks terribly impressive when you put it on the table, but it's really straightforward as long as you start in good time. You ask your butcher to bone the lamb but not roll it. You end up with a slab of lamb, which you rub with lemon juice and season with salt and pepper, and garlic. Then you cook some carrots whole and you put them in the middle of the meat with thyme or oregano. Then you wrap the meat all around these carrots, and you can use as much string and skewers as you want to make a really neat parcel of it, because you're going to take them out later before you serve it. Then you roast this parcel in a fairly low oven for about two hours and you baste it quite often. The juice that comes out of it you can keep for later to make a lovely sauce. When it's cooked let it go completely cold. Take off all the string and skewers, and then wrap it up in packet puff pastry and glaze it with egg yolk. Decorate it if you can and bake it in a hot oven. When you cut into it, there's this marvellous puff pastry round it, then succulent lamb and then a bright orange middle of carrots.

FORSYTH: Let's come now to puddings. What about a winter pudding from you, Delia?

SMITH: I think January and February is perhaps the one time of the year when you can serve a hot

269

pudding and they always seem to be a great favourite with the men. I'm a great fan of bread and butter pudding. That might sound a bit ordinary but, gosh, it really is lovely when it's fresh from the oven. If it's flavoured with candied peel and currants, then you've got this lovely toasted nutmeggy top—I think that's real luxury. If you use three-quarters of a pint of milk and three eggs, if you can afford to replace a little bit of the milk with cream, it does make it much nicer.

DIMBLEBY: A delicious pudding at this time of year, when you can get fresh cranberries in packets, is to stew cooking apples with cranberries and a pinch of ground cloves, which makes the apples go a lovely pink colour. Cranberries have this strong, slightly bitter taste and are very shiny and red. While you're doing that, you make up a Victoria sponge mixture. Put this sponge mixture into a large round flan dish in a thin layer and bake it in the oven and then, when the apples and cranberries are soft and stewed, take them out with a slotted spoon and put them on top. Bubble up the remaining juices which are all pink and lovely, till they go really thick and shiny, making a glaze for the top. Spoon this glaze over the fruit—it has a delicious taste.

FORSYTH: And I think you would like us to have a jelly at our dinner party, Delia?

SMITH: Yes, I think jellies are much neglected especially the home-made kind. I've got a nice one for winter, which is made with dried fruits. You use dried prunes and apricots, pre-soaked, and you flavour the jelly with orange and orange peel, and a little bit of cinnamon. It really does look very pretty and tastes so unusual. You make the jelly up with

the soaking water. Pre-soak the prunes and apricots, and then cook them for a little while with the pieces of stick cinnamon and orange peel. Then drain off the juice and make that up with fresh orange juice to a pint, using a level tablespoon of gelatine to a pint of liquid. And I love baked Bramley apples. I did a nice pudding with them the other day. Take the cores out with an apple corer and put the apples in a roasting tin. Rub them with a bit of butter and put some dry cider in the bottom of the roasting dish and bake them, basting them with the cider so you get a concentrated apple flavour. Towards the end of the cooking time, put a little ovenproof dish of muesli in the oven on the top shelf and this becomes rather toasted. Then serve the apples on a base of toasted muesli and pour some single cream on top.

Delia Smith's Summer Collection *and* Winter Collection *followed and, in 1998, her* How to Cook *series stripped cookery back to basics, placing importance on simple ingredients and teaching basic techniques, including how to make toast. It was her most successful book to date. Delia Smith is also a passionate director of Norwich City FC.*

In 2004, Josceline Dimbleby published A Profound Secret, *the quest to discover the truth about her great-grandmother, May Gaskell, who was the last great love of the pre-Raphaelite painter Edward Burne-Jones.*

Gloria Steinem

interviewed by Sue MacGregor
29 December 1977

The granddaughter of an American suffragette, Gloria Steinem (b. 1934) was involved in the women's liberation movement from its earliest days. In 1971, along with a small group of women (including Shirley Chisholm, see page 272159) she set up the National Women's Political Caucus. The following year, she founded Ms, *the first feminist magazine.*

MACGREGOR: Last month in America more than 20,000 women, including Mrs Rosalind Carter and Mrs Betty Ford, wives of the present and the former Presidents respectively, and not a few men—all converged on Houston, Texas, for the nation's first National Women's Conference. One of the issues that was hotly debated there was the question of the Equal Rights Amendment, which affects sexual equality before the law in the United States and which has already been passed by Congress but not yet by the required number of states. When I was in New York recently, I talked about this, and about the other issues that feminists in America still feel strongly about, with Gloria Steinem. She's been called the women's movement's 'glamour girl' (she was once actually a Playboy Bunny) and is one of their leading spokespeople, as she'd say. She also helps edit the glossy feminist magazine called *Ms* in New York

and this is how she explained the necessity in her view for an Equal Rights Amendment in America.

STEINEM: We have to remember of course that our forefathers were indeed our forefathers and they didn't include women of any race, or black men, in their definition of a citizen when they wrote the constitution. And in later years we have always had to have new constitutional amendments in order to make explicit and clear the fact that those groups are to be included. We fought for a long time and finally got black men included as citizens with the ability to vote. It took a lot longer to get women of any race included. Therefore it's been clear for a long time that we needed to insert this amendment as a constitutional principle.

MACGREGOR: So the amendment is an amendment to the American constitution, giving women full and equal rights?

STEINEM: Yes, it just says in a sense that no state shall make laws that abridge the rights of American citizens based on sex.

MACGREGOR: But, as I understand it, although the Equal Rights Amendment has been an issue for a long time, you're quite a long way from getting it passed in all the states?

STEINEM: Well, we need thirty-eight states and we have thirty-five, so we're only three states away, but unfortunately in this system our state legislatures are a kind of 'Catch 22' of American democracy. They're extremely conservative, not all of them but many of them, and they really don't represent the majority of the people in their states. They have been infiltrated and controlled by business and by very right-wing interests. And so 'states rights' in this country is a code word for extreme

273

conservatism. We run up against this in trying to get those last three states. In Nevada, we had elected or had helped to elect eleven state legislators based on their pledge, their written pledge to vote for the Equal Rights Amendment. We had worked with them, contributed money to them and so on. In fact about three days before the vote, they all turned around and voted against it under pressure from very conservative business interests and from the Mormon Church, which is a very, very fundamentalist group here. That's a bit difficult to deal with, you know. Not only do you have the majority of Americans in your favour, you also have successfully elected legislators who will reflect the majority of opinion and yet the economic pressures of the right wing are so enormous that they can make them change their minds. And that's the kind of problem we're having. It's not so much that the Equal Rights Amendment is having a problem, it's the democratic system that is having a problem because the state legislators just don't reflect the majority view.

MACGREGOR: But the people who are against ratifying the Equal Rights Amendment, what do they feel is threatened? Do they feel that American family life is threatened? Do they feel that women are going to be pulled out of the home away from motherhood and looking after their children, and put on to the labour market?

STEINEM: It depends how much information they have. The propaganda against the Equal Rights Amendment says that the ERA will result in unisex bathrooms and forcing women out of the home and homosexual marriage and all kinds of things. However, that is simply inaccurate. If you look at

274

the states in this country in which we already have an Equal Rights Amendment, you will see that none of that has happened. Women have not been forced out of the home; on the contrary, the economic rights of the homemaker have been strengthened. They do not have unisex bathrooms and so on. So I think one has to look a bit further and see why this propaganda is being so forcefully put out. Then of course you discover that it's the same old economic interests—equality is expensive. And sometimes, additionally, this propaganda comes from fundamentalist religious groups, who see that their culture—which is very dependent on the subservience of women and has a very limited view of the family—is endangered.

MACGREGOR: On the other hand, a visitor to the States, such as myself, might see phenomena that they hadn't seen in Europe, like women lifting heavy luggage at the airport, like women cadets at West Point—your equivalent of Sandhurst—not only marching with rifles but also marching in the band. This sort of thing has not yet been achieved in Europe so some people might wonder what women still have to achieve in terms of equality on the outside.

STEINEM: Perhaps I can state it most simply, by giving a statistic or two. If you take what's considered a lower-middle income in this country, which is approximately $15,000 a year, you find that 94–96 per cent of all of those people who receive that middle income level are white males; that leaves only 6 per cent for women of every race and black men. That is an extremely effective caste system, and the caste system is so deep that nothing will change it except a movement. Education

doesn't help. Every year the female unemployed become better educated and they're still unemployed. The average secretary in this country is better educated than the average boss but it doesn't help. Even though we have made token victories, which are important, it is important that people see women doing many different kinds of work. It is especially important for children to see women honoured in authority, to see women doing atypical things. But it's still only a token change.

MACGREGOR: But if in these last few years there have been relatively few, as you say, achievements for women, and if it suits the people who are in charge in America to keep it that way, how hopeful are you that the revolution that you really want is actually going to happen?

STEINEM: We can't underestimate its difficulty but it is also somewhat inevitable. Perhaps the whole world is in a state of exerting individual rights of various kinds against centralised rights of governments, or certainly against foreign incursions in the form of colonialism and so on. We move forward in uneven ways. Women now, feminists now, understand that we are in it for life. This is not something that we're doing for a year or two.

MACGREGOR: Does the thought of applying your whole life to this cause—and you're still a relatively young woman—daunt you?

STEINEM: No, not at all, because it is so much part of my life. Everything else seems dull to me because this impacts on everything. There's no part of life that isn't affected, whether it's architecture, city planning, foreign policy, styles of human organisation, child rearing, education or

art. There's nothing that it doesn't transform and change, and a life that is limited to the old conventional pattern, without the addition of the feminist perspective, seems to me very dull and boring.

A highly respected journalist, Gloria Steinem published her first book Outrageous Acts and Everyday Rebellions *in 1983. Other works include an acclaimed biography of Marilyn Monroe and a book about self-esteem. She still continues to be one of America's leading feminists. The Equal Rights Amendment is still not part of the US Constitution. The ERA has been ratified by thirty-five of the necessary thirty-eight states.*

Esther Rantzen

interviewed by Sue MacGregor
24 May 1978

Esther Rantzen (b. 1940) joined the BBC in 1962 as a studio manager and by the late 1960s was a television researcher, working on programmes like Man Alive. *She first appeared on screen as a reporter on* Braden's Week *and then went to work on* Nationwide. *In 1973, her series* That's Life! *hit BBC1. It was to be one of the most successful television series ever, running for twenty-one years.*

MACGREGOR: You have to appear as a kind of extrovert yourself on screen, otherwise the programme won't work. Are you naturally that way or is it sometimes quite hard to be cheerful?

RANTZEN: Two-thirds of me is, I think, wildly extrovert. I always have enjoyed talking to strangers. When I was eighteen months old my mother used to be deeply embarrassed by the fact that I used to wink at strangers from the pram, so I think I have always have been a natural stopper in the street, so that isn't a struggle with me. Sometimes, I admit, on very windy, wet February mornings, it's quite difficult to go out on to that pavement. The wind blows round your kneecaps something terrible. But the first moment someone stops and starts to play the game with us, then it takes off. You get so much back from people that after a while you really do forget how cold you are.

MACGREGOR: Women who've done very well in

the media—not only television but in Fleet Street—do get a lot of stick from their sisters and brothers in the media. This has applied to you, I think. Why do you think women get attacked for their private lives, or whatever, more than men when they're in the public eye?

RANTZEN: My sister trained as a social worker and she says that once you become a celebrity, whatever that means, people stop believing you've got blood. You become a thing that people talk about in the pub, a thing people chat about. I think people forget that you are living, breathing and can be hurt—but it doesn't just apply to women.

MACGREGOR: You don't think it applies more to women than it does to men?

RANTZEN: No. There is an interesting female adjective used about us and that is 'tough'. I think that if we were men, people would perhaps say we were strong because of what we have to do. Obviously if you've got responsibility you have to make decisions; it applies to tins of beans as much as television programmes. You have to decide whether that tin is the right shape or not, what price you're going to charge for it. The same applies if you're producing. You have to make a lot of quick decisions or you drive people insane, and you must appear to have no doubt. So you get the reputation, I suppose, of being decisive and if you're a female the adjective they use is 'tough'.

MACGREGOR: Your husband Desmond Wilcox's marriage broke up with a lot of publicity, in the press particularly. Did you feel that this was something that you had to accept? Because this is the reverse side of the coin of being famous and well off.

279

RANTZEN: Was it Truman who invented the phrase about the heat and being in the kitchen? I think certainly if I am prepared to enjoy the fact that people like the programme and therefore say nice things to me when I meet them in the street, I must put up with the fact that my private life becomes public chat. I do not like gossip columns. I have seen from my own life the damage they do to vulnerable people who haven't chosen a public career—like our family. Also, I'm very interested in the response of the newspaper readers because you would expect given the amount of publicity I receive, that I would get an awful lot of hate mail. I expected it. On *That's Life!*, I get 5,400 letters a day about people's washing machines and cuttings for Cyril Fletcher [who was famous on *That's Life* for his odes from the armchair], this kind of thing. I got nine letters as a result of the publicity. Nine hate letters. They were anonymous. That's funny, how when people dislike you greatly they won't put their names to it.

MACGREGOR: Esther, we're all delighted you've brought along Emily Alice as we hoped you would today and she's sitting next door, sort of—well, not looking terribly interested in us. I think she's more interested in having a snooze at the moment. But you have, one reads, taken her into the office quite a lot since she was very, very little and she's still quite little now. Is this because there aren't facilities? I mean, she's literally in your own office. Aren't there facilities enough for her to be left somewhere else? Or is it because you feel very strongly that she must be with you? Are you a mother who believes in touch?

RANTZEN: Put at its most basic, they say that

280

breast is best. I have been feeding her myself and it's awfully difficult to do that across a distance of five miles if I leave her at home. I may have achieved a new voluptuousness since having her, but I'm not so voluptuous that I can reach over five miles! So she has to come at what they call in the zoo, 'feeding time'. That is very nice for me because it means that I have a reason why I have to see her at lunchtime and at six o'clock in the evening. There is another reason too, which is that I adore her company and if it came to a point where work prevented me seeing the baby, work would have to go.

MACGREGOR: Is this a possibility? Perhaps in another context, can you see yourself in another ten years still being Esther Rantzen and going down the North End Road on a cold February morning?

RANTZEN: I think people would be so fed up with me by then. And if Emily has a brother or sister or two, I really ought to spend more time at home. Probably I will start to bore people terribly in ten years' time. So someone else will be going down the North End Road, meeting just as nice people and having just as much fun.

After That's Life! *Esther Rantzen hosted her own talk show* Esther *for the BBC, and ITV's social action programme,* That's Esther. *Since 1986 she has been Chair of Childline, the national children's helpline for children in distress or danger.*

281

Shirley Conran

interviewed by Sue MacGregor
20 June 1979

Before writing her runaway best-seller, Superwoman, *Shirley Conran (b. 1932) had been a fabric designer and editor of the woman's page of the* Daily Mail. *Her marriage to designer Terence Conran had ended in 1962, leaving her to bring up their two sons alone.* Superwoman, *published in 1977, spoke to a generation, as did her most famous quote from it: 'Life's too short to stuff a mushroom.'*

CONRAN: A Superwoman is not in my opinion a woman who can do everything or who tries to do everything. I think these sort of people are a pain in the neck. A Superwoman is somebody who specifically doesn't try to do too much, who knows her own limitations and sticks within them. That, Sue, is much more difficult than it sounds these days, I think, when we're under so much pressure. Life has got so much more difficult and complicated in the last ten years. I think one really has to sort of take a grip on it and decide what you want to do and what you don't want to do.

MACGREGOR: You've become extremely famous since you wrote these books but has the success that you've enjoyed through them, do you think, been something that you've been working towards for a long time?

CONRAN: Absolutely not. People talk about my career. I never had a career until I was forty-two. I

never thought of having a career. I thought of doing what most other women who have jobs do—earning money to support myself and the children and the family. I was actually helped a great deal by Audrey Slaughter of *Over 21* magazine who took me under her wing and encouraged me and gave me a part-time job to do and was absolutely, marvellously motherly—or perhaps I should say sisterly—and of course the women in Fleet Street knew and helped me a lot. But what could I do though? I thought I could do two things. I could do housework and I could write. So I sat down and wrote *Superwoman*. But certainly, when *Superwoman* was so successful, it was an amazing surprise to me because it went straight to number one in the first week. I was working for a little publisher that nobody had ever heard of and I then had to decide whether the book would be published round the rest of the world or not. And at that point, I decided that I'd got to have a career for a bit because I won't let the books go anywhere unless they are totally adapted for that particular country. But I just find it terribly hard work. That's why I'm going to stop after the next book.

MACGREGOR: But, Shirley, you say you didn't have a career until you were forty-two. In fact you've had a lot of very interesting jobs in journalism and in Fleet Street. Don't you count them?

CONRAN: I define a career in terms of a man planning a career. He thinks about where he wants to get to, where he wants to be by such and such an age, how he's going to get there, what steps he's going to take and so on. I've actually never gone out after a job. I've just had them

283

thrown at me—except my first job. I think recognising a problem is halfway to solving it but you can't always just blot it out as psychiatrists sometimes claim. So I'm sure you'll understand that one of the most horrifying moments of my life was last week when I found myself speaking up for mothers on a live television broadcast from Newcastle. There were about a hundred people in the audience and I found to my horror, once I was on the show, that they were all headmasters or school inspectors, and I sat through the show for about half an hour not daring to say anything.

MACGREGOR: But do you think that the experiences that you had when you were very small made you want neatness and order in your life? I wonder whether that was a seed for your books telling people how to cope?

CONRAN: No. I'm actually a very vague head-in-the-air character. I'm very much of an artistic temperament and I wander through life with my head in a cloud. I found out when I got married that you simply couldn't, that it didn't work. That if you weren't neat and orderly—I think order is almost more important than being neat—and if you didn't have some pre-planning, then you were just laying up trouble for yourself later on.

MACGREGOR: And yet, of course, husbands and children don't always fit in with this, do they? They can cause one's life to become totally disorganised and disordered.

CONRAN: I think it's very difficult with young children when life is chaotic and you have to decide whether you have ornaments or children. But there is a section in the chapter 'Futures', on improving the system at home, which is about getting the rest

of the family to help in the home. I've never had this problem because my children have always been brought up to help. I think one of the advantages of being divorced is that you're not exactly a mother and you're not exactly a father, you're suddenly a sort of leader of the troop. And I think quite often, or certainly in my case, there's a whole new family relationship with far more family discussion. We always discussed what we were going to do with the money—or what we were going to do because we didn't have any money— and I think, as a result of it, my sons have grown up to be far more responsible than I was at their age.

MACGREGOR: They're now nineteen and twenty-three. What are they doing with themselves?

CONRAN: I'm delighted to say that they're about to go into business together and I think no mother could be more pleased. We're a very, very close family, partly because I'm the eldest of six children, partly perhaps as a result of having to deal with Dad. But one of my brothers, when he went on honeymoon, he took another of my brothers with him, which I think was taking things a bit far. But all the brothers went into business together. I remember my mother being terrifically pleased and I know why, because the most one can hope for is that when they grow up and leave home, they will keep in touch with each other and, if it isn't too much to hope for, love each other. And in fact before he left home my eldest son said to me: 'I think you've done a very good job of bringing me up,' and I was stunned. I stopped peeling the potatoes or whatever I was doing and I said, 'Why? Why? Tell me, quick.' And he said, 'Well, I've got this terrible lisp, this

speech impediment, and I'm very small, almost a dwarf, and I'm practically blind—and you don't care.'

MACGREGOR: How have you managed to do these tremendous promotions of your books that you're in the middle of now?

CONRAN: I'm just being promoted at the moment and I'm going round in a pale blue Bentley with a driver and only doing six appearances a day. But when I started out, I drove round in my own bashed van with the books in the back and I delivered them to the shops myself, and what I used to do then was sleep in the van. I had a sleeping bag in the van.

In 1984, she wrote a best-selling novel, Lace. *She went on to become President of the Work–Life Balance Trust.*

The 1980s

The 1980s

Martha Kearney

The 1980s was the decade in which I entered the world of work from my girls' school and women-only college, though my less than industrious studying habits didn't qualify me for the title of bluestocking. I found a rather different climate in a local radio newsroom just off Fleet Street in 1980 and threw myself into some of its macho culture with enthusiasm. There were great opportunities to improve your sporting prowess—cricket played with rolled-up bits of copy, a table-tennis table installed in the newsroom. Working strange shifts, you could find a drinking den at any hour of the day or night. After you had worked overnight, a short walk through the bloody carcasses of Smithfield would take you to the Hope and Anchor and a huge fry-up. If you finished work in the early afternoon, you could while away a few hours in the Workers (full title: Newspaper Workers' Club) behind the *Daily Telegraph* printing works. Women were only tolerated there in the afternoons but unlike at the bar in El Vino's, we could at least buy drinks.

The radio station itself was full of surprises. One entrepreneur was running a pornography business in his spare time. Overnight, hard-core porn was played on all the screens in the newsroom. When one of my female colleagues objected (she was the only woman producer overnight), she was treated as a real spoilsport. Some of the sexism was comic book. One of my bosses used to pinch my bottom—

289

a habit that I had only come across before in *Carry On* films.

But the world outside was definitely changing for women in a decade that was dominated by the formidable leadership of Margaret Thatcher. Although fierce arguments raged about her political achievements, there is no doubt that she shattered several glass ceilings of preconceptions about women. A woman Prime Minister in Number Ten showed them that anything was possible. Strength and determination now had a female face, and many women were inspired to step forward and take responsibility in the public sphere. I have never agreed with the *Spitting Image* satire of Margaret Thatcher as a fake man in a pinstripe suit. She was always a woman in many guises— whether the warrior Boadicea driving a tank, Mitterrand's 'the eyes of Caligula with the lips of Marilyn Monroe' or the careful housewife who guarded the nation's budget. As Prime Minister, she cooked Denis his breakfast every morning and her Cabinet ministers still reminisce about her fish pie in the Downing Street flat. Mrs Thatcher appeared on the programme in 1985 and talked about unemployment, her own political convictions and career, Denis Thatcher and her attitude towards feminism. In 1983 it was her daughter Carol who was invited into the studio to talk about being the PM's daughter.

The other female icon of the decade was Diana. In 1980 I lived around the corner from her flat in Coleherne Court in Earls Court and used to walk past the crowds of photographers on my way to the tube. On the day of the wedding the hardbitten hacks in my newsroom (see above)

poured out on to Fleet Street to see the royal couple on their way back from St Paul's. I will always remember the dazed expression on Diana's flushed face as she waved to the crowds from the coach. *Woman's Hour* celebrated the royal wedding in style, including a quiz on royal occasions and an item on how to organise a street party.

The country was in a more sombre mood in 1982 with the Falklands War. *Woman's Hour* carried a report on the female side of the task force in the South Atlantic. In the years to come the fear of nuclear war would motivate many women to become peace activists. The camp at Greenham Common featured frequently on the programme. The movement spread by word of mouth, and women who had never before taken political action in their lives found themselves linking hands, putting flowers and drawings through the wire netting and discovering their ability to protest. Women became politicised too during the miners' strike of 1984. As the dispute became more bitter with men returning to work, *Woman's Hour* talked to wives and daughters from both sides of the divide.

But the 1980s weren't all baton charges and political protest. As if to escape from political conflict and the fear of IRA bombs in mainland town shopping centres, Britain retreated into a fantasy world at home. *Dallas* and *Dynasty* were the favourite television programmes. Big hair, puffball skirts and shoulder pads became the fashion symbols of the decade. Zandra Rhodes and Betty Jackson came on the programme to discuss their new collections. Katharine Hamnett was

interviewed in 1984 on her notorious protest T-shirt about Cruise missiles, which she wore to Number Ten. 'Sweater Man of the Year' appeared in 1984 when, perhaps most surprisingly, Boy George was interviewed on the 'androgynous look'. But I'm pleased to say that order was restored by 1988 when a feature was broadcast on vests.

It was certainly a decade of milestones for women. Early on, Kate Adie's coverage of the Iranian embassy siege and Moira Stewart's appointment as newsreader changed many preconceptions about female broadcasters. The police force saw its first female Assistant Chief Constable. Jenny Pitman became the first woman to train a Grand National winner and was proclaimed 'Trainer of the Year'. In 1984 the Equal Pay Act introduced the concept of equal pay for work of equal value—an aim that has yet to be achieved.

Woman's Hour was still finding new subjects of interest to women, reflecting changes in their lives. These included assertiveness, bulimia, job-sharing, workplace nurseries, cosmetic surgery, sexist language and page-three girls. What's interesting, looking back, is how many of the serious subjects discussed still have a place on the programme today, for example the way in which rape victims are treated by the criminal justice system; women parliamentary candidates; paternity leave; and domestic violence.

Eccentrics then as now make great features. There were interviews with a young woman who bred stick insects and female crane drivers who wrote poetry.

Relationships between women and men have

always been fascinating to the programme. After the freedoms of the 1960s and 1970s, what did the modern woman expect from her partner? A revolutionary creature had appeared on the horizon: the 'new man'. Who was he? Did he eat quiche? Would he really put the top back on the toothpaste tube? The programme took much delight in exploring and discussing the various sightings of this exotic beast. In 1981 Shere Hite published her report into male sexuality, causing a lot of controversy.

The 1980s saw more men appearing on the programme, including Prince Andrew, Kaffe Fassett, Terry Waite and the Archbishop of Canterbury, Dr Runcie. Willy Russell came on *Woman's Hour* to talk about his film, *Shirley Valentine*, which had touched the hearts of middle-aged women across the nation. Bruce Kent discussed his decision to leave the Roman Catholic priesthood and his recent marriage. Deric Longden talked about his book, *Diana's Story*, which recounted the tragic illness and death of his wife; its *Woman's Hour* serialisation attracted a huge response.

Woman's Hour even briefly let men take over; there were several editions of *Man's Hour*, the first on April Fool's Day 1986 (surely not a sexist joke), presented by Terry Jones. Auberon Waugh and Willy Russell hosted later editions.

Health took a new turn with the discussion of fitness workouts; suddenly everyone seemed to be on the F-Plan diet (fibre, fibre, fibre) and was jogging. Preoccupation with keeping fit led to a boom in afternoon discos for housewives. Cellulite mysteriously appeared on our thighs—though

some suspected it had just been hiding until someone developed a cream that could allegedly make it go away. And a new term, 'burn-out', described the feeling that many women recognised: that in trying to have a career and a family as well as time to themselves, they were spinning too many plates.

Progress in technology, particularly in regard to women's health, was not universally welcomed. In 1982 the French champion of natural childbirth, Michel Odent, appeared on the programme to rail against modern technological births. The following year saw the first scare about the contraceptive Pill, linking it with cervical cancer, 'to put matters in perspective and our minds—we hope—at rest'. The debate continued between what might be called technology and nature as it affected women's health. Robert Winston, the pioneer of IVF treatment at Hammersmith Hospital, gave new hope to many women who had problems conceiving. In 1984, Dame Mary Warnock, who was to become a regular in our *Woman's Hour* studio, published her report from the Committee of Inquiry into the ethical and legal implications of new developments in human fertilisation and embryology. The following year, Kim Cotton became Britain's first surrogate mother.

Wendy Savage, the pioneering gynaecologist and champion of women's rights in childbirth and fertility, was the first woman consultant to be appointed in obstretrics and gynaecology in London. In 1985, Wendy was elected Fellow of the Royal College of Obstetricians and Gynaecologists. Her anti-caesarian views led to allegations of incompetence and she was suspended from

practice. She appeared on the programme on the morning that she took her appeal to the High Court. She was subsequently vindicated and reinstated, and a fifteen-month inquiry into her case revealed deep divisions in the medical profession over modern methods of childbirth. She became an advocate for parental choice and a member of the General Medical Council.

As ever *Woman's Hour* examined the great issues of the day. But the focus changed. A new editor of the programme, Sandra Chalmers, arrived in the early 1980s and she brought a fresh spirit to the programme, which was to be more reactive to items in the news, so that *Woman's Hour* could articulate what was happening immediately and feel more in touch with women's concerns. The programme then began to move from reacting to setting the agenda itself, with items on families wrongly accused of child abuse; the story of Professor Ian Craft, whose IVF licence was taken away; Diana Lamplugh speaking on the disappearance of her daughter Suzy.

In 1985, with famine high on the political agenda, after Live Aid and the shocking films of the Ethiopian famine that made the world seem a much smaller place, *Woman's Hour* launched an appeal for Sudan with the Red Cross. Listeners sent money but also jewellery (including old wedding rings from unhappy marriages). A celebrity auction was planned; Mrs Thatcher sent two Coalport dessert stands, Steve Davis contributed a snooker cue, and the appeal raised more than £115,000.

In 1988 the programme saw a year of change; Sue MacGregor left and Jenni Murray became the

regular presenter. A new editor, Clare Selerie, was appointed and in 1998 launched a campaign to assist women to return to work after a career break. Called 'Back to the Future', it was broadcast from different parts of the country and helped women in practical ways.

In 1988, *Woman's Hour* pioneered a cervical cancer campaign, which for the first time gathered together all the experts in the field to discuss how things needed to change. Women who had the disease also came on the programme to discuss how they were coping. The campaign has been credited with changing the way the National Health Service deals with cervical cancer by encouraging a joined-up approach to tackling this illness. Edwina Currie gave an interview about screening, which came back to haunt her years later.

Many guests trusted the programme when it came to talking about deeply personal stories. In January 1988, Joan Wilson described the tragic death of her daughter Marie in the Enniskillen bomb. Brian Keenan's sisters were interviewed about his kidnapping in the Lebanon. When there was a series of highly controversial cases about child abuse, the paediatrician Marietta Higgs spoke about her role in the Cleveland child abuse case for the first time on the programme.

The 1980s will be remembered as a decade when the individual became paramount. *Woman's Hour* celebrated many of those individuals in the public and the private sphere. Whether it was Meryl Streep on *The French Lieutenant's Woman*, Margaret Atwood on *The Handmaid's Tale*, Jenny Pitman, Oprah Winfrey or Margaret Thatcher,

Woman's Hour showed the immense achievements of women in that decade from all walks of life.

Jenny Pitman

interviewed by Gwyn Richards
20 February 1981

Jenny Pitman (b. 1946) was one of the first women to be granted a licence to train racehorses. In the 1970s she opened her own stables and began her career as a national hunt racehorse trainer. Her toughness and plain speaking helped her to penetrate a world where a woman trainer was both unheard of and unwelcome. Her first winner was in 1977 and in 1981 she went on to become the first woman to train more than twenty-one winners in a season. For this Woman's Hour *interview, the reporter Gwyn Richards had arrived early at her stables.*

PITMAN: I was very fortunate in having the father I had. His father was a jockey and my dad always had ponies for us. He was a farmer and we were by no means a wealthy family, there were seven of us, but my dad always had time for us where the horses were concerned. And I also worked for Major Champneys, who now lives next door to me, and he was a very good tutor.
RICHARDS: Your former husband, Richard Pitman, was a jockey and he's now a writer. When you parted was it a case of having to earn a living?
PITMAN: Yes.
RICHARDS: Is that why you started training?
PITMAN: I started training a year before that and I'd had a good season—I had twelve winners with only a few horses—but when Richard left I didn't

298

want to sell up our home. I bought this place myself and then when Richard came to live here, we did a lot of repairs to the house and the stables. But later I was on my own and I had to borrow money from the bank. I had to pay Richard, which was half the value of the property, and take over the mortgage so I had a lot of money to earn. There was no way that I could stay here and keep the home for the children, unless I worked the hours that I do.

RICHARDS: How did you begin to convince the racing world that you could be a successful trainer?

PITMAN: In the first place I had to convince the bank manager that I was a worthy risk and because I was a woman, the bank manager really didn't want to know. I took my accountant and solicitor with me, and I said to them, 'What do you want me to do?' They said, 'Just sit there and say nothing.' They each said what they had to say in turn, but I could see that things weren't going very well. I decided that I just couldn't sit there and see my whole life go down the drain, so I said to the bank manager, 'It's not just me we're talking about, it's the people that work for me. For myself, I can work twenty-four hours a day seven days a week if necessary, I'll sweep the streets if I've got to, to keep the children at school and to keep the home together.'

RICHARDS: What kinds of people come to you as owners of racehorses?

PITMAN: All different sorts. People that want a fair deal without all the frills, that's the only thing I can offer. I can't afford to be in the cocktail party league every Sunday morning and all the rest of that social side of it. I hope to give people a fair deal and honesty, that's what I offer.

RICHARDS: When I was talking to Brendan Powell, your assistant trainer, he said that you obviously care a great deal about the people you have working for you and also your horses. Which comes first, do you think, or are they both equal?

PITMAN: Certainly the lads are not thought of any less than the horses. I do care about them both. I do insist that the job is done properly.

RICHARDS: You tear people off a strip, don't you?

PITMAN: If the job's not done properly, actually I've found a good way to solve that. You send them back when all the rest have finished at night-time. They don't want ever to do that again, so they make sure it's done right in the first place.

RICHARDS: So your horses obviously must mean a lot to you, because they are your meal ticket. Do you treat some horses better than others, do you think?

PITMAN: No, they're all treated the same, whether they're Gold Cup or Selling Hurdle horses. They all get fed the same and they are all treated the same. They're good friends to me. I really do like horses—in fact I love them, and yet I'm not too soft with them either. If one is disobedient I would certainly straighten him up.

In 1983 Jenny Pitman was the first woman to train a Grand National winner—Corbiere, and in 1984 the first woman to train a Cheltenham Gold Cup winner—Burrough Hill Lad. She went on to win the Gold Cup a second time in 1991 with Garrison Savannah, ridden by her son, Mark Pitman. In 1998 she published her autobiography. She has gone on to write several novels set in the racing world, including Double Deal *and* The Inheritance.

Sheila Kitzinger

interviewed by Sue MacGregor
11 March 1981

Sheila Kitzinger (b. 1929) is a trained social anthropologist, who became a guru for those advocating a natural approach to pregnancy and childbirth. She wrote The Experience of Childbirth, *the first of many books, in 1962.* Pregnancy and Childbirth, *published in 1980, sold more than a million copies. She also wrote widely on childbirth in other countries and within other cultures.*

KITZINGER: When I first became pregnant I discovered that we really didn't know much about how women felt, and how they behaved in different countries, and that all the anthropological work had almost exclusively been done by men. They hadn't asked questions about birth. There was a great deal of literature on what was done to the placenta, because they'd seen that happening, but they didn't really know what went on inside. So I became very interested in what it felt like to be a woman giving birth in different societies.

MACGREGOR: You've studied West Indian women. From the point of view of a social anthropologist, would their birth-giving methods have anything to teach us?

KITZINGER: Oh, I think so. When my youngest child was about two and a half I took the whole family to the West Indies. I studied West Indian peasant women and the rural poor, and one of the

really important things that I noticed there was that women didn't spontaneously get on a bed and lie down to have a baby. Whenever possible they kept moving around, right through the first stage of labour, and indeed even in the second stage. If they could get into an upright or semi-upright position, they did. The midwives in the hospitals didn't like this, because they thought women ought to lie down and be good patients, but in fact if a West Indian woman had a chance, she would, for example, rock her pelvis in almost a kind of belly-dancing movement. The whole approach to labour is something that the mother does for herself, and she's mobile and active; she isn't just passively lying there, having something done for her.

MACGREGOR: And what would hospitals in this country think if women started rocking and crouching to have their babies? Or perhaps they are doing that in some hospitals?

KITZINGER: I think there have been enormous changes over the last two or three years. We've now discovered that it's much safer for a woman to have at least the upper part of her body well raised, or even to be standing for much of labour. The uterus contracts better, the woman has less pain and the baby is better oxygenated. Now, no woman in her right mind would choose to lie down on her back, with her legs in the air to push a baby out, because then she has to push uphill. Most women who are allowed to do what they want to do, and what comes naturally, will adopt either a modified squatting position, or crouching or kneeling forward, or will even get on all fours. And now hospitals are beginning to see that they're getting more effective second stages where

302

they encourage women to adopt any position that is comfortable for them. This means we have to do away with the old-fashioned delivery-room beds. We have to put mattresses on the floor and we have to provide lots of pillows and we have something more like perhaps the medieval birthing stool, which women right through history used to sit on to have babies.

MACGREGOR: All this sounds rather primitive in a way. Isn't there much more of a movement in this country now towards what I might call mechanised birth, in that women are lying flat on their backs with their legs in the air, being monitored all the time by machines? When they're certainly in bed and not on stools, and the hospitals are very much in charge?

KITZINGER: I think this is the big challenge we have to face. What is the point of rupturing the membranes—you know, breaking the bag of water— and inserting an electrode and putting a clip on to a baby's scalp and having a woman lying down and monitoring every heartbeat, if by doing so you are producing a state of affairs in which there is a dip in the foetal heartbeat and the heartbeat gets slower? There is plenty of evidence to show that when a woman is immobile and lying down, if you take away the bubble of water in which the baby is lying, which of course protects the baby and the baby's head, and the cord through which the blood is flowing, doing all that may actually produce the very conditions that we then have to monitor.

MACGREGOR: But isn't the rate of baby death just before or around the time of birth, very high in this country?

KITZINGER: No.

MACGREGOR: Isn't that really why doctors are trying to monitor the way mothers give birth?

KITZINGER: We actually have a rather low perinatal mortality rate, so I don't think we have to be deeply disturbed by that, but I do think—

MACGREGOR: It's higher than in lots of parts of Europe, though, isn't it?

KITZINGER: The rate is going down more slowly than in some parts of Europe, so yes, of course babies are precious and we don't want babies to die unnecessarily, but sometimes I hear a doctor say that the one thing that matters is a live and healthy baby. Well, quite honestly, for most families it isn't the only thing that matters. There's really no point in producing a perfect, well-oxygenated, healthy little animal, unless the relationship between the parents and the baby is a growing concern. That's why I think we have to look at our whole environment of birth, our whole culture of childbirth, and see what we can do to make it a celebration, a joyous occasion.

MACGREGOR: You've had five daughters of your own, now aged between seventeen and twenty-three. What do they and your husband think of your work?

KITZINGER: I suppose they like to see me enthusiastic and involved and alive with it, and I am. It's tremendously exciting. I think they enjoy discussing things connected with the psychology of womanhood, what it is to be a woman and all the feelings, the very intense and passionate feelings, that one has.

Sheila Kitzinger continues to campaign for women to have the information they need to make choices

about childbirth and lectures to midwives in many countries. She also set up a helpline, The Birth Crisis Network, for women who have undergone traumatic births. Her most recent book, The Politics of Birth, *was published in 2005.*

'My Mind Said I Could Do It'

21 December 1981

As a child, Maureen Towner (b. 1955) caught polio and as a result had no muscular control of her arms and hands, and very little use of her legs. Despite this, Maureen and her husband Ted decided to try for a baby—and Emma was born. Woman's Hour *reporter Barbara Myers went to visit Maureen, Ted and Emma, now aged three.*

TOWNER: I never really thought, I must have a baby; I was just a woman who would like to have a baby and although I had extra problems, I've coped with them for such a long time that they didn't seem extraordinary problems to me and so I just went ahead.

MYERS: Take us right back to that day your daughter was born. You have no use of your arms, limited movement in your legs. How did you pick her up? How did you feed her? Change her? Bath her?

TOWNER: I used to pick her up in my teeth. I always used to dress her in Babygros, so that when I picked her up, all of her body came along too. If she was in a dress and you picked her up, she used to fall—never on the floor, but it was a bit uncomfortable, so I always dressed her in Babygros, and I used to bend my leg and sit up on a chair and rest her in the crook of my leg. She used to sit there for ages. In my right hand I can use my fingers a little bit. I used to hold the bottle

and feed her. And when she was four months old, she held the bottle herself.

MYERS: That's all very well, but someone has to prepare the bottle. I take it when your husband was at work, that was you. How did you manage with that?

TOWNER: We used to have a great session in the evenings of getting bottles ready because although I could spoon the actual feed in, I couldn't shake it, so he used to do the six bottles every night and just put them in the fridge. Nappies weren't very easy, I must say. To start with, I had terry nappies, triangular in shape and instead of pins somebody sewed two buttons on each side, and then between Emma's legs I used to have two elastic loops and I just hooked my finger in the loops and pulled them up and hooked them over the buttons. I wanted to have disposable nappies, but I couldn't find anything on the market that didn't have a popper and as I would have to do the popper with my teeth I felt it would be a bit difficult. I did try, as Emma got older, but it wasn't easy because you can't make a child keep still. When you do a popper with your fingers, you can see what you're doing, but doing it with your teeth you're just feeling with your tongue and there's always that terrible danger that you might bite. I bit her once as I was pulling her sock off, she was most amazed, but I've never bitten her since.

MYERS: And now that she's reached toddler stage, how does that work out?

TOWNER: When she was about nine or ten months old I had a friend who used to come in the morning and help me to bath her, because she was quite heavy to lump about then. She used to put reins on

her, tighten them up and then leave them on her all day, so that I had something to get hold of if Emma really got into a situation where I just needed to get grab her.

MYERS: With your teeth?

TOWNER: With my teeth, yes, or my fingers. I could pull her with my fingers, but having the reins actually got her walking more quickly because I used to pull her up on to her feet a lot and she just learnt to stand quickly. When she was about eleven months old, she could stand and take a few steps, and by the time she was one, there weren't really problems as far as moving her because she'd just move herself.

MYERS: You actually declined help, didn't you, in the early days?

TOWNER: Yes, I wanted to do it for myself. She's my child and I did it my way for my child. She is full of confidence today. She can speak to anybody, she can almost dress herself, she's just, at the moment, learning how to do her buttons up. When she was just fifteen months old, she would get herself in and out of the bath, I only had to stand there and instruct her what to do. She had enough sense to comprehend and do it, whereas most children haven't a clue. When she was four months she would hold her bottle—I've pictures of her holding her bottle at four months. Emma could do it because I used to encourage her to put her hand on the bottle and that's all I've done all the way through, just encourage her to do things for herself and she will do them. Children have a great capacity for learning and understanding and if you take the trouble to sit down and explain something, rather than shouting or hitting them, it will come out much better. I've

308

proved it with Emma. She's quite capable of sitting down and putting her socks and shoes on at three years old, and she's been doing it for a little while, because I sit down and tell her how to do it. I say to her, 'Oh it's very big, it's very grown-up to do it yourself'—and she does it herself. She knows I can't.

MYERS: Now that Emma has herself reached a new stage, going to her playgroup and becoming very much more independent, what does she make of you, do you think?

TOWNER: I think she isn't actually aware that I am disabled. I think she just thinks I'm her mummy. She may realise that I'm different than the other people, but I think she thinks it's the other people that are strange, not her mummy, because when you're a little girl your mummy is everything; I know mine was. But she knows exactly what she has got to do. She knows she's got to climb into my car, she knows I won't pick her up and lift her in, and she knows how I'm going to drive it. She knows when we get out there are certain things she has to do—she holds the door for me and then she closes it. It's just her life and she doesn't expect anything more or less of me. I must say that all the time when I've been taking her to mother and toddler groups, I never had any adverse questions from the children. They would ask you once what's the matter with your leg and you tell a child and it's finished. Grown-ups in general are far more difficult. They have inhibitions that children don't have and I get on much better with children. If I've never met a child before, I can guarantee that within half an hour I'm feeling quite at home and comfortable with that child—but it doesn't apply with grown-ups. They won't see you as another mother or someone equal to them, but just as

someone with a disability and so of course it makes it all harder.

MYERS: Now that Emma is three, a lot of mums at this point would begin to think, what about another one? Do you also think you might possibly have another child?

TOWNER: I think it's a possibility.

MYERS: Are you up to it again?

TOWNER: If you look at my disability on paper, I can't do anything really. I mean, I am paralysed, my arms are paralysed, my legs are very weak, my back is very bent as a result of weakness from polio, but my mind says I can do things, so I can do it. I'll probably get very tired and think I'm absolutely mental by the time I'm nine months' pregnant, but the compensation is when you see that you have a healthy child and it's worth all the sleepless nights, I think.

Now Maureen Fenner, she went on to have a second daughter, and in 2002 published her autobiography With These Hands.

Joan Ruddock

interviewed by Sue MacGregor
29 June 1982

One of the themes of the 1980s was the importance of the peace movement. There was a surge in support for the anti-nuclear movement, catapulted into the public conscience by the women peace protesters at Greenham Common and their campaign against the siting of US Cruise missiles there. As Chair of CND, Joan Ruddock (b. 1943) was at the forefront of the campaign. Prior to her appearance on Woman's Hour, *she had just returned from addressing the United Nations Special Session on Disarmament in New York.*

Sue MacGregor started by asking Joan Ruddock whether, in the aftermath of the Falklands crisis where conventional weapons were shown to be highly effective, were CND as a movement against them?

RUDDOCK: No, we're not. As a movement we feel that at this stage Britain must have conventional weapons for conventional defence. But that doesn't mean that all CND people support sending task forces overseas. On the contrary, I think most people in CND feel the need to have conventional weapons to defend our shores against invasions.

MACGREGOR: Mrs Thatcher preceded you at the UN Special Session on Disarmament and she pointed out in her speech that she felt that the best deterrent was strength and that nuclear weapons

311

had kept the peace on a global scale for thirty-seven years. What's your answer to that argument?

RUDDOCK: I think Mrs Thatcher's speech was a simple prescription for every nation in the world to say we must be armed to the teeth and, moreover, we need nuclear weapons. The world can only be made safe if we de-escalate. Mrs Thatcher's speech really talked in terms of constant escalation. There is no end to the arms race if you use the kind of justification that she used.

MACGREGOR: But if Britain withdrew unilaterally from the nuclear arms race, would anyone else follow suit? Would the world be any safer?

RUDDOCK: There's a very good reason for believing that we could be safer. It's important to remember that there are quite a number of countries in Western Europe that are non-nuclear states, which have got civil defence programmes and which believe that they could protect their citizens much better by not having nuclear bases, which would be targets in a nuclear war. We believe that it's safer not to threaten other countries with nuclear weapons because that obviously would add to world tension. And finally we do believe that, because of the strength of peace movements in other countries of Europe, there is a great desire to get nuclear weapons out of Europe to prevent a third world war being fought within Europe and for that war to be nuclear.

MACGREGOR: But do you actually see any signs that anyone else would copy our example if we did such a thing?

RUDDOCK: Yes, because there are already very strong movements in Scandinavia, for example, trying to secure a Nordic nuclear-free zone. There

312

is an agreement, albeit at a very early stage, between Bulgaria and Greece about trying to form a Balkan nuclear-free zone, and, as you will know, in West Germany there is tremendous fear that they will have a nuclear war or at least nuclear weapons used on their soil. So yes, I think there's every reason to believe that if we could show we had the courage and commitment to do it, others would want to follow us.

MACGREGOR: It must have been an extraordinary experience for you to talk to the Special Session of the United Nations. How did you feel about it?

RUDDOCK: First of all I felt extremely nervous as you might imagine and quite overwhelmed by the whole setting of the General Assembly of the United Nations. I didn't feel Mrs Thatcher's act was hard to follow, because I felt that I went there able to say, 'I come to express British public opinion and British public opinion is opposed to Cruise missiles, is opposed to Trident missiles, and is opposed in a majority to the siting of American bases in Britain.' I felt that I was addressing delegations from countries all over the world, who therefore needed to hear that view. I must say I was very well received by quite a number of them.

MACGREGOR: Where did you get your main support from, the third world?

RUDDOCK: Yes, third world delegates certainly appeared to appreciate what I had to say. I'd also like to say that the British delegation were present and that the ambassador invited me to have a talk with him afterwards and I regard that as useful. Interestingly enough, there were a number of people who work in the United Nations who came to speak to me—mostly they were young

Americans—and they expressed great relief at having heard a different view because they were not in any way pleased by what they heard from Mrs Thatcher.

Joan Ruddock has been the Labour MP for Lewisham, Deptford since 1987. In 1997 she was appointed the first full-time Minister for Women in the new Labour Government—a post that was discontinued after one year. She is Vice-President of the Family Planning Association. After 9/11 she set up the UK Women's Link with Afghan Women.

Jane Grigson

interviewed by Sue MacGregor
13 October 1982

Jane Grigson (1928–90) began a weekly column in the Observer *magazine in 1968. She was seen as the successor to Elizabeth David in the food writing world. Her weekly column was famous for not only telling you how to cook but for giving a historical and literary context to the food. Her award-winning* Vegetable Book *(1978) and her* Fruit Book *(1982) are both still considered definitive works. In 1977 she was voted Cookery Writer of the Year. Her first food book,* Charcuterie and French Pork Cookery *(1969), was the result of her living in France.*

GRIGSON: It was really through going to France that I found my trade, because we were there for about five weeks. I was really completely amazed by the quality of the cooked food in butchers' shops. I was very puzzled by it too; I knew sausage and hams, a few pâtés, but there were many more things than that, so I said to the friend who had found us the cave we had rented—

MACGREGOR: The cave?

GRIGSON: It's the cave village that we live in, and I said to him, 'I wonder if you could write a little short book for holidaymakers coming to France to describe what you can buy in the charcuterie.' He started but he didn't get very far, he had troubles of one kind or another. And the publisher said to me, 'Well, you write it.' So I did.

315

MACGREGOR: Now tell us about this cave you live in France.

GRIGSON: We've had to line it inside with concrete blocks to hold it up—stop it falling on our heads, and in front we have two little rooms, which are built out from the rock. But quite a few people do have holiday homes in the caves and our next-door neighbour on one side is a cave dweller. She has always lived in a cave.

MACGREGOR: And can you cook in it? I mean, is your kitchen elaborate? I don't suppose it's exactly fitted, is it?

GRIGSON: It's becoming more elaborate. For a long time we didn't have running water and we didn't have electricity and I had just a little two-burner gas.

MACGREGOR: And no fridge?

GRIGSON: Oh no, which was a bit difficult; it meant you really had to shop every day, but I think that's one of the joys of France. You learn that to have good food you need to shop well, perhaps not every day, but every other day.

MACGREGOR: And to have good food you can just go out and buy it ready cooked in the shops, which you can't necessarily do here.

GRIGSON: Oh, I don't think you can at all here. For instance, in France if we're having a large lunch party and I get a bit overwhelmed by hospitality, I just ring up the charcuterie and say, 'Will you do me this, that or the other?' And I go in and collect it a couple of hours before the meal and I know it's going to be excellent and that the guests will appreciate it.

MACGREGOR: You were brought up in Sunderland and in a time when food was really

pretty scarce, during the depression. Are you affected by that at all, in your attitude to food and to good things?

GRIGSON: I was eleven when war broke out; I think it really affected other things in my mind, not my sense of eating things. I think that to have known what poverty smelt like, and what people had to put up with, quite formed my whole attitude towards life. I think my interest in food only really began with the war when my mother lost the cook and the housemaid and the nanny, and she had to do all their work herself and loved doing it. We had delicious meals; we used to go out and pick nettles and make nettle soup, and we'd pick blackberries. With her I began to explore exciting new things just as they began to come back.

MACGREGOR: There's a new term that's been coined lately, 'foodies'—people who think about nothing but food. Some people think that it really isn't right to devote a lot of time to food in a world where people are starving, that it's an unnecessary luxury to cook well.

GRIGSON: Yes, I know people say this but I think this is very disrespectful. Many people have spent centuries improving our food. I think it is very disrespectful for all this hard work to treat it casually. One very famous French writer has said that if you don't care about what sustains life, what else will you care about?

MACGREGOR: How important do you think it is to improvise when you're a good cook? Because you may disagree with this, but I have a theory that men improvise better in the kitchen than women. Women tend to follow recipes a little bit more slavishly but maybe because men don't do it that

often, it's more of a game for them.

GRIGSON: Yes, I think it's more of a game for men. For women, perhaps the thing is that they can't waste things. I myself always do follow a recipe. I may make changes in it, but I very rarely improvise because I think when you improvise, unless you're a genius, your food becomes very monotonous. Because most of us, as would be the case if we were playing a musical instrument, will need music written by other people.

MACGREGOR: Do you think that the British have become rather more interested in food than they used to?

GRIGSON: Oh yes. I remember when I was a child being told not to comment on the food when I was taken out because I did have a habit of saying, 'Oh, this is lovely.' You weren't even allowed to say it was lovely. But of course when your hostess began to cook the food herself, that was a different matter.

MACGREGOR: You've written big, glossy and delicious books on vegetables and on fruit; you probably couldn't have written those twenty years ago, could you?

GRIGSON: I don't suppose I could have written them ten years ago. This has been a marvellous change in my life. When people complain a lot about food in England, I wish I could take them back to my childhood and see what it was like then and how dull food in winter was, with the limited amount of vegetables and what little fruit we had.

MACGREGOR: What were some of the vegetables that you can get now that you couldn't have got, say, ten years ago?

GRIGSON: I suppose the big success story is

avocado pears. We can get them in our small town shops in Wiltshire without difficulty. We can get peppers everywhere, aubergines, courgettes, of course, which grow very easily in this country. In fact my complaint is that you get all these fancy things but you can't get decent spinach, and watercress isn't even as available as it might be, and I don't think I've seen seakale in a shop outside London—for about ten years.

Jane Grigson died in March 1990. She is still regarded as one of the leading food writers of the twentieth century and many of her books have been reprinted for another generation. Her daughter Sophie Grigson is also a food writer.

Joan Collins

interviewed by Sue MacGregor
23 October 1984

Joan Collins (b. 1933) is a traditional Hollywood star in the grand style. She studied at RADA, making her public debut in Ibsen's A Doll's House *in 1946. Preferring the screen to the stage, she then went on to make numerous films, most famously* The Stud *in 1979 and* The Bitch *in 1980. She gained international superstar status when she joined the cast of* Dynasty *as Alexis in 1981. The show topped the US ratings in 1983–4, watched by millions around the world.*

When Sue MacGregor spoke to her, she asked Joan Collins—resplendent in a navy blue coatdress—whether she would rate her part as Alexis as one of the most important things she had ever done.

COLLINS: The most important thing that I ever did was when I was put under contract to Twentieth Century Fox. I was twenty when I went to Hollywood, but I never really became a household name at that particular time, because it's very, very difficult to get well known throughout the United States and throughout the world just by doing films. Television is an absolute phenomenon, because it goes into everybody's homes all over the world. If I actually sat and thought before I did any scenes in *Dynasty* how many millions of people were going to see it, I think I'd have been so terrified that I would never

have got out of the make-up room. But I do know that within two or three weeks after *Dynasty* was first aired, I was very well known in America. I must say, though, that I didn't envisage in any way that it would turn out to be the phenomenon it is.

MACGREGOR: Is it really fun? I can imagine it's fun to make lots of money and to be whizzing back and forth across the Atlantic, but are the pressures of that long working day that you do on *Dynasty* really fun?

COLLINS: No, I must say that sometimes, when I come in at half past five in the morning and leave at half past seven or eight, and we are working on a stage which, although air-conditioned, is still eighty-five degrees, and one is having to look perfect in every shot, draped in fur coats and boots and gloves and hats, and everybody else is sitting around in shorts—no, it is not fun by the afternoon.

MACGREGOR: There is obviously a great advantage to you now, being British and working in Hollywood, that perhaps wasn't there a few years ago, but does that seem to have been one of the secrets of Alexis's success in the series, do you think?

COLLINS: No, I don't think so. In fact, I think that it was a drawback first of all. The producers were very vehement about me not doing Alexis with an English accent. They wanted me to do her with an American accent because they said that nobody with an accent had ever made any kind of an impact on television because Americans just aren't keen on foreign accents. It isn't that they don't like them, it's just that they haven't made any significant breakthrough whatsoever in television there. As far as the producers were concerned, my being English

321

was a tremendous drawback.

MACGREGOR: Where's home now? Are you tempted to make it permanently now in the States?

COLLINS: No, not really, because I truly consider that home is where I'm working, wherever my children are, wherever Katie goes to school: that is home.

MACGREGOR: But could you ever settle back in this country, do you think? You've been critical of it in the past . . .

COLLINS: I've never been critical of England, ever.

MACGREGOR: You've been quoted as saying people don't know how to work here . . .

COLLINS: I said that in an offhand, rather casual jokey remark, which was taken totally out of context. I will repeat the remark if you like, which is that I think—and if you disagree with me I would like you to tell me—there is a certain segment of the population, both in the United States and in Britain, who do not like to work, because they make more money from the welfare state on handouts than by working. Am I wrong?

MACGREGOR: You could be right . . .

COLLINS: Ah—she's not committing herself. That is what I said and that was what was taken out of context. No, I love this country, I'm very patriotic. I'm very British and that's why I come back so often.

MACGREGOR: You mentioned your daughter Katie and she's your youngest child. She had an awful accident happen to her before you started on *Dynasty* and as far as I know she has now pretty well recovered, but she was in a coma for a long time. How is she now?

COLLINS: Katie is doing absolutely fantastically.

She was in a coma for six weeks. She was badly brain injured. The chances of her surviving to be normal, as it were, were pretty dim and it was miraculous that she came through. I've written a bit about the whole thing in a book of mine that's just come out, called *Person Imperfect*. I felt that so many people helped me, by sending letters and messages of hope and comfort, that I in turn wrote about it to help other people in the future who will have this kind of terrible tragedy. Katie is at a new school; she complains that there's too much homework and that the teachers are too strict—the usual kind of thing that children complain about—but we're very lucky.

MACGREGOR: What was the most helpful piece of advice that you got from all the people who wrote in when Katie had her accident?

COLLINS: What was repeated constantly throughout the letters I received was, never give up. That has been my credo since then and it was a bit before, but I do believe that you must never give up on something that you believe in. It's a very good piece of advice.

Joan Collins continues to appear on stage and in films and has published thirteen books; her latest novel is Misfortune's Daughters. *In February 2002, Joan Collins married Percy Gibson, thirty-two-years her junior. When asked about their difference in age she famously remarked, 'If he dies, he dies.'*

Shirley Porter

interviewed by Sue MacGregor
23 October 1985

Shirley Porter was born in 1930; her father was Jack Cohen, the founder of Tesco. She inherited his fortunes on his death in 1979. A Conservative councillor since 1974, in 1983 she was elected Leader of Westminster Council, a position she held until 1991. Under her leadership, Westminster Council was involved in one of the most serious scandals in recent times: the selling of council houses in marginal wards to potential Conservative voters.

MACGREGOR: Your background was really more in retail than in politics, wasn't it, because your father, the late Sir Jack Cohen, founded Tesco. Was he a millionaire when you were a little girl?
PORTER: No, he was on the up. I was born at home in Clapton and then we made what I think is called the voyage of the north-west: we went to live in Finchley.
MACGREGOR: Didn't he have a habit of handing out tiepins with a slightly rude message on them?
PORTER: Oh yes, I've brought one along for you and I'm sorry that I haven't been able to find something suitable for a woman. It actually says, YCDBSOYA, which, if I can be a little indelicate, means, 'You can't do business sitting on your arse,' and he gave this to trade union bosses. I do believe that's what he was all about, the fact that you can't get things done just by sitting around and talking

324

about it.

MACGREGOR: Now you are a successful woman in local politics. You have attracted a lot of enemies because women who are forceful nearly always do. What do you feel about the people who yell at you in the council chamber?

PORTER: At first I was absolutely horrified, it wasn't my kind of background at all. To be shouted at and screamed at was a dreadful experience, but then perhaps there's a little bit of my father in me. I'm a bit of a street fighter and I think you've just got to be there and stand your ground.

MACGREGOR: Thinking of the other grocer's daughter, have you ever been tempted to go into national politics?

PORTER: No, I don't want to go into the House of Commons. I think that the hours are absolutely ludicrous. I assume that they were made that way for people like barristers. It doesn't suit a woman at all and I must also say that I believe that local government is an absolutely fascinating area. You may be a big fish in a little pool, but that's where it's really happening. It's day-to-day life.

MACGREGOR: You said you went into local government when your children were just about grown-up. It does take up a lot of your time—not as much as if you were at Westminster—but presumably you have got to be on call all the time?

PORTER: It takes up a lot of my time as the leader but some of this is a matter of one's own personality. If you want to do a job and you want to do it properly, then of course you've got to put a lot of time in. I would say that it isn't a job to go into lightly but I do think that local government is at a watershed. I believe it should be minimalist, that it

325

should go back to just providing the services that nobody else can, and if it's going to have more to do, then we shall have to see paid councillors or executive mayors.

In 1996, the policy 'Building Stable Communities'—the selling of council homes in marginal wards to potential Conservative voters, which had been advocated under her leadership of Westminster Council—was deemed to be illegal. Dame Shirley, as she had become, was ordered to pay back £27 million. Following a prolonged legal battle, she eventually settled the dispute and paid £12 million to Westminster Council.

Winnie Mandela

interviewed by Sue MacGregor
2 October 1986

*In South Africa, Winnie Mandela (b. 1934) is known
as the Mother of the Nation. In 1957, a young Winnie
Madikizela met the political activist Nelson Mandela.
They married the following year when she was twenty-
four. Four years later, Nelson Mandela was sentenced
to life imprisonment with Winnie herself imprisoned
for seventeen months, in 1969. In 1977 she was
banished from her homeland, being allowed to return
to Soweto only in 1985. Throughout this time she had
been campaigning for the release of her husband.
When Sue MacGregor met her at her South African
home, she asked first about her early life.*

MANDELA: We were eleven in our family and my
father was a symbol of authority, both because of his
role in the family as a father and the fact that he was
our school principal. We never for instance had the
warm affectionate relationship that other children
had with their parents. When my father walked into
the room, we stood up until he left the room. We
never sat on his lap, or played with him; we never
really enjoyed the warmth of a family relationship.
And then on the days the school inspector had been
with him, I got the impression that my father was
not the father figure I knew. But that was how I
realised as a child that there was a difference
between races, and that this school inspector
regarded himself as the master of my own symbol of

327

authority, my father.

MACGREGOR: How quickly did you get involved in active politics? Because I know that in the 1950s there were quite a lot of important black women's organisations, like the African Women's Organisation, that you became part of.

MANDELA: In the 1950s I was still quite young and I was at high school. I was doing my matriculation at the time that we learnt of the defiance campaign launched by the African National Congress. We heard of the name Mandela as long ago as that, and that the black man was defying unjust laws in the white man's cities. Our only relationship with the cities at the time was that our uncles went to work in the white man's mines and that was all we knew, this abhorrent migratory labour, which meant that our fathers would leave home for years at a time and some of them never returned.

MACGREGOR: When did you meet Nelson Mandela first? I know that you saw him from a distance before you met him face to face.

MANDELA: I met him physically in 1957, through my friend who is married to my brother, Oliver Tambo. It was just a coincidental meeting in the street. I looked at the man with awe because we had heard so much about him.

MACGREGOR: And yet the tragic thing is that, although you've been married for all these years, you have had so little married life together, something like four months?

MANDELA: Yes, in fact not even that. I've never lived with him. I've never really known him. I never heard him give one of those famous speeches. I never dreamt that one day I would really be part of his family.

MACGREGOR: Your daughters Zeni and Zindzi were five and four respectively when Nelson Mandela was imprisoned for life, so you at least have had them. I imagine that's been helpful to you but they have the difficulty of being brought up with a famous father that they've hardly seen.

MANDELA: We were harassed from the moment their father was out of the picture. They tried everything to break one in a number of ways and it was extremely difficult to explain to very young children why it was so. It was extremely difficult to explain to young children the presence of the security branch almost twenty-four hours a day. Why we were being raided. Why I would be searched.

MACGREGOR: You were allowed contact visits when Nelson could hold his daughters for the first time. That must live with you very vividly?

MANDELA: In our country children can go to prison only when they have turned sixteen. Being placed in a position where one had to introduce his own children to him when they turned sixteen, that was traumatic. Taking them at that age to their father was one of the most painful moments actually. I could see the strain on my children both before their visit and for some time thereafter. It was only about eighteen months ago that they were able to touch him, to hug him and kiss him, and they are women already.

MACGREGOR: How much has this extraordinary experience changed your personality, do you think?

MANDELA: All I know is that I am terribly brutalised inside. I know I am bleeding inside all the time. I know the pain of my people's suffering. The pain of having a husband behind bars for

twenty-five years. The pain of bringing up children under this atmosphere.

MACGREGOR: You made a remark the other day that upset a lot of people who otherwise admire you. You said, 'together, hand in hand, with our boxes of matches and our necklaces'—necklaces being, of course, the tyres put round people's necks and set on fire—'we shall liberate this country.' Did you really mean that?

MANDELA: I don't know where you get that quotation from. All I can suggest is that you get the original tape where I made that speech. The version you have quoted to me is the version created by the state with, of course, the obvious intention. I don't have to apologise to anyone about my political views. It is my right to speak my mind as I see it. I have actually got a little bit sick and tired of having to explain what was meant that day.

MACGREGOR: I haven't heard your explanation. I'm genuinely keen to know what you meant by that.

MANDELA: I hate explaining that because, as I have pointed out, I don't really owe anyone any explanation. I explained that today our children have been reduced to the level of fighting the might of Pretoria with the matchstick and the necklace. Those are not the methods that will liberate the black man and the might of Pretoria will require us to join hands and fight with methods that will bring down Pretoria. Now, why has that been taken out of context? It's because Pretoria wants one to appear as condoning the method of necklacing, which was the only method open to these youngsters who were brutalised every day. We belong to a disciplined organisation, which will call

330

upon them one day to use methods that will bring down Pretoria.

MACGREGOR: How important to you has been the support of the whites in South Africa? I'm thinking in particular of people like Helen Suzman who, I think, you've got to know quite well over the years.

MANDELA: Yes, yes, we've known each other. We disagree a lot. Our politics are at times totally against each other's views and we have had to accept the fact that there will be those times when we really speak past each other. I value her as a person like all my people. Had it not been for her, I doubt there would have ever been any opposition to South Africa's racist regime. She occupied the position of being a spokesman for all the non-voters in this country. She went to Robben Island during those earlier years when life in Robben Island was extremely difficult. She highlighted those conditions and had it not been for her lone voice in Parliament, the rest of the world would never have known what was going on in this country.

Nelson Mandela was released in 1990 at the age of seventy-two, having spent twenty-six years in prison. In 1991, Winnie Mandela was sentenced to six years' imprisonment for her part in the kidnapping of Stompie Seipi, a fourteen-year-old who was murdered by her supporters. This was later reduced to a fine on appeal. She and Nelson Mandela divorced in 1996.

Brenda Dean

interviewed by Sue MacGregor
17 December 1986

Brenda Dean (b. 1943) joined the print union SOGAT as an administrative secretary in 1959. In 1984, she was appointed General Secretary, the first woman—and the youngest—to head a major trade union. In 1986, Rupert Murdoch moved the production of The Times *newspaper from Fleet Street to new offices in Wapping. The introduction of modern electronic print methods, which was to bring revolutionary change to newspapers, meant redundancy for thousands of workers. With thousands of other print jobs under threat, a bitter industrial dispute ensued with SOGAT at the forefront of the strike action.*

MACGREGOR: You're saying that you personally are not opposed to the new technology but of course the new technology means many job losses from your union. How do you square those two views?
DEAN: Because one's got to look at the whole picture and if we oppose new technology, it would have a much more damaging effect on the industries we cover. We are an international industry. If one puts Fleet Street on one side for a moment—that's only 12 per cent of our member-ship—the rest of our membership are involved in papermaking, general printing, that sort of thing, and new technology has been accepted in those areas. If we don't compete internationally, if

we don't retool our industry to go forward with new technology, we'll end up not just with redundancies but complete closures of companies.

MACGREGOR: So you're having a major problem persuading your Fleet Street members to accept this?

DEAN: The Fleet Street situation has been very different. In the rest of the industries covering our members—some 180,000 of them—we've had evolution to introduce new technology and we've gradually moved towards it. In Fleet Street, however, there's been no change at all for many, many years and so what's happened is that a watershed has built up. What has happened in Fleet Street is we've had to go almost from the Dickensian age to the 1980s in one quantum leap. That has caused serious problems and it's caused serious job redundancies. At the end of this year 10,000 jobs will have gone in Fleet Street. Our members have accepted new technology; what they do take issue with is the way it's been introduced.

MACGREGOR: But at the moment there's a constant picket. It can only be six people by law at the moment, picketing outside the gates of Wapping News International, although you have demonstrations regularly twice a week. The situation seems to be at an impasse. Mr Murdoch has said he's made his final offer and you believe that really is his final offer. What on earth can be done now? The picket can't go on for ever, can it?

DEAN: It could do. It's been going on for eleven months now and my own view is that it could last another eleven months. But we know that Mr Murdoch wants to expand. We know that he is an embarrassment to British industry at the moment.

When you get the chairman of ICI, John Harvey-Jones, saying what Mr Murdoch had done was monstrous, I think it reflects the fact that management in Britain regard what he's done with some abhorrence. These are certainly not typical industrial negotiations. There's barbed wire around the plant and there's definitely no way that that dispute is just going to be called off.

MACGREGOR: You, on the other hand, in an extraordinary way seem—don't take this the wrong way—but you seem to be almost thriving on it. It must be very stressful for a union leader to have this problem on her shoulders day after day, seven days a week, and yet you always look remarkably calm. Do you thrive on stress?

DEAN: I don't know if I thrive on it or not, Sue, I just take each day as it comes. I've got to. And each day has a different twist and turn to it and I do feel very conscious that I have a responsibility to my members, to try to give of my best all the time.

MACGREGOR: You left school at sixteen, which was maybe a couple of years later than your granny wanted you to leave school, and you became a top shorthand typist and you immediately became a secretary. Could you at the age of sixteen have imagined that you would be where you are now?

DEAN: Oh, absolutely not. When I said I was going to work for a union, even my school chums said, 'Don't go there, you'll never get on.'

MACGREGOR: Were they bad employers?

DEAN: No, they just regarded trade unions as something that a young yuppie woman was not going to do. She was going to have her nice career as the female secretary to a male boss and have nice clothes and get married and have children.

That's what I thought life had in store for me. But it didn't turn out that way, and that move to the union was the best thing I ever did.

MACGREGOR: How did it happen, though? Did you just get sucked into union affairs by taking down minutes?

DEAN: Oh absolutely. They never thought for one moment that taking in this young woman to take minutes at meetings would result at the end of the day with the General Secretaryship of SOGAT and it surprised them probably as much as it surprised me. I was sucked in. I started to speak out and they let me because I was no threat to them, I was a young girl.

MACGREGOR: It's surprising that the first woman to head a major union comes from the North because—this maybe an awful Southern and chauvinistic view—but a lot of Southern people think that women have a harder time in the North of England. Indeed, there are still pubs, I'm told, where a screen may be pulled round a woman if she dares to go into the men's bar. Does it surprise you now that you did all that in a Northern city?

DEAN: I didn't think of it like that. I didn't feel in any way sort of enclosed by what I regarded as my rules or their rules, I simply went out and did my job. Because problems are usually so serious, within the first five minutes I forgot I was a woman and hoped that they did too. I think it would have been different if I'd gone to a university and then gone into the union. They regarded me as taking it as a career, they regarded me as one of their own. And certainly it's true, every General Secretary we've had previously has been male but also a male from a London branch—and not from the provinces—and I

did come from the provinces. That was a surprise, and I was a woman on top of that, which was an even greater surprise.

MACGREGOR: You seem to have taken to the spotlight very comfortably. Right from the word go nothing seemed to faze you. But do you regret in a way that there's very little time to step out of that spotlight and to just be yourself and relax?

DEAN: Oh yes, quite apart from an honourable settlement being the best for our members and the industry because it's a blot on industrial life. At the moment I'm hoping it will also mean that I can step back into my own private being as well, because I've lost all that over this last eleven months. I think what helped me keep my calm in the initial stage of the dispute was quite clearly the fact that we had a very principled dispute. It's very easy to defend principle.

The Wapping dispute lasted for a year, finally ending in February 1987, when the strikers were forced to back down. As predicted, it completely changed the way newspapers worked and led to the effective closure of the traditional Fleet Street. Anger and distrust in the industry lasted for years. Brenda Dean became Baroness Dean in 1993. In 2005 she was appointed chair of the Covent Garden Market Authority, the body that manages New Covent Garden Market in London. She is also a Member of the House of Lords Appointments Commission.

Margaret Atwood

interviewed by Sue MacGregor
3 June 1987

Margaret Atwood (b. 1939) is Canada's most eminent novelist and poet. Her first collection of poetry was published in 1961. Her first novel, The Edible Woman, *was published in 1969 and by the time she published* The Handmaid's Tale *in 1985, she was already a formidable force in writing, with ten novels and seventeen volumes of poetry to her name.* The Handmaid's Tale *is considered part science fiction and part social commentary on the way a state seeks to control women's bodies. Offred, the handmaid of the title and one of the few fertile women in a totalitarian theocratic state, has to have impersonal sex with her Master, the Commander, until she becomes pregnant.* The Handmaid's Tale *was short-listed for the Booker Prize.*

ATWOOD: When I first started thinking about *The Handmaid's Tale*, I felt it was too bizarre, eccentric and risky, so I went on thinking about it for four years before I finally wrote it in 1984/85. By the time it was published, reality had caught up with it enough, so that nobody considered it too bizarre, too eccentric and too risky; instead they said things like, 'How long have we got before this happens?'
MACGREGOR: Reality has caught up with it to the extent of today's stories about surrogate motherhood, but it's also about a world in which women are broadly divided into three categories:

337

the married women who are barren, the unmarried who can bear the children, the servants if you like, and the rather powerful aunts and bossy women who look after everybody else. Is that something that you think is a possibility?

ATWOOD: What you describe is merely part of that society, which is in fact a patriarchal society, within which we have the sub-society of women. The society I describe is very akin to that of seventeenth-century American Puritans when they first set up shop around Boston and Cambridge in Massachusetts. The world I predict is based partly on the declining Caucasian birth-rates, which are happening now, and partly on the rising infertility and sterility rates, which are also happening. Once you have those two things going together, people start getting very anxious about where the next generation of babies are going to come from and women who can have babies are therefore a valuable commodity.

MACGREGOR: You're getting the Arthur C. Clarke Award for Science Fiction, so the people who are giving you the award are presumably of the opinion that this is a totally impossible scenario?

ATWOOD: Of course, science fiction writers don't always think of what they do as totally impossible, but when we think of science fiction, we tend to think of space travel or black holes, and it's true that the book does not fit those categories. There's nothing in it that hasn't happened in history, that isn't happening now or for which we don't have the technology. It's not some wild invention. I call it SF, which means speculative fiction.

MACGREGOR: What's the most important thing to you about writing? You've obviously licked the

338

problem of putting the words together a long time ago. Is it now imagining what it is like to be somebody else?

ATWOOD: I don't think a writer ever licks the problem of how to put the words together. I think that writers are locked in the same kind of battle with language that painters are locked in with colours. You keep wanting for there to be more colours and you want there to be other words.

MACGREGOR: So in *The Handmaid's Tale*, what is it that you hope would be picked up by people? Is it a warning book?

ATWOOD: Some people have said to me, 'Isn't part of this book a warning against feminism? Isn't it saying that feminists have brought it on themselves, because you flash back to the past in which there were women marching and then you show this dire future, and isn't that a result of those of those nasty, bad feminists going too far?' I say, 'That's like saying that when you have those red spots on your face, the red spots have caused you to have measles.' I think that feminism is a symptom rather than a cause of anything.

Margaret Atwood's novel The Blind Assassin *won the Booker Prize in 2000.*

The Cleveland Child Abuse Scandal

Marietta Higgs interviewed by Jenny Cuffe
8 July 1988

At the time of this interview, child abuse became a matter of public debate for the first time. In 1987, the number of child abuse cases diagnosed in the Cleveland area rose substantially with scores of the suspected child victims being removed from their homes. The paediatrician Marietta Higgs was one of two doctors using a new diagnostic technique that led to 121 children being taken into care. Later that year, Justice Elizabeth Butler Sloss was brought in to chair a pubic inquiry into the allegations, which were refuted by most of the parents. Her report found that at least one-third of the children had definitely been wrongly diagnosed, with another third of the cases being uncertain. Marietta Higgs was criticised for her 'overconfidence' in the diagnostic test. This interview with Marietta Higgs took place the day after the report was published. It was the first time she had spoken publicly.

CUFFE: Did the cases come to light gradually or was there a sudden spate of child abuse cases?

HIGGS: Early in the year there was a gradual trickle of cases but in May and June the numbers did increase quite quickly. We've actually looked at what we call the index cases, that is, the children who came to our attention as cases of sexual abuse. In fact about half of them were referrals from other people, like social services, or GPs; some came

340

from schools, health visitors and so on.

CUFFE: You were using what's called the reflex anal dilatation method. Was that enough in itself to detect abuse?

HIGGS: No, it is not enough in itself. The reflex anal dilatation is a physical sign and it was one of a number of physical signs that were found in children who had been abused. I think it needs to be put in context; it's been bandied about as being a diagnostic test and it needs to be put into the context of a medical consultation. The children that we saw either were referred because other people were concerned that they might have been sexually abused, or were referred to the outpatients clinic with an apparent health problem. We are now aware that there are certain clinical conditions where sexual abuse is one of the differentials in diagnosis that you need to think of. The sorts of clinical conditions that I'm referring to are perhaps bowel problems, recurrent urinary tract infections, vaginal symptoms, behaviour problems (which is another situation that one needs to think about), poor growth and so on. Sexual abuse is one of the factors that need to be looked at. In the course of the physical examination, if the issue of sexual abuse has arisen, either by another professional raising it with you or it has come up as a cause for concern in your consultation with the family, you as part of your examination then look for signs of sexual abuse in the child. There is already a lot of other information about the child that alerts you to the possibility of abuse, before you start looking for signs of sexual abuse.

CUFFE: So you would never use that one physical

sign, reflex anal dilatation, as a reason to believe that abuse has occurred?

HIGGS: I think there is a notion that Dr Wyatt and I were actually using this physical sign as a screening method for sexual abuse, that we were lining children up, simply looking at their bottoms and claiming we saw signs of sexual abuse. It wasn't. We didn't.

CUFFE: The heart of the controversy, though, seems to be your obsessive use of that technique and your refusal to think that it might ever be wrong. The report says that you elevated it from grounds of strong suspicion to unequivocal diagnosis.

HIGGS: I think that I would take issue with that. The way that I considered the physical signs was that having taken a history, having examined the child, if the information that I had could not really be explained by any other cause apart from sexual abuse at that point, I felt that I needed to notify social services.

CUFFE: But when you make the diagnosis of child abuse, you must be aware that those children will be put through a horrific ordeal and that families will be split up. The distress involved is enormous, isn't it?

HIGGS: It was a very distressing time for the families and children although not for all of them. A number of the children in fact were quite relieved. I think the one thing I would take issue with in your question is the notion that what happens subsequently to the child is so distressing. I think one thing that has been left out of the equation at the moment is the distress of being sexually abused as an issue for the child. It is a very

difficult and distressing time when it comes to light and the consequences are serious, and therefore it is without question that one doesn't make that diagnosis lightly but one should not be inhibited from making it, if you feel that that is the right diagnosis.

CUFFE: In hindsight, Dr Higgs, would you have done anything differently?

HIGGS: At the risk of sounding inflexible, I can only say that I reached my clinical diagnosis after very careful thought and that I would reach the same clinical diagnosis in the children. The next part of the question is, what do you do then? It would be very nice to have a unit where you could deal with sexual abuse in a controlled supportive manner to the children, to the parents, to do a wider assessment. The difficulty is that we didn't have that, but what we did have was children who, in my clinical opinion, I thought were being sexually abused. I had to make a choice, of whether to leave the problem with the child or to give the problem to the professionals, in the hope that they would be able to manage it in the best way that they could.

CUFFE: Can you understand how bitter and scared those families must feel?

HIGGS: I do feel for the families, but I think I would have to emphasise that I am a paediatrician and that my responsibility is to the child. Clearly what happened subsequently needs to be handled sensitively and in a constructive manner because what we need to try to do is to assess the families, try to find ways round the problem and at the end of the day have healthy families in which children are not being sexually abused.

Marietta Higgs left her job in Cleveland three years later. She is still a consultant paediatrician. The case highlighted the lack of joined-up thinking between different services concerned with child protection. The whole issue of child abuse continues to be an issue that raises a strong and sometimes confused emotional response.

Benazir Bhutto

interviewed by Rochelle Wilson
6 February 1989

Benazir Bhutto was the first woman to lead a Muslim country in modern times. Born in Karachi in 1953 into a wealthy, landowning family, Benazir Bhutto was educated abroad, getting degrees from both Harvard and Oxford. Soon after her return to Pakistan in 1977, her father—the leader of the Pakistani People's Party and now Prime Minister— was deposed. He was executed in 1979. Benazir, who was subsequently placed under house arrest and later exiled, was increasingly looked to as the leader of his party. In 1988 she became Prime Minister. She had also agreed to an arranged marriage in 1987.

BHUTTO: When I was brought up there wasn't much sense of difference between the brothers and the sisters, and therefore I've never felt that as a woman I had to prove myself. It's been good in a way because I have not felt pressure by virtue of being a woman. I may have felt pressure by virtue of being young at times, or not having government experience, but I've never felt that I had to prove myself because I'm a woman.
WILSON: What about the majority of women in this country, do you feel that they are underprivileged, that they have difficulties to face as women?
BHUTTO: The underprivileged people—men and women—have many difficulties to face. However, I

345

know that women in my country are particularly thrilled at the victory of a sister and I hope that this government can start doing something for them. But in a closed society and one emerging from martial law, it's preferable to take things step by step.

WILSON: Many women's groups here are calling for the abolition of the Hadud laws, under which, for instance, a woman who complains of rape can actually be accused of adultery. I think it's felt that that's really the harshest of laws. Will you repeal it?

BHUTTO: It's an extremely unfair distinction we're making, because one is through willing consent—although it might not be liked—and the other is by force. The Hadud ordinance is one of the ordinances that we are considering amending in the light of Islam as a religion of justice.

WILSON: Can you do it faced with the constitutional situation that you have? You need a two-thirds majority in Parliament to do it. Can you do it?

BHUTTO: We don't seek to repeal the Hadud ordinance, we seek in the first instance to amend it. I think it would be difficult for our opposition to oppose it. The opposition is an alliance so maybe one faction would oppose it because it's an unjust law. And therefore we feel that the public debate is in order and we do feel that it may be possible to amend it.

WILSON: It's interesting that you have no women in your government. Why's that?

BHUTTO: In fact that is not correct. The deputy speaker of the National Assembly is a lady. The Cabinet at the moment is the first initial Cabinet; it is to be expanded in February and there will be ladies taken into it. But we face a larger dilemma

and that is the dilemma of the pool of talent that is available in a country where socio-functional literacy is 7 per cent. That means those who can read and understand, not just sign their signature. Where martial law has prevailed for so long, there are not many men or women who have come forward and can take part in an independent political process. And because of the strictures in society, the pool for women is even bigger and I think that is reflected in the larger composition. But I must say that the lady members of the Pakistan People's Party did very well in the elections for the National Assembly, bagging twelve out of twenty seats.

WILSON: If I could turn to more personal matters now, you're recently married and you've got a young son. Do you find that with the weight of your job you see enough of them?

BHUTTO: I always believed that it was the quality of time, not the quantity, that mattered. My father had very little time for the children but we all loved him and we all looked forward to him being with us, so the time that I do spend both with my husband and with my child is well spent.

WILSON: And you went along with tradition in entering an arranged marriage. Did that cause you a lot of soul-searching?

BHUTTO: For so many years it was an idea that I found hard to accept, but once I made up my mind for religious reasons that it was a step that had to be taken, that put an end to soul-searching.

WILSON: How big a part did the memory of your father play in what's happened to you and your determination to do what you've done?

BHUTTO: I don't think that it would be fair to think

347

of it in terms of the role that a father played. I think it would be far fairer to think of it in terms of the role of an elected Prime Minister who saved the country, defying martial law, defying death in saying, 'I prefer the gallows to compromise.' It was that act of defiance for a cause that moved so many people. Hundreds of thousands were imprisoned, hundreds were tortured, nine people burnt themselves alive in an attempt to save his life. In this sense it was the effect on an entire society, not on an individual, and I was a member of that society. Being a member of the family, seeing it close at close quarters, it affected me more, but I would certainly say what happened to me, what affected me, was not because he was my father.

In 1990, Benazir Bhutto was dismissed from office following corruption charges. She returned to power in 1993 but was again forced to resign in 1996. In 1999 she and her husband were found guilty of corruption but the charges were later quashed. At the time of going to press, Benazir Bhutto was living in exile and facing corruption charges if she returns to Pakistan.

Oprah Winfrey

interviewed by Jenni Murray
16 October 1989

Oprah Winfrey is the queen of the television public confessional. She was born in Mississippi in 1954, her childhood scarred by poverty and sexual abuse. She made it to university, graduating in speech and performing arts, and was soon a TV newsreader. By 1984, she was hosting the talk show that was to make her name. She made her screen debut in 1985 in Steven Spielberg's film, The Color Purple. *She became both the owner and producer of* The Oprah Winfrey Show, *its reputation for tackling controversial issues winning an audience of millions worldwide.*

WINFREY: My show is a forum for people expressing their innermost feelings and letting the rest of the world know that they're not alone. Whatever we are discussing, we try to get people who have experienced whatever the incident is at first-hand. It provides a cathartic experience not only for the people who are sharing the story but for people who are watching.

MURRAY: I suppose you would describe it in a way as confessional television. Does it to some extent exploit people's misery for entertainment?

WINFREY: I absolutely do not agree with that. I think that first of all it's very difficult to exploit something when so many other people share the same emotion or share some of the same tragedies

in their life. All the people who also have experienced it don't feel that—that it is exploitative. What I know is that I try to live my life with a sense of integrity and I know that people benefit by coming on the show.

MURRAY: Do you ever worry, though, that because of the very nature of television—and I'm thinking of one show in particular about marital therapy—in a way, audiences might think everything can be sorted out very quickly in forty minutes, which is a false impression?

WINFREY: I think part of the criticism of my kind of show and this kind of format is that somehow the critics believe that I think that the American public and the British public are stupid. It's absolutely ridiculous to think that any problem can be solved in an hour. What this television show provides is a forum for the beginning of confrontation. What I hope that people will get from my show is a new thought, a new idea and a new way of looking at things, so that if you watch the item on marital therapy on our show, it is not going to solve your marital problem but at least it may give you an idea that maybe you should take a step towards helping yourself. That's what it is.

MURRAY: Why are you so prepared to join in with your own confessions and your own emotions when you're talking to people?

WINFREY: Because I believe that there is a common bond in the human experience, and that that bond is simply that we all want love and to be loved. That's the basis of it. There is no pain that is singular to any human being. You know, I've been hurt, I have felt rejected, I have felt unloved, I have wished that I could be somebody else. I'm quite happy being who I

am now.

MURRAY: You talked about being sexually abused, didn't you?

WINFREY: I talked about that and the reason why I can share in my own confessions with other people is because I feel that their pain is no different than mine and by letting other people know: 'Listen, I've been hurt that way too.' It makes it easier for them to tell their story and they don't feel so alone. I was raped when I was nine years old. I remained silent about it for many, many years because I felt that I was the only person that this had ever happened to. And once I broke the silence, I kept talking about it. And now I say it to women all over the world. Because statistics in the United States show that one out of four women will experience sexual abuse. One out of four. I believe that that is an underestimation. I believe that sexual abuse occurs in homes, in families, more than it does not, and I think a lot of women have repressed it. They don't talk about it. It's this big family secret and for years I thought that it never affected me, that it had nothing to do with who I am today. But I realised it affected the way I choose relationships, it affected the kind of men I allowed into my life, it affected my behaviour in always trying to please and be liked and so forth. So the reason I share the story is because I think it will help someone else.

MURRAY: You've been a tremendous role model, I'm sure, for a lot of women. You are black, you came from a poor background and you have not been stick thin all the time . . .

WINFREY: And I'm still not stick thin.

MURRAY: Well, you're a lot thinner than you were.

Why have you become so obsessed with dieting and the way that you look?

WINFREY: Yeah, I guess I am obsessed with it. I don't think that as a fat person I hated myself, I just feel better now, I feel healthier. I feel stronger because of all the things that I have to do in my life. I do two shows a day, I need to be as fit as possible. So I made a decision last year that I was striving for a different kind of life style for myself, where I could ultimately be the best person that I could, and for me that included getting rid of the weight because for me the weight was not just an issue of fat being on my body; for me fat represented fear. It represented me not allowing myself to fly and be the woman that I know I can be. Because, see, I'm the kind of woman that never gets a headache. I never get a cold but I gain weight. I use weight as a mechanism to shelter all of my anxiety. I don't get stressed. People say, 'How do you keep this schedule?' Don't you know how? Because I ate my way through it. I always feel comforted by food and so for me losing the weight was a way to gain control of my life and to face my fears head-on.

Oprah Winfrey continues to host her daily television show. In 1996 she launched Oprah's Book Club on her show. It was a publishing phenomenon, each appearance guaranteeing best-seller sales and encouraging people across the USA to start their own book clubs. In 2000 she launched O magazine.

Glenn Close

interviewed by Jenni Murray
9 March 1989

Glenn Close was born in 1947 and won an Oscar nomination for her first film, The World According to Garp, *in 1982. Already an accomplished Broadway actor (she made her debut in 1974), she continued to perform on stage but it was her portrayal of powerful and sometimes fatally flawed women in films like* Jagged Edge *and* Fatal Attraction *that won her an international following.* Fatal Attraction *was one of a number of films that became a whole genre exploring the sexual jealousy of women. In 1989, her appearance on* Woman's Hour *coincided with the release of the film* Dangerous Liaisons, *in which she plays the scheming, revengeful Marquise de Merteuil.*

CLOSE: I think the Marquise was a brilliant woman caught in a society where women basically had no outlet except to be used and discarded. She observed this at a very young age and she decided that she was going to be a virtuoso of deceit in order to survive. I think she is struggling initially for her respect, for her dignity, and she doesn't want to be relegated to a convent again after she's been ruined by whoever it was that was going to ruin her. And I think that's actually very brave.
MURRAY: You seem to have great admiration for her. Does she have qualities that you do admire?
CLOSE: Yes, she does. I think of all the characters

353

that I've played, this is the woman that I would be very intimidated by if she walked into the room and I had to converse with her because she's so deeply witty and that's just a gift.

MURRAY: People have made comparison between this role and the last role that you played, Alex Forrest in *Fatal Attraction*. There was a huge amount of controversy around that role. Why did you take that one, what attracted you to her?

CLOSE: *Fatal Attraction* was a very, very well-written story and what fascinated me about her was that I felt she could easily be just a generalised bad woman. I thought it would be interesting to try to create a character whose behaviour was based on reality and so I did a lot of research with psychiatrists because I wanted to be sure that everything I did in that movie could happen.

MURRAY: Were you prepared for the anger that she generated?

CLOSE: Initially I wasn't because I was so subjective about her and I grew to love her, and to sympathise with her, and so when I heard that people were screaming for her blood I found it very upsetting. But, you see, the ending was changed so that in a way fed into that kind of reaction. In the initial ending, she self-destructed, she committed suicide, and I think that was the true ending for that character. She was suicidal, she wasn't psychopathic. They tacked on that psychopathic ending which made her into a monster, and that was upsetting for me.

MURRAY: It was said that she did enormous damage to the reputation of the single women, a reputation that a lot of women now hold very dear.

354

Do you believe that she damaged it?

CLOSE: I can see how people might feel that way but I personally disagree because I didn't set out to create every woman, I created a very specific woman. I think, if anything, ultimately that that movie and that character has had a very positive effect because it's got people talking about things they hadn't been talking about. It uncovered this strange anger and insecurity that I think has been kind of latent in our society, probably brought on by the 1960s and never resolved.

MURRAY: Looking back to *Dangerous Liaisons*, I'm fascinated by the acting technique. Powerful, powerful close-ups. What is the technique behind that?

CLOSE: In a very tight close-up, thought is extremely powerful. If you're thinking the thought that that character would be thinking, then that will register and it will have impact.

MURRAY: The other things apart from the performances that are particularly striking about the film are the settings and the costumes. What were those costumes like to wear?

CLOSE: It was great for me because I had just given birth. I had absolutely no figure whatsoever. I was much heavier than I usually am and without that corset I wouldn't have been able to do anything. I think actually that I was shaped very much like an eighteenth-century woman. That's probably why they had those corsets—to kind of put order in the chaos. If you look at the paintings, the women are very round and then, clothed, they have that very structured shape. And so I felt very eighteenth century.

MURRAY: So soon after having had your daughter,

where did you find the energy to do the film?

CLOSE: I think I was so excited by the company I was keeping and by the prospect of doing the piece that it never was a question of not being able to do it. I was very tired most of the time. In fact one day the director Steven Frears sent me home because I was so tired I couldn't remember my lines and that's never happened to me. It was just because Annie at the time didn't sleep through the night so I would come home after working sometimes ten or twelve hours and I'd try to stay up with her as much as possible until I would literally almost collapse and then crawl into bed. And then I'd have to get up early in the morning and so I was really burning the candle at both ends. It almost finished me physically but it didn't matter. Everything was worth while.

MURRAY: How much has she changed your perspective on life?

CLOSE: She's changed my perspective drastically. I actually think I'm much calmer now than I was before I had Annie. She has made me realise the truth of something that I heard all my life but never really understood, which is that what's important is the moment to moment. Living life is right now, it's not tomorrow, it's not six months from now, it's not the part I may have gotten or may not have gotten. It's because she's such a spontaneous moment-to-moment little being herself and I've always been very much of a perfectionist and rather single-minded. They're not too easy traits for someone else to live with but I think that Annie has mellowed me a lot.

Glenn Close has continued a glittering career on stage and screen. She appeared in the play Death and the Maiden *in 1992, for which she received a Tony award, in the musical* Sunset Boulevard *in 1994 and was Cruella De Vil in the film* 101 Dalmations *in 1996. In 2005 she joined the award-winning television series* The Shield.

The 1990s

The 1990s

Jenni Murray

It became almost a cliché throughout the 1990s for me to introduce a 'female first'. We began to wonder whether women had finally begun to crack it and at the same time to worry, slightly, whether we were perhaps talking ourselves out of a job. In September 1990 women in the Navy were allowed to go to sea for the first time, although they weren't allowed on submarines or to be deep-sea divers. Chella Franklin was the first Wren to serve during a long manoeuvre.

Despite a huge controversy that raged in the newspapers about the dangers of sending women into small, confined spaces with male colleagues—there would be affairs and distracting attractions; naval wives were among the most vociferous complainants—nothing more untoward was seen to happen than would occur in the average busy working environment.

Less so, in fact, as being cooped up together for twenty-four hours a day tended to mean less fraternisation than you'd find in an office, since any couple who fancied each other tended not to get involved as they were constantly under the surveillance of their superior officers. Later in the decade the RAF appointed its first female air commodore and the army its first woman brigadier, Patricia Purves, although women are still not allowed to fight in the front lines in hand-to-hand combat or in the tank regiment.

361

Mary Robinson became the first female President of Ireland and Tracey Edwards captained the first all-woman Round the World Yacht Race. In 1991, Stella Rimington became the first woman to head the Secret Service, MI5. Today she looks back ruefully on the way she was greeted in the press as 'Housewife Superspy'.

Later that same year Helen Sharman blasted off into space as Britain's first astronaut; Patricia Scotland was the first black woman to become a QC; Gail Rebuck was appointed first female chief executive of Random House, UK, and by the end of the decade she was head of the entire operation, responsible for the publication of 60 million books worldwide. I remember her telling me that one of the secrets of her success was to do exactly the opposite of what men tend to do. She never tried to bluff her way through her ignorance, but instead always asked the simple, straightforward question. It was a tactic that tended to leave her better informed than her peers.

Flight Lieutenant Jo Salter became the first woman RAF jet pilot, qualified to fly Tornados. Barbara Mills QC became the first female director of public prosecutions and Jackie Brambles the first woman to be a daytime DJ on Radio 1. The only women broadcasting on the station tended to be relegated to the evening or late at night—even the veteran, Annie Nightingale, had never had a really prominent slot. The change came about partly as a result of a discussion with the then head of music for Radio 1 who was shamed on *Woman's Hour* into promising to make improvements. Zoe Ball was appointed soon after as the first female DJ on the prime-time *Breakfast Show*.

On 17 May 1993, Rebecca Stevenson became the first woman to reach the summit of Everest and her achievement was topped two years later by Alison Hargreaves, who made the climb without the help of oxygen. However, later that year Alison died whilst climbing K2 and we were made only too aware of how different it still was for a woman to put herself at risk than it was for a man. Despite her incredible talent and tenacity as a mountaineer, Alison was severely criticised, after her death, for risking and losing her life because she was a mother. No one in the climbing fraternity could ever remember such a critique of any father who was killed in similar circumstances.

There were a number of firsts in politics. The end of 1991 saw Edith Cresson become France's first female Prime Minister and Begum Khaleda Zhia took over Bangladesh. Margaret Beckett was briefly the leader of the Labour Party after the death of John Smith and, of course, Betty Boothroyd was chosen to be the first woman to act as Speaker in the House of Commons. She delighted in appearing on *Woman's Hour*, relating tales of her time as a Tiller Girl and revelling in repeating her response to the MPs who weren't sure of the correct form of address. With her usual engaging quick wit she had bellowed, 'Call me Madam,' and Madam Speaker's 'Order, order' would become one of the best-known catchphrases of the decade.

And on and on went the firsts—as when the Church of England finally agreed to ordain women—all of which delighted us, but they also had inherent dangers. I'm quite convinced that it was the result of so much crowing about the

numbers of women who were suddenly 'making it' and smashing through the glass ceiling that the term 'post-feminist age' was coined, and male managers began to congratulate themselves, saying we women now 'had it all'. I would put good money on the fact that it was this thinking—that somehow 'women's issues' were passé because all the battles appeared to have been won—that persuaded the former controller of Radio 4, Michael Green, to propose a change to the title and focus of *Woman's Hour*, and we, as I said earlier, had to struggle hard to keep it.

Clearly, the women with the deepest understanding of how 'un'-post the feminist era was, and the knowledge of how far we still had to go before we were considered equal, were those with real political knowledge and a fighting spirit. One of the first calls I got when the papers got hold of the proposals to make radical changes was from Madam Speaker. 'Hello, Jenni,' growled that familiar gravelly voice, 'what do you want me to do? Bring the sisters out?'

Thus there were questions asked in the House, Early Day Motions and, together with the listener and celeb support we received, Michael Green was persuaded to change his mind. And thus began, on 16 September 1991, my years of rising at 5.30 for first a 10.30 and now a 10 a.m. start. The first week of morning programmes attracted Princess Anne, Liza Minnelli, Katharine Hepburn, Maeve Binchy, Fay Weldon, Wangari Matthai, Nina Simone and Anita Roddick as guests.

I'm told that in the early days I became something of a gay icon as young men strutted

around their kitchens just before the eleven o'clock news mimicking my 'I'm Jenni Murray and this is *Woman's Hour*'—hands on hips! Funny how you never think what the audience might actually be doing as you chatter away in front of the microphone. The poet, Carol Ann Duffy, would later describe me, after an interview about her work, as 'the head girl of England'. Perhaps that's what appealed to those boys!

The 1990s saw new trends in people's willingness to talk frankly and openly about personal tragedies that had previously been considered too private to discuss. In the early 1980s, when I worked on *Newsnight*, it had been extremely difficult to persuade women to come forward for the first film ever to examine the extent of incidents of rape and the difficulties of getting a case to court, despite my conviction and that of the contributors that we needed to make the point that there was no shame atttached to the woman. Jill Saward broke that mould in 1990. The daughter of an Ealing vicar, she was raped by two men during a burglary at the vicarage. She spoke about the viciousness of the attack and explained how angry she was that the judge in the case had claimed 'the victim suffered no great trauma.'

Breast cancer, similarly, was not considered suitable for polite conversation. Lesley Elliot came on to the programme to talk about her terminal illness and discussed how she was preparing her family for her death, writing letters and stories for her children. She astonished us by describing how her campaigning work for the newly formed organisation, Breakthrough Breast Cancer, had been criticised by locals in her home town of

365

Dorchester because her supporters had worn sashes and carried banners with the word 'breast' on them!

Liz Tilberis, a former editor of London *Vogue* and then editor of the magazine in America, joined us in May 1998 to talk about her ovarian cancer—a disease that she was convinced was connected to the fact that she'd previously had unsuccessful IVF treatment. Her two boys were adopted. I'll always remember the brave gallows humour with which she discussed her autobiography, *No Time to Die*. She'd told me some years earlier how tough it was to be a *Vogue* editor and a size 14. Ovarian cancer, she said, was the perfect diet—she'd gone down to a size 8 and could, for the last months of her life, actually wear the tiny designer clothes that came with the job. She died the following April.

Domestic violence also came out of the closet as lawyers such as Helena Kennedy and organisations like Justice for Women and Southall Black Sisters campaigned to change the laws on provocation. In a number of famous cases a man who'd murdered his wife was freed because she had nagged and provoked him. However, women who had killed husbands or partners after years of suffering domestic abuse—Emma Humphreys, Kiranjit Ahluwalia and Sara Thornton—were all given life sentences, although they were eventually exonerated, thanks to feminist analysis of the nature of provocation. A man's anger, argued the lawyers, will flair up quickly; a woman's break point tends to come about after a slow burn, but her actions were provoked nonetheless.

It would take much longer for women involved in high-profile child death cases to get justice. Sally

Clark was charged with the murder of her two children in 1998, but was cleared on appeal in 2003. Her husband, Stephen, appeared on the programme twice to express his complete faith in her innocence, his lack of trust in the evidence of the 'expert' witness, Professor Sir Roy Meadow, and his determination to come up with the proof that their children died in genuine cot deaths. There were similar campaigns for Angela Canning, Trupti Patel and Donna Anthony, all of whom were eventually freed.

In October 1996 we celebrated the programme's fiftieth birthday and invited women who were also fifty that year to join us. Clare Short and Edwina Currie bounded about in front of an audience to demonstrate that fifty was the new forty, creating no barrier to a woman's energy and ability to make a contribution. At a glittering party at the Victoria and Albert Museum we put on display the exquisite quilt made to celebrate women's achievements. The pieces had been sent in by listeners—always ready to contribute their thoughts, experiences and artistic talents whenever we asked.

There's no question that the most chilling moment of the 1990s came on 31 August 1997. It's my policy always to read books that are to be discussed on the programme (just as I see the films and plays), and I curled up in bed on the night of Saturday the 30th to read Joan Smith's *Different for Girls: How Culture Creates Women*. She'd written about Rosemary West (the mass murderer who worked in conjunction with her husband, Fred West), the model Naomi Campbell, Marilyn Monroe and Princess Diana. We were to discuss her thesis on the Monday morning.

The last words I read before going to sleep were about Diana—how she'd begun as an innocent girl, was moulded into the beautiful sophisticate, then was wounded by, but bravely stood up to, her faithless husband, and generally adored. In order to keep her fascinating mystique, argued Joan, she would need, like Marilyn Monroe before her, to die tragically young—never growing old and wrinkled. I woke the following morning to the news of the Paris car crash.

Among the more curious items that proved hugely popular with the audience was knitting with dog hair—clearly an idea that offered a solution to clearing up the mess, as well as making do and mending with it. A cookery item on making lunch from a home-delivered placenta brought a huge response, primarily of revulsion. Some of you were rather shocked when we noted the growth in the popularity of women's sex shops and looked at the history of vibrators. And in our fifth decade— which was also the era of the Spice Girls and Girl Power—we asked you to vote on your favourite, inspiring pop songs. Starting from number 10, they were 'River Deep, Mountain High', 'Girls Just Wanna Have Fun', 'Respect', 'I am Woman', 'Nine to Five', 'Me, Myself, I', 'Express Yourself', 'I'm a Woman—W-O-M-A-N', 'I will Survive' and, in the number 1 slot, 'Sisters Are Doing it for Themselves'. Annie Lennox told me she was thrilled!

Jill Saward

interviewed by Jenni Murray
13 September 1990

In March 1986 at the age of twenty-one, Jill Saward was brutally attacked and raped by burglars who also beat up her vicar father and boyfriend at the Ealing vicarage where they lived. She was one of the first rape victims to forgo anonymity in writing a book, Rape: My Story. *The two attackers were sentenced to three and five years for the rape, less than the five years imposed on them for the burglary. After the trial, the judge described Jill's trauma as 'not so great'. This caused widespread protest and discussion of the giving of evidence at rape trials.*

SAWARD: I've decided to come out and actually say who I am, because I think people need to know a name. They've got a story, but in a sense while it's still a story, it's not real. Now I've become a person to people—I'm real, and they can understand more easily.

MURRAY: There is a trend now in America for women who have been raped to come out right at the outset. Would you go that far?

SAWARD: I think I can understand why the women want to be known right from the beginning. I know that by not being known in a lot of ways, it reinforces the shame. I don't know whether it's the right thing to do or not.

MURRAY: How are you feeling now about going public and people's reactions?

369

SAWARD: It's been very interesting watching people reacting or not reacting. A lot of people whom I know are aware of what's happened, but they won't talk to me about it. They just won't mention the subject. Rape is still so much of a taboo.

MURRAY: Anonymity is often important because women fear reprisals from the rapist. What is your response to the knowledge that certainly one of the men who attacked you may be released next year?

SAWARD: I do have some sense of fear, because I know that these men are not nice men. I worry, I think, more about what will happen when they're back on the streets. But I don't think that I'm particularly afraid of them.

MURRAY: You're not afraid for yourself but perhaps for other women?

SAWARD: Yes.

MURRAY: You've expressed tremendous revulsion and anger at the press and the way they behaved immediately after the attack. What particularly horrified you about what they did?

SAWARD: I think the constancy of their presence was particularly horrendous. I had to leave my house under a blanket because everywhere I moved they photographed me; that annoyed me. An artist's impression that was done at the time annoyed me as well. It showed me dressed in clothes I wouldn't wear. I just found it totally in bad taste.

MURRAY: And yet you've allowed your story to be serialised in one of the tabloid papers. What's been your response to their using sketches this week and photographs of the three men?

SAWARD: I don't like the pictures that they've

done. I think they're in rather bad taste. I don't like the men being shown because I don't feel that they're worse than any other rapist. My reasons for taking the story to the tabloid papers is that, hopefully, I'll be able to reach a wider population of women who wouldn't necessarily go out and buy a book and hopefully I can help them to see just how you can get through rape.

MURRAY: There was this statement at the time of the trial that was made by the judge, who indicated to the court that the victim appeared to have suffered no great trauma. He was obviously talking about you. What would you say to him now?

SAWARD: I would say, if you'd talked to me at the time, maybe then you would have realised that the trauma I suffered was intensely great.

MURRAY: And what kind of things would you have told him about the trauma?

SAWARD: I would have told him how it felt to be so degraded. How it felt to not want to live any more. How it felt to struggle just coping with everyday life. And hopefully he would have understood.

MURRAY: So what would you say to other people who may have had this kind of thing happen to a member of their family or to themselves?

SAWARD: You have to bury it and bury it dead. But the only way that you can do that is to talk about it. To talk it all through, get it out of your system so it doesn't hurt any more and that way you can bury it dead.

MURRAY: And have you buried it dead?

SAWARD: I have buried it dead. It didn't really strike me at the time, but when it did it really hit home hard. I actually stared death in the face and from staring death in the face you appreciate life

371

far more. I appreciate my life far more now.

Jill Saward is married to Gavin Drake, director of communications for the Lichfield diocese of the Church of England, and they have three young boys—Myles, Rory and Fergus.

Alison Halford

interviewed by Jenni Murray
19 August 1992

Alison Halford was born in 1940 in Norwich. She was a police officer for thirty years, and in 1983 became the Assistant Chief Constable of the Merseyside Police Authority, at the time the most senior woman in the British police force. Despite nine attempts she failed to achieve the further promotion she felt she deserved and took her sexual discrimination case to the courts. She was suspended from duty in January 1992 when Merseyside Police Authority concluded that disciplinary proceedings would be restarted against her. The body made public for the first time allegations Halford had been drunk on duty while she was the senior officer in charge of the force on 24 July 1990 and she was also accused of sharing a jacuzzi with a male policeman in her underwear. The case continued until July 1992 when, after two years, Alison Halford decided to settle out of court and abandon her efforts to prove that she was denied promotion through sexual discrimination.

HALFORD: I don't agree with the expression 'caving in'. There were other matters to deal with besides the delay. First of all there was the cost to the Equal Opportunities Commission. There was no pressure on me from the EOC to settle, but I was quite appalled when I did learn that £300,000—that's half of their budget—had been spent on the Halford case. If it had continued,

bearing in mind that QCs don't come cheap and that's not being pejorative, other cases would have been penalised and personally I didn't think that was fair.

MURRAY: But one can't help but wonder whether you knew that they had information that would perhaps be damaging to you, and you suspected that you might lose. Was there ever an element of that in the back of your mind that made you want to give in?

HALFORD: No, no, not at all. I had and I will always maintain that I had an exceptionally strong case. It was a simple, unequivocal case of discrimination. Everything led to that. My Chief Constables did not treat me fairly nor did the system treat me even-handedly, which is the reason why one of the merits that has come out of this is that the system is now being looked at very carefully and new aspects have been written into it.

MURRAY: But that central question of sex discrimination has not really been resolved. Is that a matter of regret to you?

HALFORD: Clearly it would have been wonderful to have walked away from a tribunal with a judgment unequivocally saying that I was discriminated against. But quite frankly the world doesn't work like that—the law doesn't work like that. This had become a very high-profile political case and I honestly believe that I was never ever going to be allowed to win because of the ability of lawyers to delay. As it is, I think that I have a significant victory. I was offered the settlement, I was prepared to go into the witness box, I stood my ground for more than twenty-four days. I have the satisfaction of saying that, whilst the people who are my detractors

haven't got the satisfaction of saying that or doing that.

MURRAY: How much did you take the case on for yourself and how much did you do it for other women in the police force?

HALFORD: I think it was half and half. I was privileged to become the first woman Assistant Chief Constable. I achieved the job in open competition with men and I knew that I was being marginalised and rubbished behind my back, despite the fact that I was doing wonderful things in Merseyside. I know it sounds conceited and arrogant but I think I was probably one of the best ACCs that Merseyside has ever seen. My achievements will stand as witness to my own testimony on my own performance. All I wanted was to be considered for the next rank, but they never allowed me to get to the starting post and I was not therefore prepared to leave without at least saying, 'I want to know why.'

MURRAY: You talk about your competence and the good work you did there. We've heard a lot about the tangled history of the case. In retrospect, wasn't the swimming pool incident a serious error of judgment on your part?

HALFORD: Clearly it was an error of judgment. Clearly it was something that I regret but if I had not started an equality action six weeks earlier, then there would have been no swimming pool saga. The way the matter was handled was shabby and despicable. Just to put the facts in context, three days after the event, the Deputy Chief Constable, who is in fact the discipline authority of the force, having held an inquiry, decided that the matter should rest and no further action was required. The

375

Chief Constable was away at the time but he concurred with this decision of his deputy when he returned, and this decision was further concurred with by the chairman of my police authority. But then it was a leaked to a tabloid paper, which must have come from a very high level, bearing in mind the contents and the sensitivity of the story in that tabloid newspaper.

MURRAY: Throughout the tribunal we've heard a lot of unsavoury details about the whole police culture in Merseyside, particularly the heavy drinking. Did you feel when you were in the police force that you were in a way under pressure to be one of the boys to join in that drinking culture?

HALFORD: No, I think 'under pressure' is too strong a phrase. Let's remember that my pedigree goes back thirty years. You don't drink very much in uniform, but you do drink in the CID and I was a member of the CID, working in busy places such as Notting Hill and West End Central. At the end of one's shift one would go off with the lads to have a pint. That was natural and useful, and a proper way of relaxing with colleagues after a busy day in a stressful job. You couldn't say that that was really a thing that one was pressured into doing.

MURRAY: And yet it's been suggested that in a way you chose the wrong area. I think John Stalker suggested that you would have been perhaps better able to cope with a police culture in the home counties or London, somewhere where it wasn't quite so macho, quite so male.

HALFORD: If I could take issue with you, it wasn't my inability to cope that caused the problem, it was the inability of male colleagues to cope with a competent, clever, skilled professional woman.

376

Hindsight is an exact science, you only have a fairly tight window to get through for promotion and that window was beginning to slowly close. Therefore I was curious to know whether I could do a job in a provincial force. Merseyside was obviously the first one that advertised, when I was in the mood to try something different.

MURRAY: How much could the difficulties be attributed to a simple personality clash between yourself and Sir Kenneth Hoxford?

HALFORD: Sir Kenneth Hoxford would be the first to admit that he is a difficult man to work for. He will admit himself that his management style was rude and abrasive to other people besides myself. My whole point was that his style towards me was more unfair. He took things away from me, when I had the competence to do them, which I took issue with. All I can say is, as I said in the tribunal, his management style was not my management style but we're all different, and I'm not here to criticise a man who is held in high regard in the police service.

MURRAY: But there have often been comments about your tendency to cry, to get upset when arguments or disputes developed. If that kind of thing happens, can it be perceived as discrimination or just a different way of dealing with things?

HALFORD: The emotional aspect is obviously one that has been frankly milked with a view to defending the equality case. Yes, I have cried, I'll be the first to admit that, upon occasion at the way that I have been treated. The little value that has been placed on me has been quite deplorable. I think it's more important to cry and to show one's

emotion and get it out of one's system and then go on to progress rather than bottle it up. I think my capacity to cry and to have a bloody good sense of humour has seen me through two very, very difficult years, so I don't apologise for the odd tear. Maybe if some of my male colleagues cried they might be slightly better people too.

MURRAY: You have—it has to be said—been given a rough ride by some of the papers. One of them suggested that you were a lesbian and consequently unsuitable for high office in the eyes of some members of the police authority. Was there a hidden agenda?

HALFORD: I know nothing about hidden agendas or they wouldn't be hidden agendas. There was a suggestion that I was having an improper—whatever that means—relationship.

MURRAY: Are you aware, though, of bias against women who are lesbian in the police force?

HALFORD: Well, yes, but there is more bias against homosexual men, it's an issue. I feel comfortable with my sexuality, thank you very much, but it is an issue that is all bound up in equality and how we value and see each other, and it is something that has to be addressed under the whole issue of equality and even-handed treatment.

MURRAY: One of the criticisms that you made in the witness stand concerned the number of officers who retired on—I think you describe them as 'flimsy medical grounds'. Isn't it somewhat ironic that you're now retiring on medical grounds?

HALFORD: Yes, I say to you that it is an exquisite irony, but you do not go through two years of hell without having some suffering and I will stand up to anybody and say that my medical retirement

was justified. I had an arthritic knee problem, which was exacerbated by a properly recorded injury on duty. Certainly, shortly after I was suspended, which was a most traumatic thing to happen to anybody, the knee problem did deteriorate, which means that I will have to nurse it and therefore I was given a medical pension. I have not fallen into that category of abuse.

MURRAY: How much support have you had in all this from other senior women police colleagues?

HALFORD: Most of them have at least acknowledged the situation. A couple haven't and have kept their heads well below the parapet, but who can really blame them? Why should they put their career on the line? The amount of hurt and harm and damage that a senior person can inflict on a junior person cannot be ignored. I would not blame anybody for putting up and shutting up and allowing me to fight my own battle. I chose to fight it, not them; it must be my decision.

MURRAY: Might you not have set the clock back, might you prevent other women from leaving junior ranks because of the fear that they might turn out to be another Halford?

HALFORD: No, I don't accept that at all. Since I started my case four women have been made ACCs. It took from 1983 to 1991 for a woman to follow me into the rank of Assistant Chief Constable and I would suggest to you that we would not be holding the rank of six ACCs between us if I hadn't aired the problem as I aired it. And one other thing: just to show that your suggestion is wrong, look at the number of medals that have now been awarded to women officers. It was virtually unheard of for a woman to be awarded a Queen's

Police Medal and now four or five have been awarded since 1990, even an MBE. That shows to me that women are now being valued properly for the first time. I am not setting the clock back, but moving it forward quite a few clicks of the wheel.

MURRAY: What about your own future? You've been in the police force a long time. What do you envisage as a future?

HALFORD: I'm still obviously coming to terms with what has been a pretty difficult and traumatic time. It hasn't been easy to see one's career evaporate, it hasn't been easy to cope with the venom and the spite heaped on me. At the moment I propose to write a book, which hopefully should be a blockbuster. I would also like to put my shoulder to the wheel of equality because obviously over the long months I have received hundreds of letters of support both from men and women. Many women, professional women, have shared with me their own sadnesses and I would like to, if I am able, do something to keep pushing the rock of equality uphill in some shape or form.

Alison Halford took early retirement from the police force in 1992. In 1997, she alleged that her phone had been tapped by Merseyside Police Authority during the sex discrimination case. She took her case to the European Court of Human Rights and won a landmark victory, which led to a change in the law. From 1999 to 2003 she was Labour Welsh Assembly Member for Delyn.

Lesley Elliot
interviewed by Jenni Murray
7 December 1993

When Lesley Elliot appeared on Woman's Hour, *she was thirty-five, married, with three children all under seven. Her breast cancer had metastasised into what was likely to be a terminal disease. She was hugely instrumental in making it acceptable to talk publicly about breast cancer and in getting the organisation Breakthrough Breast Cancer better known. Breakthrough Breast Cancer was set up in recognition that a new approach was needed to tackle the disease.*

ELLIOT: When I first time found the lump, I was breastfeeding my youngest child Eve who was then seven months, so I went immediately to the doctor who found nothing that worried her. But I talked to friends and we decided the best thing would be to give up breastfeeding, note the changes in the breast and then return to the doctor in six weeks' time, which was what I did.

MURRAY: And still you were given reassurance by the doctor?

ELLIOT: Yes. I saw a different doctor on this occasion and he reassured me that my breasts were normal, which left me feeling happy.

MURRAY: So when you finally were diagnosed with a lump under your armpit, how did you then view your chances of recovery?

ELLIOT: To start with, I thought that if my lymph nodes were involved, that's got to be curtains. Then I found out that only two out of the twelve lymph

381

nodes were involved, which was good news. It was the first good news I'd had and that meant I could develop a positive attitude, which was what I did. I had radiotherapy and chemotherapy—Tamoxifen, the full works, and I thought, right, we're going to beat this.

MURRAY: A close friend of yours had the disease earlier. How much were you prepared for the kind of treatment that you would go for?

ELLIOT: I was very prepared. I was also very well informed about breast cancer. I'd been very much there with her. The mastectomy was something I came to terms with fairly early on, but the chemotherapy I found terribly difficult. When you're in the hospital, they inject into the vein this burning substance, which smells like bleach. I couldn't even clean the loos at home afterwards because the smell of bleach took me back to those hospital rooms. The only way I coped with that was by thinking that if I was taking my child in for doses of chemotherapy, I would wish it was happening to me.

MURRAY: You have three young children. How have you approached telling them about your illness and about the operation?

ELLIOT: We've told them all about it. They saw the mastectomy scar very early on and were terribly impressed by it, as children are. I had a big plaster so I was a bit of a hero. But things changed, a year later, when I discovered I had secondary cancers, distant metastases of the lungs. That was when I knew I was coping with a terminal illness. And then what do you tell the children? Well, we waited and after I'd had a lot of treatment, going into hospital every two weeks

for chest drains, my son asked me whether I was going to die. And I said I probably was.

MURRAY: And how did he deal with that?

ELLIOT: He asked what would happen if Daddy died as well, and I said that Grandma and Grandad would look after him. And he said, 'Don't be silly, they're so old, they haven't got long to go.' So I then pointed out that there were lots of friends and aunties and uncles who would help out and he seemed fairly happy with that.

MURRAY: You're very aware that, because they're very young now, it's going to hit them very hard, and that this is perhaps not the time that they're going to do their main grieving. What have you done to prepare them for the future?

ELLIOT: I've written three books—one for each of them, which range from a diary to fiction. This is partly written to them as they are now because it is as one would write to a child, and partly written as how one would write to an adult, so they chop and change quite a bit. They fill in all the details that I know my husband John will never remember, like when they first learnt to crawl and when they first learnt to walk and when they lost their first tooth, and that sort of thing. But apart from that, it goes on into a fictional world of a family with no mother.

MURRAY: You've also thrown yourself into a lot of hard work for a charity called Breakthrough. In fact you did this very soon after you'd had the mastectomy. Why did you in a way push yourself into a public life?

ELLIOT: Because there was an awful lot of anger deep inside me and it was either going to destroy me or I had to get it out and focus it. When I was first diagnosed as having breast cancer, my friends

383

were more horrified by my mastectomy than they ever were by the fact that I had cancer. For me, the loss of a breast—although one would have preferred to have kept it—compared with the loss of my life was nothing. And—I really feel that all the time we're too concerned with the mastectomy and the surgical modifications. I know that this has certain psychosexual implications, but it's the mortality rate that really concerns me, how many women are dying.

MURRAY: We know that the breast carries certain cultural messages. Does that affect people's attitudes to the work that you are doing now, to the Breakthrough work, where you're trying to publicise breast cancer?

ELLIOT: Oh, definitely. I was selling balloons for Breakthrough in Tesco's supermarket and people purposely avoided coming anywhere near the stall. I'm sure it's because the word breast is just not an acceptable word. People get terribly embarrassed by it and I don't think they mind you saying 'cancer' as much as they mind you saying 'breast'.

MURRAY: We've talked about the children and how you've tried to prepare them. We've mentioned your husband John. What about you and him? How have you been able to prepare for your death?

ELLIOT: We've always been terribly open about it and it's a very difficult thing. It's taking every day as it comes, making time for ourselves because that's terribly important and giving him the freedom to live a life after my death. This terrible lack of control after dying is something I find terribly difficult. I like to think I'd be there somewhere just giving my family a bit of advice, so I write it all

down. There are instructions for my funeral, and instructions for life ever after, and what to do about the children's schooling, and how to tell the girls about having periods, and how to explain sex to the children, even to the extent of stocking the freezer, so that if it happened suddenly they'd have something to eat for a few months afterwards.

MURRAY: You are working extremely hard to spread the word about breast cancer. What is the message that you most want people to hear?

ELLIOT: Women do survive breast cancer but a lot of women die from it. I want people to work towards finding a cure, whether it be raising money or working in some scientific field. At the end of the day what we've got to concentrate on is reducing the mortality rate.

Lesley Elliot died in 1994. The Lesley Elliot and the People of Dorset Research Laboratory was opened by Tony and Cherie Blair in her name at the Institute of Cancer Research in May 2001.

Betty Boothroyd

interviewed by Jenni Murray
28 March 1994

Betty Boothroyd (b. 1929) became Madam Speaker in the House of Commons in 1992. She was the first woman to hold the post in its 700-year history. Edwina Currie was allegedly rebuked by the Speaker for using the official emblem of the Houses of Parliament—the portcullis—on the cover of her novel, A Parliamentary Affair. *One of the first things Betty Boothroyd did as Speaker was to was ask Members of Parliament to be more succinct.*

BOOTHROYD: Yes, I have done this. I felt there were two reasons why we should be more brisk. One is so that I can get down the order paper more quickly and those Members who have taken the trouble of placing questions have an opportunity of being called. At the same time, of course, I have to bear in mind that the executive, that is, the government, are accountable in this House and that they must be held to account. It has paid off, I have to tell you. It's been proved by the research that I have done since I started it. I'm very pleased about it but I don't want the House to slip back into the old-fashioned ways.

MURRAY: Sir Edward Heath has said that, in his view, the House is becoming virtually uncontrollable. He's said that most Members have too little experience and the rest have no knowledge. Does he have a point?

BOOTHROYD: I think Sir Edward's been here a very long time and we always yearn for what I call 'the good old days', but I don't think the House is ungovernable. It's a very robust House. We have people come here with strong views and they want to make their views known, but there are ways and means of controlling it.

MURRAY: And what are those ways and means? [*Betty laughs*] What skills do you have to bring?

BOOTHROYD: Skills? I think, a sense of humour and a smile on one's face. The Members do have a sense of discipline. At the end of a few minutes of noise I stand up and demand order, and I find that I do get it. And if I don't get the attention that I want, I can always name people or use the standing orders to demand that they leave the House for a day or even for five days.

MURRAY: What about other skills besides the smile and the famous powerful voice? It is said that occasionally you've yawned?

BOOTHROYD: Oh yes, I can do that. You know, the job of the Speaker lies somewhere between being a bungee jumper and a trainspotter. Sometimes it's very dull and you think instead about what you're going to do at the weekend or the weekend shopping list, and you take your eye off the ball for a moment. That's when all sorts of things break loose. Then, of course, there's the bungee jumping—you never know whether you're going to jump into difficulties or not, so every word has to be guarded.

MURRAY: The headline grabber of the last few months has been Edwina Currie's alleged dressing-down by you. Were you personally angry at the use of the House of Commons portcullis for

commercial purposes?

BOOTHROYD: Not quite for commercial purposes, but for advertising purposes. That is what it was being used for, in this case to advertise something that was perhaps for personal gain. And, indeed, it was raised on the floor of the House. I didn't take an initiative there. It was raised by more than one Member who was very annoyed about it. We do regard the portcullis as something very precious and rather serious.

MURRAY: The insignia is personally very precious to you, isn't it?

BOOTHROYD: I like it very much. I wear a brooch of the insignia in the House on my gown, which I take off when I'm doing other things and wear it instead on my jacket—I certainly wear it at weekends. I must have had it for ten or fifteen years and I had it made a very long time ago. I love it and it's greatly admired.

MURRAY: Is it true that you actually gave Edwina Currie a dressing-down personally?

BOOTHROYD: I wouldn't quite say that. We had a talk.

MURRAY: It's said that she said of you that you'd joined the establishment and lost your sense of humour.

BOOTHROYD: I think I've still got a sense of humour. Edwina and I had a good exchange. I think we understand each other but it was a personal conversation.

MURRAY: You're two years into the job now. Are you still as thrilled with it as you were at the beginning?

BOOTHROYD: Yes, I am and I feel that I'm only just now getting into my stride. I'm enormously

388

privileged to have this job. I am still excited about it and I want to do it well, for the sake of all womankind. Whenever I go out of the House of Commons and meet people, so many women come up to me and make comments. I just feel that I want to do it well for their sake.

MURRAY: I know that you've also said that you're alone but not lonely. Here in your apartment, looking out over the river, we can see the balcony where all your friends must go and sit and chat. Don't you miss all that gossip?

BOOTHROYD: Yes, I miss the socialising. When I look out on to the terrace, particularly in the summertime, and Members are just taking their lunch trays out there, oh, I miss that like anything because I'm very much a social being. But I've got a lot of other things in exchange for all of that. The only time that I feel an occasional loneliness is when I have decisions to make that are very difficult. I get quality advice, but at the end of the day the buck stops with me and I have to make the decision. And there have been two or three occasions when I've looked out from my study at the Thames going by and I've said to myself: I wonder whether I've made the right decision. But I've never been in doubt for too long because so far, thank goodness, the decisions that I have taken have been the right ones.

The first time Madam Speaker presided over Prime Minister's Questions, she astonished MPs by bringing the session to a close with what became her catchphrase: 'Right, time's up.' She retired as Speaker in 2000 and is now in the House of Lords.

Elizabeth Maxwell

interviewed by Jenni Murray
29 November 1994

Elizabeth Maxwell appeared on Woman's Hour *following the publication of her autobiography,* A Mind of My Own. *Her husband, Robert Maxwell, was born in Czechoslovakia and was self-educated, eventually becoming the multimillionaire publisher of the* Daily Mirror *and a dominant figure in newspapers for decades; he was also a notorious bully. They had six children together. On 5 November 1991 he was found floating near his luxury yacht in the sea off Tenerife. It was then discovered that the Mirror Group pension fund had been stripped of more than £400 million. At the time of the interview her sons Kevin and Ian faced charges of conspiracy.*

MURRAY: It was an affair of extraordinary passion. What happened when you met?

MAXWELL: Well, it's difficult, you know, for anyone who is young now to realise the man he was then. He was a very, very attractive man. He was very forceful and very charming as well.

MURRAY: And yet very soon after you were married the cracks began to show. Why do you think he so quickly accused you, for example, of not being selfless enough in your love when he came home on leave?

MAXWELL: He had lost everything and everybody in life, and once the fighting [in the Second World War] was over, then he was entirely concentrated

390

on me. Although I resented the fact, it was an enormous demonstration of love in a way. You feel wanted. It raises you somehow in yourself that you can have this power over a man. I had enormous power on him inasmuch as he loved me, but the bullying was much more difficult to get on with. He wanted me perfect and I realise that I had shortcomings. He stretched me. He wanted so much from me that I gave things that I didn't know that I possessed. He certainly made me a better person than I was and for all of his bullying I'm grateful.

MURRAY: What about when he bullied the children?

MAXWELL: Well, when he bullied the children, that's a much more difficult proposition. It's easy for people to say, why didn't you leave him, but you can't leave a man when you've got six children under eight. You can't just go. I married for life, I didn't marry to leave when the going got tough. Then, you know, there were good moments. It wasn't all bad.

MURRAY: There is a poignant description of a visit that you made together to Auschwitz where his family had been destroyed. I wonder how much your devotion—your continued devotion—was born of guilt and a sense that a tragic past in some way excuses all?

MAXWELL: I think you cannot really judge a man in any way without really looking at what happened in the past. It's a strange thing to expect a man to be completely normal after having his entire family murdered in that way. I must say that I felt enormous guilt, enormous pity, an enormous love at that particular time and, you know, I felt very

motherly. He had lost everyone, in particular his mother. And perhaps that is part of our tragedy. We were both lovers and yet I was really a mother for him and I was a mother figure for a very long time.

MURRAY: And yet there are those now who would say that in your book you're looking back at this tragic past because you seek to excuse a man who callously stole money from pensioners?

MAXWELL: If he had a hand in that, it is a catastrophe and I am deeply hurt about it all, but I'm not trying to excuse him in the book. I'm trying just to put the man back into the context of his whole life. Something certainly went on because I can't think that an intelligent man would have done whatever he did with the knowledge of would happen not only to his family, and to me, but to all the people that he had cared for all his life.

MURRAY: But to some extent you portray him as a monster, a monster who tried to take away even your own mind. Can you look back on a man who bullied you and humiliated you in the way that he did and still love him?

MAXWELL: Love to me is not something you turn on and off like a tap. You don't say, well, he's done that and therefore I don't love him. I loved the man for all the happy times that he gave us. In spite of what anyone said, he did love me; he could, in fact, never leave me. Although he threatened to, he couldn't do it. All these parts of me still love him. He was really a Jekyll and Hyde, and of course he deteriorated in the last ten years of his life. He was ill with megalomania and it's difficult to live with a man who is always right.

MURRAY: Is this devotion of yours, do you think, a

peculiarly female trait of another age or do you see other younger women trying to hold on to a mind of their own in the way that you did?

MAXWELL: I really do come from another generation. Young women who are now in their thirties have a lot of freedom, which I didn't have. However, I think that these days there still are a great many battered wives. I don't mean only physically, because Bob never ever laid even a finger on me. And I think if he had, I would have left, as that is something that would have been intolerable to me. But there are many people who are battered mentally and they do leave these days. When it became intolerable for me—which was really in the very early 1980s, it would have been immensely better if I had left. I think that the kind of man that he was would have respected me for it, would have come home and stayed and been quite decent for a few days. It would have been a better thing than going on in this very difficult relationship. I lacked courage at that time and now I regret it.

Elizabeth Maxwell has become a scholar and lecturer on the Holocaust. In 2001 she co-edited a book, Remembering the Future: The Holocaust in an Age of Genocide. *Kevin and Ian Maxwell were cleared of conspiracy to defraud Mirror Group pensioners in 1996.*

Waris Dirie

interviewed by Wendy Austin
9 August 1995

Waris Dirie (whose name means desert flower) was one of twelve children born into a traditional family of tribal desert nomads in East Africa. Born in 1965, when she was five years old she suffered the ancient custom imposed on most Somalian girls: genital mutilation. Then at the age of twelve, when her father arranged her marriage to a sixty-year-old stranger in exchange for five camels, she ran away. After a death-defying escape through the dangerous Somalian desert she travelled to London and worked as a maid for the Somalian ambassador, until his family returned home. Penniless, and with little English, she started working in McDonald's, where she was famously discovered by a fashion photographer.

DIRIE: I had a great childhood. It was simple, it was peaceful, it was beautiful. All you had to worry about was just getting something to eat or hope nobody would get sick.

AUSTIN: You say you had no worries, but you write in your book about being raped at the age of four and that your father tried to sell you to a much older man for the price of five camels.

DIRIE: Yes, but I'm not going to let a man destroy the beauty of what I remember of my childhood, my family and my land.

AUSTIN: As you grew older, you became more rebellious and spoke out.

394

DIRIE: I don't know where that came from because in my country we're Muslim and women are more subdued. You don't make too much noise and so you don't say much, no matter what you're feeling. I used to say to my mother, 'Mum, why don't you say that,' or 'Why don't you do that,' and I used to get in trouble for it. I used to tell my father, 'I don't like it like this, or this' and he just go, 'No, no, no, girls don't do that, darling.' Not long after that he decided he had a husband for me.

AUSTIN: And your final act of rebellion was to run away?

DIRIE: Exactly. I just thought, this doesn't look like it's going to be a fun life.

AUSTIN: Why not?

DIRIE: I thought about it for half a day and I thought, OK, I'm going to have as many kids as I can until one of us dies. I'm going to be struggling all my life for survival—chasing water and food. And I just thought there was something better than this.

AUSTIN: But you did manage to find a better life through your uncles?

DIRIE: Well, it's a different life, but I don't know how I did it. I made it to the capital, Mogadishu, and a couple of months later an uncle of mine who lived in London who was an ambassador came to Somalia. Amazingly he was looking for somebody who could work for him in his house as a housemaid and I begged him and he said, 'All right, let's go,' and here I am.

AUSTIN: Seeing white people for the first time?

DIRIE: Oh God, that was funny. Pure ignorance. I really thought, you know, these people need the sun, because, I thought, you can't look like this all

your life. Look at me, I'm dark and you're white. What's the matter with you?

AUSTIN: You've got a much more serious role now as the United Nations special ambassador, which has meant you reliving some of the most painful moments of your life. Why did you decide that you were prepared to do that?

DIRIE: I knew I was going to do something with the experience. I just realised one day, what the hell is the matter with me, you know, this is really life and death. Young girls every day are being brutalised and I thought, think about how many little girls are going through what I went through. So I just let it all out.

AUSTIN: You tell the story of your circumcision very vividly. You talk about how as a little girl you wanted this to happen to you. You were very keen, nagging your mother for this to happen.

DIRIE: You think, this is the big thing, this is a part of our life. If I don't go through this, I'm nothing. To me it was a game, I was so happy for that day I couldn't sleep that night.

AUSTIN: Do you feel any bitterness now towards your mother, who had led you towards the circumcision when one of her own daughters had already died from it?

DIRIE: You have to understand. Momma is a victim herself. My mother did not want to harm me that day; from her viewpoint she was doing me good. I don't feel any anger towards her.

AUSTIN: What do you think is going to be the best approach to try to stop this practice? Recently we had the writer Germaine Greer on the programme and she was talking as if such an approach was the cultural arrogance of the West; she says that

Western governments are trying to criminalise it, drive it underground, when actually what should be happening is just providing proper medical intervention and assistance.

DIRIE: Women are still women. You don't have to be slicing her in order to make her good enough for you. All we need is love and respect and trust. Because this whole thing is about men not trusting women. One hundred and twenty million women worldwide went through this and that's a lot of women. Six hundred women are at risk every day and this is just inhumane. We don't need to be doing this.

In 1997 Waris Dirie published her autobiography, Desert Flower, *which became an international best-seller. In 1998, twenty years after running away, she returned to visit her family in Somalia and published a second book,* Desert Dawn. *She now lives in Vienna and has been appointed a UN ambassador in the fight against female genital mutilation.*

Aung San Suu Kyi

interviewed by Jenni Murray
22 May 1996

Aung San Suu Kyi (b. 1945) is the daughter of Myanmar's (Burma's) independence hero General Aung San. He was assassinated in 1947, just six months before independence, when she was two years old. She studied at Oxford University where she met and married the Tibetan scholar Michael Aris and had two children. As a pro-democracy campaigner and leader of the opposition party National League for Democracy (NLD), Aung San Suu Kyi has spent ten of the past sixteen years in detention under Myanmar's military regime, often in solitary confinement. The military government called national elections in May 1990. Aung San Suu Kyi's NLD convincingly won the polls, despite the fact that she herself was under house arrest and disqualified from standing. The junta refused to hand over control and has remained in power ever since. In 1991 Aung San Suu Kyi was awarded the Nobel Peace Prize for her efforts to bring democracy to Myanmar. This interview was conducted by telephone.

MURRAY: Last year the Foreign Office minister, Jeremy Hanley, told the British Parliament that the Burmese people would gain experience of the democratic principle through commercial contacts with democratic nations like Britain. What is your response to that kind of idea?

KYI: We already have experience of democratic

principles. When Burma became independent in 1948, we became independent as a democracy. I do not think we need businessmen to teach us the principles of democracy.

MURRAY: How much has your release and your profile around the world encouraged companies to think that it's OK now to invest in Burma?

KYI: I don't think it has made much difference. The countries that have invested and the few businesses that are investing would have done so anyway. They are the ones that would have done so whether or not I was released.

MURRAY: Why were you released or why was the offer of release made, do you suppose?

KYI: I don't know. It is possible that they did expect my release to bring in a lot of investment, which of course it has not, and as you probably know there is a great move now going on against business investment in Burma, so I do not think things have turned out as happily as they thought they would.

MURRAY: There was a time, at the time of your so-called release, when you wanted a joint approach with the regime to try to sort out the problems of the country. Is it still realistic to expect any kind of dialogue with the junta?

KYI: No authoritarian regime is ever keen on dialogue. They never like to take part in negotiations that will end up with any loss of power on their side, but in the end such negotiations do take place, so I think it is quite realistic for us to suppose that we will end up at that negotiation table. Of course we can't say when that will be. But as I've said frequently, the intelligent ones get to the stage of dialogue more quickly than the ones

who are not so intelligent.

MURRAY: How likely is it as, one assumes, the people's chosen leader that you and your party can achieve democracy?

KYI: It is very likely. In fact, we are absolutely confident that democracy will be achieved, although we cannot say when, partly because this is the trend in the world, and partly because the Burmese people have demonstrated very clearly that what they want is democracy. I think the will of the people, expressed so strongly, is bound to come to fruition some day. The League for Democracy is the party that received the mandate of the people in 1990. The regime decided that they would ignore the results of the elections because the results were not to their liking but they cannot ignore them because the results do represent the will of the people.

MURRAY: The army did warn last year that they would annihilate those who disturbed the peace of Burma. Do you personally fear annihilation or are you too well known a figure now around the world not to feel personally at risk?

KYI: They've always been saying that they will annihilate us and it's one of their pet phrases, although I do not guarantee that they will not try to assassinate me, if that's what you mean. I do not think about that question.

MURRAY: But how brave does a Burmese have to be openly to support the National League for Democracy?

KYI: That is very difficult to say. One can't really measure people's bravery but certainly there is a lot of pressure and there is a fear of persecution, fear of imprisonment, fear of torture, fear that their livelihood will be taken away. There is a lot of fear

about, so people have to work at overcoming fear all the time.

MURRAY: Where do you find the courage to do what you do?

KYI: I've never thought of myself as particularly brave. I think of myself as just doing what I do have to do. The kind of answer you will get from my colleagues, who have had to make far greater sacrifices than I have, is that they are just doing what they feel they have to do.

MURRAY: But when we in this country look at the situation that you find yourself in—we know that you've missed your sons' adolescence, their entry into manhood—it almost seems impossible that anything should be worth that kind of sacrifice. Is it worth it?

KYI: It's not much of a sacrifice compared to what other people have had to go through. My colleagues who are in prison do not have the comfort of knowing that their children are safe and yet they went on because they believed in what they were doing. Of course if one thinks of one's family, one misses them, but if you have to work as hard as we have to do in Burma, you really do not have much time to indulge in your own personal emotions.

In 1999, Aung San Suu Kyi's husband died of cancer. He had been refused permission to visit his wife in Myanmar; the military authorities offered to allow her to travel to the UK to see him on his deathbed, but she felt compelled to refuse for fear she would not be allowed back into the country. Aung San Suu Kyi is still under house arrest.

Sara Thornton

interviewed by Jenni Murray
17 June 1996

The Sara Thornton case was one of a number of high-profile cases in which women killed their partners, sometimes after many years of violence, which led to a change in the courts' attitude to provocation.

Malcolm Thornton was an alcoholic and, during their eighteen-month relationship, he was constantly violent and abusive to both Sara and her ten-year-old daughter, Louisa. On 14 June 1989, she stabbed and killed him. At the trial, Sara pleaded guilty on the grounds of diminished responsibility, a plea that focused on her own state of mind rather than the batterings she had received. She was found guilty of murder and sentenced to life imprisonment.

After several appeals, in May 1995 Michael Howard, the Home Secretary, granted a further appeal. On 28 July 1995, Sara was freed on bail pending appeal. In December 1995, her murder conviction was quashed on the grounds that the judge at her original trial had not directed the jury to consider all the relevant characteristics in the provocation defence and ordered a retrial.

On Friday, 29 May 1996, Sara was found not guilty of murder by a jury at Oxford Crown Court. They found her guilty of manslaughter but did not indicate whether it was on grounds of provocation or diminished responsibility or a combination of both. As she had already served over five years in custody

402

she walked free from the court.

MURRAY: Do you accept that there was perhaps an element of madness in what you did, at the time you did it?

THORNTON: Yes, I think that anybody who kills somebody else must be relatively unbalanced. I don't think you can kill and be logical and cold and a perfectly normal human being.

MURRAY: So why object then to the concept of madness?

THORNTON: It's too wide-ranging as a term and I think people in this country have a great fear of madness. I don't want to be seen as a madwoman. I've got a life to lead now.

MURRAY: You were also painted, or have been painted on numerous occasions, as a scarlet woman. I notice in your letters you say that you have a healthy disrespect for authority and your probation officer frequently exhorted you to be good. How do you think this influenced the hearing that you had?

THORNTON: I think it's easier to convict a woman of murder if she can be seen as bad anyway. When I say I have a healthy disrespect for authority, what I mean is that I don't just accept straightaway what authority tells me. I like to evaluate it and see how it fits with what I feel.

MURRAY: Are you bad?

THORNTON: No.

MURRAY: But a lot was made of the fact that you'd only known your husband for two years and you'd been married for just ten months, so the provocation of beatings over a period of ten months couldn't have been great. How do you

403

respond to that?

THORNTON: I think that for me personally there was a lot of provocation because of the vulnerabilities that I had as a human being. I grew up believing that my sense of self-worth was based on how other people treated me and so the more badly Malcolm treated me, the worse I felt about myself. This, to my mind, helped a great deal to bring me to a point where I couldn't take any more.

MURRAY: But a lot of people will ask themselves, how come an articulate intelligent woman, with another home—which she actually owned—to go to, didn't simply leave, especially when her daughter was begging her to? Why didn't you go?

THORNTON: I think that that's quite complicated. There isn't just one issue there. I loved Malcolm very much. I was very frightened that if I left and he did hurt himself, I would feel tremendous guilt for the rest of my life, which I wouldn't have been able to live with. Also towards the end I got so tired that just trying to formulate my life from day to day took tremendous energy. The thought of actually uplifting everything and moving to Coventry, taking Louisa out of her school where she was getting tuition for dyslexia, was just too much.

MURRAY: You have always said that you wanted to be punished. I wonder what you think you deserve to be punished for, if you are suggesting that your crime is excusable on the grounds of provocation?

THORNTON: I think this again has a lot to do with my childhood and the way I was brought up. I learnt very early on to accept guilt and when I went into prison, full of self-hatred, I felt that self-hatred needed punishment because hatred and punishment go together.

MURRAY: But there are people now who are saying that cases like yours are giving women a licence to kill?

THORNTON: Men have had a licence to kill for a long time.

MURRAY: So are you saying that you have got a licence to kill and that's OK?

THORNTON: No, I don't think so. I think that nobody should have a licence to kill.

MURRAY: Since you've been released, some say you're a feminist icon. There are others who say you're an absolute insult to those who've resisted the temptation to kill a violent partner. Which are you?

THORNTON: I don't think I'm either. I don't want to be an icon or a martyr—that implies a degree of suffering. I don't think that I'm an insult to women who've resisted the need to kill. If they believe that, then that's their belief system. There's nothing I can do to change that.

MURRAY: Why didn't you resist the need to kill?

THORNTON: It was never a thought. I never thought, I'm going to kill him. I didn't plan it, so it wasn't a case of resisting a conscious thought to kill.

Germaine Greer and Julie Burchill

interviewed by Martha Kearney
1 March 1999

Germaine Greer, born in 1939, has been a leading feminist voice since her book The Female Eunuch *was published in 1970. It laid down a challenge to women that the personal is political and that the battle for liberation began with women's bodies and their relationships.*

Julie Burchill, born in 1959, has long been the enfant terrible of Fleet Street and a leading controversial columnist in many national newspapers. She was known as the queen of the Groucho Club in London and in the 1980s wrote the blockbuster Ambition.

In her new book, The Whole Woman, *Germaine Greer argued that in many ways life has got worse for women and says it's time to get angry again.*

KEARNEY: Julie, what do you make of Germaine's new book?

BURCHILL: What I find disappointing about this book is that it seems to be part of the search for authenticity that now marks so many areas of thought—hugging trees and stuff. I think the reliance on nature to do the right thing by women is a terribly misguided one. If we had relied on nature we'd all be dying in childbirth at twenty-nine and always pregnant. I just don't think nature is to be trusted.

KEARNEY: Is this something that you're saying, Germaine?

406

GREER: I don't actually mention nature, but it's Julie's way of translating my concern for the body, so I can see what she's saying. I don't think that nature will do the job for you. You've got to know what you want from the technology and you've got to say not, 'Oh gosh, I've got to have my ten-week scan because they say I have to have it,' you have to say to yourself, 'Well, do I really want to meet my child on television or do I want to be able to say this is my pregnancy, I'll handle it.'

BURCHILL: I find it very surprising that Doctor Greer is against things like caesareans or cosmetic surgery, but doesn't seem to believe that the African and Arab custom of cutting off the clitoris and sewing up the vagina with barbed wire is really all that bad. She says in her book that penetration of a tight, dry vagina causes pain, but that pain can become indistinguishable from pleasure in a state of sexual arousal, which to me is straight from a Black Lace novel and it made me very, very angry.

GREER: Oh well, I anticipated this. The principal argument of the chapter on mutilation is that we in the West practise mutilation.

BURCHILL: It's not the same.

GREER: But we don't recognise it for what it is.

BURCHILL: So you're saying a nose job is like having your clitoris cut off?

KEARNEY: In the book you make the comparison; you say that mutilation occurs in Western societies just as it does in African societies.

GREER: There's a specific sentence there. In America if a baby girl is born with a clitoris that is deemed to be outsized, it will be bobbed by a surgeon but when she's newborn. The problem with female genital mutilation is that it comes in all

shapes and sizes. Some of it is simply ceremonial and some of it is actually devastating. It's certainly not true that vaginas are sewn up with barbed wire. One of the things I have to do as a feminist is take other women's evidence. When Sudanese women tell me that they get a great deal out of sex, I cannot tell them that they're lying, I can't do that.

KEARNEY: Let's move on to some of the broader points that Germaine was making. Do you agree, Julie, with this idea that things have got worse for women in many ways?

BURCHILL: No. I think there's a long way to go and there's lots to be angry about, but I think we degrade how much has happened and, specifically, what young women are like today. I also have very little sympathy for the type of middle-class teenage girl that Dr Greer talks about. They should stop listening to Alanis Morissette and pull themselves together.

KEARNEY: But aren't there role models for women of all classes? We're constantly seeing supermodels—

BURCHILL: I know but I don't think we should mistake supermodels for real life; it is just a gorgeous, freakish side-show. I care about who Cindy Crawford gets engaged to, I don't know why, but I just like her. However, this isn't the way that women should look; men have thought it up. It's what twelve fags in Paris, New York and London think women should look like. You know, if we want to let male homosexuals have that much influence over the way we look, more fool us. But it is not the fault of men generally. Men are very sweet because they will often say something like, she's too thin. No woman ever says, she's too thin, but men often say

that.

KEARNEY: How about Germaine's idea that men actually hate women more than they used to?

BURCHILL: In my experience men are desperate to get married. They're desperate to make you settle down. They want to marry you from the moment they meet you and then you have to dump them. They always want to get married. I bet lots of them wanted to marry Germaine as well.

GREER: No, they never did, this was a problem I did not have. Most men had more self-preservation than to think marriage to me was a going concern . . . One of the other issues is that you have to be young—young, young, young, young. During the run-up to this book, all I hear is, 'Oh, she's sixty, what can she know, she must be out of it, she's lost the plot.' No one ever stopped to think, how outrageous to say such things. You wouldn't say that about a sixty-year-old Norman Mailer, or a sixty-year-old John Wayne or whoever.

BURCHILL: Oh, they were always saying that about Ronald Reagan, that he was an ancient old duffer.

GREER: Not at sixty, they didn't, sixty's kind of young. There is no role for a woman to play who has reached a certain age. She becomes socially redundant and the terrible thing is that, under current predictions, I've got another forty years to live. Forty years of having lost the plot is not going to be much fun.

Julie Burchill is currently a Times *columnist and in 2004 published a teenage lesbian romance novel,* Sugar Rush. *Germaine Greer is currently a writer, academic and broadcaster. She walked out of* Celebrity Big Brother *in 2005.*

Monica Lewinsky

interviewed by Jenni Murray
10 March 1999

This was one of the rare occasions when much of Woman's Hour *was given over to a single interview.*

In 1995, Monica Lewinsky (b. 1973) was an intern in the White House. In January 1998 the news broke that Linda Tripp, a former co-worker, had Monica on tape, talking about an illicit affair between Lewinsky and President Bill Clinton. Eventually Lewinsky was granted immunity from prosecution, in exchange for detailed testimony of her liaisons with Clinton, who, in public and under oath, had denied any sexual relationship. When Clinton was forced to admit an 'inappropriate relationship,' the House of Representatives impeached him.

LEWINSKY: Fortunately my father and I have been able to patch up our relationship over the past year, but I think, growing up, I was a very loving little kid who always wanted to be Daddy's little girl. My father, having been raised by German parents, is quite reserved, and reserved in the way he expresses his emotion. I couldn't quite understand that he loved me, but he loved me in a different way than I wanted him to show it. He and my mum had different ideas of how to raise a child. So I spent most of the time with my mum, as my father was always working, so it seemed that she was the 'yes' parent and he was the 'no' parent.

MURRAY: But he had an affair as well, didn't he,

with somebody at work? How did you react to that?

LEWINSKY: Not well. I felt betrayed and it was a painful experience for me. The way I found out, was—really, within the hour of finding out that my parents were going to be separating for divorce so it was not pleasant.

MURRAY: When you had gone through college and it came to deciding what kind of a career you were going to have, up came this question of going to work at the White House. Your interest was in psychology, not politics. Why did you decide to apply for the intern's job?

LEWINSKY: I had wanted to go to graduate school for forensic psychology and decided that I needed a little bit of a break before I went for five more years of school. The grandson of a friend of my mom's had done the internship and had enjoyed it. So it seemed a once-in-a-lifetime experience opportunity that I might learn from.

MURRAY: It must, though, be a job to die for. Every young person in America must want to get that job. Why do you think you got it? Was it because you were able to pull strings in the White House?

LEWINSKY: I think that was part of it. We had this family friend, but I also had a friend whom I had met working in Los Angeles, who was working at the White House and who put in a good word for me. But I hope that some of it had to do with my application since my position was writing letters for the Chief of Staff. I think they were pleased with my writing ability.

MURRAY: When you arrived, there were rumours about the President, that he might be a womaniser,

411

indeed, a serial adulterer. Did it ever occur to you that getting involved with him might be a very bad thing for you?

LEWINSKY: Of course it did. When I first went to the White House, that was the furthest thing from my mind—the idea of having a relationship with the President. I didn't find him remotely attractive and couldn't understand what everyone else was talking about, until I saw him in person. I think when the flirtation started, which was really a surprise to me, it was exciting. And I think unfortunately because I was so young I didn't see it as clearly as I should have.

MURRAY: But you had been there before. You'd had a long and painful relationship with someone else, whom you had met before he got married but the relationship had continued whilst he was married. Didn't it occur to you not to risk it again?

LEWINSKY: I'm sure it did and those are the issues that I'm working on now in therapy. I think I didn't have enough feelings of self-worth, in order to be number one in a relationship, so that I sort of felt more comfortable in that situation—not consciously but subconsciously, I think . . . There was a level of excitement for me about it being the President when it first started, but I came to see him quite quickly more as a man than as a President.

MURRAY: You said you didn't really find him attractive at first. I haven't met him, but people who have met him have described this extraordinary fatal charm that he has. What is it, what's his secret?

LEWINSKY: I don't know. What I felt at the time was that he was someone who was very comfortable

412

with his sensuality and allowed that energy to emanate from within. That's what it was for me.

MURRAY: But when you get the full Clinton, what do you get?

LEWINSKY: Tingly. What he did with me is no different from what he's done with millions and millions of other women. He loses the smile, the eyes become intense, there's an animalistic stare. You sort of feel like he's undressing you with his eyes.

MURRAY: You talked about when your father had his affair and how betrayed you felt. Did you never think for a minute, if I get involved in this, I'm doing the same to another girl, to Chelsea?

LEWINSKY: I'm sure on some level I did think that. I think people can understand that when we're doing something we shouldn't do, a lot of times we trick ourselves into believing certain things. In retrospect it certainly is something that weighs on my mind a lot more now than it did then.

MURRAY: And his wife?

LEWINSKY: Yes, more, I think, than for Chelsea, because she means so much to him and I can only imagine how painful this has been for her. I have a lot of guilt about that.

MURRAY: Some people have been terribly shocked at the kind of things that have come out. The fact that you appear to have set your cap at him, that you revealed your underwear to him and some of the things that you did together. They say, well, she was a shameless hussy. Were you?

LEWINSKY: No. I'm comfortable with my sexuality. I don't think I'm a hussy.

MURRAY: But did you suspect he was using you?

LEWINSKY: No. I think there were some occasions

413

when I felt slightly uncomfortable, but no different from any other relationship. This relationship was a lot more than just the physical intimacy. We spent a lot of time just being emotionally intimate.

MURRAY: If there really was something special and different about this relationship from other relationships, what was the key to his interest in Monica Lewinsky?

LEWINSKY: I don't know. I don't know much about his other relationships with other women. I'm sure he's had them but—

MURRAY: You suspected there was a girlfriend who was away, when he first—

LEWINSKY: Yes, I mean, that was my initial thought. When we first connected, we were both pretty comfortable with each other quite quickly and I think there was some sort of familiarity there, so that for some reason I saw him more as a man than as a President. I just treated him like a regular person and I think that was refreshing to him.

MURRAY: I think some people have been surprised to learn that whilst it was going on, you had an affair with somebody else.

LEWINSKY: I had a relationship with someone else, it wasn't an affair.

MURRAY: You got pregnant and had to have an abortion.

LEWINSKY: Yes.

MURRAY: Which must have been terribly hard for you, but how, if you were so in love with the President, could you have a relationship with someone else?

LEWINSKY: Somehow as a woman I'm questioned about this, yet the President was already involved

414

in at least one other relationship—with his wife, and yet I'm somehow questioned almost in a negative way as to why I might be trying to look for a more fulfilling relationship with someone who was single. I could also see how unhappy I was a lot of the time, especially having lost my job.

MURRAY: I think anybody reading that relates to it and remembers a time when they too became temporarily unhinged at someone not calling them. Do you look back on that as a period of being ever so slightly off your head?

LEWINSKY: Oh yes. I look back on a lot of this relationship and see it in different parts. One of the reasons that I spoke about having had the termination in the book was that I felt that it was important for people to understand what was going on in my life right before I made the horrible judgment of confiding in Linda Tripp, which was out of character for me. Not necessarily to talk about the relationship but to choose to confide in someone in whom I didn't have much trust, with whom I didn't have a long-standing relationship. I think I was clinically depressed at the time and unfortunately I didn't have the wits about me to seek the kind of help that I needed. I think that my reactions were in part out of control and I'm embarrassed about that. It was hard for me to have that put down on paper; it's not something I'm proud of.

MURRAY: You see, the dress is another question. I can understand the phone calls you made and I can understand you almost wanting to batter down the gates of the White House, but what happened to the dress was kind of yucky. Why did you keep it?

LEWINSKY: This is one of the things, especially in

415

America, that I was really grateful to finally have the opportunity to clear up. I don't know about over here, but over there, there is this notion that I had 'saved the dress' and kept it as souvenir. The next time I went to put the dress on, I had noticed that it was soiled.

MURRAY: But you didn't notice it at the time?

LEWINSKY: No, gosh, no—not at the time. I wore the dress out to dinner that night. It was something that you might not even notice, it's sort of embarrassing to talk about. I'm sorry but it was not very obvious. I think it's no secret to anybody who reads the book that my weight has fluctuated my entire life. I had gained weight and I couldn't button up the dress so in frustration I threw the dress back in the closet. Then I lost weight and was going to wear it at Thanksgiving. It was then that Linda said to me, 'Oh, you can't wear it. Don't clean it etc.' I thought it was rubbish until she said to me, 'You look fat in the dress.' That was all I needed to hear to not wear it.

MURRAY: Did you never think, though, that you could use it as revenge?

LEWINSKY: No.

MURRAY: Your father's been very outspoken about the President in the last twenty-four hours. He clearly places the blame on the President and says he was totally irresponsible to have an affair with someone as young as you. Is that really where the blame should lie?

LEWINSKY: I don't think all of the blame should lie with the President. I, of course, have to take responsibility for my actions and there are also other people who need to take responsibility for how this became public knowledge. But when you

look at just the relationship, I think he was more responsible than I was, although I certainly needed to take part of the responsibility.

MURRAY: How did you react to what he said last week: that he apologised and he hoped you would have a good life?

LEWINSKY: I appreciated it. I was also sad because I now look at him and I think, gee, I've heard that tone of voice, I've seen that look before, I've heard those sentiments before, and it wasn't true, so I don't know any more when he's being honest and when he's not.

MURRAY: Aren't you furious with him?

LEWINSKY: Some days. Some days he makes me sick to my stomach. I think I will have a lot of hurt for a long time to come as a result of what he said about me to his aides. I thought, the White House is saying all these things about me—the 'Nuts and Sluts' sort of image—and I thought, he's either directing it or he's turning a blind eye to it. And it was heartbreaking to me to learn that he was the one who had initiated it.

MURRAY: And is it a daily battle to go out and face the world because you wonder what they're thinking about you?

LEWINSKY: I sort of pretend I have blue hair, and that's why people are looking. If I start to get so internal, I'll never leave the house. So I have to try to begin to rebuild my life in some way and try to focus on who I am and what my constitution is.

MURRAY: I suspect it's quite a strong one underneath.

LEWINSKY: Stronger than I thought, certainly. My father is a radiation oncologist and we've all, in my family, reminded ourselves almost every day this

past year that what we're going through is not more difficult than someone who's facing a terminal illness.

Monica Lewinsky is currently taking a master's degree in psychology at the LSE in London. The only other item in the same programme was an interview with then little-known author Joanne Harris about her new novel Chocolat.

Dame Stella Rimington

interviewed by Martha Kearney
27 April 1999

Dame Stella Rimington (b. 1935) was appointed the first woman Director General of MI5 in 1992 and held the post until 1996. She was also the first MI5 chief to be publicly named after a campaign by the British press to identify her and encourage more transparency in the security services. She was made a Dame in 1996.

RIMINGTON: The decision to publish my name was one that I thoroughly approved of and it was taken because I was the first Director General to be appointed under the Act of Parliament that made my job a statutory position. However, I think we didn't really anticipate quite how much interest there was going to be and the level of press coverage that drew attention to me and particularly to where I lived. At the time we just lived in an ordinary London street, but very rapidly, because the press drew attention to where we lived, we had to move and effectively go underground, which was a rather strange reverse when one had been trying to be more open.

KEARNEY: 'Living underground': did that mean you had to change addresses?

RIMINGTON: Yes, we had to sell that house and go somewhere where we actually lived anonymously. It was a rather strange reversal, because we'd always just lived like anybody else in an ordinary

419

London street and my neighbours just thought I was that nice quiet lady who went off to work every day like everyone else.

KEARNEY: How did you get into all of this? You studied English at university and then worked as an archivist. How were you recruited?

RIMINGTON: I was recruited by the usual method of those days and we're talking now about 1969, which was a tap on the shoulder. I had given up my job as an archivist when my husband was posted to a job in the British High Commission in New Delhi. As women did in those days, I stopped work and went off to be a diplomatic wife. However, after a bit, when we'd done all the things one did in India in the 1960s, I began to get a bit bored. That was the moment when I received the tap on the shoulder, from the person who was then the MI5 representative in the High Commission in New Delhi. They had got too much work to do and wanted someone locally to help. So I started as a sort of locally engaged part-time clerk typist.

MURRAY: So what did he say to you: 'How do you fancy becoming a spy, Stella?'

RIMINGTON: I jokingly say that he said, 'Psst, do you want to be a spy?' but in fact he didn't. He said, 'Would you like to come and help me out with a bit of clerk typing?' And he didn't actually explain to me at the beginning what the job was about. It was only when I joined that I realised that I'd actually been recruited as a part-time member of MI5. When we came back to London, of course I had to decide whether to go back to being an archivist or whether to look for a full-time job in MI5, and for me there was absolutely no contest. I thought MI5 would be more fun and that was really the level of it.

420

KEARNEY: You really thought it would be fun?

RIMINGTON: I thought it would be fun and it was a wonderful career. I loved every day of it. Obviously it had its dark sides but it was a career that I really, really enjoyed.

KEARNEY: How unusual was it for a woman to be working in MI5 then?

RIMINGTON: There were quite a lot of women working in MI5 but they were regarded as second-class citizens. I have to say, in those days there were two career structures—one for men and one for women, and as a woman one could never really rise beyond being what was effectively a support worker. One was thought to be OK to deal with the papers and make the tea, but women were not regarded as suitable to do the sharp end intelligence work, to recruit; that was regarded as men's work.

KEARNEY: Has that changed now?

RIMINGTON: Oh yes, that's changed totally. It changed gradually over the years. I remember being told at one stage by one of my bosses that dangerous work was not for women. However, all that's changed now and women do all the jobs that the service offers. Of course they do them differently from men but, I would say, they do them just as well and they provide the diversity that an organisation needs.

KEARNEY: Do you think sometimes that women might be better at the sharp end, in recruiting agents?

RIMINGTON: One of the things that people say about women is that they are very good at interpersonal skills and you do find lots of women in business in the human resources function, so I

think women are very good at personal relations.

KEARNEY: But isn't infiltrating a terrorist organisation rather different from working in a personnel department?

RIMINGTON: Yes, it is different, but ultimately what you are doing is assessing the people, working out what particular approach will appeal to them, giving them confidence and guiding them, because the sort of agents that I'm talking about are recruited for the long term. They're not just people who ring up and give you a bit of information, they're people whom you effectively take on and direct for a long period and who give you vital information from the inside of the organisations that you're trying to penetrate.

KEARNEY: Who in the end makes a better kind of spy? Is it the flashy James Bond figure or is it somebody with a background more like your own?

RIMINGTON: If you're talking about people who work in MI5, the last kind of people you want are the flashy mavericks—the James Bond types. You're looking for people who are well endowed with sound common sense, whom you can rely on to do sensible things when they find themselves in unexpected situations. They're people who will obey the rules, obey the law, but who are able to think on their feet. But of course the other side, as you implied, in intelligence work is assessing what you've got. You've got to sit down and analyse, work out very carefully what it all means, before action can be taken to stop the bomb going off or whatever it is.

Stella Rimington caused huge controversy when she decided to publish her memoirs, Open Secret: The

Autobiography of the Former Director-General of MI5 *in 2001. She reignited the debate about whether former intelligence staff should be bound by lifelong confidentiality agreements. In 2004 she published* At Risk, *a novel about a female secret agent. A second novel,* Secret Asset, *was published in 2006.*

The 2000s

The 2000s

Martha Kearney

Before the programme each morning we get briefed by the producers. It's also a time to gossip (don't tell the editor), swap recipes—yes, really—and discuss the state of the world. The other day as we talked about a history discussion, the producer and I concluded that there'd been no better age to be born as a woman, and perhaps no better country to be born in than Britain. In general we don't face dying in childbirth, spending our days fetching water or being excluded from political and business life. As juggling work and home seems increasingly stressful, perhaps it's good to remember the benefits of twenty-first-century life for women.

The new millennium didn't start on an optimistic note. There were all sorts of superstitions that bubbled to the surface, showing that twenty-first-century woman was not that different from her eleventh-century counterpart; she just had more bells and whistles that could potentially go wrong. Technological fears centred on the so-called millennium bug that might cause the meltdown of computers across the world and the ensuing chaos of there being no working bank machines, petrol stations or telephone systems. In the event, the world held its breath—and let off probably the biggest transworld, cross-time-zone firework display the planet had ever seen. Next day the hangovers were equally massive and of course the various groups of end of worlders who had seen in

the new millennium on the top of a hill, confident that it was their last dawn, had to sheepishly come down again.

There was no apocalypse. But the first years of the decade have been a turbulent time for the world in many different ways. Terrible natural disasters happened across the world, including floods and earthquakes that were breathtaking in their size with millions left homeless in China and South-East Asia. A heatwave in Europe left thousands dead. Forest fires raged out of control across the globe and in December 2004 the tsunami in the Indian ocean claimed more than 225,000 lives.

Woman's Hour looked back at what had been achieved in the twentieth century for women and ahead at what the future might hold. A series talking to women centenarians evoked memories for many listeners. In July 2005, after a campaign by Betty Boothroyd, the Queen unveiled the memorial in Whitehall to women in the Second World War.

The programme also imagined what women's lives might be like in another hundred years. The internet had become such a part of our lives that we wondered how we had ever managed without it. *Woman's Hour* launched its own website and podcast, and it seemed that modern twenty-first-century woman was happy to conduct parts of her life online—with the launch of Friends Reunited and eBay. And was it just a feeling or were our lives actually speeding up? We seemed to be better off but time poor. The furious pace of modern life was extended to romance with the introduction of speed dating.

In 2000 a fashion for 'reality television' appeared, which slowly came to dominate our televisions and would fascinate and horrify us in equal measure—the first *Big Brother*. As the decade wore on every combination was tried in which the ordinary person sitting at home got to vote for their favourite, sometimes with surprising results. Celebrity and amateur couples ice skated, danced, sang, visited the jungle and cooked for our entertainment and our votes.

The geopolitical world also rocked on its axis. On 11 September 2001 terrorists changed the political landscape for ever with the attack on the World Trade Center. New political alliances and enmities were formed. Suddenly the world grew smaller and nowhere seemed to be safe. There were terrorist attacks and bombs in Bali and Madrid. In July 2005, London was attacked. In February 2003 there were anti-war demonstrations across the country, yet in March the war on Iraq was launched.

Woman's Hour looked out into the wider world with special items from different countries including Afghanistan. That was one of my most interesting experiences at the BBC. I went inside the women's gaol in Kabul and talked to young women who'd been imprisoned under sharia law for marrying someone of whom the family disapproved. I also went out wearing a burqa and could convey on radio how claustrophobic it felt, whereas on television it would just have looked comic.

News from Iraq also became important. Akila Al-Hashemi, who was interviewed on her appointment to the governing council of Iraq, was murdered on 25 September 2003. The twentieth anniversary of

Live Aid in 2005 offered a chance to look at both the progress and the failure in combating poverty in the developing world. Birhan Woldu, a child who featured in the original Live Aid campaign and was not expected to live, appeared on the programme, now twenty-four and thriving.

There were still many women 'firsts' and *Woman's Hour* was there to mark and celebrate them. The first women to conquer the North and South Poles sent us updates on how they were doing; Diana Hoff became the oldest person to row the Atlantic solo. I will always remember interviewing Ellen MacArthur live from the South Atlantic when she described the giant waves she was facing. Marin Alsop made first woman principal conductor of a British orchestra when she joined the Bournemouth Symphony Orchestra. In January 2003 we ran an item on women in orchestras and the resistance to the first woman to play in the Vienna Philharmonic after they were forced to drop their all-male rule and hold blind auditions. Women singers faced fewer problems and we interviewed K.T. Tunstall, Amy Winehouse and Ms Dynamite among many other successful stars.

It seemed that, despite changes that a listener in 1946 could hardly have dreamt of, women were not quite there yet and still had some way to go. *Woman's Hour* continued to reflect the desire for change and equality with discussions about breastfeeding in public and taking babies into the House of Commons. In May 2000, Leo Blair appeared, the first baby to be born to a serving British Prime Minister for more than 150 years. He prompted much discussion about late babies. His mother Cherie appeared on the programme in

2004 and we discussed life inside Number Ten, the infant Leo and whether she really was obsessed by money.

Family life at large has often been discussed. There were fears that the family was disintegrating, with research showing how rarely families cook and eat together. There was also much debate in this decade about the behaviour of children and how far parents should be held responsible.

In 2001 there was an outbreak of foot-and-mouth disease, which left much of the country out of bounds and led to the sight of whole herds being destroyed. By the time that the last recorded case of the outbreak was found in Cumbria, over six million animals had been slaughtered, and the disease had cost the country billions. *Woman's Hour* followed the diary of sheep farmer Daphne Tilley during this difficult period.

Health continued to be a major topic of interest for women on the programme, going from serious analysis to the latest fashions and fads. In April 2002 severe acute respiratory syndrome (SARS), a deadly form of pneumonia that was first detected in southern China, was responsible for more than 388 deaths. Avian bird flu threatened to be the worst pandemic since the Spanish flu that had killed millions after the First World War.

Technological progress in medicine brought other ethical issues to the fore. Sperm became an issue: sperm donor anonymity in January 2003 led to sperm stealing; a man spoke about his sperm being stolen by a woman to make herself pregnant and then claim child support. In February 2003, Diane Blood, who had won the right to use her dead husband's sperm to have children, talked about her

fight to have the father's name on the birth certificate.

Various diets came and went (all passing me by), including Atkins, low carb and low GI. There was a fashion for colonic irrigation. I rather preferred the cooking items and enjoyed interviewing Nigella Lawson (she brought in cupcakes) and Nigel (he brought apple cake).

The debate about whether women could have it all extended to whether anyone was having the right work–life balance. Theories emerged from the USA about women needing to be more submissive and surrender to men in order to find and keep a husband, which prompted furious debate on the programme. Men listened in ever greater numbers to the programme and had a greater say in our discussions.

It may have seemed that all the questions that had been brought up by feminists in the 1970s were now on the mainstream agenda but there was a lot of debate about what had actually been achieved in terms of women's pensions, childcare, domestic violence, rape, paternity leave and the gender pay gap. Women had been ordained as priests in the 1990s but the topic of the stained-glass ceiling was one that regularly surfaced on the programme, with the ordination of the first woman bishop still being resisted.

Equal rights for gay partnerships were formalised with civil partnerships in 2005 and *Woman's Hour* talked to the first two women to enter into partnership. The discussion of rights extended the debate to the right to die and the controversy over voluntary euthanasia, highlighted by several cases including that of Diane Pretty who died of motor

neurone disease in May 2002. In April 2002, in an historic ruling at the European Court of Human Rights, she lost her claim that the British courts were contravening her human rights by refusing to allow her husband to help her commit suicide. Win Crew came on the programme in February 2003 to talk about taking her husband Reg to Switzerland to help him die.

Many of the cases that *Woman's Hour* had followed, where women had been convicted of murdering their children, were resolved. Sally Clark's conviction for murdering her first two baby sons was quashed by the Court of Appeal in January 2003.

For a nation more accustomed to being gallant losers, sports fans had an unprecedented spate of wins to celebrate. In November 2003, England won the Rugby World Cup against Australia with an unforgettable last-minute drop goal from Jonny Wilkinson, and in the summer of 2005 we suddenly found ourselves glued to the television and becoming expert in the more arcane rules of cricket as England won back the Ashes in a nail-biting series against Australia. London was also the surprise winner against Paris to stage the 2012 Olympics.

But amid all the celebrations, it was clear from other subjects that *Woman's Hour* tackled that much remained to be done. The programme covered many issues in the wider world that showed that for some women, despite good intentions, things had barely changed in all the time we had been on the air; indeed, some things had got worse. Rape was being used as a weapon of war in many conflicts across the globe. Women were still the

victims of so called 'honour' killings both abroad and at home. Young girls were still being forced into marriage against their will. Sex trafficking of young women, particularly from the newly opened up former Eastern bloc countries and Albania, became a major concern. *Woman's Hour* highlighted the plight of asylum seekers who have been raped before they come to the UK and their unsympathetic treatment by the immigration authorities. In May 2003 there was a discussion about child asylum seekers being locked up. *Woman's Hour* also looked at stories of hope—from the past with Kim Phuc, the child covered in burning napalm running down in the street in what was to become the iconic photo of the Vietnam War; she came on the programme to talk about forgiveness and her mission for peace. Cara Henderson, a young Glaswegian woman, discussed her starting an antisectarian campaign after a friend of hers had been murdered.

Old friends of the programme reappeared to assess the progress that had been made and to identify areas where we still needed to change. Claire Rayner talked about health, her own and that of the nation; Germaine Greer discussed whether feminism had moulded education, whether modern women were more unhappy than their mothers and gave her prescriptions for the future. The cookery writer Marguerite Patten, who has been with the programme from its early years, came on *Woman's Hour* to celebrate her ninetieth birthday.

Woman's Hour has never been afraid to tackle difficult subjects and this decade was no different. In May 2002 we interviewed Beverly Ward who

brought an unfair dismissal case against Nissan when she was forced to eat her lunch in the toilet while men watched hard-core porn in the canteen. In September 2003 we revisited the case of disappeared women in Ireland when Jean McConville's body was recovered.

Changes in technology mean that the programme has a developing relationship with the listener: men now form a large part of the audience; technology allows you to listen to the programme where and when you want, we can know what you think of an item almost instantly with the messageboards and e-mails. *Woman's Hour* continues to do what it has always done best: tell the unfolding stories of women's experiences. Women from every imaginable sphere come on the programme to talk about what is happening to them. Some of them are famous or have hit the headlines—like Hillary Clinton, Edwina Currie and Sharon Osbourne. But it is the ordinary listeners, whose mothers and grandmothers first started listening to the programme in 1946, who make the programme what it is: the woven sound tapestry of women's lives.

'The Stained-glass Ceiling'

Canon Patience Purchas, Revd Narissa Jones and Dr Helen Thorn
interviewed by Martha Kearney
6 March 2000

Women priests in the Church of England claim they face a stained-glass ceiling, according to a new survey of the first female vicars to be ordained. This discussion features Dr Helen Thorn, who did the research at the University of Bristol that found continuing hostility to women priests and a failure of the Church establishment to give them senior posts; Revd Narissa Jones, Vicar of St Chad's Church in Coventry; and Canon Patience Purchas, who is responsible for women's ministry in the diocese of St Albans in Hertfordshire.

THORN: I found in the survey that women are still experiencing discrimination and very difficult behaviour from members of their fellow clergy. They are also experiencing these things from people in the community, but when that happens it appears to be a bit more transitory. What I'm concerned about is the evidence of discrimination from the institution of the Church, which appears to be more intransigent. Therefore, I think, there needs to be something very strong done to change that.

KEARNEY: What kind of specific examples are we talking about here?

THORN: It ranges from instances of petty

behaviour, disrespect, being rude, through to women being forced to leave their jobs because their male priest is unable to work with them as a female priest, through to instances of bullying and harassment.

KEARNEY: Patience, with your work with the women's ministry in the diocese of St Albans, what has your experience been of this kind of discriminatory event?

PURCHAS: I have to say that I don't recognise the picture that Helen paints. I expect there's a patchy experience throughout the Church of England and in some dioceses there is a much more generous approach to women, as there is in my own. I took it on myself to do a survey in my own diocese and there were actually very few such instances, and there are over a hundred women priests in our diocese. I found very few instances where people would articulate experiences of real discrimination or even that kind of insulting rude behaviour. I have to say we wouldn't put up with it if there were.

KEARNEY: Revd Jones, is your experience that this is something that is patchy, with very few incidents?

JONES: I was very pleased, although depressed, to read Helen's study, because it brings out of the anecdotal and into the academic what a lot of us have been aware of, but only aware of patchily. I think there's something very serious about the whole issue of discrimination against women in the Church, and that is that the Church just doesn't have a leg to stand on when it pontificates about any human rights or justice issues; it has nothing to say when its own house is in such disrepair. I'm really always surprised that, as soon as the issue of discrimination against women became a live issue

437

in the Church, the Church didn't immediately say, something must be done about this. I think there's a deep theological flaw in the Church as long as it accepts discrimination on grounds of gender or anything else that makes us human.

KEARNEY: A deep theological flaw, Patience?

PURCHAS: Can I say that I agree with some of the things that Revd Jones is saying? I don't think she's actually fair—in fact the Church is responding at the centre; it's not my business to answer for them but it is so. The present Director of Ministry is taking very seriously issues of discrimination and bullying, and is actually doing research, keeping statistics, following up stories. So Revd Jones is not fair when she says that; it may have been true in the past, but it certainly isn't true now.

JONES: I think that I'm being perfectly fair because there doesn't seem to be any thrilled acceptance by the bishops even of the women priests that they've got. And that comes out very clearly in Patience's work, which shows how very many priests, who are also women, have to work for nothing. The numbers are astounding. However few people are what might be called 'promoted', the fact is that deans and canons and so forth get more money but they're actually just doing a different job out of a parish ministry. Very few women achieve these posts at the moment.

KEARNEY: The way things stand at the moment, women can hold these positions but they can't actually become bishops, can they, Helen?

THORN: No, women can't be bishops and on the face of it people say to me, 'Well, they've only been ordained since 1994 so they shouldn't expect to be bishops'. But these are women who have served the

Church for very many years; the average length of service for women is fifteen years. So they've been involved as deaconesses, missionaries, parish workers; they really do have a depth and a length of experience that should be recognised through their access to the episcopate.

KEARNEY: Patience, isn't this illogical?

PURCHAS: We're getting there. I guess that within the next fifteen years the first woman will be consecrated a bishop; it really is as near as that. That's not that long. I can feel Revd Jones getting desperate at the end of the line.

JONES: I do feel that for our Church to accept fifteen years longer of discrimination of people entirely on the grounds of their gender is an astonishing thing do.

PURCHAS: But, Revd Jones, you've been around in the Church as long I have. I've been in the ministry for twenty years and you know that the gradualist approach in the Church of England works.

JONES: I'm certainly not going to accept that that is the right way; we must think more about what is right, what actually is more in keeping with the person of Jesus that we're supposed to be following.

THORN: I'd really like to pick up on this whole issue of whether the kind of softly softly approach works or whether campaigning is the way forward. History shows us time and time again that campaigning does produce results.

PURCHAS: Look, I was almost a founder member of MOW and I campaigned and argued.

KEARNEY: This is the Movement for the Ordination of Women?

PURCHAS: Absolutely, but I have also worked

439

within the structures. Because I was on the standing committee of the General Synod, I know how the Church of England works, and just shouting and stamping your feet doesn't, in the end, get results. It was the patient negotiation, it was the patient talking and talking to people that finally got that vote on that glorious day, on 11 November 1992. I was there to vote, I saw how hard-won it was, I saw people at the last minute change their minds. I was here in the *Woman's Hour* studio the day before, trying to persuade people. And that's what paid off in the end.

THORN: This isn't stamping our feet and shouting, it's a rigorous in-depth study, which is very systematic. Speaking as somebody who is not in the Church of England, the fact that we are still discussing this at the dawn of the twenty-first century just seems outrageous. And the Church really needs to do something about it to remain relevant to the rest of society.

J.K. Rowling

interviewed by Martha Kearney
11 July 2000

The Harry Potter books, first published in 1997, have become a modern publishing phenomenon, selling millions of copies worldwide, credited with getting reluctant readers interested in books and being translated into 64 languages and sold in over 200 territories (as of 2006). Born in 1965, Joanne Rowling got the idea for Harry Potter while stuck on a train. 'Harry just strolled into my head fully formed,' she said. She finished the first book in a café in Edinburgh while on welfare. She used her initials because publishers thought boys wouldn't read a book on magic written by a woman. There are to be seven books in the series.

KEARNEY: You said Hermione is a bit like yourself as a child?

ROWLING: Yes, I was very, very earnest. I still can be quite earnest actually, but I was very earnest when I was fourteen; I thought I was the only one who really properly understood the ills of the world, I was the only one really feeling it.

KEARNEY: In the third book Hermione has to confront the thing that frightens her most. In her case—we did say she was a swot—it was failing her exams. What do you think would be the thing that scared you the most?

ROWLING: I'm with the girl who had to put the book down for two days when she read about Dementors. I think they're the most frightening

things I've written.

KEARNEY: These are these ghoulish guards that can somehow suck out your soul?

ROWLING: Well, yeah, they have the effect when they get too close of you of removing all hope and happiness from the immediate environment, and they induce a feeling of despair, numb despair. And I would be most frightened of that emotion, I think.

KEARNEY: Is that something you've ever experienced yourself?

ROWLING: Briefly, yeah. When I was broke and was famously a single mother, that wasn't a fun time.

KEARNEY: But you managed to pick yourself up again from that and you started to write. How did you do that?

ROWLING: I'd been writing for years and years and years; I've literally been writing or wanting to be a writer since I was six years old. It was just something I loved doing and it was something I could still do, broke or no. So I just couldn't be deflected. I was also very aware at that time that if I didn't do it, then it was going to be almost impossible to do it. Because once I was teaching again full time and raising my daughter, there was going to be very little time for writing. So it was kind of a race against time. I just wanted to finish that first book and try to get it published. I never dreamt it would make me any money. In fact, I was warned continually by people that children's writers generally do not make any money at all, not real money. I simply hoped I would make just enough maybe to feel not too guilty about teaching four days a week and writing one day a week. That was my big hope.

KEARNEY: You've got a little girl yourself. Do you worry about how she's going to react to the writing?

ROWLING: No, because she's an obsessive Harry Potter fan and she was fuming with me that I didn't let her read Book Four first. But I was worried that she would be kidnapped by kids in the playground and tortured behind the bike sheds to reveal secrets, so I didn't want to give her that burden.

KEARNEY: You taught at a comprehensive school and here you are romanticising English public school culture.

ROWLING: I really don't think I'm doing that at all. We could argue that one out for hours and I'm not sure I would convince anyone, because people do have a tendency with books they like to assume that the writer absolutely shares their views.

KEARNEY: What was it about the school that appealed to you to want to write about it?

ROWLING: It's just enormous fun to write. It's a place that's full of rules and it's also full of danger where almost anything can happen, although there is some sense of control because you have this very wise figure at the head of it. And when you put characters like mine, when you put children, fictional children, in a place that is bounded by rules, obviously the most fun you're going to have is by breaking those rules continually. So that's where the drama and conflict come from in the story.

KEARNEY: You've planned seven Harry Potter books and I gather you've even written the last chapter of the last book?

ROWLING: I have—it was a kind of act of faith. It was me telling myself I would one day get there. I know I will get to that chapter finally and I will

443

rewrite it completely. It will need rewriting because the tone will probably be inappropriate as I wrote it so long ago. By that time I will have been writing about Harry for at least thirteen years and that's a very long time to spend with one group of characters. It will be my last farewell and so I'll probably be pulling it back from my editor's grasp and saying, I just have to tweak one more paragraph. It will be very emotional saying goodbye to those characters.

KEARNEY: So where are you keeping the last chapter? I bet there are quite a few people who would like to get their hands on it.

ROWLING: Certain children who shall remain nameless, who are friends of mine, started sidling hopefully towards my study at one point, so that chapter is no longer in my house. I started to take the problem seriously because I thought that if anyone does read that chapter, I might just as well down tools now. Because you can deduce from that chapter exactly what must have happened in Book Seven, so it is now in a secret location.

J.K. Rowling is currently working on the final book in the Harry Potter series. There has been frenzied speculation about what will happen to the characters.

Kim Phuc
interviewed by Martha Kearney
12 September 2000

The image of Kim Phuc (b. 1963) as a young nine-year-old girl, running naked and terrified down a road with other refugees after a napalm attack, became one of the iconic images of the Vietnam War. The photographer, Nick Ut, won the Pulitzer prize for the photograph. Kim almost died of the burns she suffered. Now thirty-seven years old, Kim is living in Canada after defecting there on the way back from her honeymoon in Moscow. That picture still has a huge influence in Kim Phuc's life and it has continued to haunt people, in particular Captain John Plumber, who ordered the original napalm attack.

PHUC: We hid in the temple and when we saw the aeroplane drop the colour mark, it mean they were bombing in that area and so the soldier ask everybody to go out, to move to another place. And so they have the children running first and I remember I run in the front of the temple and I saw the aeroplane and I saw four bombs. I didn't hear the explosion but just 'boop, boop', like this. Fire everywhere and suddenly my clothes just burn off by fire and I saw the fire on my left arm and I was so scared. And I keep running out of the fire.
KEARNEY: How were you able to get help?
PHUC: I run out of the fire and I saw my brothers and another soldier running, and we kept running and running until I feel so tired to run any more

445

and I screaming out, 'Too hot, too hot!' And I remember one of the soldiers tried to help me, he gave me some water to drink and he poured the water over me and after that I lost consciousness. I didn't remember anything, but I learn later that the photographer, Nick Ut, he took the picture and then he took me to the nearest hospital and from that, they moved me to another hospital. My parents found me in the children's hospital in Saigon and finally they transfer me to Barsky Burn Unit in Saigon, and there I received the big help and I stay there about fourteen months.

KEARNEY: Meanwhile the whole world was so shocked by the impact of that one photograph. When was it that you yourself actually realised what importance that photograph had?

PHUC: At the beginning, I didn't understand because I just nine years old, but later on I learn that that picture is very important image. Is a wonderful gift for me too. I'm very proud of that picture because that picture helped people learn war is terrible. Why do children have to suffer like this?

KEARNEY: You've gone on to work with children yourself?

PHUC: Yes, I set up the Kim Foundation to help the children who are victims of war around the world. That is the way I want to give back to the people helping me twenty-eight years ago.

KEARNEY: You've also visited the United States where you were brought together with the man, Captain John Plumber, who ordered the napalm attack. It was obviously a very important meeting for John Plumber, but what did that meeting mean for you?

PHUC: Later on when I became Christian, I realise that forgiveness, it's a very very important step to world peace. And so I learn to forgive, all of the people who cause my suffering and that help me very much. I suffer of course; I still have scars, pain all the time.

KEARNEY: Still today?

PHUC: Yeah, like when the weather changing, or I feel sick, I have a pain. I feel like cutting into somewhere. But in my heart, I am free from hatred, from bitterness. I learn that, about the war, it's so wrong and war make everybody suffer. We need help each other to move on because we cannot change the past and I think we really need forgiveness and reconciliation.

Kim Phuc was named a Unesco Goodwill Ambassador for Culture of Peace in 1997. Her international Kim Foundation provides medical and psychological assistance to children who are victims of war and terrorism.

Nigella Lawson

interviewed by Martha Kearney
12 October 2000

Nigella Lawson is a journalist and food writer. She was born in 1960 and her first book, How to Eat, *appeared in 1998.* How to Be a Domestic Goddess, *the subject of this interview, was published in 2000 and was the subject of heated debate; she was accused of romanticising the era when women were stuck at home in the kitchen, baking.*

LAWSON: There's something very elemental in baking; it sounds quite odd, the chemistry that happens when you put eggs, sugar, flour and butter together and make a cake. Even though of course it doesn't require a lot of effort, the change is profound; it's the act of transformation, which in turn, I suppose, feeds into our fantasies about the transformation of ourselves. I suppose there's also an element that we associate with childhood and although I am the last person on earth ever to start glorifying childhood—I don't think it's a wonderful time—perhaps the baking's the best bit of it.

KEARNEY: Yes, and licking the bowl and all of that.

LAWSON: It's not about a real childhood, it's about an idealised picture because it's at a dream level. I suppose it is much more poignant or at least resonant than it would be if it were just a sort of chronicle of our own musty lives. Also, I think, people generally have certain views about what we should and shouldn't be eating, and women in

particular have a very tricky relationship with certain foods, and foods that they feel they should deny themselves.

KEARNEY: Chocolate cake would be top of that list.

LAWSON: Yes, it would be top of that list probably. One of the things that astonished me and, I suppose, what made me want to write the book was that when I was writing *How to Eat*, of course I did a bit of baking and I'd never really done that before. Because although I come from a family of greedy pigs and cooks, none of them have ever baked. So I did a bit and I thought, is this how easy it is? Because in many ways the most simple, casual, rustic little Tuscan supper requires a certain amount of balance and timing. Whereas when you're making a cake, all you do is stir in various things.

KEARNEY: And the bit I like is huge acclaim for minimal effort. People think—oh you've baked a cake.

LAWSON: I don't think it's just cooking to impress, but, as you said, it makes you feel good about yourself. When I talk about comfort cooking, I mean we know about comfort eating, which actually is a bit of a misnomer because it simply makes one feel more miserable and desperate. But in fact comfort cooking is a way of pottering about in the kitchen, making yourself feel better, maybe a bit more grounded. By this I really do not mean drudgery or chaining yourself to the stove in a resentful and put-upon fashion. So I think it's been a kind of revelation for me.

KEARNEY: But there's been a bit of a backlash about your book. It's provoked some kind of furore

because it seems to be romanticising an era that our mothers were desperate to escape from, the kind of the slavery of the 1950s kitchen where they were forced to make cupcakes.

LAWSON: I think the problem there has been a certain amount of misunderstanding. People have presumed that I'm writing about the joys of housework and how domestic life is the only true and proper way for a woman to achieve anything worth while. Despite the various things I've said or written, there seems to be this impulse to describe me as this kind of perfect creature who is whipping up cakes at all hours, reading stories to my children, spraying myself with expensive French scent.

KEARNEY: It isn't true, which is a big relief!

LAWSON: Well, you can see that it's not true, half of it! But this is difficult. It's seen that you must be perfect at everything, you must be wonderful. And actually what I'm saying is that women are interested in the world at large, we operate in the world at large but we also have domestic sides and we enjoy that too. And the idea is not that you do everything brilliantly but that you're allowed to do a bit of everything. If I bake a cupcake, how many points does it knock off my IQ? So I don't see there's a problem. What I'm never saying is, let's put our fluffy mules on and a pair of baby dolls and pretend to be stupid and just bake.

Nigella Lawson has become a much-loved character in Dead Ringers. *She married Charles Saatchi in 2003. In 2005 she hosted her own daytime television show in which celebrity guests joined her in the kitchen.*

Madeleine Albright

interviewed by Martha Kearney
2 March 2001

In 1997, Madeleine Albright reached the highest rank ever achieved by a woman in the United States when she took up her post of Secretary of State at the age of fifty-nine. She was born in Czechoslovakia in 1937. Her father was a diplomat who discovered he was on a Nazi hit list and so brought his family to safety in Britain.

KEARNEY: You were a refugee more than once in your childhood, fleeing Nazism, and then later on communism in Eastern Europe. Do you think that that has helped your role in foreign affairs in later life?
ALBRIGHT: I truly do believe that when the United States is involved, it makes a difference. And when it isn't, it also makes a difference. So that when the US and the Western powers didn't do anything about Hitler, we had to leave Czechoslovakia the first time and because the United States didn't liberate Czechoslovakia (it was liberated by the Soviets), we had to leave a second time. So I have believed, both as UN Ambassador and as Secretary of State, that an activist American role is very important and that the US can make a difference.
KEARNEY: Despite your very turbulent childhood you managed to excel academically, going to Wesley College. Then you married and had

451

children and decided to spend time at home. Did you ever worry that you were simply vegging because you were at home with your children?

ALBRIGHT: Yes, I did for sure. I graduated from college, I was married three days later and had twin daughters two years after that. And because they were premature and they had to be fed every three hours, and it took them each an hour to feed, I just went pretty crazy. I watched television and just kind of sat there. That's when I decided to go and get my graduate degrees so I tried to intersperse an academic life with being a mother.

KEARNEY: Even learning Russian?

ALBRIGHT: Learning Russian, yes. It was a way to retain sanity. It took me so long to write my dissertation, but at a certain stage I thought I was being a bad example to my daughters. Because if I couldn't finish my dissertation, why should they finish any of their papers? So we began to help each other get things done.

KEARNEY: You finished your part-time PhD in 1976. Within two years you were a staff member of the Security Council. Was it ever intimidating often being the only woman in all-male meetings?

ALBRIGHT: It was very evident to me then that women usually wait to be called on in meetings. It taught me that you have to be an active listener— that you have to interrupt when you have a thought, and not wait for some man to say what he thinks and it's always kind of regarded as brilliant, and if you'd only said the same thing earlier, you might have been able to make that point.

KEARNEY: You certainly learnt how to be forthright. President Clinton said that you said

something that was the most effective one-liner in the whole administration's foreign policy about a Cuban attack. What was it that you said there?

ALBRIGHT: I was at the United Nations and the Cubans had just downed some unarmed American civilian planes. I had the audiotape that had been recorded of what the Cuban pilots were saying to each other. And they were expressing all kinds of vulgarities, basically saying that they had 'cojones' and that the Americans didn't, and that they would get them and it was all done with such great glee.

KEARNEY: 'Cojones' being balls?

ALBRIGHT: Right. They were just so gleeful and macho about it. So I came up with a line, which was: 'This is not cojones, it's cowardice.' It really caught on and so when I went down to Miami, I was Queen of the May because I had told it like it was.

KEARNEY: When you were appointed Secretary of State, the *Washington Post* decided to investigate your background and discovered that even though you'd been brought up as a Christian, your parents were in fact Jewish. Unknown to you, three of your grandparents were in fact killed by the Nazis. Did that come as a total shock to you?

ALBRIGHT: It did come as a total shock. I felt terribly sorry for them because they clearly had given up a great deal, I was very touched and moved by what they had done. I said that they basically gave me life twice. When I went back to Czechoslovakia the first time that I was Secretary and went to this synagogue in Prague—the Pink Synagogue, and I saw the names. It was evident to me that my name would have been up there, with my parents', and that their doing what they did

saved our lives and so I was very grateful to my parents. I haven't really had time to absorb all aspects of it.

Madeleine Albright is the first Mortara Endowed Professor in the Practice of Diplomacy at the Georgetown School of Foreign Service and is a principal in the global strategy consulting group the Albright Group. In 2003 she published her memoirs Madam Secretary.

Daphne Tilley

interviewed by Jenni Murray
8 March 2001

At that time there had been ninety-six outbreaks of foot-and-mouth disease confirmed in Britain and Northern Ireland. Daphne Tilley (b. 1940) and her family raise sheep and cattle near Denbigh in Wales. Woman's Hour *asked Daphne to keep an audio diary as the current crisis began to take hold.*

TILLEY: It's a lovely day, the sun's shining and the birds are pink-pinking. The snow's about nine inches deep and my little black puss has walked up through the steep snow to the top of the field—where I'm about 900 feet above sea level. It's hard to believe there's a great cloud of foot-and-mouth hanging over this farm and every other farm that I can see around. Where I am, I can probably see twenty or thirty farms because I can see as far as the Snowdonia range. How can this terrible devastation hang over us, through no fault of the farmer?

We're sheep farmers. My husband, my son and I work a 300-acre farm. All our ewes, apart from the ones that are away (and we can't bring them home because of the restrictions), are in the shed—warm and cosy with straw. Most of them won't be lambing for another month. Down to work. I must go and get some hot water—to put in the footrot dip for disinfectant, at the gate, and at the back door, and at the front door, and down at the farm

455

gate. Goodness me, that robin is singing so strongly behind me; he makes me not feel like doing any work at all. But because all the disinfectant buckets are frozen, I must put some more water in them.

One of our few contacts with the outside world is Mary on the milk; we're very lucky to have milk delivered. Of course, now the milk crates will stay outside the gate on the road. The postman, the milkman, we don't need anybody coming on to the premises; you never know what will come on their tyres and you just cannot be too careful. I'm quite proud of my old carpet. It was bought before we were married, forty years ago, for the living room. And here it is, a good pure British wool Wilton carpet outside our gate. It's really absorbent, so when I soak it well with disinfectant any vehicles that pass in and out get all their wheels well coated in disinfectant and of course any visiting people we spray with our knapsack spray as well, which is like a weedkiller spray tank. Right, that's the disinfectants redone, the carpet looked at. The next thing is to feed the hens.

We have three big sheds down here at this farm. All 600 sheep live in one and 120 cattle and a couple of horses live in another, plus the silage and the feedstuffs in the third shed, which has got more sheep in it. It's just a matter of getting water, feed and bedding to everything every day. Up this end of the shed we've got some lambs ready to go to market; they will make lovely fat lambs for somebody but we can't take them to sell, because of all the restrictions on. Perhaps soon we'll be able to get a licence to get some of them away to a licensed depot, because they're costing quite a lot to feed. The next thing is they'll be getting overfat and then

nobody will want them. And we can't not feed them.

Daphne Tilley is still farming in Wales and now supplies local restaurants, as well as top restaurants in London, with her lamb.

Jerri Nielsen

interviewed by Jenni Murray
19 March 2001

In 1999, Dr Jerri Nielsen (b. 1952) went to the South Pole to work as a doctor for the staff of the Amazon Scott research station. While she was there she found she had breast cancer, but couldn't get away for nine months because of the severity of the winter. So she had to treat herself.

MURRAY: You were the only qualified person around. You had to diagnose yourself and then treat yourself. How did you make the full diagnosis?

NIELSEN: Originally I felt a lump in my breast while I was just rubbing my chest reading a book. And I thought, I'm cooked, because that was two weeks after the station closed for eight and a half months with no way in and no way out. And it had been described to us in great detail that there was no way in or out; that there was no way to get any supplies to us and that that was just part of the deal. This is in total darkness, in temperatures down to 100 degrees below zero Fahrenheit, and in a little station that had been built for seventeen people and we were forty-one people—so conditions were extremely crowded. I found this thing, and realised—well, it's probably cancer, and I can't get treatment for eight and a half months. I didn't tell anyone. Instead I readied my hospital for my death. I took a whole bunch of plastic bags

and put all of my equipment in the bags that you'd need for everything, and sterilised them in little packages. And then I xeroxed the instructions, out of books, and then highlighted them, and made detailed instructions. And then told everyone that I was organising the hospital and had people make me pegboards and such to hang these things on. The idea was that if something happened to me, my people would be able to take care of themselves.

MURRAY: How did you do the biopsy, because you did come to a point where you knew you had to biopsy the lump?

NIELSEN: After three months of not telling anyone but training people, I felt lymph nodes under my right arm and the breast mass got very large quickly. So I thought, this is more aggressive than I suspected and I might not make it off the ice. And so at that point I told my superior—I was second in command—I told the head of the station, not so that they would get me rescued, because we were told there was no way that that could happen, but simply because I wanted people taken off work so that I could increase their training as physicians, teach them how to use the X-ray machine, teach them how to set bones, things like that. And instead he contacted the National Science Foundation and told them what was going on by e-mail, and they decided to make an unprecedented attempt to save my life.

They dropped me medication that would send me into the menopause, and chemotherapy. As soon as we got those packages, I put myself into the menopause by shutting down my ovaries with medication that would help to starve any

oestrogen-dependent tumour, and then I had to decide whether or not to give myself chemotherapy. Well, we were at an altitude of 9,600 feet, and in extreme cold. Wounds don't heal in that situation and any infection that gets started is almost impossible to treat. So I had to make a decision about that. I didn't want to give myself chemotherapy and knock out my immune system unless I had to, unless I definitely had cancer.

So my girlfriend built a device with a Polaroid camera, a microscope and a computer. It took about a month to do it. But she was able to then send the microscope slide images, magnified, through a camera, through the computer, to the pathologists in the United States, over the internet. In the meantime I taught a welder and a carpenter to help me operate because they were good with their hands and they had good tools skills and innovation-type skills. And we actually did two biopsies, one to make slides to be sent over the internet and then later another to obtain tissue prior to me obtaining chemotherapy—to take back with me to the United States for other studies.

MURRAY: It sounds horrific; it must have been terrifying.

NIELSEN: It sounds scary but it wasn't and the reason is, I think, that it's more frightening here, because here you have people, you have to make decisions. And when people have to do something to save their life, it isn't really very frightening. You just act, you must act, and to not have a choice makes it so easy. What makes it hard here is that you have your mother-in-law telling you to go to her doctor, someone else telling you to go to their doctor, people giving you options for treatment,

460

and you have to make a determination. For me—I didn't have any of those anxieties because I had no choice.

MURRAY: They did eventually manage to get you out as it got a little bit warmer and you've had treatment since. How are you now?

NIELSEN: Fine. I've had a lot of surgery and a lot of post-operative problems but I haven't had any recurrence of my cancer. I'm sure that the airdrops saved my life. The reason they got me out early was because I was deteriorating and the concern was for the station to get in another doctor because there isn't another doctor for 800 miles.

MURRAY: You've called this experience 'an interesting adventure in my life', which is a very cool way to describe it.

NIELSEN: Oh, my life has been a really insane journey with a whole lot of roadblocks and things blowing up in front of me, but I've always found a pathway around the explosions basically. And I'm glad that I've had that kind of a life. I think some people just make their life that way.

Cara Henderson

interviewed by Jenni Murray
8 May 2001

Celtic is a Roman Catholic football club that was set up in the 1880s as Irish emigrants moved to Scotland. Rangers became a predominantly Protestant club in 1920. In the past five years there have been eight murders following games and after one match last summer there were thirty-four serious assaults, thirteen stabbings, two attempted murders and one murder. Cara Henderson is a twenty-one-year-old Glaswegian who set up an organisation called Nil by Mouth to try to stop the sectarian violence.

MURRAY: How aware were you of sectarian rivalry in the city as you were growing up?

HENDERSON: I don't really think I was that aware. It's something that's very subtle and kind of creeps into your consciousness without you even realising it. I always knew there was a rivalry between Rangers and Celtic. I grew up in a Protestant family and that meant that I supported Rangers. And we didn't really question it and I didn't really think about it.

MURRAY: What about the kind of songs that are sung on the terraces? Is that something that you would have grown up with?

HENDERSON: I came from a very middle-class and sheltered background so I wasn't well acquainted with the songs. But I do remember singing some of them like 'The Billy Boys' and I wouldn't have had

462

the first clue what they meant at all.

MURRAY: What kind of words are there that you now realise were the sort of thing you wouldn't necessarily want to sing?

HENDERSON: Some of the lines in it are 'We're up to our knees in Fenian blood', 'Surrender or you'll die'. I probably didn't even know what Fenian meant. I probably would have realised it had something to do with Catholics but wouldn't have really questioned it, wouldn't really have acknowledged the violence of it.

MURRAY: You were prompted to form Nil by Mouth because of the death of a friend, Mark. What happened to him?

HENDERSON: It was just over five years ago now. My friend Mark was a Celtic supporter and had just watched Celtic beat Partick Thistle and was walking back into the centre of Glasgow through an area called Bridgeton, which is known for its Protestant affiliation. He had a team shirt on, but the police said that his jacket was zipped right up and covering it. He was in a crowd of Celtic fans. As they passed by a Rangers pub, a Rangers fan stepped out of the pub doorway and slit his throat. It was just random.

MURRAY: The fan who did that was found and convicted with his murder. I know that you weren't proper boyfriend and girlfriend but you did go out together a couple of times. You were friends rather than boyfriend and girlfriend, but I know you asked yourself whether you should go out with him because he was a Catholic. What problems did you think it might cause?

HENDERSON: I was fourteen at the time that I went out with Mark a few times to the cinema. I do

463

remember sitting in art class, speaking to my best friend and asking her, 'Do you think I can go out with Mark?' Because he was Catholic. I don't know where that came from. I couldn't see that it would have made any practical difference to my life, because I wasn't particularly religious. But it was based probably purely on prejudice. I regarded Catholics as being less equal to Protestants. I was fourteen.

MURRAY: What do you want Nil by Mouth to achieve?

HENDERSON: It was set up primarily to trigger the debate and also to focus attention on the sectarian attacks and murders that take place in the West of Scotland. Many people in the West of Scotland, and wider in Scotland in general, are well aware of the trouble that arises after matches between Celtic and Rangers, but they probably don't acknowledge the extent of it. As a society we were, or have been, in danger of simply accepting it. So really it was to give voice to the fact that it is a ridiculous situation and it shouldn't continue.

MURRAY: Nil by Mouth suggests you want to silence people, that you don't want them singing those songs. Is that right?

HENDERSON: That is the kind of ultimate aim of it. We believe as an organisation that it has been made socially acceptable for people to make sectarian jokes and to sing sectarian songs. You have to bear in mind you've got as many as 50,000 people singing sectarian songs at football matches. It condones sectarianism and feeds a violent element, which all too often results in attacks and murders.

MURRAY: You have had your critics. I know that

one writer in a newspaper suggested that the organisation should be called Eyes Wide Shut rather than Nil by Mouth. Was there a certain naïvety at the outset when you set this up?

HENDERSON: Yeah, I think there was. I can absolutely say I was naïve but I believe that my naïvety in the first place was one of my greatest strengths because I could see that the situation was ridiculous and that I didn't want to grow up in a society like that. Too many people are hardened by it; they grow up with it, they accept it, it's just very normal to them and it's very easy for cynicism to creep in and for it to become acceptable. I don't think I'm quite as naïve as I was when I first went into it. But if I hadn't been that naïve I don't know if I would have started it because I would have known what I was up against. I started off simply by writing to the football clubs because I didn't know why they hadn't done a joint initiative to openly denounce religious bigotry and sectarianism, which would seem the most logical and positive way forward. Over the course of a few months of persistent contact with them, they let me in and at least gave me a hearing. It really started from that. Also, once the Scottish media got hold of the story, that sort of catapulted it into the public consciousness.

MURRAY: I gather the police force can see immense difficulties; it would mean arresting hundreds of fans, probably for a few sectarian songs. Where would you like to see the clubs and the police go with it?

HENDERSON: The clubs have come out and openly backed it. The police have said that it's unenforceable at street level. I disagree with that

and am very disappointed with that, firstly because with the legislation that we have on racism, we don't see that being abused or taken to a ridiculous length. It would equip the police to go in and sort out problems, where before they might just take a step back and wait for the violence to ensue, and sort of have a kneejerk response to it. I do have an element of criticism of the police in the West of Scotland; they have a tendency to minimise the extent of the violence, only they don't actually record the statistics on sectarian attacks. If these happen two hours after matches, they don't actually relate them to the Celtic–Rangers rivalry.

Cara Henderson is now a barrister. Nil By Mouth continues to campaign against sectarian violence.

Professor Margaret Cox

interviewed by Sheila McClennon
26 September 2001

*Professor Margaret Cox (b. 1950) is head of forensic
sciences at Bournemouth University and is best known
as the forensic anthropologist for Channel 4's* Time
Team. *In the 1990s, Margaret was asked to assist with
several UK criminal investigations involving the
recovery of human remains from clandestine graves.
This ultimately led to her involvement in the
excavation of mass graves in Kosovo in 1999 and to
her subsequent work in the investigation of serious
international crime in such places as Rwanda and
Iraq. Now Margaret wants to set up the world's first
centre for the investigation of genocide.*

COX: The need for such a centre really arises from
the availability of a breadth of forensic expertise
that incorporates a wide range of disciplines such
as archaeology, anthropology, entomology,
pathology and so on. And in most investigations
this expertise is applied not as part of an overall
strategy but rather in a disparate way. What we
want to do is to provide a service that actually
includes everything from the location of mass
graves, to the identifying and repatriation of
victims.
MCCLENNON: Is that what drives you in this
particular field of archaeology?
COX: It is. Archaeologists are trained to
contextualise the information and material that

467

they find, so the archaeologist with a fragment of pottery doesn't just look at a fragment of pottery but thinks about where did the clay come from? How was the pot made? Who used it? Was it traded? What does it represent within society? So when people like me go and work in the genocide arena, our intellectual training makes us ask what this means in terms of not only human experience but the state of humankind in the world that we live in.

MCCLENNON: How difficult was it working on those graves in Kosovo? Where do you actually start when you're faced with a mass grave?

COX: It's a very difficult job because you don't have very good information before you get there. At that time almost the whole country was still in a state of war. Everything was broken down, nothing worked, there were no facilities that could easily be obtained. It wasn't very secure. The site was mined and there were all sorts of problems with it. But what you do as an archaeologist is you have a range of skills, about location, about excavation, about recovery.

MCCLENNON: And what kind of clues can you as an archaeologist actually discover?

COX: Everything from locating a grave using the sorts of skills that you might see on *Time Team*; from geophysics to changes in vegetation to earthworks—that type of thing. What we can do is work out how a grave was dug: is it a primary grave or a secondary grave? We can tell what sort of machine dug it, what season of the year it was dug up, from the information that pollens give us. Looking at how the bodies are put in a grave can tell you about possibly whether they were executed on the site of the grave

or whether they weren't—that type of thing. Our work continues right the way through to the anthropology, which is used alongside the pathology to look at things like cause of death, to help try to identify who the person was. Overall, you're trying to provide evidence that contributes to the process of justice but also fulfils basic human rights needs.

MCCLENNON: This is evidence that then will be used in court. But is it also important for the relatives of these people to understand what happened?

COX: I think it is. Anyone who lives through that sort of experience needs inevitably at some stage to have some sort of closure on it. And clearly one aspect of closure if you've lost friends and family is to actually have your relations' remains back so that you can bury them in the religious manner that you wish, so you can know where they are and have closure on that aspect and try to rebuild your life.

Professor Margaret Cox has since established a charity, Inforce, based at Bournemouth University, as an international forensic centre of excellence for the investigation of genocide, war crimes and crimes against humanity. Professor Cox was awarded European Woman of Achievement Award (Humanitarian section) in 2002 in recognition of her work for the MoD and in establishing Inforce.

Anne Robinson

interviewed by Jenni Murray
17 October 2001

Anne Robinson was one of the old school of hard-working, hard-drinking Fleet Street journalists She was born in 1944 in Liverpool and worked for the Daily Mail *before becoming the highest-paid woman journalist in Britain with columns for the* Mirror, *the* Sun *and* The Times. *She came on to* Woman's Hour *to discuss her book,* Memoirs of an Unfit Mother.

ROBINSON: My mother was very beautiful, very over the top, she ran a really excellent business and she was very much the breadwinner. I didn't know until 1969 that you were meant to take men seriously. She turned her market stall into a major business, and she'd take you shopping and you'd say, 'I can't decide whether to have the green dress or the red dress,' and she'd say, 'Have both.' So on the one hand it was a terribly indulged childhood; on the other hand she made us work. We went to boarding school but we had to work on the market stall for half the holidays. She always taught me to think that each of us was a business, so even when my confidence was terribly lacking everywhere else, it never occurred to me not to negotiate. And women are, in particular, very bad at it. I mean, really bad at it.

MURRAY: So how did you get the gall, especially when you were working for Maxwell, to constantly go in and ask for more money?

470

ROBINSON: I asked and other people didn't. I remember someone else in the newsroom at the *Mirror* saying, 'Why have you got a car?' And I said, 'Because I went and asked for one.' But also when I met Maxwell, I felt I'd been in the movie before; he had a lot of my mother about him in that he was a bully, but if you laughed with him and you had a sense of humour he absolutely melted.

MURRAY: When you came to London, your first break as a journalist was when you wrote about the death in 1967 of Brian Epstein, and the other journalists made the mistake of thinking you were a team player when you were a loner. What did you do?

ROBINSON: I was on trial with the *Daily Mail* and Brian Epstein had just taken an overdose and died. It was a very big story, it was a Bank Holiday Monday in August and we were all doorstepping his house. When it came to lunchtime, they all went to the pub. I was on a day's trial, so there was no way I was going to go to the pub. But they assumed that because I was a girl and a young trainee, I would just take all the notes and hand them over—because that was the practice and it still is to a certain extent. You share your notes with whoever's on watch. But I hadn't agreed to it; they'd assumed it. So during the lunch hour the family solicitor came out and he couldn't find a cab. I said, 'Get in the car and I'll take you to Euston station.' And of course I got the story, I got the job, and I got the lead in the paper the next morning. I was trained from kindergarten not to be a team player.

MURRAY: A large part of the book is how you got into such trouble with drink. It seems extraordinary that someone with your self-possession could have

ended up as ill as you were as a result of alcohol. How did it happen?

ROBINSON: I think it runs in our genes in our family. My mother had a drink problem; she was a bender drinker. I think my number was marked. And it was extraordinary, having gone through a childhood where my mother's drinking was very much part of it. I was very conscious of this and it was very upsetting. There was a certain sort of inevitability about it, rather than a choice. I hope also that the book shows that you can get that bad, and you can still recover. Even though for me the first few years of being sober were very, very tough because by that time I'd lost so much that there wasn't that much to stay sober for. I haven't had a drink for twenty-three years. It's not that tough, once you get the hang of it; it's certainly less tough than drinking and dying.

MURRAY: The other terribly tragic story is losing the custody of your daughter, to Charlie, who was your first husband. It turns out that this was not because of drink but because of ambition. What actually drove that judge's decision, that you should lose Emma?

ROBINSON: There was an acceptance that both of us were Fleet Street-style drinkers, so that was just put to one side. It was decided that I was more ambitious than Charlie, although at no point did he have to say, 'I'll stay at home.' He simply had to produce a good nanny. At one point, his barrister said to me, 'Is it true, Mrs Wilson, that you said you'd rather cover the Vietnam War than hoover the sitting room?' Which of course I had; there were a lot of lovely remarks like that.

MURRAY: But you could argue that the judge

made the right decision?

ROBINSON: For the wrong reasons. Had he made the judgment because of my drinking, then you would have assumed that with it would have come the suggestion that I sought help, a suggestion that the situation was reviewed in a year's time. I had in a sense a life sentence.

Anne Robinson now presents The Weakest Link *game show on television.*

Dame Mary Warnock

interviewed by Martha Kearney
9 August 2002

Dame Mary Warnock (b. 1924) is a philosopher, writer and academic. She has been a headmistress, Oxbridge don and Mistress of Girton College, Cambridge, but her greatest influence has been on the ethics of public policy. She has been influential in many committees including, in the seventies, the committee of enquiry into special education, which changed the way children with special educational needs were treated in school. In 1982 the government asked her to chair a committee which came up with a legal framework to regulate in vitro fertilisation. Two decades on she wrote a book Making Babies: Is there a right to have children? *She was made a Dame in 1984 and awarded a life peerage in 1985.*

KEARNEY: When you began to look at this whole area, how did you begin to draw up a framework?
WARNOCK: It was quite difficult, particularly because, being a philosopher, I was totally ignorant of the science involved. But it became fairly clear that we wanted to draw a distinction between the very early embryo, before the beginnings of the formation of the spinal cord, and the embryo thereafter, or perhaps two embryos, because we draw the line at the moment when identical twins might form spontaneously. So that was one very important thing. But we also had to take a broader look, and although things have changed

enormously in connection with the kind of cases we're now considering, we did foresee that the issue of genetic intervention might arise. The main recommendation of the committee was that the HFEA (Human Fertilisation and Embryology Authority) should be set up as a statuary body to examine all the cases, look at them in detail and issue licences. So what's happened in the last twenty years has gone along the way we wanted as far as the existence and powers of the HFEA go.

KEARNEY: You did say at the time that there must be some barriers that are not to be crossed, some limits fixed, beyond which people mustn't be allowed to go. You went on to say that the very existence of morality depends upon it. But don't a lot of these new cases mean that those limits become less clear?

WARNOCK: I think that when I said that, rather rashly, I was distinguishing between issues of public policy and the kind of things that people's individual consciences would not allow them to do. One has to allow that people's consciences draw lines at different places. For example, there are some people who would in no circumstances contemplate abortion, and those people's views have to be respected. But in my view they can't be supposed to underlie public policy, which is a different thing. My personal view is that the one really important aspect of giving birth to children— seeking treatment if you're infertile and so on—is that having a child should not be trivialised. This means that in cases where somebody seeks genetic intervention to produce a child who they think will be a violinist or a ballet dancer, or have blue eyes, this is, it seems to me, a trivialisation of the relation

between child and parent, which in my view should be essentially loving of the child whatever he or she is like.

Dame Mary Warnock continues to be an influential philosopher in public life. In 2004 she published An Intelligent Person's Guide to Ethics.

Edwina Currie

interviewed by Jenni Murray
2 October 2002

Edwina Currie was born in 1946 in Liverpool. In 1983 she was elected as the Conservative MP for South Derbyshire. In 1986 she became Minister of Health, but was forced to resign in 1988 after she issued a warning about salmonella in British eggs. In the 1997 General Election she lost her seat.

Health issues have always been paramount to Woman's Hour and March 1988 saw the programme's first ever week-long campaign concerned with a specific health issue: cervical cancer. It was the first time the disease had ever come under such scrutiny on the airwaves. There were discussions on the causes of the disease, how the different regions were evolving their smear-test systems and, on 17 March 1988, an interview with the Conservative minister with special responsibility for women's health, Edwina Currie. She was asked when she had had her last smear test. After answering, she added 'I think one should also say that one should try to make sure one doesn't take too many risks. I don't get through lots of sexual partners. I've been married to the same chap for seventeen years, I don't smoke. I think I don't do too many stupid things that put me at risk of getting cancer and on that sort of basis I think I'd like to advise people to do the same.' It was later revealed that at the time of the 1988 interview Edwina Currie had been involved in a four-year affair with John Major, then Chief Secretary to the Treasury, later Prime Minister.

In 2002 she published Diaries 1987–92; *they record that the affair ended on 20 March 1988, three days after her appearance on* Woman's Hour.

CURRIE: I wish I'd made the affair public before now, because it was about time that, in every sense, the history books were written accurately. I'd carried this secret, this burden, for a very long time. It was somebody else's secret and I carried it.

MURRAY: Did you anticipate the kind of vitriol that was written about you?

CURRIE: Oh yes, there will always be people who divert attention away from their own misbehaviour.

MURRAY: Vanessa Feltz, who is a wronged wife, was one of the most critical. Yvonne Roberts, who's a huge admirer of your record as Minister for Health, said how disappointed she was that you will be remembered for your sex life. Doesn't that disappoint you?

CURRIE: I don't think I'll be remembered just for that. I hope sincerely that that is not the case. It seemed to me that the time had come when it was safe to talk about the affair. It was very much part of history. I was part of the making of a Prime Minister. It was a long, big chunk of my life. Four years is not nothing and it meant an enormous amount to me at the time. I was absolutely not going to say anything to anybody and I really didn't as long as there was any danger of damaging the Prime Minister, or danger of damaging the Conservative Party, or its options and hopes in General Elections. Last year I divorced and remarried. I'm very happily remarried now, so the reason for holding on to somebody else's secret had simply evaporated.

MURRAY: But a lot of women will remember you as being so supportive of women. You were a really supportive Minister for Health, you were concerned about women's issues, and what you've done now is commit the unforgivable sin of humiliating another man's wife. Norma didn't ask for this.

CURRIE: No, she didn't, and that is always something that's in the back of one's mind. I'm pleased to see that John confessed to her a very long time ago, and according to him she forgave him.

MURRAY: But you would not want your John to go out in public and say that he was having an affair with someone or during your marriage. How would you feel?

CURRIE: I feel that I hear the tinkle-tinkle of double standards here. How about thinking about the other side of the equation? Somewhere along the line, women get it in the neck when they are ambitious, or able, or stray. I can't hear the men getting it in the neck in the same sort of way.

MURRAY: But if you're supportive to women, you should be supportive to Norma Major, and keep the secret for her benefit.

CURRIE: Well, it clearly wasn't a secret to Norma.

MURRAY: But what I'm disputing is how supportive to women you can call yourself, when you have placed Norma Major's private life in the public sphere in the way that you have, and frankly she must be terribly embarrassed and humiliated.

CURRIE: I think that's an issue that she needs to take up with her husband. And he did not end the affair, I did. And she did not end the affair or tell him to do so—I did. And at no time in all the

479

period that he was in the public eye, and he's not any more, did I tell anybody and that, I think, is the burden I took on myself. It was very, very hard not to, especially when I saw him doing things like the Back to Basics campaign, when I saw the way he left women—any woman, not just me—out of the Cabinet. We had the first Cabinet for a quarter-century with not a single woman in it.

MURRAY: But there have been some suggestions that he didn't give you a Cabinet post because he actually knew you so well.

CURRIE: If that had been the case ... Yeah, I puzzled about it. Much of what I wrote down in my diaries at the time was along the lines of, 'What is going on here, why doesn't he put Emma Nicholson in the Cabinet, she's excellent? Why doesn't he put in Linda Chalker?' He stands at the dispatch box and he says he promotes women on merit. Well, a raspberry to that because he's promoting some of the chaps and they're clearly not being promoted on merit.

MURRAY: You suggested this morning on BBC Radio *5 Live*, and you've hinted at it just now, that there was hypocrisy in some of the things that he did—the Back to Basics campaign, for instance, and you said that it was a big mistake for Major to put his colleagues under scrutiny. I wonder whether you were not averse to a spot of hypocrisy as well—because you told me on 17 March 1988 that you weren't worried about cervical smears only being offered every five years because you didn't put yourself at risk. I quote: you said, 'I've been married to the same chap for seventeen years.' It seemed to me that you were implying that women who aren't faithful are at risk, which now seems a

bit rich given what was going on.

CURRIE: I think we know a lot more about cervical cancer now as well. I think I would stick to what I was saying about Back to Basics; for any government to start telling the rest of the nation how to behave is a bit rich.

MURRAY: But were you being hypocritical, sitting here and telling me that you were faithful to your husband of seventeen years, when you weren't?

CURRIE: Well, I think in those circumstances I was trying to keep a secret, which is what you charged me with doing earlier.

MURRAY: It was indeed that night—I've checked in the diary across to that date—it was that night that you wrote the letter ending it.

CURRIE: Maybe you had a good influence on me.

MURRAY: Are you ashamed of the affair, as John Major seems to be?

CURRIE: I'm not ashamed at all. We were two decent people who had a lot of fun, gave each other a lot of support and I think loved each other, at least then.

Since losing her seat as an MP in 1997, Edwina Currie has become a writer and media personality. She presented a phone-in radio show for five years, Late Night Currie, *and in 2004 she won* Celebrity Mastermind, *choosing the life of Marie Curie as her special subject. She also appeared in* Hell's Kitchen *with Gordon Ramsay. Her sixth novel* This Honourable House *was published in 2003.*

Ms Dynamite

interviewed by Sheila McClennon
27 December 2002

At twenty-one, Ms Dynamite was the youngest ever winner of the Mercury Music Prize, beating David Bowie. Then she swept the boards at the Mobos (Music of Black Origin), taking the awards for best single, best newcomer and best UK act.

MCCLENNON: On the night of the awards you sent a very strong message to other young women in the business, when you said, 'You don't have to take your clothes off.' What did you mean by that?

MS DYNAMITE: A lot of women who are in the music industry often use beauty or their body as kind of a selling point, as an object; they really play on it. That's up to them. I'm not judging anyone or telling anybody what to do. But what I am worried about is that a lot of younger women growing up, wanting to get into the music industry, feel that that is the way forward. I just felt it very necessary to show them that you do not have to be like that at all.

MCCLENNON: It's all right for you saying that, because you've made it on your own terms, but isn't there still this most enormous pressure—as there always has been, and always will be—on women in the entertainment industry to fit into a certain mould?

MS DYNAMITE: Well, there's pressure there but I think what makes that pressure even more immense is that women who are already in the industry bow

482

down to that pressure. You know, I think if every woman in the industry said, 'I'm not prepared to do that, I want people to judge me on my talent, rather than my body,' there wouldn't be any women flaunting their bits about. And what would people do? Not play women's songs because they don't show their body? I don't think that would ever happen. There is a pressure there, but as women we make it worse for ourselves.

MCCLENNON: One of the things that you have referred to is how you left home during a period in your teens when things at home were getting a bit too much. You decided eventually to go and live in a hostel. What was life like for you there? It sounds a very difficult thing for a young girl to cope with.

MS DYNAMITE: It wasn't the greatest thing to do and I would never advise it for any young women who are out there now. For six months I think it was all right because it was like, wow, I'm out, I'm free, I can do what I want to do when I want to do it. And then suddenly it was like, OK, I've only got £35 a week to live on; I have to feed myself out of that and pay rent. I had to pay £5 rent a week and £5 service charges, I remember. So by the end of it I had just £25 to get to college and to feed myself. It was just really, really hard to survive and I was way too stubborn and too proud to ask anyone for help.

MCCLENNON: You describe your voice as like— what is it—a cat being thrown up? (*laughter*) This is slightly unfair.

MS DYNAMITE: Well, it was in the beginning, you know. The more that I practise, the better it gets, but it's still not as good as I'd like it to be. There's still so much I've got to learn about about singing.

MCCLENNON: And the importance of the lyrics is still paramount to the current single, 'Put Him Out'. This touches on how your partner isn't treating you right, and that you should get rid of him. In the last verse you also touch on the importance of fathers as role models. What are you trying to do there?

MS DYNAMITE: A lot of women often complain about their men. Don't get me wrong, I do think that a lot of the time men deserve it. But I do think part of it's unfair because I think men are often seen in terms of a stereotype. The fact of the matter is that there are a lot of women out there who complain about men and their relationships. But they're not willing to do anything about it. Love is not a reason to stay with someone if they're not treating you right. And I think that is even more important when there are children involved. It isn't about whether you love someone; it should never be about your feelings when you're in a negative relationship or a relationship where a man is not the best that he could be, for his children. I don't think it should be about yourself. I think that's very selfish. I think we've spent a long time saying, men this, men that. I think the men who are out there are the way they are; they are never going to change, unless we as women stop putting up with it.

MCCLENNON: And can a pop song change that?

MS DYNAMITE: I don't think it can change it in a sense that women are now going to think, Ms Dynamite's right, let me get shot of this guy that I've been with for the last ten years, who's been treating me like an idiot. I don't think that's going to happen, but I hope that it just makes them think.

Dame Margaret Anstee

interviewed by Sheila McClennon
28 March 2003

During her long career with the United Nations, Dame Margaret Anstee (b. 1926) worked passionately for developing countries. She also rescued people from Pinochet's brutal coup in Chile, she was in Kuwait after the first Gulf War, in Mexico after the earthquake, in Chernobyl and in Angola.

MCCLENNON: You've given your book a very cheeky little title—it's called *Never Learn to Type*. What did you mean by that?

ANSTEE: When I was at university, if you did an Arts degree and were female, if you learnt to type, then you inevitably became a secretary. There were very few openings for women. So I just decided I didn't want to learn to type so that I would have the possibility of having a professional career of my own rather than being a kind of sidekick for men who quite often weren't as capable as some of my women friends who did follow that particular route.

MCCLENNON: You began your career in the Foreign Office. Was it unusual, I presume, at the time for a woman to work at the Foreign Office and not just that but a woman from your background, Margaret, which was quite just sort of a normal working-class, Essex background, wasn't it?

ANSTEE: That's right and a rural background to boot. We were among the very first intake and it

485

was quite difficult. There were two sorts of attitudes. One was very patronising, of did you really do this, did you draft this all on your own? Or outright opposition, and really quite aggressive behaviour.

MCCLENNON: You had to leave the Foreign Office because you got married. In those days you had no option; once you married you had to give up your job.

ANSTEE: This was the case right up to 1971, which I find incredible.

MCCLENNON: Yes, I can't believe it it was so recent. In fact, it was because of the breakdown of your marriage that you actually ended up in the United Nations. How did that come about?

ANSTEE: When I found myself stuck in the Philippines without a passage home, I was very anxious. It was one of those problems that still affects so many women today that I was dependent, so I accepted a job in the local UN office in order to be able to earn my fare home.

MCCLENNON: Because you had a very philandering husband, didn't you?

ANSTEE: Well, not so much philandering as— well—I say in the book that he took to Manila life like a duck to water, but unfortunately he did not stick to water. And at the age of twenty-nine I had given up three careers, but when my marriage irretrievably broke up I was very fortunate because the UN sought me out again. I think I am still the only person who started life as a local staff member who ended up as an Under-Secretary General.

MCCLENNON: One of your early postings was in Colombia, back in 1956, working as the first female field officer for the United Nations. You were

barely thirty at the time. How daunting was it to find yourself there?

ANSTEE: It was quite daunting. Women didn't even have the vote. I was supposed to be the number two in the office but by a series of circumstances I found myself at the head of the office. I remember a big programme, entirely run by men, who were much older than I was. I remember trembling all the way back from the airport, but it was a very good experience. I think it's something that most women should seize if they have that opportunity. You're thrown in at the deep end of the swimming pool and then you discover that you can swim. It was a tremendously maturing and confidence-building experience.

MCCLENNON: Another experience was in Angola and that also seems to have left a lasting sadness with you. Did you think that the UN failed in its role with Angola?

ANSTEE: I think the international community failed to give Angola the support it needed at the time that I went there, because we were given 350 unarmed military observers and 130 police officers to deal with a supposedly post-conflict situation where there were 200,000 armed men still to be dealt with. And afterwards the whole attention of the UN was on Bosnia Herzegovina and when the war broke out again I could not get the support that I needed to bring about peace. And of course it was very daunting personally because there was Jonas Savimbi, that Union leader, who first of all called me mother when he thought he was going to win the elections, and afterwards accused me of smuggling diamonds and mercury, and then said that I was an international prostitute. The BBC, by

the way, sent this item round the world. It was heard by my elderly aunt on the Welsh Marches who said to me, 'Darling, I don't mind so much about your morals though I do think a prostitute would be the first in the family.' But she added, 'Do be careful of the stray bullet' that he'd also threatened me with.

MCCLENNON: You have been on *Woman's Hour* before, back in 1955, when you talked about a boat trip in the Philippines. Do you recall that?

ANSTEE: Yes, I do, and I got paid £24 for it and I went out immediately and bought myself a new suit.

Since leaving the UN in July 1993, Dame Margaret has continued to travel extensively—acting as an advisor and trainer on peacekeeping and conflict resolution for the UN, but also taking part in scenario based training with NATO. She is a member of Jimmy Carter's International Council for Conflict Resolution. In 1994 she was made a Dame Commander of the Most Distinguished Order of St Michael and St George. The Order is awarded to men and women who have held, or will hold, high office, or who render extraordinary or important non-military service in a foreign country.

Hillary Clinton

interviewed by Martha Kearney
4 July 2003

Hillary Rodham Clinton was born in 1947. In 1969 she went to Yale Law School where she met her future husband Bill Clinton. In November 2000 she was elected senator for New York, the first First Lady to be elected to the United States Senate and the first woman to be elected statewide in New York.

CLINTON: The role of the First Lady doesn't have a job description. It comes to each woman who has held it up until now with no expectations other than that you are a symbol. Therefore you have to invent it, you have to create it and shape it to suit your personality. All of those things have to be redone every single time there's a new President.

KEARNEY: From the outset at the White House you decided that you were going to be a very different kind of First Lady. You embarked on this very ambitious programme for health care reform, which ultimately ended in failure for all sorts of different reasons. Do you think that taking that on did reinforce people's idea of you as a power behind the throne? The kind of Lady Macbeth figure that they talk about?

CLINTON: I suppose. I was surprised to learn that Washington ended up being in some ways more conservative than Arkansas. Because Arkansas is a small state. Everybody knew one another and when my husband asked me to work on improving

489

education there, I was more than happy to do it. Of course I ran right into all kinds of differing expectations about the role of the First Lady, and when my husband asked me to work on health care, I was ready to roll my sleeves up. But it caused a lot of consternation. The policy itself was controversial; we don't have a national health care system in America. We have 41 million people uninsured. I would still like to see this situation changed. But it just didn't work out for many reasons and my role was one of the contributing problems.

KEARNEY: Do you really think so?

CLINTON: I became a lightning rod for some of that criticism.

KEARNEY: All the time you were being a lightning rod and getting involved in the intensity of policy reform, you were doing the other First Lady stuff, the flower arranging, the table plans, and this perennial problem of your hair.

CLINTON: I like the traditional duties of keeping a house. I'm not the greatest at it in the world but I loved doing it. It was inviting people to come to your home and therefore it mattered to me what china we used, what the flowers looked like, what the menu was. And that also created some cognitive dissonance.

KEARNEY: I've never heard the phrase 'cognitive dissonance' used about flower arranging before!

CLINTON: But think about it. If we were to take snapshots of what we were all doing, there might be a snapshot of you covering Westminster but then what was happening in your private life? You're all of it. And yet because I was on this very large stage, the fact that I would care about the flowers and about health care, that I would worry about my

490

daughter and do what I had to do in the many roles in my life, caused people to say, 'Does she care about flowers, or does she care about health care?' There's no contradiction. And then, oh, the hair, the hair is the only part of the body you can change at will so why not do it? I wish I were taller, I wish I were thinner—but the hair you can do something about.

KEARNEY: You're obviously a very tightly knit family so when the whole Monica Lewinsky affair erupted, one of the hardest things was having to talk to your daughter Chelsea about it, wasn't it?

CLINTON: Absolutely; these were very private and personal matters. They're not unique to people who live in the White House, I'm well aware of that. They're painful no matter where you live and they need to be dealt with in private. Unfortunately what should have remained private was dragged into the public eye for partisan political purposes, which I found deplorable. The people who were pushing the story and calling for my husband's head literally cared nothing about me or my family, and I knew that. So we had to deal with this as a family and at the same time we had to deal with the public ramifications of an attempt to impeach him and end his presidency.

KEARNEY: When your husband first told you about it, he lied, didn't he? Why did you believe him then?

CLINTON: By January of 1998, when this story first appeared, I personally had been accused of so many ridiculous and absurd fabrications. It was not at all surprising to me that yet another accusation would be made. So when my husband said there wasn't anything to it, I had no trouble believing

that it was yet another one of these terrible stories that people were putting into the press in order to undermine his presidency.

KEARNEY: So when he finally did tell you truth, which was more painful: the fact of the affair or the deception?

CLINTON: Oh, I don't think you can separate it out, it was very difficult.

KEARNEY: There were some extraordinary moments, which you write about, where you can see this tension within you. I think a lot of women will understand how furious you must have been. Yet at one stage you go upstairs and you help him write a speech because that's what you do.

CLINTON: Well, you know, I wasn't in much of the mood to do it, but when you love someone, you accept that there is no perfect person, as far as I'm aware. Love and marriage happen between two imperfect people, and they have strengths and weaknesses, attributes and detriments. But then I had this enormous additional responsibility, which I felt keenly, because I knew that the people who were behind this story, pushing it and making it public, were people who disagreed with my husband's agenda for our country, who wanted power for themselves. That threw an entirely different set of issues into my mind that I had to sort out.

KEARNEY: How do you think that the way that you're perceived by the American people has changed as a result of this experience? Some very unkind things were said about you over the years. You have these nicknames—'chillery', 'Lady Macbeth', 'Heil Clinton'—sorry to go over them all again. But do you think that the Monica Lewinsky

episode was a turning point? Do you think that you did gain a lot of sympathy? Or did women say, 'Why are you staying with that philandering man?'

CLINTON: I think that there's a lot of debate about the issues that present, not only the ones you're referring to, but certainly being the first professional woman to be in the position of First Lady. I've had to stand my ground, not shrink away from controversy because I care deeply about the direction we're going. So I'm ready to take the slings and arrows that come with being in the public eye.

KEARNEY: How would Bill Clinton cope with being First Man?

CLINTON: I don't know that he'll ever have a chance to figure that out. I had a friend say that there will eventually be a woman President and I hope it will be in my lifetime. And then what will we call this person? Someone suggested, how about First Mate?

Hillary Clinton is widely predicted to stand as the Democratic candidate in the 2008 presidential elections.

Akila Al-Hashemi

interviewed by Jenni Murray
28 July 2003

Akila Al-Hashemi was fifteen in 1968 when the Ba'ath Party took power in Iraq. An Iraqi diplomat of twenty-five years' standing, she was one of only three female members of the US-appointed governing council set up by the coalition in the aftermath of the Iraq War as a first step towards an Iraqi-led government. Dr Al-Hashemi represented 'independent liberal democrats'.

AL-HASHEMI: Women in Iraq don't feel safe in going out and working, for multiple reasons, such as the looting, the armed aggression in the street and action that has been directed against women in the workplace. We have two women electrical engineers who worked very hard to repair the power-generating stations, one in Baghdad and the other one in Musab. Both women were killed. Nobody knows who killed them but they were found murdered in their homes. So, you see, these incidents discourage a lot of women from going outside and working.

MURRAY: The country has a long history of female participation. You give me two examples of women in engineering. There are concerns about the influence of radical Islamists on blocking women's participation. How concerned are you about that?

AL-HASHEMI: I don't feel that they are right in these concerns. Iraq by nature is a secular society;

494

it comprises a lot of religions, a lot of nationalities, a lot of minorities, a mosaic of populations. So you cannot find a fundamentalist in Iraq; Iraqis are believers rather than diehard religious.

MURRAY: But whilst Iraq has been, as you say, a secular society, can it remain so? We have had reports from women who have been in perhaps more remote parts of Iraq who tell us about women's rights being eroded, of women's groups not daring to declare themselves, not going to school or to work.

AL-HASHEMI: This is because of the hardship that all Iraqis suffered during the last four decades, and these difficulties not only affect women but men also. The difficulties can be seen more in women than in men because the first victim in any society is of course women.

MURRAY: But it has been commented on widely that there were very few women at the first big tent meeting in Athrea, only three women out of twenty-five on the council, when the UN hopes for a 40 per cent participation of women in the reconstruction. With that long history of participation, why would you say there are relatively so few women coming forward to these meetings?

AL-HASHEMI: We are just emerging from four decades of oppression. Don't forget this. You see, the prosperity of women follows on from the prosperity of society and the freedom in a society. You cannot expect to see half of the participations at the Nasria conference being women; you don't even have that here in Britain. I think that even three women out of twenty-five men in the council is very good. The council is not representing all Iraqis, it's just a

council, just a civil administration for the country. We hope that in the future government, in the future Parliament, there will be greater participation of women. Because Iraqi women have a high standard of culture, of education, of knowledge. We are preparing for democracy so, compared to other countries, I think what we do have is really great.

MURRAY: How much do you and the other two women on the council feel a responsibility for preserving women's rights?

AL-HASHEMI: This is our responsibility; we will have a subcommittee from the council responsible for women's affairs and I think three of us will be in this committee.

MURRAY: I must put to you something that was said to me by an Iraqi woman who had lived in this country in exile and who had just returned to Iraq; she said, 'We view the women who are on this council as puppets. What I observed when I was in Iraq was women being in a position that was worse than in Kabul.' What do you say to that?

AL-HASHEMI: I think it's exaggerated and it's not true. That lady should go to the universities to see how women are doing. She should go to hospitals to see how doctors are doing; she has to go to schools, she has to go to banks. But maybe she's right if she considers how thirty-five years of hard life has affected a lot of women. This is how it is, but as for Iraq being like in Kabul or worse, no, this is not true.

Dr Akila Al-Hashemi was ambushed on 25 September 2003 and died five days later of her wounds. She was buried in the holy city of Najaf.

496

Jane Juska

interviewed by Jenni Murray
11 November 2003

Jane Juska (b. 1936) had just retired from her job as a high school English teacher and had been celibate for some thirty years when she placed a personal ad in the New York Review of Books. *It read: 'Before I turn sixty-seven next March I would like to have lots of sex with a man I like. If you want to talk first, Trollope works for me.' That was four years ago. She received more than sixty replies and spent a year following them up before writing a book about the experience,* A Round Heeled Woman.

MURRAY: Why were you so graphic? You said exactly what you wanted: 'I would like to have a lot of sex with a man I like.' People usually couch these things in romantic notions. You didn't do that, you were absolutely straight.

JUSKA: I thought I would tell the truth. I didn't care what anybody thought at this point. I had no reason not to tell the truth. I was not after long walks on the beach, I was not after going to the opera with someone, I could do all those things myself.

MURRAY: You added the Trollope line as well, which indicated a little sense of humour about it, I thought.

JUSKA: Well, yes, if you're going to do something like this, you need to keep your sense of humour, otherwise you go nuts. I added Trollope because

497

that was true too. He was my favourite writer. I read all of Trollope and it would be nice to talk to somebody about Trollope.

MURRAY: You had sixty-odd replies pretty quickly and divided them into three piles: yes, no and maybe. What were the criteria?

JUSKA: The writing, really. The ones that went immediately into the yes pile were beautifully written, all of them, and the men were not married and they lived in a geographical area that I wanted to go to. So those were my criteria, I guess.

MURRAY: And what sort of encounters ensued?

JUSKA: All different kinds. There was one public display in a restaurant in San Francisco that should have sent me into another thirty years of celibacy.

MURRAY: This was the man who'd been a teacher, who had been chucked out of teaching for sexual harassment and appeared quite mad.

JUSKA: Yes. He claimed it was just his sense of humour. He turned to the people in the restaurant and he screamed, 'Who's got my medication? I do terrible things without it.' Then he got up and he went to the window—we're on the third floor of the restaurant—and he put his foot on the ledge, as if he were going to jump out. And I said in my loudest teacher voice, 'Sit down,' and he did. But then he turned to the people in the restaurant again and said, 'This is our first date. How do you think I'm doing?'

MURRAY: He didn't last. What about the more successful ones?

JUSKA: The more successful ones were men that I got to know, I thought very well, by way of phone, by way of e-mail, by way of letters. Somebody said to me once, 'How could you sleep with all those

498

strangers?' And I said, 'But they weren't by the time we met.' We had come to know each other very well, I thought.

MURRAY: What do you mean, 'I thought'?

JUSKA: I wrote a warning in the book—be careful of thinking you know a person too well by way of his writing, because what we can do by way of writing is revise ourselves into our own best notion of ourselves and then send that out. And that of course was what I did and what they did. Then came the phone calls, I don't know, sometimes it's just so romantic. I was just like a teenager: oh, a phone call at midnight! What am I wearing? Let's see.

MURRAY: Was the sex great when it came to it?

JUSKA: I was very unschooled really, I mean, thirty years is a long time. So I was scared, I was terrified. So the first one wasn't so hot but I thought, well, you're not used to this, Jane. And then it got better and then, when I began to write about it, I had to think about how it was different with John from what it was with Robert, that sort of thing. It made for interesting writing but writing about sex is very hard. When I came to describe sex with Graham, who is much younger than I, I thought, how am I going to make this palatable to a reader?

MURRAY: And where does it all stand now with the men? I think you're still seeing several of them, but why no plans to settle down with anyone?

JUSKA: I would if I were forty or thirty and wanted a family, but I'm seventy. I haven't met anybody I want to settle down with to the exclusion of everybody else.

MURRAY: Are you shocking yourself?

JUSKA: Sometimes. Once I was doing a reading and I was getting to a part that was kind of graphic

and I just said to myself, 'I can't read this out loud,' and some woman in the audience said, 'Oh my God, you wrote the book, you can certainly read it to us!'

Dame Kathleen Ollerenshaw

interviewed by Jenni Murray
8 July 2004

In 1921 when she was only eight, Kathleen Ollerenshaw became completely deaf. Nevertheless she went on to win a place at Oxford to read Mathematics. She got a doctorate, became a leading educationist, and at eighty-six published a book on mathematical magic squares to international acclaim. She is now ninety-three, a Dame and has published her autobiography, To Talk of Many Things.

OLLERENSHAW: As a very little child, just from nowhere, I discovered that I loved doing sums, loved doing tables with pencil and paper, and multiplying by two. Then I found I could do it well and people said, 'Clever girl,' so I did some more.

MURRAY: What were the attitudes to people who were deaf in the 1920s?

OLLERENSHAW: You were considered dense, or inattentive, or naughty. But I was very lucky because I was in this Montessori school where they were sympathetic to it, so I was extremely lucky.

MURRAY: Your interest in maths seems to have intensified after the deafness. Why?

OLLERENSHAW: One reason was that it was the one area where I wasn't at a disadvantage, when every other subject depends much more on hearing. Also I could do it and I knew my tables and so I was top.

MURRAY: You did have to fight hard to get into Oxford. I think at one point your teachers were reluctant to allow you to apply. What happened?

OLLERENSHAW: They were reluctant in the first place at school, because they said the only future for a person with mathematics, for a girl, was in teaching and as I obviously wouldn't teach, because I was deaf, they said that I ought to do something else. When they said that, I went through the roof and really threw a tantrum, and said, 'I only want to do mathematics.' So the school gave way and that was great.

But at the interviews at Cambridge I gave away that I was deaf, and they were very unsympathetic and said I'd never manage. In the Oxford interview, however, I was quite extraordinarily lucky, because they never knew I was deaf and I was able to lipread sufficiently well. They asked me this question: what had I done in the summer holiday? I'd just been to Geneva to the Disarmament Conference, in 1930, and I had written the article on it for the school magazine, and so I had every name and every fact right at my fingertips. They were incredibly impressed.

MURRAY: What was the reaction at the university when they actually discovered you were deaf?

OLLERENSHAW: They were completely bemused, they didn't know what to do really, and there were no mathematics dons in Somerville at the time. I didn't make the best use of my undergraduate years at Oxford, because I got engaged to Robert in my very first term. I played hockey all the time and was good at sport and became captain of the university hockey team. But I had a second chance ten years later, because of the war. The second chance was

502

that I became a wartime don. Then I lived an absolutely solid life of the mind and it was a wonderful way to be able to do it. After the experience of the First World War when I lost relatives and friends, it never crossed my mind that my own husband would come back; I was a pessimist. I thought that everybody was killed in war.

MURRAY: So how did that influence your attitude to work and earning your own living? Did it make you feel very independent?

OLLERENSHAW: I thought that I had got to be independent. It never occurred to me that I would have the bliss of a real, happy, married life after all that.

MURRAY: In 1949 you got a hearing aid. What difference did that make?

OLLERENSHAW: It was just like a miracle, just like when you read about blind people who can suddenly see. I couldn't believe it; it was quite extraordinary, like being born again, because I could suddenly hear the sounds that I didn't know existed.

MURRAY: What do you remember of what you first heard?

OLLERENSHAW: We had parquet floors in the house and a wooden staircase, and what I remember most vividly was hearing my footsteps going down the stairs and nearly falling over with the shock, and then going outside and hearing the birds for the first time. I remember that very vividly.

MURRAY: You say that your maths has helped you through the most difficult times in your life, such as the loss of your husband and of your children. Why did the maths sustain you through such hard times?

OLLERENSHAW: Because it could absorb my total attention and it could take you away from your troubles. It's no good grieving; you can grieve and you just get worse and worse, and go on grieving. For me it was an act of will. I go to my desk and always at night I do some mathematics. I take some problem with me to bed at night, and the answer's often there in the morning. Never go to bed at night worrying or grieving.

Professor Mary Midgley

interviewed by Jenni Murray
30 July 2003

Professor Mary Midgley (b. 1919) is a philosopher with a special interest in science. She began her studies in wartime Oxford where she was a contemporary and close friend of Iris Murdoch. A senior lecturer in philosophy at Newcastle University, she wrote her first book, Beast and Man, *in her fifties. She has since published many books, including* Evolution as a Religion, The Ethical Primate *and* Science and Poetry. *She appeared on* Woman's Hour *to talk about her latest book,* The Myths We Live By, *which examines myth and science.*

MIDGLEY: They seem not to go together but really they do. People have the notion that the imagination is something quite separate from science, that when we deal with science we're dealing with hard, definite, objective facts, and when we use our imaginations we have no facts at all. I think this is really a very great mistake. Science, like all the rest of our thought, has its roots in our visions, our images, our emotions. I picked the word myth deliberately but I don't want this to imply that I mean falsehoods. 'Myth' is already quite a powerful word for the imaginative patterns that we know are important in our lives. When we come to do more precise thinking, as in science, we are already dealing with a world that is shaped by these imaginative patterns.

MURRAY: You pick out particularly two images that you say have an impact on our thinking: the machine and the microscope. Why do you focus on those two?

MIDGLEY: Machines generally and microscopes in particular are among the symbols that have this terrific force for us. In times past, most of the patterns that people were most obviously moved by were probably patterns about human interaction, but now machinery is so important to us that it dominates our imagination and we are in the habit of seeing things as machines, whether they are or not. In the seventeenth century clockwork began to have this tremendous impact on people; other things were seen as clockwork too and when people came to think about the living world, they sorted it out as if it related to the clock. Since that time, other things have had the same impact as the clock, and the microscope, I think, is one. It is a notion of a device that breaks things down into their tiny parts and thereby explains everything, so that that's the explanation you always want to have for everything else. It's terribly powerful today. It's not necessarily anti-rational to think in this way but there's no absolute need to think that that's the only way to understand things.

MURRAY: But seeing things in smaller and smaller parts does lead to some understanding of, let's say, the human genome, for instance, and the machine does shape our environment in terms of transport, heat and light.

MIDGLEY: Oh yes, there is real advantage here. But it's not the only way to think. Take a leaf. A botanist is handed a leaf and asked to explain it; the first thing that he does is not to boil it down

506

and chop it up into its smallest parts. The first thing he does is to look at the shape of it, think what tree it came from, what sort of forest that tree might have been in, what climate. This is equally scientific but somehow the habit has developed of looking at things in the other way first.

MURRAY: You write about the myth of progress. What do you mean by that?

MIDGLEY: The idea that life on earth will go on getting better and better came into fashion just when people stopped thinking they were all going to heaven, at around the end of the eighteenth century. Notions of history, of a rosy and hopeful kind, were invented then and we all know they were very strong in Victorian times. People are not seriously arguing that so much any more but we are all very used to the thought that machines will make things better and better. This is a dream, I think, a story that we tell ourselves. There is something in it; it has been an advantage to people to get clean water, and maybe to move around more quickly and so forth. But it's not an unlimited advantage that's going to go on increasing.

MURRAY: You're approaching eighty-five now, I think. What motivates you to keep tackling these big issues and writing about them?

MIDGLEY: I see people believing things that I'm sure aren't right and having a bad effect by so doing, and I think that I could help here by explaining it a bit differently. I have compared philosophy here to plumbing and I think it's a good comparison. There is a system of ideas running under the world that we live in, and we don't notice it a great deal of the time, any more than we notice the water. Then sometimes awful smells start

507

coming up from below or the taps don't run. You've got to take up the floorboards and see what's wrong. This is what I see myself as trying to do and I haven't stopped feeling like that about it.

In 2005 Professor Midgley published her autobiography, The Owl of Minerva: A Memoir.

Sharon Osbourne

interviewed by Jenni Murray
7 September 2004

Sharon Osbourne (b. 1952) has moved from being known as the manager and wife of Black Sabbath's Ozzy Osbourne and mother of Kelly, Jack and Aimee, to being a star in her own right. Fame came with the cult television show The Osbournes.

OSBOURNE: I think my biggest regret in all of it was that my eldest daughter Aimee didn't want to be involved in the filming and therefore it made a situation where Aimee wasn't comfortable coming home because of the cameras, so she was kind of pushed aside. I don't honestly think, to be really truthful with you, that my kids went off the rails; just because the cameras were there; they would have gone anyway.
MURRAY: You've said that you partly blame yourself for that in some ways. Why?
OSBOURNE: Because I'm their mum. You're meant to know your kids better than anybody in your life and I didn't see it happening.
MURRAY: But how are they now?
OSBOURNE: Jack is unbelievable. For nearly a year and a half he's been clean and sober, and he does a lot of work for teens in America. He goes around and lectures at schools about alcohol and drugs. I'm just so proud of him.
MURRAY: And what about Kelly? She got addicted to painkillers, didn't she? Has she got off those?

509

OSBOURNE: Yeah, touch wood. But every day you never know. You know what it's like being a mum and kids today don't have it easy; they have so many pressures. I'm not making excuses, but honestly I wouldn't want to be a teenager now. So far she's doing great.

MURRAY: I also read in a woman's magazine that you had lots and lots of plastic surgery.

OSBOURNE: Yes, I have.

MURRAY: Face, boobs.

OSBOURNE: Boobs, bum, legs, everything.

MURRAY: Why?

OSBOURNE: Because I'd always had a weight problem my entire life. I'm one of these girls that put on fifty pounds. Lost fifty pounds, then put on sixty-five. Then lost the sixty-five, then put on a hundred pounds. My entire life I have been yo-yoing. About five years ago my back was really hurting and my feet. When I'd go up the stairs Jack would have to be behind me, lifting my bum up the stairs, because I couldn't make those stairs, they were killing me. I thought, what am I doing? I've tried every diet in the world and I just couldn't stop eating. So I had an operation on my stomach to make my stomach smaller. I lost 125 pounds and then I had all this hanging skin everywhere. So I decided, when I lost all the weight, now I can get rid of it all and have nice boobs and things.

MURRAY: What does Ozzy think of the way you look now?

OSBOURNE: He's really proud of me, he is, but he doesn't want me to have anything else done. Eating, though, is a worse addiction than drinking. It's a terrible addiction to have and it never ends.

Even though I had my stomach stapled and I lost 125 pounds, now I've put on thirty, because I still eat. I just don't think you ever get over it.

MURRAY: And what about Ozzy and the drinking? Because you walked out, didn't you, at one point?

OSBOURNE: Yeah, I did last year because my son was doing so well and it was destroying him to see Ozzy still drinking. I'd always had it in my mind that if his drinking ever got to the children, then I would have to go. So that was when I left, though I went back after four days because he got sober. And he's been sober ever since, so he's really trying.

MURRAY: You've been married since 1982, a tremendously long marriage in an area, I suppose, where marriages tend not to last. What is it about him that you love so much?

OSBOURNE: I was never really a mover and a shaker as far as the dating side of my life goes. I didn't have a different date every night of the week. I just adored him from the minute I saw him. He makes me laugh and he's very honest and he's very naïve too, which I find really attractive. And with all his bad behaviour and everything he's done and everything I've done to him, I still feel happier with him than without him, so that's it.

Sharon Osbourne gained more celebrity in the UK with her appearance as a judge on The X Factor. *In 2005 she published her autobiography,* Extreme.